FLASH® **MX**

[inside
macromedia®]

[inside macromedia®]

Shannon Wilder

Chris Volion

Scott J. Wilson, Ph.D.

THOMSON
★
DELMAR LEARNING™

Australia Canada Mexico Singapore Spain United Kingdom United States

THOMSON
DELMAR LEARNING

Flash MX
(Inside Macromedia)
by Shannon Wilder, Chris Volion, Scott J. Wilson, Ph.D.

Business Unit Executive:
Alar Elken

Executive Editor:
Sandy Clark

Acquisitions Editor:
James Gish

Editorial Assistant:
Jaimie Wetzel

Executive Marketing Manager:
Maura Theriault

Marketing Coordinator:
Sarena Douglass

Channel Manager:
Fair Huntoon

Executive Production Manager:
Mary Ellen Black

Production Manager:
Larry Main

Production Editor:
Tom Stover

Cover Design:
Brucie Rosch

Editorial:
Daril Bentley

Full Production Services:
Liz Kingslien
Lizart Digital Design, Chicago, IL

For permission to use material from this
text or product, contact us by
Tel (800) 730-2214
Fax (800) 730-2215
www.thomsonrights.com

ISBN No. 1-4018-1479-4

The authors would like to thank the follow-
ing parties for allowing us to use their images
in our book and exercises. The images may
appear individually or as part of a collage.

Corel
Digital Imagery © Copyright 2002
Corel Corp.

PhotoDisc
Digital Imagery © Copyright 2002
PhotoDisc, Inc.

Chris Volion

NOTICE TO THE READER

FLASH MX TABLE OF CONTENTS

CHAPTER 10

CHAPTER 11

CHAPTER 12

CHAPTER 13

CHAPTER 14

Introduction

Artistic and Technical Skills

Learning how to use Flash MX is only one aspect of what is required to create a functional and professional-looking web application. Generally there are many different skill sets involved. These skills may exist within a single individual or may be represented in the composite skill set that exists among a team of people. At a minimum, this set of skills should include a proficiency in:

* *Design and layout principles*

* *Artistic creativity and execution*

* *Writing*

* *Program, message, or instructional design*

* *Audio techniques*

* *Use of the authoring software*

* *Project management*

Although the focus of this book is to help you learn how to use the Flash MX software program, the acquisition of these technical skills should be considered within the context of other skills that may be required. The extent to which you may need other skills will depend to a large extent on the type of application you are creating, its intended use, and how "professional" you want the result to be.

We realize that many readers may not have an art background. Therefore, the exercises included in this book do *not* require an art background, although you can enhance them on your own if you do have artistic talent. In that case, we encourage you to take creative license to modify and embellish the subject matter of the exercises.

Instructional Approach

Because of the many features and functions, Flash MX may at first seem intimidating. We do not want to overwhelm you with a lot of details all at once, and therefore begin by introducing the aspects of Flash MX that are the most practical and most commonly used to build programs in the real world.

With this book you have an opportunity to learn Flash MX in an intuitive way while practicing some of the techniques and shortcuts typically used by developers using Flash MX for real-world applications. Each chapter builds upon the last, adding new features of Flash MX to your builder's toolbox.

The chapters in our book break up the material into "learning chunks" that are about right for most people during a single session, whether you are learning on your own or using this book within a classroom setting. The learning activities used in these chapters are centered on the concept of "learning by doing." These learning activities are a synthesis of the authors' many-years experience in teaching multimedia software and as authorized Macromedia Training Providers.

Learning Activities

Macromedia supplies both print-based reference material and online help, not to be duplicated here. This book was written to help new users more quickly come up to speed in using Flash MX so that they can build high-impact web applications that include graphics, animation, sound, and interactivity. The learning activities found within the book are designed to accommodate different learning styles and situations. A brief description of these learning activities may help you to better use the material presented within the book.

Guided Tours

Most chapters include a structured "walkthrough" of how to perform tasks such as making menu/window selections or looking at the various properties or options listed. A guided tour is not really an exercise, but follows the notion of learning by actively "looking and doing."

Practice Exercises

Most chapters will include hands-on experiences that introduce the basic skills of using tools and techniques to build Flash animations typical of real-world applications. The scope of an exercise is fairly narrow, focusing on the concepts and skills introduced in the chapter. The content is generally simple so that the emphasis remains on building structures and using techniques, and so that there is no dependence on preexisting artistic or programming talent. Again, feel free to modify and embellish the exercise content. Each practice exercise includes the following project elements, which reflect aspects of the real-world development process.

- Description: *Provides a general description of the purpose of the exercise and of the components used within it. Generally, real-world projects include a project description, although they are typically much more detailed than those found in these exercises.*

- Take a Look: *Asks you to make use of the companion CD-ROM by loading and playing a file that is the completed version of the exercise you are about to create. This section includes notes on aspects of the exercise you should pay attention to as you examine it.*

- Storyboard: On Screen: *Provides screen captures of what will be seen on screen when the exercise is completed, to serve as a printed reference. A storyboard that includes on-screen descriptions or illustrations is a vital real-world project deliverable. (A deliverable is a phase of the development process where there is something tangible that is "delivered" to the client/customer.)*

- Storyboard: Behind the Scenes: *Provides screen captures illustrating the Flash MX timeline of the completed version of the exercise, to serve as a guide for development. A storyboard that includes programming descriptions or illustrations is a vital real-world project deliverable.*

- Go Solo: *You will see this icon immediately following the storyboard sections. At this point in an exercise, you should have the information necessary to complete the exercise on your own, and you are encouraged to give it a try. If you need help, however, you can use the step-by-step instructions that follow.*

- Step-by-Step Instructions: *For those who would like structured help with the details of the tasks involved in the exercise. The numbered steps state what needs to be done, whereas the lettered substeps describe how to perform a given step.*

Application Exercises

Application exercises provide hands-on experience in building structures that combine the concepts and skills learned across several chapters. Each application exercise is a component of a "real-world" application representing a complete web application. The companion CD-ROM contains the completed version of each application exercise, so that you may skip over some content areas and still be able to work on the application project.

Using the Book on Your Own

Each book in the Inside Macromedia series has been designed to be used either on your own or within a classroom setting. Those of you who use this book to learn Flash MX on your own will find that you are guided through the process and are given the freedom to modify what you want.

Keep in mind that there are generally several approaches to building something. You may end up performing exercises using steps (or sequences of steps) different from those outlined in this book, which is fine if your structure does what it needs to do. Note also that the step-by-step instructions provide two levels of detail.

- *Numbered steps: State what needs to be done.*
- *Lettered substeps: Describe how to perform particular steps.*

Using the Book Within a Classroom

As instructors for Flash MX, Dreamweaver MX, Fireworks MX, Authorware 6 (and others), we also think these same learning activities (presented somewhat differently) are equally effective in the classroom. There, we use the book as a point of reference and organizational guide for the presentation of material. As a point of reference, we do not read from the book, nor ask students to do so (in class). Rather, we use the book to organize the classroom presentation. We encourage students to take notes, directly in the book. In regard to the elements used in this book, in the classroom we employ the following strategies for each chapter covered.

- Conceptual overviews: *We verbally present an overview of the chapter, with each instructor adding her or his additional details or points of emphasis.*

- Guided tours: *Using a projection device attached to the instructor's computer, as a class we walk through the essence of a particular tour.*

- Practice exercises: *Using a projection device, as a class we walk through the beginning of an exercise, including use of the following elements found in this book.*

 - Take a Look: *We look at the completed version of an exercise, pointing out noteworthy characteristics.*

 - Storyboard: *We use the completed version to look at what is on screen and what is programmed (making reference to the screen captures in the book and to what is on the projected classroom screen).*

 - Go Solo: *For exercises found in the beginning chapters and those involving more difficult concepts, the instructor (using the projection device) leads the class through the initial process of putting together the fundamental structure. Thereafter, we ask students to complete the exercise on their own.*

 We occasionally stop the class and point out common difficulties. As students continue on their own, we suggest that they first look at the numbered steps that state what needs to be done, and then try to figure out how to perform those steps on their own, falling back on the lettered substeps if they need help.

 - Instructor help: *We walk around the classroom, providing help and additional information as needed.*

 - Tips: *Each instructor contributes his or her own additional information based on professional experience.*

- Application exercises: *We have found that the application exercises are an excellent means of helping students integrate, practice, and solidify their newly learned skills, in an environment in which they can receive help and guidance if they so choose. Depending on the content of an exercise and the characteristics of a particular class, our instructors will either put the class in "workshop" mode (in which students work on the exercises by themselves) or begin an exercise as a collective effort, subsequently having students finish the exercise on their own.*

Icons for Quick Access

The Inside Macromedia series uses the following icons, appearing in the minor column, to provide quick, visual cueing to particular types of information.

CD icon: Indicates that material from the companion CD-ROM is necessary at this point in an exercise or guided tour.

Tip icon: Provides additional information related to an aspect of an exercise or guided tour.

Caution icon: Occasionally there is information about what to do or not do that is pretty important. Generally, ignoring this type of information results in or has the potential to result in unpleasant events that the Undo function cannot undo.

Go Solo icon: Indicates that at this point the learner has enough information to take control of the starship (exercise) and at least attempt to complete the exercise on her own.

Necessary Basic Computer Skills

It is assumed that you will already have the skills necessary to work in the basic Windows or Macintosh environment prior to undertaking learning Flash MX. Specifically you should be able to:

* *Use the mouse and keyboard for basic input and selection*
* *Select and drag objects*
* *Resize windows*
* *Locate directories (folders)*
* *Locate files within directories*
* *Create directories (folders)*
* *Copy files*

Getting Your Computer Ready for Practice Exercises

Throughout the course of this book, you will be creating many Flash MX files you will want to save on your computer. To make it easier to locate these files and communicate to you about these files, it is strongly recommended that you create a new directory (folder) on your computer's hard drive to store these files.

Before beginning any of the exercises in this book, create a directory (folder) on the root directory of your computer's hard drive. Name the directory (folder) *SaveWork*.

Files on the Companion CD-ROM

This book makes use of numerous learning activities, which include pre-existing Flash MX files and a variety of media elements. All of these files and elements are contained on the companion CD-ROM found at the back of the book.

Acknowledgements

First and foremost we want to thank the thousands of students who have attended our classes over the last nine years. Through your enthusiasm and probing questions, you have given us not only enjoyment in teaching the classes but have helped us become better at what we do.

We would like to thank the many people at Macromedia with whom we have worked over the years: in the Authorized Training Program; Authorized Developer Program; Value Added Reseller Program; Technical Support; Marketing / Trade Events; and Development / Engineering teams.

We would like to thank the past and present faculty members at Media Magic, who have not only done a great job in providing instruction, but who have also helped us revise and improve our instructional methodology in teaching the many classes over the years.

We want to sincerely thank the many people at OnWord Press / Thompson Learning for the help and encouragement they have provided: James Gish, for helping us to better target and focus the Inside Macromedia Series; Daril Bentley, – your help, guidance, encouragement, feedback, and suggestions have been greatly appreciated; Thomas Stover, for technical expertise and work behind the scenes, Liz Kingslien (Lizart Digital Design) for your wonderful production work and enjoyable working relationship; and Vincent Nicotina, for work on our CD-ROM.

From Shannon

Thanks to all my colleagues and friends at the University of Georgia, especially everyone in OISD and ECT. To my good friend Meg who lives up to her name spelled backwards. And most of all to my wonderful husband, Lance.

From Chris

I'd like to thank my wife for her support and patience while I was busy juggling this book, two teaching jobs and an administrative role at church (yes Janet... now I'll have time to scoop the kitty-litter and take out the trash on a regular basis). I also thank God for the utterly unexpected career opportunities I've seen in the last couple of years and the U.S. Army for teaching me how to Be All That I Can Be. I'd also like to point out to the teachers and school counselors of my past that I am not, as it were, incorrigible.

From Scott

Shannon and Chris – many thanks for all your hard work helping to bring this work into being. Marie-Claire, my wise and beautiful wife, thank you from the bottom of my heart for your continued support, faith and love. Many thanks to my family, teachers, students, friends, colleagues and fellow human beings – from whom I have learned so much along the way.

C H A P T E R

1

Getting Started with Flash MX

Introduction

Over the years, as Macromedia has created and acquired new software products, its software interfaces have not only improved but with the integration of related products have become more and more consistent. This consistency has reached a new standard with the MX software family, the essential components of which are shared among the Macromedia MX offerings. This shared MX interface allows users to cross over and begin to use the other MX software family products much more easily and quickly.

Flash Applications

Macromedia's Flash is one of the industry's leading authoring software programs used to create high-impact web sites that include graphics, animation, sound, and interactivity. Flash uses a highly visual interface in which elements can be introduced, positioned, and easily animated without the heavy-duty programming commonly required only a few years back.

Flash integrates drawing and paint tools similar to those found in Macromedia's Fireworks MX and Adobe's Photoshop, making it possible to easily create new elements from scratch, or import and modify them if developed in another graphics program. Flash can output (or publish) files using a variety of file formats, greatly increasing the distribution options for your projects. The programs you build with Flash can be:

- *Run in a web browser as a standalone program*
- *Easily inserted in HTML pages*
- *Exported as animated GIF files*
- *Exported in QuickTime video format*
- *Published as projector files*
- *Exported in other formats, allowing you to use Flash for many types of multimedia projects*

This chapter introduces you to the Flash MX interface, which consists of four primary components: menus, the stage, the work area, and a variety of dockable panels. The overview in this chapter is extended to the details of each of these interface components as they are encountered in subsequent chapters.

Windows Versus Macintosh

Flash MX, like most of Macromedia's software, is virtually the same on both Macintosh- and Windows-based computers. The biggest variation stems from minor differences in a few keyboard keys and the absence of the right button

on the Macintosh mouse. Table 1-1 compares the Windows and Macintosh basic keyboard functionality differences.

Windows	Macintosh
Alt in combination with er key	Opt in combination with anoth- another key
Ctrl in combination with another key	Cmd in combination with another key
Right mouse button click	Ctrl with mouse click

Table 1-1: Windows Versus Macintosh Basic Keyboard Functional Differences Under Flash MX

Throughout the book these differences are minimized in that we most often make selections through the use of menu options, which are the same across both platforms (unless otherwise noted). You will note in exercises that the keyboard shortcut icon points to Macintosh and Windows keyboard shortcuts.

To provide a consistent look for screen captures, most illustrations depict the Windows version of Flash MX. When necessary, Macintosh screen captures are also provided. By the end of this chapter, you will be able to:

- *Open the Flash MX program*
- *Create a new document (movie), setting properties as you do so*
- *List the Flash MX menus*
- *Briefly describe the concept of layers as they are used within Flash MX*
- *Work with the options in the Layers panel*
- *Briefly describe the function of the Properties panel*
- *Dock and undock panels*
- *Reset panels to their factory default settings*

Let's begin with Guided Tour 1A, which takes you through the process of opening Flash for the first time.

Before You Start

Before you start going through the guided tours or practice exercises, you may want to read through the Preface, if you have not done so already. The Preface contains information that may help you work with the exercises in this book more easily. The Preface includes sections on:

- *Artistic and Technical Skills*
- *Instructional Approach*

- *Learning Activities*
- *Using the Book On Your Own*
- *Icons for Quick Access*
- *Necessary Basic Computer Skills*
- *Getting Your Computer Ready for Practice Exercises*
- *Files On the Accompanying CD-ROM*

Guided Tour 1A: Opening Flash for the First Time

Before we begin to examine the Flash interface, you may find it useful to open your copy of Flash MX and look at the software screen, menus, and panels as discussion of them proceeds in the sections that follow.

Windows Computer

After you have successfully installed Flash MX on your computer, you can open it like any other Windows software program, as follows:

1. Click on the Start button on the Windows Navigation bar to open the Windows main menu. Select Programs. See figure 1-1.

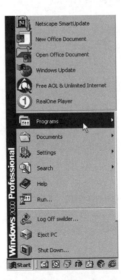

Fig. 1-1. Selecting Programs from the Windows main menu.

2. Select Macromedia | Macromedia Flash MX. See figure 1-2.

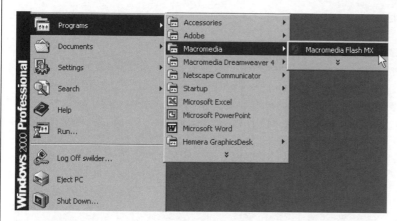

Fig. 1-2. Macromedia folder and Flash MX program.

As Flash MX opens, it presents an opening title screen. The exact appearance of this screen will differ, depending on whether you have a commercial version or an educational version.

3. Once Flash has loaded, verify that you see the Flash MX main interface, including the menu and many panels, as they are located according to the factory default settings.

Macintosh Computer

After you have successfully installed Flash MX on your computer, you can open it like any other Macintosh software program, as follows:

1. Double click to open the Macintosh hard drive, where you installed Flash MX.

2. Select the *Macromedia* folder. See figure 1-3.

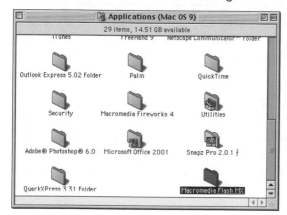

Fig. 1-3. Macromedia folder.

3. Select Flash MX. See figure 1-4.

Fig. 1-4. Flash MX.

As Flash MX opens, it presents an opening title screen. The exact appearance of this screen will differ, depending on whether you have a commercial version or an educational version.

4. Once Flash has loaded, verify that you see the Flash MX main interface, including the menu and the many panels, as they are located according to the factory default settings.

A Metaphor for the Flash Interface

Before we dive into looking at how Flash works, it would be useful to consider the metaphor that has been used to build the Flash interface. The metaphor and many of the interface elements are very similar to another Macromedia software program, Director. Flash's metaphor is the key to understanding the program's interface, development process, and language used to create projects. The metaphor is based on the notion of a movie or theater production.

Think of it like this: You are creating a production, essentially a *movie*. Each time you work on a project in Flash, you are working on a movie. Your role is executive producer. It is your task to decide on the setting for the movie, how the story line will play out, who the main characters will be and what actions they will take, and what types of special effects will be needed to make your movie appealing to audiences.

Everything that appears (or that is heard) in your movie takes place on the *stage* (like a Hollywood sound stage). The actors, scenery, and props used in the production are referred to as *objects* within Flash. As on a sound stage, objects appear on the stage, to varying degrees toward the front or back (i.e., foreground or background). Although Flash works as 2D animation, you can create the illusion of depth by placing objects in the foreground or background of the stage.

Objects appear more toward the front or back of the stage by placing them in different layers that are either in front of or in back of each other. The action on the stage is captured in individual *frames*. A *frame* is like a "single moment of time" that includes everything in every layer, at just that moment. As each one of these frames is created, they are "strung together" to make up a *timeline,* which consists of the entire movie production from beginning to end. You will look at each one of these interface elements in more detail as you proceed through the chapter.

Introduction to the Flash MX Interface

Flash's interface provides you with a complete workshop of authoring tools you use in the creation of your movie. The following are the major components of the Flash interface, as shown in figure 1-5.

- *Menus*
- *Stage*
- *Work area*
- *Main panels*
 Timeline

 Tools

 Properties

 Answers

 Library

 Controller

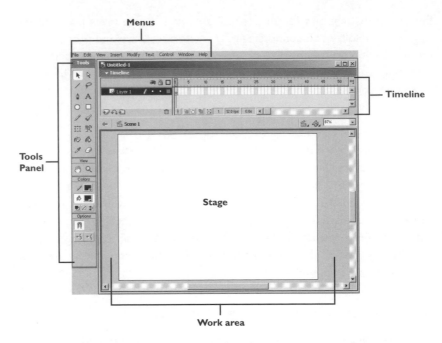

Fig. 1-5. Major components of the Flash interface.

Flash Menus

The menus run along the top of the Flash interface. The menus (and many of the options within the menus) found in Flash are fairly typical in organization and function to those found in many software programs. See figure 1-6. The sections that follow describe the functionality of each menu, including some of the more frequently used options contained within them. You will take a closer look at the full range of the options for each menu as they are encountered in the guided tours and exercises of subsequent chapters.

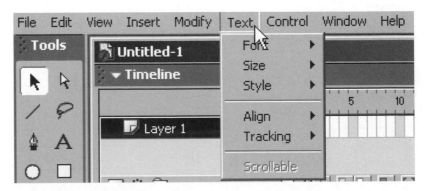

Fig. 1-6. Menus in Flash MX.

File Menu

In your copy of Flash MX, select the File menu and examine its options. Note that many of the menu options also include the designation of Keyboard Shortcuts. The exercises that follow include keyboard shortcuts for both Windows and Macintosh computers.

The options listed in the File menu pertain to things you can do to Flash files. The common options include creating a new file, creating a new file from a template, opening an existing file, opening a file as a library, and saving a file. You also use this menu to import graphics from other programs for use in Flash, as well as to export and publish your movie files in various formats.

Edit Menu

Select the Edit menu and examine its options. Most options are currently not available (are grayed out). Several options listed here are the same as those you have used in many other software programs: Cut, Copy, Paste, and of course the indispensable Undo. Note the variations of these common options that will provide you with far greater capability: Paste in Place, Paste Special, Duplicate, a set of options specific to frames, and a set of options specific to various types of edits. You will have the opportunity to work with all options in the exercises that follow.

View Menu

Select the View menu and examine its options. The options in the View menu allow you to turn on/off a variety of display options (Rulers, Grid, Guides, Timeline, Work Area), as well as to select from various types of zoom and display control (Zoom In, Zoom Out, Magnification, Outlines, Fast, Antialias, and Antialias Text).

Insert Menu

Select the Insert menu and examine its options. The options listed here allow you to insert layers, layer folders, motion guides, frames, keyframes, and other elements into the timeline of the movie.

Modify Menu

Select the Modify menu and examine its options. The Modify menu contains options that provide the capability to change the overall characteristics of the file (via the Document option) or organizational elements (Layer and Scene options) within the file. Some options are identical to those found in Fireworks MX and other programs, allowing you to transform the shape or

orientation of images, arrange images from front to back, and group images. Others are specific to Flash MX. You will examine the details of these options as they are encountered in exercises in subsequent chapters.

Text Menu

Select the Text menu and examine its options. Several of the options listed here should be very familiar to you: Font, Size, Style, and Align. Others are specific to Flash, such as Tracking and Scrollable.

Control Menu

Select the Control menu and examine its options. All options of the Control menu are pertinent to running/viewing either the entire file or a portion of it. You will make use of some of these options later.

Window Menu

Select the Window menu and examine its options. The options listed within the Window menu control the display (or absence) of a variety of informational windows and panels. The panels displayed by default are Tools, Actions/Frame, Properties, Color Mixer, Color Swatches, Components, and Answers.

Help Menu

Select the Help menu and examine its options. The options listed within the Help menu represent a variety of methods of obtaining additional information. These options are Welcome, What's New, Lessons, Tutorials, Using Flash, ActionScript Dictionary, Flash Exchange, and others.

The Stage

When your program opens, the white rectangle you see in the middle of the screen is called the stage. Following through with our metaphor of the theater or movie production, the stage is the window that will display the finished program. Aptly named, the stage is where your movie is created and where all action is played out. This is where you will place every element you want to be seen by the user. See figure 1-7.

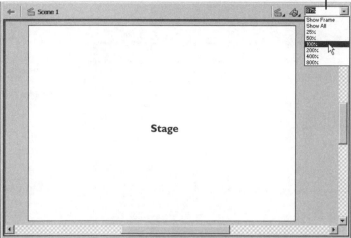

Fig. 1-7. The stage in Flash MX.

There are a number of ways to change the way your finished movie looks, just by changing certain attributes of the stage. For example, you can change the size of the stage and its background color via the Document Properties option (Modify | Document), as you will learn in the next chapter. At 100%, the stage is displayed in authoring mode, as it will appear during playback through the Flash Player.

Sometimes you need to increase the viewable size of the stage and to zoom in on sections on the stage. This is associated with making precise visual edits of items placed on the stage. You can use the pull-down menu located in the upper right-hand corner of the stage to select various zoom settings. See figure 1-7. Because Flash can have multiple windows and tools open at the same time, your screen can get crowded pretty quickly. To help you better manage the screen real estate, you can zoom out, decreasing the size of the stage and providing more room on screen. This can also help you more easily view animations that start or end at positions off the viewable stage.

The Work Area

The gray area surrounding the stage is called the work area, similar to the backstage or wings of a theater stage. See figure 1-8. The work area always surrounds the stage. However, the content of the work area can be hidden using a simple menu option. If you currently do not see the work area, the option to hide it may be turned on. You can turn the work area on and off by

selecting the menu option View | Work Area. A check mark indicates that the work area is on.

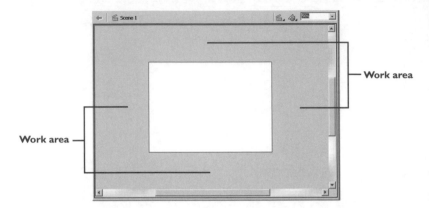

Fig. 1-8. Work area in Flash MX.

If you have a small screen, you may need to scroll to the left/right or up/down to see where the edge of the stage ends and the work area begins. You can also zoom out using the pull-down menu shown in figure 1-7, decreasing the size of the stage until the surrounding work area is visible. The work area allows you to view objects placed partly or entirely off the stage, where they are no longer in the viewable region of the movie. In a sense, objects placed in the work area are waiting in the wings to make their big entrance into the Flash movie. The work area gives you the option of moving objects on and off the main stage area while in the process of creating animated effects on the main stage.

Panels

To this point we have taken a brief look at the first few components of the Flash MX interface: the menus, stage, and work area. The majority of the rest of the screen consists of a variety of panels. This chapter provides an overview of the three primary panels you will use most of the time: Timeline, Tools, and Properties. This chapter also provides a quick introduction to three additional panels that you will find helpful: Answers, Library and Controller. This chapter takes a "50,000-foot view" of these panels, with greater depth of coverage provided in subsequent chapters, in which other panels are explored.

The Timeline

Another component of the interface essential in creating projects using Flash is the timeline. Any action that takes place on the stage is controlled by what happens in the timeline. The timeline organizes all objects involved in a movie and determines how the various media elements will perform. The major components of the timeline are layers, layer folders, frames, and the playhead. See figure 1-9.

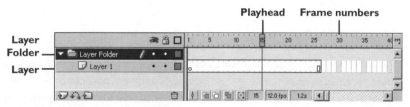

Fig. 1-9. The timeline in Flash MX.

As you look at the timeline in figure 1-9, you can see a grid pattern of rows (layers) that have names and columns that are numbered (frames). The red square (and red line extending below it) represents the playhead. The playhead resides on the row that contains the frame numbers. The playhead can be dragged from frame to frame using these numbers.

Layers

Content placed in your Flash movie is contained in a layer. Layers are a common organizational feature in most graphics programs, and work in a similar manner in Flash. Layers can be thought of as a stack of transparencies, each containing a graphic element. With the use of layers, objects can be placed in front of or behind other objects. Layers can be given specific names that correspond with the objects placed on them. Placing an item on a layer protects it from being altered by items placed on other layers. As you will see in later chapters, you can add, delete, and control the attributes of layers, including locking, hiding, and outlining a layer. You will find more information on layers in an exercise later in this chapter.

Frame

A frame is a single point in time, represented as a unit on the timeline. The small rectangles that appear in the timeline, as shown in figure 1-10, delineate individual frames. Each frame, which can consist of multiple layers, is numbered in the timeline.

·TiP·

The timeline by default is docked at the top of the screen. However, as you will see later in this chapter, it can be undocked to become a floating window and can be moved around the screen (as can many of the panels in Flash MX).

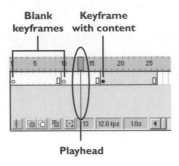

Blank keyframes **Keyframe with content**

Playhead

Fig. 1-10. Frames and keyframes on the timeline.

Whatever you see or hear on screen at any given point in time (in a particular frame) is a result of combining the content of all layers associated with that particular frame. For example, if you were to look at frame 2 on the stage, you would see the result of overlaying all content in all layers associated with frame 2.

Keyframe

A keyframe is a specially defined frame that contains either an action or a change in an animated sequence. When you insert a keyframe, you are telling the timeline that some type of change will occur or begin with that particular frame. A filled circle, as shown in figure 1-10, indicates a keyframe that has content, whereas an empty circle indicates an empty (or blank) keyframe.

Playhead

The playhead in Flash is analogous to the playback head on a video tape player. It "picks up" and displays whatever it is currently aligned with. You can drag (scrub) the playhead back and forth along the frames of the timeline. As you drag the playhead along the timeline, you will see your movie play out on the stage.

Putting It Together

Here is another way to think about layers, frames, and the timeline. Think of the timeline as an electronic filmstrip. When you hold this strip of film (let's say from the movie's opening title screens) up to a light source, you see a series of movie frames. Each frame is the final result of layers combined to represent the "total movie" at that particular point in time. In like manner, within Flash, a single frame represents the "total movie" at a single point in time. As a Flash movie is viewed from beginning to end, the playhead moves along the timeline, from left to right, playing all content from all layers as it encounters each frame.

Tools Panel

The Tools panel is the vertical panel placed (by default) along the left edge of the interface, directly below the File and Edit menus. See figure 1-11.

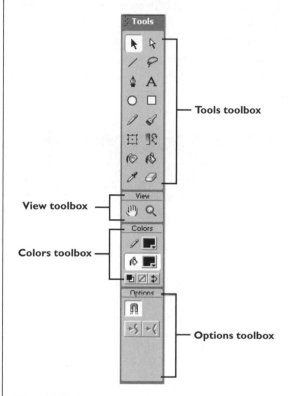

Tools toolbox

View toolbox

Colors toolbox

Options toolbox

Fig. 1-11. Tools panel.

The Tools panel is an assortment of drawing, painting, and text tools used to create objects for use in your movies. The drawing tools found in the Flash Tools panel are very similar to tools found in many other graphics programs, including Macromedia's Fireworks MX, FreeHand, and Director. With these tools you have a convenient method of creating elements for use in your Flash projects, and of modifying graphics imported from other software programs. The Tools panel can also be used to manipulate elements on the stage by positioning, scaling, and rotating objects, and to change the color attributes of elements.

The Tools panel is divided into four toolboxes: Tools, View, Colors and Options. Chapter 2 provides an overview of each toolbox, along with guided tours showing how to use the tools within each toolbox.

Properties Panel

The Properties panel is the horizontal panel that runs along the bottom of the interface (by default, but can be placed elsewhere). The Properties panel is where you can very easily change the properties or characteristics of whatever object you have currently selected. Figure 1-12 shows the Properties panel as it appears when a new document has first been opened. The Properties panel is context sensitive and will change in appearance (including the specific properties it lists), depending on what type of object or tool is selected. In Guided Tour 1C you will examine various configurations of the Properties panel.

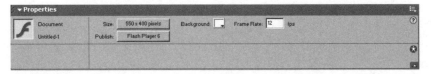

Fig. 1-12. Properties panel for a new document (movie).

Answers Panel

The Answers panel is a new feature of the MX family of software and is where Macromedia has centrally placed reference material and web links to help you quickly find answers to software questions. By default, the Answers panel is located in the lower right-hand portion of the interface. See figure 1-13.

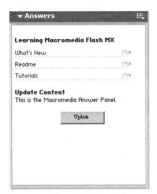

Fig. 1-13. Answers panel.

The Library

The library is where certain types of objects used in a Flash movie are stored so that they can be reused. Some of these objects are referred to as symbols. Although the library is mainly used for storing symbols, it can also store bitmap images, sound files, and fonts. See figure 1-14.

Flash comes with six common libraries: Buttons, Graphics, Movie Clips, Sounds, Learning Interactions, and Smart Clips. These contain graphics and other symbols you can use in your movies. Use the menu option Window | Common Libraries to open and explore these built-in libraries.

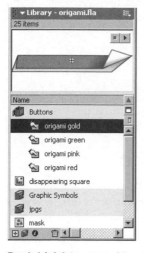

Fig. 1-14. Library panel.

There are three main types of symbols used in Flash: graphics, buttons, and movie clips. When you drag one of these symbols from the library and place it on the stage, you are creating an instance (or copy) of that symbol. Flash allows you to edit these instances without altering the original symbol. Later in the book, as you start to create movies, symbols and symbol terminology will be covered in greater detail.

Using symbols can significantly reduce the size of your Flash file, because regardless of how many instances of a symbol you create on the stage, Flash stores the symbol only once, in the library. By storing these symbols in the library, Flash can keep your movies smaller. This is an important factor if you are considering distributing your application across a narrow bandwidth (typical Internet modem connection). Flash includes a variety of useful common libraries you can incorporate in your movie, or you can create a library of your own. You can also use libraries that have already been created in other Flash files. They can be shared, or you can use the File | Open as Library menu option to pull symbols out of other movies and use them in your current movie.

The Controller

The controller contains all controls needed to play, pause, rewind, fast forward, and step through the frames in a movie timeline and preview the action on the stage. The Flash controller contains buttons similar to those found on a VCR. See figure 1-15. Unlike most VCRs, however, with the controller you can play the movie using the Step Back and Forward feature, which allows you to preview one frame at a time.

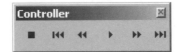

Fig. 1-15. Controller panel.

Guided Tour 1B: The Power of Flash Layers

Before we take a closer look at layers, let's first step back and consider why you would want to use layers. Creating layers within a graphic is a way of organizing graphic elements so that they are separated from one another. The use of layers is fairly common within the world of computer graphics. If you have previously worked with Flash, Photoshop, or most other graphics packages, you may have encountered layers. If this is the case, you will need to pay attention as you begin to work with layers within Flash MX, in that layers within Flash MX may not be exactly what you have encountered previously.

For those of you unfamiliar with layers, let's start at the beginning and create an example of how layers are used within Flash MX by using an analogy. Assume you have a stack of five sheets of tracing paper (in the old days it was called "onion skin" paper because it is semitransparent). On the first sheet, you use a pencil to draw a tree in the left-hand portion of the paper. Call this first sheet the *Tree* layer. On the second sheet, you draw a house over in the right-hand portion of the paper. Call this second sheet the *House* layer. On the third sheet, you draw a small pond in the middle of the paper. Call this third sheet the *Pond* layer.

As you continue, you draw a single image on each of the remaining two sheets. If you now pick up the stack of tracing paper and hold it in front of a light source, you can see the composite graphic, consisting of each image residing on its own sheet (i.e., layer). If you placed a large paperclip on the stack you could think of the stack of paper as a single image. By analogy, each sheet represents a layer, whereas the stack represents a a layer folder containing all the elements of the complete graphic image.

You might also then create another layer folder of the sky, consisting of a *Clouds* layer, a *Sun* layer, and a *Flying Birds* layer. Placing each image on its own layer allows you to go back and modify a given image without danger of accidentally changing another image. By organizing related layers into layer folders, you can more easily keep track of the constituent layers of a complete graphic image.

In the following steps, you will open a file created for you (found on the companion CD-ROM). Working with this file, in the following steps you will examine more closely how layers are used within the Flash environment, as well as explore the Layers panel.

1. Locate the companion CD-ROM at the back of the book and place it in the CD-ROM player of your computer.

2. Select the File menu.

3. From the menu that opens, select the Open option.

4. Note that the Open Document dialog window has opened. See figure 1-16.

CD-ROM

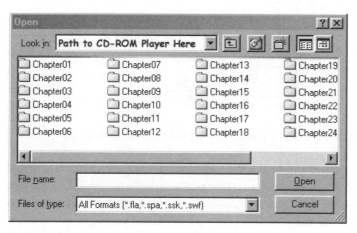

Fig. 1-16. Open Document dialog window.

Because this is the first time you have seen the Open Document dialog window, let's take a quick look around. This window is very similar to the Open Document dialog window found in other software programs.

5. Examine the Look In field at the very top of this dialog window. This field shows you what computer device (hard drive, CD-ROM, or removable disk) or folder within a device you are currently viewing. To the right of the Look In field is a down arrow, indicating a pull-down menu.

6. Note that to the right of the Look In field down arrow are familiar graphic icons that you have seen in many other software programs.

7. Note that below the Look In field is a large white area. This is where the content of the area (device, folder, and so on) you are viewing is displayed.

8. Note that the Files of Type field at the bottom of the window lists all files within the area. You can adjust this to list specific types of files.

9. Click on the down arrow to the right of the Look In field, to open the pull-down menu.

10. Using the browse function associated with this pull-down menu, locate the CD-ROM player within your computer. Click on the CD-ROM player icon.

11. Double click on the CD-ROM icon to open it. Locate and double click on the *Chapter01* folder, located on the companion CD-ROM.

·T/P·

To open a file, you can also simply double click on its name.

12. Locate and click on the file *origami.fla*. Click on the Open button.

13. Examine the timeline. As you can see, there are two layer folders (Buttons and Text Elements) and three independent layers (blue paper; fold designs; and background). See figure 1-17.

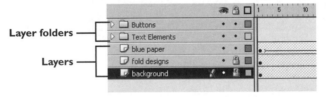

Fig. 1-17. Timeline showing two layer folders and three independent layers.

You can separate and place objects in different layer folders to facilitate organization of these objects and to help gain control over object attributes. Specifically, by placing objects on different layers you are able to show/hide the image and lock/edit the graphic. These controls allow you to work on a specific section of the artwork without other sections getting in the way, and without risk of accidentally changing these other sections. Continue with the following steps:

14. Select the *Buttons* layer folder by clicking on it. Note the four columns to the right of the *Buttons* label. You should see a Pencil icon in the first column, a dot underneath an Eye icon in the second column, a dot underneath a Lock icon in the third column, and a colored rectangle under a Rectangle icon in the fourth column.

15. To the left of the *Buttons* layer folder label, you should see gray a triangle. Click on this triangle. You have now expanded the *Buttons* layer folder to list all layers located within this folder. This folder contains four layers: *pink button*, *gold button*, *green button*, and *red button*.

16. Note that to the right of each layer there are frames, in which the content is actually stored. To the right of the layer folders there are *no* frames (just a solid gray area). This is because the layer folders are simply organizational categories.

17. Click on the triangle to the left of the *Buttons* layer folder to collapse, or close, the folder.

18. Click the mouse cursor on the playhead (the red rectangle in frame 1 of the frame numbers), and as you hold down the mouse button drag the playhead to the last frame in the timeline, frame 50.

19. Click on the dot under the Eye icon in the *background* layer. You will have to use the scroll bar to the right of the timeline. The *background* layer is all the way at the bottom of the stack of layers. Note that as the dot is replaced with a red X, the image in that layer disappears as the image is "hidden." Click on this same column to make the dot reappear, along with redisplaying the image. Clicking on the dot under the Eye icon for a layer will toggle between showing and hiding the image contained within that layer.

20. Click on the Eye icon for the *Buttons* layer folder (scroll back to the top). This hides all images located within the *Buttons* layer folder. The Hide/Show control is for the selected folder only, not the entire graphic. Click on this column again so that the dot under the Eye icon reappears and the *Buttons* layer folder images are redisplayed.

21. Click on the *background* layer to select it (scroll to the bottom). Note that the Pencil icon has a red slash through it. This indicates that the layer is locked and objects on it cannot be selected or edited. Click on the Lock icon in the third column to redisplay the Pencil icon and unlock the layer.

22. Double click on the *background* layer label. You should now see an open field, in which you can modify the name of the layer. Type in *torn paper* and then press the Enter/Return key to close the dialog window. You just renamed the layer *torn paper*.

23. Examine the lower left-hand corner of the Timeline panel. You see there icons for manipulating the Layers panel. See figure 1-18.

· T*i*P ·

In order to see all the layers within the expanded Buttons layer folder, you may need to use the scroll bar located on the right-hand side of the timeline.

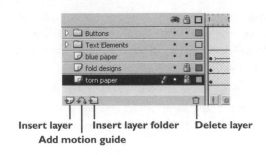

Insert layer | Insert layer folder Delete layer
 Add motion guide

Fig. 1-18. Options on Timeline panel.

24. Click on the Insert Layer icon. Note that Flash has now inserted a new layer above the *torn paper* layer. To name this new layer, double click on the label for this layer, type in *Sound*, and press Enter/Return. You have just added and named a new layer.

25. Click on the Insert Layer Folder icon. Note that Flash has now inserted a new layer folder with the name *Folder 26*. To change this name, double click on the Layer Folder label, type in *Sound & Actions*, and press Enter/Return. You have just added and named a new layer folder.

26. Click on the new *Sound & Actions* folder and while holding down the mouse button drag this folder to the top of the stack within the timeline. As you drag the folder, you should see a thin black line, corresponding to the position of the layer folder you are moving. Drop the layer folder above the *Buttons* folder by letting go of the mouse.

27. Click on the *Sound* layer and while holding down the mouse button drag this layer on top of the *Sound & Actions* layer folder. When your cursor is on top of the *Sound & Actions* folder, the yellow folder icon will *darken*, indicating that you can drop the *Sound* layer into the folder. Drop the layer here by letting go of the mouse. The *Sound* layer is now located within the *Sound & Actions* layer folder.

28. An important aspect of using layers centers on the ability to rearrange images in order to simulate screen depth. Our eyes and mind perceive the image of an object in front of (and possibly partially covering) another object as being closer to us than the object behind it.

Layers at the top of the list will appear in front of objects further down in the list. By placing images in layers and then reordering these layers, you can manipulate whether objects are perceived to be in the background or foreground. The order that layers appear (top to bottom) is frequently referred to as the stacking order. Again, those layers at the top of the stack (list) appear to be in the foreground, whereas those at the bottom of the stack (list) appear in the background.

The concept of stacking order applies to layers and layer folders. The stacking order can be changed at any time. Let's see how this affects the display of objects on the stage. Continue with the following steps:

29. Drag the playhead to the last frame in the timeline (frame 50). Click on the *blue paper* layer. While you hold down the mouse button, drag the *blue paper* layer below the *torn paper* layer and drop it there. The *blue paper* layer should no longer be visible, because the *torn paper* layer now covers it up; that is, it is more toward the front (higher in the stacking order) than the text and logo.

30. Let's change it back. Click on the *torn paper* layer and drag/drop it below the *blue paper* layer. You should now be able to see the *blue paper* layer again, because it is now higher in the stacking order.

This same reordering process is also possible using layer folders. Let's give it a try.

31. Click on the *Buttons* layer folder. While you hold down the mouse button, drag the *Buttons* layer folder below the *fold designs* layer (within the *Text Elements* layer folder). Drop it. All objects on layers within the *Buttons* layer folder are now partially covered by the object on the *fold design* layer.

32. Move the *Buttons* folder back above the *fold designs* layer so that it is unobstructed.

33. Throughout the course of this book, you will be creating many Flash MX files that you will want to save on your computer. In order to make it easier to locate these files and communicate to you about these files, it is strongly recommended that you create a new directory (folder) on your computer's hard drive to store these files.
 a) Please create a directory (folder) on the root directory of your computer's hard drive.
 b) Name the directory (folder) *SaveWork*.
 c) Save all files that you work with in this book, into this *SaveWork* directory (folder).

34. Select the menu option File | Save As to save a copy of the file in the *SaveWork* folder on your computer and use the same file name.

You will work extensively with the Timeline panel in subsequent exercises. Let's now take a look at another primary panel. In Guided Tour 1C, you will work with the Properties panel.

Guided Tour 1C: The Changing Look of the Properties Panel

You should still have the file *origami.fla* open from the last guided tour. If not, see step 1. You will use this file to change the look of the Properties panel.

1. If the *origami.fla* file is not open, open this file now. Figure 1-19 shows the Properties panel, as it is when you first open *origami.fla*.

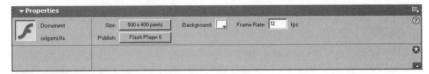

*Fig. 1-19. Properties panel with **origami.fla** opened.*

2. Select the Text tool from the Tools toolbox. See figure 1-20.

— Text tool

Fig. 1-20. Text tool selected in the toolbox.

3. Examine the Properties panel. Figure 1-21 shows how the Properties panel looks when the Text tool is selected. Note how many options for manipulating text are available to you in one location. Try selecting various tools in the toolbox to see how the Properties panel changes dynamically, depending on what is selected.

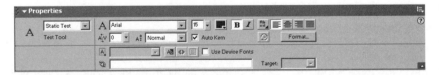

Fig. 1-21. Properties panel with Text tool selected.

4. Now let's try selecting something on the timeline. Expand the *Buttons* layer folder. Move the playhead to the last frame in the timeline (frame 50). Click on the *green button* layer. Note that the Properties panel shows Frame Properties. See figure 1-22. With the layer highlighted, you do not have an object selected on stage. Instead, clicking on the *green button* layer highlights the frames in the timeline.

·T/P·

If you are unsure
of what you have select-
ed, look in the top left-
hand corner
of the Properties
panel for an icon and
description of what is
selected on the stage,
toolbox, or timeline.

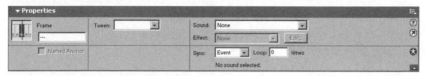

Fig. 1-22. Properties panel for a frame.

5. Examine the stage. Note that a rectangle and circle have appeared around the green button that looks like a folded piece of paper, as shown in figure 1-23.

Fig. 1-23. Green button on stage.

6. Select the Arrow tool and click at the center of the green button image on the stage. Examine the Properties panel. See figure 1-24. This is how the Properties panel looks when a library symbol is selected. In this case, the symbol is a button symbol. You will learn more about the function of button symbols in a later chapter.

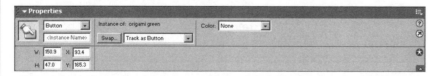

Fig. 1-24. Properties panel for button symbol.

Details of the options listed in the various Properties panels are explored in subsequent chapters. In Guided Tour 1D, you will work further with the basic functionality of panels.

Guided Tour 1D: Working with Panels

In this guided tour, you will take a closer look at some general properties typical of all panels within Flash MX. The tour is fairly short and is organized around looking at how these general properties can be manipulated. To this point, all panels you have examined have been positioned as they are in the factory default position. However, you can change these default positions. Let's explore this functionality.

Docking and Undocking Panels

By default, the panels that are on screen when you first open Flash MX are docked at (or attached to) the side of the interface, making them immobile. However, you can easily undock a panel so that it is free floating and can be dragged to any other location. To experiment with docking and undocking panels, perform the following steps:

1. Let's look at the Tools panel first. Examine the upper left-hand corner of the panel. Note the series of dots in this corner.

2. Move the cursor over this dots icon. Note that the arrow cursor turns into a four-pointed cursor, which indicates that the object can be moved. Hold down the mouse button (left mouse button on PC) and drag the Tools panel into the center of the stage. Drop the panel on top of the stage. Once you release the mouse button, the panel turns into a floating window.

3. Let's try to dock this panel somewhere else on screen. Click on the very top of the Tools panel, and while holding down the mouse button drag the panel to the upper right-hand corner of the screen and nuzzle it directly against the bottom portion of the menu bar and over the Color Mixer panel. Let go of the mouse to dock the Tools panel. Note that the Tools panel is now docked to the right of the stage.

4. Let's try undocking the Properties panel, now located below the stage. Move the mouse cursor over the dots icon until the arrow cursor changes to the four-pointed cursor. Now click and hold the mouse button down as you drag the panel up and over the stage. Let go of it.

Grouping and Ungrouping Panels

Panels can be grouped by dragging a panel by its tab (the "dots" icon located in the upper left-hand corner of each panel) to the tab of another panel. You can group panels either side by side or one on top of another. See figure 1-25. They can be ungrouped by dragging a tab away from a group.

·T/P·

The Tab (the "dots" icon located in the upper left corner of a panel) is like a magnetic handle for undocking and docking panels. Click on these Tabs to grab the handle and detach and move the panel. When you move a panel on top of another panel and drop it, the panels act as if they are magnetized and stick near each other.

Collapse/Expand panels

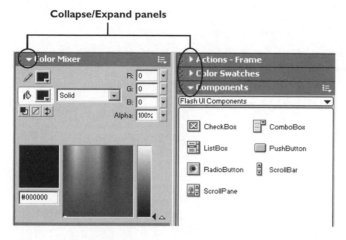

Fig. 1-25. Panels grouped side by side and on top of each other.

Collapsible Panels

You can collapse or expand (acts like a toggle) any panel by clicking on the arrow in the upper left-hand corner of each panel or panel group. See figure 1-25.

Resetting Panels to Factory Default or Custom Setting

You can reset panels to their default settings by selecting the menu option Window | Panel Sets | Default Layout. This automatically returns the panels to the position they were in when Flash was installed.

You can also select a panel layout that is optimized for your screen size and for how you use Flash MX. Select Window | Panel Sets to examine the options, shown in figure 1-26. If you select a designer setting, Flash opens panels frequently used by those who draw, animate, and otherwise design things with Flash. If you select a developer setting, Flash opens other panel sets that help with programming the ActionScript of Flash movies.

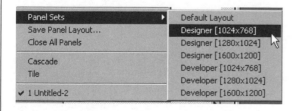

Fig. 1-26. Custom panel sets.

C H A P T E R

2

Working with the Tools Panel

Introduction

Flash MX incorporates a powerful set of drawing and paint tools that make it possible for designers to create vector objects to be used as static graphic images, as well as to create animated images for use on the Web – all within one program. As you will see in a later chapter, Flash MX also allows you to import artwork created in other programs, such as in Macromedia's Fireworks MX or in a bitmap editor such as Adobe's Photoshop.

This chapter focuses on the needs of novice users who may not be familiar with the use of tools common to many graphics programs. More experienced users may want to browse through this chapter, as there may be tools in Flash MX with which you are not familiar. As you open up the Flash Tools panel, get ready to explore the design possibilities available to you with these powerful tools. By the end of this chapter you will be able to:

- *Briefly describe the difference between the raster and vector graphics formats*
- *Use the Tools toolbox*
- *Use the View toolbox*
- *Use the Colors toolbox*
- *Use the Options toolbox*

Graphics Formats

When creating and using graphics, it is important to understand the difference between the two types of graphics file formats: raster and vector. The foundation of a raster graphic lies within a 2D matrix (basically rows and columns) that consists of individual pixels defined by (mapped by) specific X (row) and Y (column) coordinates. Raster graphics (more frequently referred to as bitmapped graphics) are typically created in "paint" programs that build an image by electronically defining the color of specific pixels. For example, to create a line in a bitmap format, pixels are "painted" (electronically turned on) as the drawing tool moves over the surface. The line consists of "painted" pixels lying side by side, defining the length and width of the line.

A pixel is the smallest unit of measurement when working with bitmap graphics. Each graphic consists of numerous pixels of varying shades of color. These pixels are so small that when the graphic is viewed at normal size, the pixels of various colors blend to form an image recognizable to the human eye. Your computer monitor's resolution is also defined in terms of pixels: one standard monitor resolution is 800 by 600, or 800 pixels (along the X axis) by 600 pixels (along the Y axis). The greater the number of pixels, the more information (or detail) the image contains.

A raster file must store the location and properties of each pixel. The strength of bitmapped graphics is that they are capable of very high resolution, with brilliant colors. The downside is that bitmapped graphics tend to have large file sizes (because of all the information being stored) and are difficult to resize and otherwise manipulate. Bitmap graphics are the most common graphic type used on the Web today, in that most web graphics are in either the GIF or JPEG format, both of which are bitmap graphic types. Both of these bitmap file formats employ compression formulas designed to reduce the size of specific types of graphics.

In contrast, vector graphics files contain algorithms (mathematical equations) used to generate the objects they represent by creating a path (or outline) of an object. Algorithms can easily represent circles, arcs, lines, squares, and other such objects. As you might guess, vector graphics have file sizes that are much smaller than their bitmap cousins, but the downside is that they generally do not possess the brilliant color of bitmaps, which can contain complex color patterns with millions of colors.

Another benefit of using vector graphics is that they can be scaled proportionally to any size, larger or smaller, and still retain the same crisp shape and outline as their original size. This characteristic is not true of bitmap images, which are built around pixels. Looking at side-by-side close-ups of two circles (one created as a vector image and the other as a bitmap) may help you visualize the difference between the two formats. See figures 2-1 and 2-2. Note that the circle in the bitmap image (figure 2-1) is pixelated (i.e., shows jagged edges), whereas the vector circle (figure 2-2) has a smooth, curved surface. The vector circle can easily be resized, whereas the bitmapped circle will become distorted as you enlarge it. Bitmapped images that include text frequently become difficult to read if either enlarged or reduced in size.

Fig. 2-1. Close-up of Circle – Bitmap Image.

Fig. 2-2. Close-up of Circle – Vector Image.

Guided Tour 2A: The Tools Toolbox

In this chapter you are going to take a closer look at the tools in the Tools panel. You saw this panel for the first time in Chapter 1. Note again that it divides the tools into four toolboxes: Tools, View, Colors, and Options. See figure 2-3.

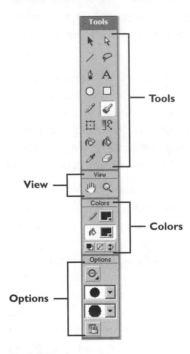

Fig. 2-3. Tools panel.

We have also divided the Guided Tours in this chapter to reflect the division of tools found in the Tools panel, so that each tour is focused on just one section of the Tools panel. This organization is intended to help you come back to these Guided Tours for refreshers on how to use the tools, as you progress through the Practice Exercises found in later chapters in the book. The first section to look at is the Tools toolbox. See figure 2-4. Descriptions of these tools follow.

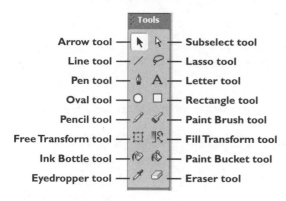

Fig. 2-4. Tools toolbox.

Arrow: Used to make selections, and to move or manipulate objects on the stage.

Subselection: Used to view and select anchor points that make up vector objects drawn on the stage.

Line: Used to draw straight lines. Holding down the Shift key restricts the lines to a vertical or horizontal axis or to a 45-degree angle. The width, color, and style of the line is determined by the selections located at the bottom of the palette and in the Stroke panel.

Lasso: Used to make free-form selections of objects on the stage.

Pen: Used to draw Bezier paths on the stage, using path points.

Text: Used to add text to the stage.

Oval: Used to create elliptical shapes on the stage. Holding down the Shift key restricts the shape to a perfect circle.

Rectangle: Used to create rectangular or square shapes on the stage. Holding down the Shift key restricts the shape to a perfect square.

Pencil: Used to draw free-form outlines of shapes.

Brush: Used to paint fluid shapes and apply color fills to objects on the stage.

Free Transform: Used to scale, rotate, distort, and envelope or change the shape of an object on the stage.

Fill Transform: Used to manipulate the way fills, such as gradients and bitmaps, appear inside a shape by allowing you to rotate, scale, and move the center point of these fills.

Ink Bottle: Similar to the Paint Bucket tool, but instead is used to apply color and other stroke attributes to lines in your drawings.

Paint Bucket: Used to fill shapes and outlines with a color or pattern.

Eyedropper: Used to pick up a sample color from anywhere on the stage and with the use of the Paint Bucket tool pour that color somewhere else.

Eraser: Used to delete objects, or portions of objects, on the stage.

Shortcut

Press the following keys to select the corresponding drawing tools (for Mac and PC):

Arrow	V
Subselect	A
Line	N
Lasso	L
Pen	P
Text	T
Oval	O
Rectangle	R
Pencil	Y
Brush	B
Free Transform	Q
Fill Transform	F
Ink Bottle	S
Paint Bucket	K
Eyedropper	I
Eraser	E

Perform the following steps.

1. Locate the companion CD-ROM at the back of the book and place it in the CD-ROM player of your computer.

2. Select File | Open.

3. Verify that the Open Document dialog window has opened. See figure 2-5.

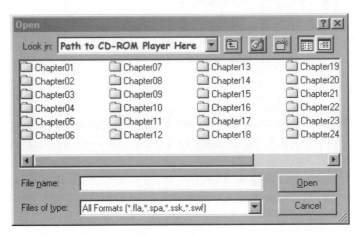

Fig. 2-5. Open Document dialog window.

4. Click on the down arrow to the right of the Look In field, to open the pull-down menu.

5. Using the browse function associated with this pull-down menu, locate the CD-ROM player within your computer. Click on the CD-ROM player when you see it.

6. Double click on the CD-ROM to open it. Locate and double click on the *Chapter02* folder, located on the CD-ROM.

7. Locate and click on the file *GuidedTour_2A.fla*. Click on the Open button.

8. Examine figure 2-4, which includes the Tools toolbox you will work with in this Guided Tour.

·TIP·

You could also simply double click on the file name. This will open the file without needing to click on the Open button.

Why Do You Need to Select an Object?

Before you can copy, modify, transform, or otherwise do something to an object or frame, you must first select it. Some people find the idea and the necessity of selecting something first before acting on it somewhat confusing. In this regard, perhaps an analogy will help.

Suppose you want to draw a picture of a sunny day at the beach using a box of colored pencils. You first select the black pencil and sketch an outline of the

seashore, with saw grass and sea oats. You then sketch the ocean and gently rolling waves breaking onto the beach. Then you add a few birds walking on the beach. Then you select the blue pencil and color in the ocean, and then select a green pencil to add some shading to the ocean. Then you select a tan pencil, and then a light brown pencil, to color in the beach.

In each case you had to select a particular tool you wanted to use – specifically which colored pencil to use. You then mentally selected the blue pencil to use for the ocean, and the tan pencil for the beach. Typically when you work with a movie in Flash, that movie will consist of many separate frames, and objects within those frames (just as this seaside picture consists of various objects, such as the ocean, the waves, the beach, the seashore, and some birds). Within Flash, frames are the equivalent of such objects, and you will have to tell Flash which frame (and/or object) you want to work with.

If you are going to *create or modify* an object within Flash, you therefore must first select the frame and then select a tool to work with. If you want to *modify* an object, you first have to select the frame and then select the object you want to modify.

Arrow Tool

You can use the Arrow tool for the general selection of frames and objects on the stage or in the library. Selecting an object with the Arrow tool allows you to then be able to act on that object; that is, to move it, transform it, or adjust the object's properties with the use of the Properties Inspector. To work with the Arrow tool, perform the following steps.

1. The Arrow tool should already be selected (by default, as you open the file). However, if it is not currently selected, click on the Arrow tool to select it.

2. Let's first take a quick look at what the animation looks like. Click on the playhead (red rectangle on the Frame Number row). See figure 2-6. While holding down the mouse button, scrub (drag) the playhead slowly to the right until you reach frame 55. Scrub the playhead back and forth so that you can see all objects on stage that are involved in the animation.

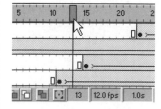

Fig. 2-6. Playhead on timeline.

3. It might be easier to see all objects if you reduce the size of the stage. Click the cursor in the Magnification field, located in the upper right-hand corner of the stage. Type in *50* and press the Enter/Return key. The stage should now be at 50% magnification, with more of the work area and objects showing. See figure 2-7.

Fig. 2-7. Stage and work area set at 50% magnification.

4. Drag and leave the playhead at frame 1, on the far left side of the timeline. Click on the scroll bar on the far right of the timeline and scroll through the various layers in the timeline. Note that there are several black circles in frame 1. As you may remember from Chapter 1, a black circle indicates a keyframe that has content. Let's use the Arrow tool to look at the content.

5. Click on the black circle in frame 1, in the *Meteor 2* layer. Look at the stage and you should now see *Meteor 2* with a colored rectangle around it, indicating that this object is selected.

6. Click on the black circle in frame 1, in the *Meteor 6* layer. Look at the stage and you should now see the *Meteor 6* with a colored rectangle around it, indicating that this object is selected.

7. Now let's try selecting an object directly. Use the Arrow tool to click on the UFO object in the middle of the canvas. Note that this object now has a colored rectangle around it, with the *Ship* layer in the timeline highlighted as well.

8. Look at the Properties panel displayed at the bottom of the screen (unless you have moved it elsewhere). Once an object is selected, you can use the Properties panel to view or modify any of the properties displayed here. Let's try it.

9. Click the mouse cursor inside the W field and highlight the current setting (142.0). Now type in *100*. Click the mouse cursor inside the H field and highlight the current setting (77.3). Now type in *60* and press the Enter/Return key. Note how you have just modified the width and height of the selected graphic object.

10. Click on the gray work space to deselect the UFO, or select the menu option Edit | Deselect All.

11. Let's try selecting multiple objects, one at a time. Click on the UFO image on the stage. Holding the Shift key down, click on the meteor in the upper left. As you continue to hold down the Shift key, click on the meteor in the upper right. All of these objects should now have blue rectangles around them.

12. You can deselect a selected object by clicking on any portion of the gray area in the canvas. Go ahead and do that now. All highlights should have disappeared.

Up to now, all objects you have selected have been graphic symbols, which are permanently grouped objects that have become uneditable. Let's try selecting a vector object that is still editable. Watch carefully! At first this can appear somewhat confusing.

13. In the work area to the far left of the stage is a red rectangle. Because this rectangle never appears on stage, it will not be seen when the program is run. Single click on the interior portion of the red rectangle. Now click and as you hold down the mouse button, drag the mouse cursor to the right.

Whoa! The red fill moved, but the black line (stroke) for the rectangle remained where it was!

14. The red rectangle is a vector object. When you single clicked on it, you selected the fill only. In Flash, the fill and stroke of an object are treated as separate objects, unless the object has been grouped. Select Edit | Undo to undo the fill movement. Click on the gray work area to deselect it.

15. Double click on the red rectangle. With the fill and stroke selected, try moving the object to another part of the stage. As you can see, you have just moved both the fill and outline (stroke) of the rectangle.

Shortcut

The keyboard shortcut for Deselect All is:
Ctrl + Shift + A (PC)
Shift + Cmd + A (Mac)

·T*i*P·

Holding the Shift key down as you click on multiple objects is a quick method of selecting a group of objects on the canvas.

Shortcut

You can select all graphics on unlocked layers at one time by simultaneously pressing:
Ctrl + A (PC)
Cmd + A (Mac)

Arrow Tool with the Properties Panel

To use the Arrow tool with the Properties panel, perform the following steps.

1. Double click on the red rectangle selecting both the stroke and fill. Look at the Properties panel, located (by default) below the stage. See figure 2-8.

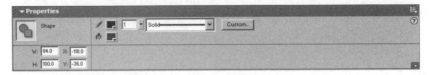

Fig. 2-8. Properties panel with vector shape selected.

2. Note that there are two general sections for this Properties panel, each section divided by a vertical line. The first section on the left provides options for the general shape that has been selected.

3. Examine the fields available in this first section. These fields and their functions are described in the following:

 Element Selected: Displays the name and icon of the element currently selected: Shape, Symbol (graphic, movie clip, and button), and so on. These elements can be an object, tool, or timeline element.

 W, H, X, Y: Display the current values for width, height, X axis, and Y axis. These fields show the values of an object if drawn freehand. They also allow you to type in values to resize and reposition the object based on the values you enter.

4. Examine the fields available in the second section. These fields and their functions are described in the following:

 Stroke Color Well (Pencil icon): Clicking on the down arrow in the color swatch will display a pop-up panel used to select a color for the stroke (line). You can simply click on a color or type in the corresponding hexademical value in the color name field at the top of the panel.

 Fill Color Well (Paint Bucket icon): Clicking on the down arrow in the color swatch will display a pop-up panel used to select a color for the fill. You can simply click on a color or type in the corresponding hexademical value in the color name field at the top of the panel. Also note that there are special gradient fills located in the lower left-hand side of the pop-up panel.

 Stroke Height (Stroke Width): Clicking on the down arrow displays a slider bar you can use to select the width of the stroke. Alternatively, you can simply click the cursor in the color name field and type in the value you wish to use for the stroke width.

Stroke Style: Clicking on the down arrow displays a pull-down menu in which you can select the type of line you want to use. There are a variety of solid lines, dotted lines, and wavy lines.

Custom Stroke Style: Clicking on the Custom button displays a pop-up panel in which you can select and save particular stroke attributes you may want to save for reuse.

5. Click on the gray work area to deselect it.

Arrow Tool with the Options Toolbox

The options listed in the Options toolbox are context sensitive, like those of the Properties panel, and change according to the primary tool selected. This being the case, you will look at the Options toolbox at the end of exploring each primary tool. With the Arrow tool selected, you can see that there are three options displayed in the Options toolbox: Snap to Objects, Smooth, and Straighten. See figure 2-9. Each of these buttons acts like a toggle switch, so that the option is toggled on or off. To work with the Arrow tool using the Options toolbox, perform the following steps.

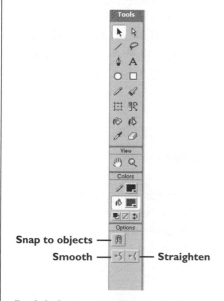

Fig. 2-9. Options toolbox for the Arrow tool.

1. In the gray work area, you will see two identical jagged lines to the left of the stage. Using the Arrow tool, click to select one of these lines.

2. Click on the Smooth icon in the Options toolbox. See figure 2-9 for which icon is the Smooth option. Continue clicking on this icon and

watch how the shape of the line changes and the path becomes smoother and less jagged. If you click on the Smooth option several times, the line actually straightens out into one long curve.

3. Select the second jagged line. Try the same thing using the Straighten icon in the Options toolbox. Note that when you click on the Straighten icon the line becomes more angular.

4. You can also use the Arrow tool to change the shape of objects on the stage. With the Arrow tool selected, move the cursor over one of the straight sides of the red rectangle. A crescent shape appears next to your cursor, as shown in figure 2-10.

Fig. 2-10. Arrow tool with crescent shape.

5. This crescent shape indicates that you can edit the curve of the line. With the crescent shape showing, try pushing and pulling the line by clicking and dragging to change the curvature of the line, as shown in figure 2-11. This is an easy way to change the shape of strokes and fills of objects on the stage.

Fig. 2-11. Changing the curvature of a line using the Arrow tool.

6. You can also use the Arrow tool to edit angles and straight lines in an object. Try positioning the cursor over one of the corners of the red rectangle. This time, note that instead of a crescent shape a right angle appears next to the cursor, as shown in figure 2-12.

Fig. 2-12. Arrow tool with the angle shape.

7. When the right angle appears, click and drag with the Arrow tool to change the shape and degree of this corner's angle, as shown in figure 2-13.

Fig. 2-13. Changing the degree and shape of an angle using the Arrow tool.

Now that you have learned to edit objects with the Arrow tool, let's explore the last toolbox option associated with the Arrow tool, Snap to Objects. Continue with the following steps.

8. Click on the Snap to Objects icon (looks like a large magnet), shown in figure 2-9. Once you turn Snap to Objects on, this feature will stay on until the button is clicked on again to turn it off.

9. Snap to Objects allows you to more easily align objects with one another. Make sure the playhead is in frame 1 of the timeline, and select the meteor in the upper left corner of the stage. A circle appears in the center of this object, as shown in figure 2-14. This does in fact indicate the center point of this object.

Fig. 2-14. Center point of a selected object.

10. Once selected, click on the center point and drag the object to one of the jagged lines you were just working with. As you move the meteor closer to the line, at some point you will feel the meteor snap to a point on the line.

11. You should be able to see the outline of the meteor and the outline of the center point as it snaps to the line. See figure 2-15. Move the meteor over the contour of the line and note that it feels as if the meteor is moving along a track. This is a great feature if you are trying to align objects with one another. (This will also come in handy in a later chapter, when working with motion guides.)

Fig. 2-15. Outline of the object and its center point.

Subselection Tool

As you saw in the previous section, you can use the Arrow tool for general object selection. However, if you want to edit the points within a vector object (perhaps to change the shape), you use the Subselection tool from the Tools panel. To work with the Subselection tool, perform the following steps.

> A vector object is an object created by a path or outline. It might be helpful to think of vector objects as graphics created by playing a "connect-the-dots" game. Each line segment whether curved or straight is linked by an anchor point, or dot. These dots act as joints that can be used to change the shape of the path that makes up a vector object.

1. Click on the Subselection tool in the Tools panel.

2. Using the Subselection tool, click on one of the sides or corners of the red rectangle (clicking in the middle does not work). Note that the current selection is highlighted and now includes anchor points (dots) connecting each segment of the rectangle, as shown in figure 2-16.

Fig. 2-16. Anchor point in an object's outline.

3. Click on an anchor (corner) point and, holding the mouse button down, drag the corner in any direction you wish. As you can see, the Subselection tool allows you to edit the shape of a vector object.

4. Click on another anchor (corner) point. Note that this anchor point is a solid red, whereas the other anchor points have a white center. The solid red color indicates that this anchor point is selected.

5. With an anchor point selected, press the Delete key. You have just deleted an anchor point from a vector object.

Subselection Tool with the Options Toolbox

The options listed in the Options toolbox are context sensitive and change according to the primary tool selected. With the Subselection tool selected, as you can see, there are no options listed.

Line Tool

To work with the Line tool, perform the following steps.

1. Start with a new file by selecting File | New.

2. Select the Line tool. Note that when you move the cursor to the stage, the cursor now looks like a crosshair.

3. Move the Line tool cursor to the lower left-hand portion of the canvas. Click and continue to hold down the mouse button as you drag the cursor to the right for a distance of about 4 inches. While still holding down the mouse button, move the cursor up, and then down, to change the angle of the line. Release the mouse button to form a line.

As you drew this first line, you may have noticed how the line could have been drawn at any angle you wished, prior to the release of the mouse button.

4. Let's try a straight line. Press and hold down the Shift key. (The Line tool should still be selected.) Click the cursor anywhere on the canvas and, as you hold down the mouse button (and keep the Shift key down), draw another line. As you can see, holding the Shift key down constrains the line to a straight line.

Line Tool with the Properties Panel

To work with the Line tool using the Properties panel, perform the following steps.

1. Note that the lines you drew were all the same color and thickness. These properties for vector lines are referred to as the stroke (line) color and the stroke (line) width.

2. Look at the Properties panel, located below the stage. See figure 2-17. Let's change the stroke (line) properties.

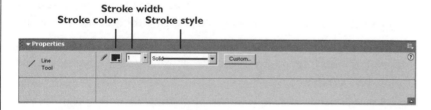

Fig. 2-17. Properties panel with Line tool selected.

3. In the middle of the current Properties panel you should see an icon that looks like a pencil, with a block of color next to it. This is the Stroke Color picker. Click on the Stroke Color picker. The Stroke Color palette opens, as shown in figure 2-18. Click on any color to select a new stroke color. When you select a color from the palette, the palette then closes automatically.

·T/P·

A quick and easy way to draw a straight line is to press and hold the Shift key and then draw the line using the Line tool. Holding down the Shift key constrains the line to a straight line that is either horizontal, vertical, or at a 45-degree angle.

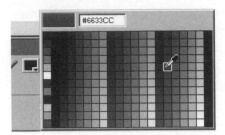

Fig. 2-18. Stroke Color palette in the Properties panel.

4. Next to the Stroke Color picker is the Stroke Width field. Click on the down arrow, which displays a slider bar that allows you to slide to a thicker or narrower tip width for the Line tool, as shown in figure 2-19. You can also click the cursor in the open field, type in a number for the point size, and press the Enter/Return key. Set the point size to 10. Draw a few lines.

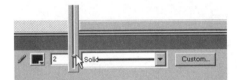

Fig. 2-19. Stroke Width slider in the Properties panel.

5. Next to the Stroke Width field is the Stroke Style field. See figure 2-17. Click on the pull-down menu and look at the options listed. These options alter the appearance or style of the line.

6. Clicking on the Custom button to the right of the Stroke Style field displays a pop-up panel that allows you to assign attributes and save a custom stroke style.

7. Take a few moments and experiment by drawing lines with various stroke colors and stroke widths.

8. Look at the Tools panel, in the Colors toolbox. Note that you can also select the stroke color using the first tool listed in this section. You will practice using this tool later in this chapter.

Line Tool with the Options Toolbox

The options listed in the Options toolbox are context sensitive and change according to the primary tool selected. With the Line tool selected, as you can see, there are no options listed.

Pen Tool

Drawing point by point with the Pen tool is the most precise way of drawing complex vector shapes. Think back to when you last saw a "connect the dots" coloring book. Basically, it consisted of a series of dots. The object was to draw the lines between the dots to reveal an image. Once the dots were connected, the shapes could be colored.

This is very similar to the process used when drawing with the Pen tool. In this section, you will draw a series of points using the Pen tool, and the lines that connect them will automatically appear when each point is added. Points, or anchors, are the joints that connect each line segment in the outline of a vector shape. There are two types of anchor points. To adjust the curve of the lines between the points, you will move a pair of handles that will appear at each point to be edited. If the lines between the points are perfectly straight, you do not see any handles. If the lines between the points are curved, you will see handles extending from the points, as an "interface" for modifying the shape of the curve. To work with the Pen tool, perform the following steps.

1. Let's clean up the stage a bit before drawing with the Pen tool. Select Edit | Select All. To clear the screen, press the Delete key or the Backspace key on your keyboard. You can also select Edit | Clear.

2. Select the Pen tool. Let's create a simple house. Hold the Shift key down and click five (5) points in the shape of a house (do not close the shape yet). After the second point, and each successive point, a line is automatically drawn between the two points. See figure 2-20. Do not worry about what your house looks like. You will get a chance to modify the drawing in material to follow.

Fig. 2-20. Simple house drawn with Pen tool.

3. After you have drawn the fifth point, move the Pen cursor over the first point you drew and note the circle icon (o) that appears below the Pen

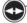

Shortcut

Select All
Ctrl + A (PC)
Cmd + A (Mac)

Flash retains the last stroke properties you used in your document. To change the stroke width, style, or color, take a look at the Properties panel.

Holding the Shift key down with the Pen tool works in a similar fashion as you saw before with the Line tool. Holding the Shift key down constrains the points and paths to straight lines. This is often a good technique to use when drawing with the Pen tool: place the points, and then shape the curved lines between them.

cursor. See figure 2-21. This indicates that clicking on this point will close the shape. Click on that point to complete the shape.

Fig. 2-21. Pen cursor indicating that the image can be closed.

4. Let's adjust the location of a few points. You learned in the previous section that to edit anchor points you must use the Subselection tool. Using the Arrow tool selects the entire outline of the shape, not the anchor point. First, select the Subselection tool, and then click on an anchor point in your house shape. When selected, the anchor point will change from the outline of a dot to a filled dot. As you hold the mouse button down, drag the point to a new location on the stage. Try another point.

5. There is also an easy way to toggle between the Pen and Subselection tools without going to the Tools panel. Click on the Pen tool. Move the Pen tool toward an anchor point you want to edit. Hold down the Ctrl (PC) or Cmd (Mac) key and you will note that the cursor changes to a small white arrow, indicating that the Subselection tool is now active as long as the key is held down. You can now adjust the location of this point, or any other point, with the Subselection tool. When you release the Ctrl/Cmd key, the Pen tool returns as the active tool.

6. Let's delete a point of the drawing. Click with the Pen tool on any existing anchor point. Look for the Subtraction icon (-) below the Pen cursor before you click. See figure 2-22. Now you can remove any anchor point from the path.

Fig. 2-22. Pen cursor indicating that the point can be deleted.

7. Now let's work with a curve. The house outline has only straight paths connected by anchor points. To make one of the sides of the house more rounded, you can use a trick you learned earlier in this chapter, when working with the Arrow tool. Select the Arrow tool and place the cursor

over the middle of the line segment until a crescent (or semicircle) appears next to it. See figure 2-10. Push or pull the line segment until it bulges slightly, as shown in figure 2-23.

Fig. 2-23. *Straight line modified to a curve.*

This, however, is not the only way to create a curved line in Flash. With the Pen tool, you can create both straight and curved line segments when you originally create your anchor points. Continue with the following steps.

8. Select the Pen tool and, next to your bulging house in a white area of the stage, click and release to create an anchor point. Click to create another anchor point that connects to the previous one — but wait! Do not release the mouse button yet! Instead, once you have clicked with the Pen tool, drag with the mouse. As you drag, handles will sprout from the anchor point you started, as shown in figure 2-24. These handles allow you to control the direction and curvature of the line segment. Drag the handle right, left, up, and down to get a feel for how the line segment reacts to your movements.

Fig. 2-24. *Creating a curved segment with the Pen tool.*

9. Release the mouse button. Hold down the Ctrl (PC) or Cmd (Mac) key to toggle to the Subselection tool. Click on the anchor point you just created and note that one of the handles appears. Keep holding down the Ctrl (PC) or Cmd (Mac) key and select the end of the handle to again alter the curvature of the line. Release the mouse button and the Ctrl (PC) or Cmd (Mac) key when you are finished playing with the handles.

Often the Pen tool is easiest to use if you trace a sketch or a screen shot. This way you can connect the dots (points) over a rough image instead of guessing where to place the points.

Pen Tool with the Properties Panel

To examine the Pen tool as used with the Properties panel, perform the following steps.

1. Select the Pen tool and look at the Properties panel, located (by default) below the stage. See figure 2-25.

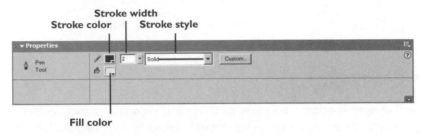

Fig. 2-25. Properties panel for the Pen tool.

2. Examine the Properties panel. Note that this panel contains two general sections, divided by a vertical line.

The properties displayed here are identical to those listed and described for the Line tool, with one exception: the Fill color picker. See figure 2-25. The Fill color picker allows you to select fill colors for shapes you draw with the Pen tool. It works just like the Stroke color selector.

Pen Tool with the Options Toolbox

The options listed in the Options toolbox are context sensitive and change according to the primary tool selected. With the Pen tool selected, as you can see, there are no options listed.

Lasso Tool

Now let's move back to the Lasso tool. Whereas the Arrow and Subselection tools provide the capability of selecting an entire object, or anchor points of an object, the Lasso tool allows you to define and select an area that includes any part of an object within the defined area. With the Lasso tool, you can draw an irregular area for selection and modify anything inside that "lassoed" area. This tool is much easier to use than to describe, so let's stop talking about it and do something with it! Perform the following steps.

1. Click on the Lasso tool.
2. Click and hold down the mouse button as you drag the cursor to draw whatever selection area you want around or through the image of the

house you created earlier. Finish the selection by bringing the cursor back to the point you started. Let go of the mouse button. Any part of the image that was selected should now be highlighted with a crosshatch pattern.

3. Make the menu selection Edit | Cut. The selected area is removed into the clipboard.

4. Select the Edit menu. Note that there are three options for pasting. Select the first one, Paste. With the pasted portion of the house still selected, select the Arrow tool and click and drag this pasted copy to another location on screen. Let go of the mouse button.

5. Click the Arrow tool anywhere on the gray work area or anywhere on the stage to deselect the object.

Lasso Tool with the Options Toolbox

The options listed in the Options toolbox are context sensitive and change according to the primary tool selected. With the Lasso tool selected, you can see that there are three options displayed in the Options toolbox: Magic Wand, Magic Wand Properties, and Polygon Lasso. See figure 2-26.

Fig. 2-26. Options toolbox for Lasso tool.

1. Select File | Open and browse in the *Chapter02* folder on the companion CD-ROM. Find the *lasso.fla* file and open it in Flash. You will see a small image of a duck that has been placed on the stage.

2. Select the Magnifying Glass icon from the View section of the toolbox and click on the duck to enlarge the image. If you make it too big, select the Magnifying Glass icon and hold down the Alt (PC) or Opt (Mac) key until a subtraction symbol (–) appears in the Magnifying Glass cursor. Hold down the key and click to zoom out.

3. Select the Lasso tool. Select the Magic Wand option. See figure 2-26. Click anywhere on the black head of the duck. Note that part of the head becomes selected. The selected portion should have a crosshatch pattern, similar to that shown in figure 2-27.

·T/P·

This image of a duck is a bitmap file imported into Flash. Once it was imported, the command Modify | Break Apart was used so that you can select and edit pieces of the image.

Fig. 2-27. Magic Wand selection.

4. The Magic Wand tool looks for adjacent colors that are similar to the color of the spot at which the Magic Wand was clicked. You can control the degree of similarity by working with the Magic Wand properties. To change the color range, click on the Magic Wand Properties (Settings) button in the Options toolbox. See figure 2-26.

5. The Magic Wand Settings window will pop up, as shown in figure 2-28. To control the color range, you can adjust the Threshold setting. The higher the number, the greater degree of difference between colors the Magic Wand tool will tolerate. The lower the number, the less degree of difference the Magic Wand tool will tolerate.

Fig. 2-28. Magic Wand Settings window.

The second field in this window is the Smoothing field. The options in this pull-down menu control how the borders of the selection look. The options are Pixels, Rough, Normal, and Smooth. Continue with the following steps.

6. Type *40* in the Threshold field and then click on OK.

7. Select Edit | Deselect All to clear the previous selection. Click in the same spot on the duck's head and note how much more the Magic Wand tool includes in the selection! The higher tolerance allows for a wider range of values in adjacent pixels to be included in the selection. Note that the lightest areas of the duck image are still not included in the selection,

because they exceed the acceptable tolerance. Increasing the number further will include a still wider range of values.

8. Click in the water area of the image to add to the selection. Once a portion of the image is selected, you can delete, duplicate, or otherwise edit the selection in any way you choose.

9. The last option is the Polygon Lasso tool. See figure 2-26. Turning this option on allows you to select areas with the Lasso tool using straight-line segments. Instead of drawing a free-form selection around areas in the duck image, you will click to create a polygon shape to select portions of the image. This tool is very handy if you have a geometric area you want to select.

10. Let's try it out! Deselect everything on the stage. With the Lasso tool selected, make sure to turn off the Magic Wand tool and turn the Polygon option on. Click and release on the image of the duck. Move the cursor to another spot and click. As you move the cursor, you will note that it seems to have a line trailing behind it, as shown in figure 2-29. Click several more times to define the polygon selection. When you are finished, go back to where you started and double click on that spot to finish (close) the selection. Voila! Everything inside the area you defined is now selected!

Fig. 2-29. Lasso tool with the Polygon option.

Text Tool

To work with the Text tool, perform the following steps.

1. Select File | New to work with a blank stage.

2. Select the Text tool from the Tools panel. Move the cursor over the stage. Note that the cursor looks like a crosshair with an A. Click the cursor anywhere on the stage and type *The Power of Flash MX*.

3. Click on the Arrow tool. Note that the text object is still selected, indicated by a blue rectangle.

Text Tool and Properties Panel

To work with the Text tool using the Properties panel, perform the following steps.

1. Take a look at the Properties panel for the Text object. See figure 2-30.

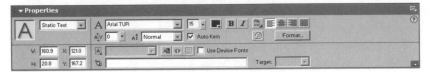

Fig. 2-30. Properties panel for Text object.

2. As you can see, the Properties panel is divided into sections by vertical and horizontal lines. More detail about working with these options is presented in Chapter 7.

3. Examine the first section, located in the upper left-hand corner of the panel. The fields found here, and their functions, are described in the following:

 Object Type: Displays an icon of the object type currently selected, which in this case is the Text object type.

 Text Type: The pull-down menu offers the selection options Static Text, Dynamic Text, and Input Text. Static text is what you will use most often, as it is "ordinary" text that exhibits the text attributes you are used to seeing in a word processing program. Dynamic text is text that uses a variable as a placeholder in the Flash file, and that dynamically updates the text content of that variable from a server-side application. Input text is used where the user/learner is required to type information into a Flash page. Much more detail is provided on these text type options in Chapter 7.

4. Examine the fields available in the second section (located in the lower left-hand corner). The following describes these fields and their functions.

 W, H, X,Y: Display the current values for width, height, X axis, and Y axis. These fields will also allow you to type in values to resize and reposition the objects.

5. Examine the fields available in the third section (located in the large upper right-hand quadrant). The following describe these fields and their functions.

 Font: The Font pull-down menu allows you to specify a particular font to apply to a selected text object.

 Character Spacing (Kerning): The pop-up slider bar allows you to specify how much space should be used between characters in the selected text object. A setting of 0 (zero) indicates normal spacing. Negative values will close the space, whereas values greater than 0 will increase the spacing. You can also click the cursor in this open field and type in the value you want.

Character Spacing (Kerning) Character Position: The pull-down menu provides the options Normal, Superscript, and Subscript.

Font Size: The pop-up slider bar allows you to specify a particular font size to apply to a selected text object. You can also click the cursor in this open field and type in the size you want.

Auto Kern: Placing a check mark in this field will allow Flash to automatically space the letters in the selected text object. Making a selection from the Character Spacing field will override the Auto Kern selection.

Text (Fill) Color: Clicking on the Color icon will display a pop-up panel used to select a color for the text. You can simply click on a color or type in the corresponding hexademical value in the open field at the top of the panel.

Toggle Bold: Clicking on this button will apply the bold style to the selected text. Clicking on the button a second time will remove bolding from the selected text.

Toggle Italic: Clicking on this button will apply the italic style to the selected text. Clicking on the button a second time will remove italic from the selected text.

Change Direction of Text: Note the presence of a small black triangle in the lower right-hand corner of this button. Clicking on the button displays a pop-up menu containing the options Horizontal (the default), Vertical (left to right), and Vertical (right to left). These options allow you to change the direction the text letters flow.

Alignment Buttons: The next four buttons will align the selected text according to the button selected: Left/Top Justify, Center Justify, Right/Bottom Justify, and Full Justify.

Rotation: This selection is inactive if Horizontal has been chosen in the Change Direction of Text field. With the selection of the Vertical option in the Change Direction field, the Rotation field becomes active and will change the rotation of the vertical placement of letters to horizontal placement while still within a vertical column.

Format: Clicking on this button displays a pop-up panel in which additional formatting attributes can be set. These attribute options are Indent, Line Spacing, Left Margin, and Right Margin.

6. Examine the fields available in the last section (located in the lower right-hand corner). The following describe these fields and their functions.

Line Type: When the Dynamic or Input text option is selected from the Text Type field, the Line Type field becomes active. This field determines the size and security of the selected text object. The options in this field are Single Line, Multiline, Multiline No Wrap, and Password.

Selectable: This button serves as a toggle that determines whether the selected text object can be selected (clicked on) by the user/learner. It is not active if the Input text option is selected in the Text Type field.

Render Text as HTML: This button serves as a toggle that determines whether the selected text object will be converted into HTML text with hyperlink functionality. This field is not active if the Static text option is selected in the Text Type field.

Show Border Around Text: This button serves as a toggle that determines whether the selected text object will include a line border around it. This field is not active if the Static text option is selected in the Text Type field.

Use Device Fonts: This field only appears if the Static text option is selected in the Text Type field. Placing a check mark here instructs Flash to use device fonts for the selected text object.

URL Link: This blank field allows you to type in a URL address that corresponds to the selected text. This field is only active if the Static text option is selected in the Text Type field.

Target: This pull-down menu is used in conjunction with the URL Link field and allows you to specify areas of a frame set or anchors on a web page to link directly to. The options here are _blank, _parent, _self, and _top, or any other target you type in this field.

Variable: This field only appears if the Dynamic or Input text option is selected in the Text Type field. This blank field allows you to type in a variable name to be associated with the selected text object.

Edit Character Options: Clicking on this button displays a pop-up window that allows you to select which font outline attributes you want to include for the selected text object.

Maximum Characters: This field only appears if the Input text option is selected in the Text Type field. This field allows you to type in the maximum number of characters the user/learner will be permitted to enter into the selected input text object.

7. Select the Static text option in the Text Type field (if you have changed it). Experiment with the various text attributes found in the Properties panel. In particular, try changing the Font, Font Size, Character Spacing, Text Color, Bold, Italic, Alignment, and Change Direction of Text options.

Text Tool with the Options Toolbox

The options listed in the Options toolbox are context sensitive and change according to the primary tool selected. With the Text tool selected, as you can see, there are no options listed.

Rectangle Tool

The Rectangle tool can be used to create rectangles and rounded rectangles, with both stroke and fill attributes. To work with the Rectangle tool, perform the following steps.

1. With the Rectangle tool selected, move the cursor to the stage and note that it has now changed to a crosshair.

2. Click and hold down the mouse button as you pull the mouse to the lower right corner. You should now see a rectangle.

Rectangle Tool and Properties Panel

To work with the Rectangle tool using the Properties panel, perform the following steps.

1. Examine the Properties panel for the Rectangle tool. See figure 2-31.

Fig. 2-31. Properties panel for the Rectangle tool.

2. Note that you have already seen the options offered here, as they are the same as those for the Line tool. Review the section on the Line tool if you wish to.

3. Experiment with the Rectangle tool, using whatever shapes, colors, stroke styles, and sizes you wish.

Rectangle Tool with the Options Toolbox

The options listed in the Options toolbox are context sensitive and change according to the primary tool selected. With the Rectangle tool selected, you can see that there is only one option displayed in the Options toolbox: Rounded Rectangle Radius. See figure 2-32. To work with the Rectangle tool using the Options toolbox, perform the following steps.

Fig. 2-32. Options toolbox for the Rectangle tool.

1. Click on the Rounded Rectangle Radius button in the Options toolbox in the bottom part of the Tools panel.

·T/P·

If you hold the Shift key down as you create the rectangle, the shape will be constrained to a square.

2. In the pop-up window that appears, the cursor should already be inside the Corner Radius field. Type in *10* and then click on the OK button.

3. The Rectangle tool should still be active. If it is not, select it. Draw a new rectangle. The new rectangle should have rounded corners, according to the value you entered in the Options toolbox. The larger the value, the more rounded the corners will appear.

Oval Tool

The Oval tool can be used to create ellipses with both stroke and fill attributes. To work with the Oval tool, perform the following steps.

1. With the Oval tool selected, move the cursor to the stage and note that it has now changed to a crosshair.

2. Click and hold down the mouse button as you pull the mouse to the lower right corner. You should now see an oval.

Oval Tool and Properties Panel

To work with the Oval tool using the Properties panel, perform the following steps.

1. Examine the Properties panel for Oval tool. See figure 2-33.

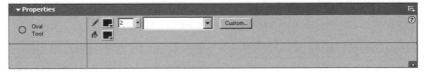

Fig. 2-33. Properties panel for the Oval tool.

2. Note that you have already seen the options offered here, as they are the same as those for the Line tool. Review the section on the Line tool if you wish to.

3. Experiment with the Oval tool, using whatever shapes, colors, stroke styles, and sizes you wish.

Oval Tool with the Options Toolbox

The options listed in the Options toolbox are context sensitive and change according to the primary tool selected. With the Oval tool selected, as you can see, there are no options listed.

If you hold the Shift key down as you create the oval, the shape will be constrained to a circle.

Pencil Tool and the Properties Panel

As you might guess from its name, the Pencil tool can be used to draw free-form objects, much like you would using a real pencil. Let's give it a try.

1. First, let's clean up again. Select the menu option Edit | Select All and then press the Delete key.

2. Click on the Pencil tool. Look at the Properties panel at the bottom of the screen, which shows you the options available for this tool. You have seen these options before. Select whichever stroke color and width you want to use.

3. Move the Pencil tool to the stage. Click and hold the mouse button as you draw a rectangle, making sure that as you finish the last line touches or crosses over the first line, so that the rectangle is closed. Did your rectangle automatically "straighten up"? If you have not changed any of the default settings, it should have done so. This feature is controlled in the Options toolbox at the bottom of the Tools panel. You will examine this option in the next section.

4. Select the Arrow tool and approach one side of the rectangle. Note that the cursor has changed from an Arrow with a very small rectangle to an Arrow with a very small curve. This should be familiar to you from the earlier section describing the Arrow tool's function. Recall that you can edit the outline of a shape using the Arrow tool.

5. Click the Arrow tool on one side of the rectangle shape. That side is now highlighted, indicating it is selected. Remember that even though the shape looks like a rectangle, you created it with the Pencil tool, so that each side can be considered an individual line that can be separately selected. You can now click and drag that selected side to another location.

6. Select Edit | Undo to put the side back.

7. Click the Arrow tool on the gray work area (or empty stage) to deselect the object.

8 Select the Subselection tool for a quick review. Click on one corner of the rectangle. Click and hold the mouse button down as you move the corner toward the center. Try pulling the corner out. The Subselection tool also allows you to modify the shape of any of the sides by editing the anchor points.

·T*i*P·

The keyboard short-cut for Undo is:
Ctrl + Z (PC)
Cmd + Z (Mac)

Pencil Tool with the Options Toolbox

The options listed in the Options toolbox are context sensitive and change according to the primary tool selected. With the Pencil tool selected, as you can see there is one option displayed in the Options toolbox: Pencil Mode. See figure 2-34.

Fig. 2-34. Options toolbox for the Pencil tool.

1. Click on the Pencil Mode button in the Options toolbox. Note that in the pop-up window that opens there are three options: Straighten, Smooth, and Ink. Let's take a quick look at each one.

2. If Straighten does not already have a check mark next to it, click on it to select it, and turn on the check mark next to it.

3. Try to draw a long, straight line with the Pencil tool (without holding down the Shift key). Let go of the mouse button. As you can see, the Straighten option will transform a nearly straight line into a straight line. With the Pencil tool, draw a Z-like shape. As you can see, the Straighten option converts each line segment into a straight line.

4. Draw a circle. The Straighten option also works on a circular shape because it straightens any imperfections in the circular shape.

5. Click on the Pencil Mode button in the Options toolbox and select the Smooth option.

6. With the Pencil tool, draw an S-like shape. As you can see, the Smooth option converts each line segment into a curved line.

7. Click on the Pencil Mode button in the Options toolbox and select the Ink option.

8. Draw a long, straight line. The Ink option cleans up the pixelation in the line, but leaves it in whatever shape you first drew. Try drawing a couple more shapes.

The Ink option is basically a free-form drawing mode tool that leaves your lines just as you created them.

Brush Tool and Properties Panel

The Paint Brush and the Pencil are the two drawing tools that do roughly the same thing, which is draw lines. The primary difference between these tools is that the Paint Brush has options to paint with adjustable line styles. Let's try it.

1. Select the Paint Brush tool. Look at the Properties panel associated with this tool. You can see that you only have one option here, which is to change the color of the brush stroke.

2. Select whichever color you would like. Paint a couple of shapes on the stage.

Brush Tool with the Options Toolbox

The options listed in the Options toolbox are context sensitive and change according to the primary tool selected. With the Brush tool selected, as you can see there are four options displayed in the Options toolbox: Brush Mode, Brush Size, Brush Style, and Lock Fill. See figure 2-35. To work with the Brush tool using the Options toolbox, perform the following steps.

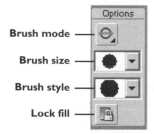

Fig. 2-35. Options toolbox for the Brush tool.

1. Note that in the lower right-hand corner of the Brush Mode button there is a small black triangle. Click on it. The pop-up window displays five options: Paint Normal, Paint Fills, Paint Behind, Paint Selection, and Paint Inside. Leave it set to Paint Normal. Let's see what this mode looks like.

2. Click on the pull-down menu for Brush Size. Select a medium-size tip.

3. Click on the pull-down menu for Brush Style. Select whichever style you would like.

4. Experiment drawing shapes, changing the Brush Size and Brush Style options.

5. To have some shapes to work with the other options, select the Rectangle tool. In the Rectangle tool's Properties panel, set the following attributes.

Stroke Color: Black

Stroke Width: 5

Color: Green

6. Draw a couple of rectangles in an empty area of the stage.

7. Select the Brush tool again. In the Properties panel for the Brush tool, select a red color.

8. In the Options toolbox, click on the Brush Mode button, this time selecting the Paint Inside option.

9. Move the Brush cursor within one of the rectangles. Click the mouse button and while holding it down paint strokes within and outside the rectangle. Release the mouse button. As you can see, if you start painting from within an object, the Paint Inside option will only leave paint on the inside of the object you started painting on.

10. To avoid confusion about which object is going to be painted, let's use the next option. In the Options toolbox, click on the Brush Mode button, this time selecting the Paint Selection option.

11. Select the Arrow tool and single click on the fill of one of the rectangles you drew earlier.

12. Select the Brush tool again. Click and hold the mouse button on the outside of the selected rectangle and paint a line all the way through the rectangle. Start from inside the rectangle and draw lines. As you can see, the Paint Selection option allows you to first select an object and then paint just that object.

13. In the Options toolbox, click on the Brush Mode button, this time selecting the Paint Behind option.

14. Click and hold the mouse button on the outside of one of the rectangles and paint a line all the way through the rectangle. As you can see, the Paint Behind option allows you to paint only behind (and on the outside of) an object.

15. In the Options toolbox, click on the Brush Mode button, this time selecting the Paint Fills option.

16. Choose a new paint color for the Fill Color selector in the Tool panel. Paint freely over the fill and stroke of one of the rectangles. Note that as you paint, the paint color ignores the stroke portions of the rectangle. Painter beware! Unlike Paint Inside, this option will paint anything that is not a stroke.

Free Transform Tool

To work with the Free Transform tool, perform the following steps.

1. Select the Free Transform tool.

2. Click the cursor above the upper left-hand corner of one of the rectangles you created on screen. Hold the mouse button down as you drag the cursor past the lower right-hand corner of the rectangle. Let go of the mouse button.

3. A selection highlight (with anchor points) now covers the rectangle. Take the cursor and approach a side anchor point and watch as the cursor changes to a double arrow. This cursor shape indicates that the side can be moved in or out. See figure 2-36. Click and hold the mouse button as you move the side in and/or out.

Fig. 2-36. Free Transform tool showing cursor for adjusting sides.

Fig. 2-37. Free Transform tool showing cursor for rotating object.

4. Using the cursor, approach a corner anchor point, without moving over the corner point (keep the cursor a short distance away from corner point). The cursor changes to include a circular icon with an arrowhead on the end. This cursor shape indicates that the object can now be rotated. See figure 2-37. Click and hold the mouse button as you move the cursor down to rotate the object clockwise, or move the cursor up to rotate the object counterclockwise.

Free Transform Tool with the Options Toolbox

The options listed in the Options toolbox are context sensitive and change according to the primary tool selected. With the Free Transform tool selected, as you can see there are four options displayed in the Options toolbox: Rotate and Skew, Scale, Distort, and Envelope. See figure 2-38. To work with the Free Transform tool using the Options toolbox, perform the following steps.

You have just worked with the Rotate and Skew option, the default setting.

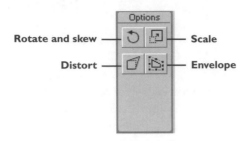

Fig. 2-38. Options toolbox for the Free Transform tool.

1. In the Options toolbox, click on the Scale button. Click on a corner anchor point and move the cursor toward the center of the rectangle, and then pull the corner out past the original position. Click on an anchor point in the middle of a side. Move the side in, toward the center, and then outward. As you can see, the Scale option allows you to change the overall size of the entire object, or change the size either by height or width.

2. In the Options toolbox, click on the Distort button. Click on a corner anchor point and move the cursor toward the center of the rectangle, and then pull the corner out and up. As you can see, the Distort option allows you to change the overall shape of the original object.

3. In the Options toolbox, click on the Envelope button. This is kind of a strange name for it, but take a look. Click on a corner anchor point and move the cursor toward the center of the rectangle. Click on an anchor point on the side and move the cursor toward the center of the rectangle. Click on another couple of anchor points on the side and move them toward the center of the rectangle. As you can see, the Envelope option provides control in completely changing the overall shape of the original object by manipulating the anchor points revealed along the side of the objects.

Fill Transform Tool

The Fill Transform tool is used to manipulate the way fills, such as gradients and bitmaps, appear inside a shape by allowing you to rotate, scale, and move the center point of these fills. To work with the Fill Transform tool, perform the following steps.

1. First, let's learn how to fill an object with a gradient. Clean up the stage area by selecting Edit | Select All. Press the Delete or Backspace key to clear the stage.

2. Select the Oval tool. Apply no stroke by selecting the No Stroke option in the Stroke color picker, as shown in figure 2-39.

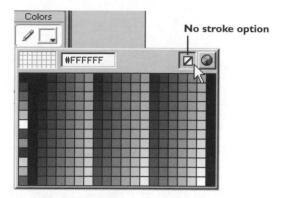

Fig. 2-39. No Stroke option.

3. From the Fill color picker, select a gradient fill from the bottom row of the swatches, such as the rainbow spectrum linear fill shown in figure 2-40. As you can see, there are radial and linear fills with different color settings. You can also create your own custom gradient patterns.

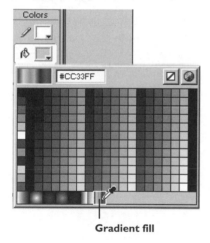

Gradient fill

Fig. 2-40. Selecting a gradient fill.

4. Draw a medium-size oval on the stage. Note that it is filled with the gradient pattern and has no stroke, as you specified.

5. The Fill Transform tool allows you to change the way a gradient fills an object. Select the Fill Transform tool and then click on the oval you just drew. A selection box appears around the oval, as shown in figure 2-41.

Fig. 2-41. Fill Transform selection box.

6. A circle appears in the middle of the oval. This indicates the center point of the fill. Click and drag the center point up and to the left to change the center point of the fill. When you do this, it changes the way the colors in the gradient appear.

7. The circle in the upper right-hand corner allows you to rotate the gradient. Place the cursor over this circle and note that a circle of arrows appears. Click on this circle and drag the fill transform square to the right to rotate the gradient so that the pattern now fills from top to bottom.

8. Use the square on the side of the Fill Transform selection box to scale the gradient. Move the cursor over the square and note that it turns into a double-headed arrow. Click and drag inward to make the gradient range smaller, as shown in figure 2-42. You can also drag outward to make the range larger.

Fig. 2-42. Scaling the gradient fill.

9. Select another tool to turn off the Fill Transform tool.

Fill Transform Tool with the Options Toolbox

The options listed in the Options toolbox are context sensitive and change according to the primary tool selected. With the Fill Transform tool selected, as you can see there are no options displayed in the Options toolbox.

Ink Bottle Tool

The Ink Bottle tool can be used to pour a selected color, width, or stroke style into a stroke that already exists on stage, or to add these attributes to an object without a stroke. To work with the Ink Bottle tool, perform the following steps.

1. Click on the Ink Bottle tool. Take a quick look at the Properties panel. As you can see, there are just a few options listed, and you have already worked with them all.

2. In the Properties panel, select a color, width, and stroke style.

3. Move the Ink Bottle cursor over the edge of the oval with the gradient you were just working with. Click the cursor directly on the edge of the oval. A stroke will be added to the oval, and whichever attributes you selected in the Properties panel should now be displayed.

4. Select a new color, width, and style from the Properties panel. Click on the existing stroke to apply these new settings.

5. Experiment with this tool and its attributes in the Properties panel as much as you wish.

Ink Bottle Tool with the Options Toolbox

The options listed in the Options toolbox are context sensitive and change according to the primary tool selected. With the Ink Bottle tool selected, as you can see there are no options displayed in the Options toolbox.

Paint Bucket Tool

The Paint Bucket Tool is a standard tool found in most paint programs. It allows you to pour a fill color or pattern into an object that is completely enclosed, to provide an interior color or pattern for that object. To work with the Paint Bucket tool, perform the following steps.

1. Click on the Paint Bucket tool. Look at the Properties panel for the Paint Bucket tool. Obviously the only option here is to change the color of the fill. Click on the color swatch to display the pop-up color palette. Select whichever color you would like.

2. Move the cursor (note that the cursor now looks like a small paint bucket) over the interior portion of any object you have drawn on stage. Click and release the mouse button. You should now see the color you selected appear throughout the interior of the object. Note that lines or sections of the image that are a color other than that which you poured will stop the fill from going any further.

·**T/P**·

When using the Ink Bottle to add or edit a stroke, line up the bottom portion of the ink spilling out of the bottle with the stroke placement.

Paint Bucket Tool with the Options Toolbox

The options listed in the Options toolbox are context sensitive and change according to the primary tool selected. With the Paint Bucket tool selected, as you can see there are two options displayed in the Options toolbox: Gap Size and Lock Fill. See figure 2-43. These options are used when you have drawn an object with a drawing tool such as the Pencil tool. Sometimes there may be unnoticeable gaps between line segments that cause the Paint Bucket tool to think the shape is not fully enclosed. As a result, it cannot fill the object. To work with the Paint Bucket tool using the Options toolbox, perform the following steps.

Gap size

Lock fill

Fig. 2-43. Paint Bucket Options toolbox.

1. Select the Pencil tool and draw a circle on the stage, leaving a small gap in the path.

2. Select the Paint Bucket tool and in the Options toolbox select Don't Close Small Gaps. Select a fill color and click inside the circle to fill the shape. With this gap, the shape will not fill!

3. Try experimenting with the Close Small Gaps, Close Medium Gaps, and Close Large Gaps options to see which option it takes to fill the circle.

Eyedropper Tool

·TIP·

You can also sample colors into either the Fill or the Stroke color wells in the Colors toolbox, using a similar Eyedropper tool.

The Eyedropper tool is used most frequently in combination with the Paint Bucket tool. The Eyedropper tool allows you to pick up a sample color from anywhere on the canvas and with the use of the Paint Bucket tool pour that color somewhere else. To work with the Eyedropper tool, perform the following steps.

1. Click on the Eyedropper tool. Move the cursor over one image on the stage and click the Eyedropper tool on that image. Look in the Colors toolbox, at the Paint Bucket icon. It should be the same color as you just clicked on.

2. Click on the Paint Bucket tool. Move the cursor over the interior area of a differently colored object. Click the Paint Bucket tool on this area. You should have just picked one color with the Eyedropper tool and poured it into a second area using the Paint Bucket tool.

Eyedropper Tool with the Options Toolbox

The options listed in the Options toolbox are context sensitive and change according to the primary tool selected. With the Eyedropper tool selected, as you can see there is no option displayed in the Options toolbox.

Eraser Tool

The Eraser tool is pretty straightforward. Let's take a look.

1. Click on the Eraser tool.

2. Click and drag the Eraser tool over any object that is currently on screen to erase that object.

Eraser Tool with the Options Toolbox

The options listed in the Options toolbox are context sensitive and change according to the primary tool selected. With the Eraser tool selected, as you can see there are three options displayed in the Options toolbox: Eraser Mode, Faucet, and Eraser Shape. See figure 2-44. To work with the Eraser tool using the Options toolbox, perform the following steps.

Fig. 2-44. Eraser Options toolbox.

1. The Eraser Mode button in the Options toolbox has a small black triangle indicating there are other options. Click on the Eraser Mode button. As you can see, the pop-up window displays the options Erase Normal, Erase Fills, Erase Lines, Erase Selected Fills, and Erase Inside.

2. The Erase Normal mode is set by default, and you should see a check mark by it. Click on the gray work area to close the window. Move the

Eraser cursor over an object. Hold down the mouse button as you drag the Eraser across the object. Erase Normal erases everything in its path.

3. Click on the Eraser Mode button and select the Erase Fills mode. Move the Eraser cursor over an object. Hold down the mouse button as you drag the Eraser across the object. As you can see, Erase Fills erases just the fill of the object, leaving the stroke.

4. Click on the Eraser Mode button and select the Erase Lines mode. Move the Eraser cursor over an object. Hold down the mouse button as you drag the Eraser across the object. As you can see, Erase Lines erases just the stroke of the object, leaving the fill.

5. Click on the Eraser Mode button and select the Erase Selected Fills mode. Select the Arrow tool and click on the fill of an object. Move the Eraser cursor over the selected object. Hold down the mouse button as you drag the Eraser across the object. Try erasing an object that is not selected. As you can see, Erase Selected Fills erases just the fill of the selected object.

6. Click on the Eraser Mode button and select the Erase Inside mode. Move the Eraser cursor within an object. Hold down the mouse button as you drag the Eraser out of the object. As you can see, Erase Inside erases just the fill of the object you designate. This mode also leaves the stroke.

7. Click on the Faucet button in the Options toolbox. Move the Faucet Eraser cursor inside an object. Click the mouse button. This option pours an erase function into the area you have clicked on. It will erase all internal areas that are the same color as you clicked on.

8. Click on the black arrow for the Eraser Shape button in the Options toolbox. As you can see in the pull-down menu, there are a variety of eraser shapes you can choose from.

9. Experiment using a variety of eraser shapes, modes, and the Eraser Faucet option.

Guided Tour 2B: The View Toolbox

There are two View tools in the View toolbox, shown in figure 2-45: Zoom and Hand. Each View tool provides a different function. Let's take a closer look.

Hand tool —— —— **Zoom tool**

Fig. 2-45. View toolbox.

Zoom Tool

To work with the Zoom tool, perform the following steps.

1. Click on the Zoom tool (Magnifying Glass icon). Move the cursor to an object. Click and hold the mouse button as you drag the expanding marquee over a section of the object. Let go of the mouse button. You are now looking at a magnified view of that section of the object you selected with the Zoom tool.

2. Look at the upper right-hand corner of the stage, where you can see a Magnification field. This field allows you to either use the pull-down menu or type in another value for magnification.

3. Single click anywhere on the stage or work area. As you can see, the more you click, the more you further enlarge the magnified area. You can also use the following keyboard shortcuts.

 PC: Zoom In (Ctrl + =), Zoom Out (Ctrl + -)

 Mac: Zoom In (Cmd + =), Zoom Out (Cmd + –)

Zoom Tool with the Options Toolbox

The options listed in the Options toolbox are context sensitive and change according to the primary tool selected. With the Zoom tool selected, as you can see there are two options displayed in the Options toolbox: Enlarge and Reduce. To work with the Zoom tool using the Options toolbox, perform the following steps.

1. By default, the Zoom tool is set using Enlarge. Click on the Reduce button in the Options toolbox.

2. Single click anywhere on the stage or work area. As you can see, with the Reduce option selected, single clicking will reduce the enlargement (that is, it will zoom out).

Hand Tool

To work with the Hand tool, perform the following steps.

Shortcut

You can also hold down the Alt (PC) or Opt (Mac) key to toggle from enlarge to reduce. Holding down this key makes a minus sign appear inside the Zoom tool, which allows you to zoom out.

1. Click on the Hand tool. Move the Hand tool anywhere on stage or in the work area.

2. Click and hold the mouse button down as you drag the Hand tool in any direction. Let go of the mouse button. As you can see, the Hand tool allows you to move the magnified area of the stage and work area within the viewable area. The Hand tool is especially useful when viewing a portion of the stage in a magnified view.

Hand Tool with the Options Toolbox

The options listed in the Options toolbox are context sensitive and change according to the primary tool selected. With the Zoom tool selected, as you can see there are no options displayed in the Options toolbox.

Guided Tour 2C: The Colors Toolbox

You have already been using the Color toolbox (shown in figure 2-46) in combination with other tools previously introduced. However, let's look more closely at the tools found here, and some of the options available.

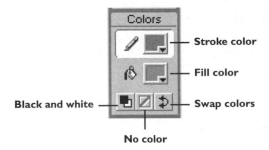

Fig. 2-46. Color toolbox.

Stroke Color Tool

To work with the Stroke Color tool, perform the following steps.

1. Start with a new file by selecting File | New.

2. So that you have an object to work with, click on the Rectangle tool and draw a rectangle on the stage.

3. Look at the Properties panel for the rectangle you just drew. Note that the panel includes fields for color of the interior (Paint Bucket icon) and for the color of the stroke (Pencil icon). These same icons exist in the Colors toolbox, to provide access to the same properties.

4. In the Colors toolbox, click on the Pencil icon. Let's take a little closer look at the pop-up window that has opened. See figure 2-47.

Hexadecimal field **No fill** **System color picker**

Fig. 2-47. Stroke Color palette (pop-up window) from the Colors toolbox.

5. Selecting a color is pretty easy. All you need to do is click the cursor (note that the cursor is in the shape of the Eyedropper tool) on the color you want. Do this now. If you are trying to exactly match a color and you know the color's hexadecimal code, you can also type this code into the entry field at the top of the pop-up window.

6. At the top right-hand corner, there are two other options to look at. The first, the button with the red line through it, allows you to set the stroke to transparent or no stroke color. To the right of this is a button that will open another pop-up window for the System color picker. Go ahead on click on this button. You should now be looking at the pop-up window. See figure 2-48. This window is generally used by more advanced design-ers, as they create and save a custom color palette. Click on the Cancel button to close the System color picker.

Fig. 2-48. System color picker.

7. The Stroke Color palette closed. In the Colors toolbox, click on the Pencil icon. Select a stroke color by clicking on the color you wish.

Fill Color Tool

To work with the Fill Color tool, perform the following steps.

1. In the Colors toolbox, click on the Paint Bucket icon for the Fill Color tool. Let's take a little closer look at the pop-up window that has opened. This color palette looks identical to the pop-window for stroke color, with the exception of the fill options displayed on the lower left of the color palette. Click on the red circle (red gradient) located in the lower left-hand corner of the color palette.

2. Now that you have selected both a stroke color and a fill color, experiment by drawing rectangles as you change stroke and fill colors.

Getting Your Computer Ready for Practice Exercises

Throughout the course of this book, you will be creating many Flash MX files that you will want to save on your computer. In order to make it easier to locate these files and communicate to you about these files, it is strongly recommended that you create a new directory (folder) on your computer's hard drive to store these files.

1. Please create a directory (folder) on the root directory of your computer's hard drive.

2. Name the directory (folder) . . . SaveWork.

3. Save all files that you work with in this book, into this SaveWork directory (folder).

Practice Exercise 2-1: Using the Basic Tools

Description

This practice exercise is designed to help you get started using the basic tools within Flash's Tools panel. Do not be concerned about the results of what the drawing may look like. Rather, focus on experimenting with the use of these tools.

Take a Look

Before beginning the exercise, let's take a look at the exercise in its completed state so that you can clearly see what it is you are about to build. The objects you draw may be somewhat different from those shown in the completed exercise file. This is as intended, and feel free to take artistic license in making whatever modifications you would like. Perform the following steps.

1. Select File | Open and using the browse function in the pop-up window, locate on the companion CD-ROM the directory named *Chapter02*. Within this directory, locate and double click on the file named *Practice2_1.fla*.

2. Verify that file *Practice2_1.fla* has appeared in your copy of Flash MX.

3. Take a look at the graphic images you will create.

Storyboard: On Screen

For this exercise, the result of what you create may vary somewhat from what you see here, but when the exercise is completed you should have something similar to that shown in figure 2-49.

Fig. 2-49. Completed graphic.

Step-by-Step Instructions

To work with the basic tools, perform the following steps.

1. Start with a new file by selecting the menu option File | New.

2. Let's start by creating a sky image, as follows.

 a) Select the Rectangle tool from the toolbox.

 b) Select the Stroke color picker and choose the No Fill icon from the pop-up color palette. The No Fill icon is located in the upper right corner of the palette and looks like a white square with a red line through it (kind of like the ghost buster symbol). Select the Fill color picker and then select a light blue.

 c) Draw a rectangle large enough to cover the top two-thirds of the stage. See figure 2-50. This will become the sky.

·T/P·

You certainly do not want the sky to have a "border color." This is why you selected No Color for the stroke color. However, another approach would have been to use the same light blue color for both the stroke and the fill. In general, there are typically several ways of accomplishing the same thing in Flash MX.

Fig. 2-50. The sky area.

3. Add a sun to the sky by performing the following steps.

 a) The sky will need a sun to look more natural. Select the Oval tool from the toolbox. Select the Stroke color picker from the Color section of the toolbox, and select the color orange. Select the Fill color picker, and select the color yellow.

 b) To change the width of the stroke, look in the Properties panel and use the Stroke Width slider to change the width to a value of 4.

 c) Hold down the Shift key as you click and drag the Oval tool to draw a small circle in the upper right-hand corner of the sky area. See figure 2-51.

Fig. 2-51. Sun drawn in the sky.

This "cookie cutter" problem is very commonly experienced when first drawing objects in Flash. What happens is that "ungrouped" objects, when placed on top of each other, will actually "merge" and become part of a larger composite graphic. When you try to move what used to be a separate object, you discover that when it became "merged," whatever used to be underneath it is lost in the "merger" and thus a "hole" appears when the object above is moved. You can solve this problem by "grouping" an object (even if it is just one object) or drawing on another layer.

d) Select the Arrow tool from the toolbox. Click and drag the yellow fill of the circle you just drew. Note that the stroke was not selected and did not move with the fill.

e) You may have noticed another very common problem when you moved the sun fill. By drawing the sun directly on top of the sky, when you moved the sun the image acted almost like a cookie cutter and cut out part of the blue in the sky. See figure 2-52. Select Edit | Undo. Whew – that was one mistake narrowly missed.

Fig. 2-52. "Hole" cut out of sky by moving the fill.

f) You can fix the fill problem and the "hole" at the same time. Let's first deal with the fill problem. Double click inside the circle to select both the fill and the stroke of the sun graphic. Drag the sun down to the bottom third of the stage, outside the blue sky. Click on the white area of the stage to deselect the sun. Note that you now have a "hole" where the sun used to be. Double click to select the sun graphic again, and then select Modify | Group to group the fill and stroke of the sun.

g) Let's now fix the "hole" in the sky. Click on the Eyedropper tool. Click the Eyedropper on the blue sky to pick up this color. Select the Paint Bucket tool and position the Paint Bucket cursor over the hole, where

the sun once was, and click inside the hole to fill it with the sky color again. If you have more than one hole in the sky, fill them all.

h) Now let's correct the second half of the "cookie cutter problem." Click on the sky. Select the menu option Modify | Group. Note the rectangle that now surrounds the "grouped" object. Click on the sun and drag it to the upper right side of the sky graphic. By grouping the sun and then grouping the sky, you have protected each graphic from merging with any other objects you place on top of them. By grouping the sun, you can also now select the stroke and fill with just one click (because it is now a grouped object).

i) But wait a second – where did the sun go? Because you are now working with two grouped objects – the sun and the sky – the sky is probably covering the sun. Objects on layers have a stacking order. The rule is that the most recently grouped object goes to the top of the stacking order, covering whatever is underneath it. The sky was the last grouped object, so it will be on top of the stacking order. Let's change the stacking order. Click to select the sky. Select Modify | Arrange | Send to Back. The sky is now underneath the sun in the stacking order.

4. Now on to the mountain range! Create this element by performing the following steps.

a) Select the Line tool from the toolbox. Click the Stroke color picker and change the color to medium purple. The stroke already has a value of 4, carried over from the changes you made to the yellow circle. There is no need to adjust any settings of the Fill color picker prior to using the Line tool.

b) Starting below the blue rectangle, so that none of the drawing overlaps onto the blue, start at the left of the stage and draw a series of short, connected line segments (i.e., a zigzag). Continue this zigzag until it has gone beyond the right side of the stage. See figure 2-53.

Fig. 2-53. Beginning of the mountain range.

c) Click the end point of the zigzag and draw a line straight down. Continue this line to the left side of the stage, and then connect the end of this line to the starting point of the zigzag to close the shape. You are now ready to add a color for the fill inside the outline. See figure 2-54.

Fig. 2-54. Mountain range ready to be filled.

d) Select the Paint Bucket tool from the toolbox. Select the Fill color picker from the bottom Color section of the toolbox and select a light purple color. With the Paint Bucket tool, click anywhere within the zigzag shape to give it a light purple color. You have just created a mountain range!

e) Let's now add a few snow-covered peaks. Select the Eraser tool from the toolbox.

f) Select the Eraser mode modifier at the bottom of the toolbox, and set the Eraser Mode option to Erase Fills. Click on the Eraser shape modifier and select a medium, round eraser.

g) Position the Eraser tool over the peak of your first mountain and click and drag to erase the light purple fill at the mountain peak. Note that you can see through the mountaintop to the stage. See figure 2-55.

Fig. 2-55. Using the Eraser tool to create room for snowcaps.

·T/P·

You can use the Arrow or Sub-selection tool to reposition and refine the shape of your mountain range.

·T/P·

Remember to check your Paint Bucket options if you are having trouble filling the mountain range. Change the options to Close Large Gaps just in case you have some gaps in your drawing you cannot see at the current magnification.

·T/P·

If you are having trouble seeing what you are doing because the background is white and the color fill is white, try changing the background color of the stage by selecting Modify | Document to open the Document Properties window. Use the Background color picker to choose a contrasting color. Once you are finished filling in the snow caps, select Modify | Document again to change the background color back to white.

h) Continue to erase the other mountaintops until they each have a space for a snowcap. Even though it looks as though there is snow at this point, it only appears white because the stage is currently white. These snowcaps are now actually transparent. If you were to drag the mountain range up to overlap the sky, you would see blue where you just erased. You need to fill these areas in with a color.

i) Select the Paint Bucket tool from the toolbox. Click on the Fill color picker in the Color section of the toolbox and select white from the palette.

j) Using the Paint Bucket tool, click inside each erased area until you have filled each with white. Instant snow! Even though it may not look any different, you now have a solid white color for the snowcaps.

k) Select the Arrow tool from the toolbox and double click on the light purple fill of the mountain graphic. Note that both the light purple fill of the mountain and the corresponding stroke were selected, but not the snowcaps. To select the entire mountain graphic, you must position the Arrow tool at the upper corner on one side of the mountain range. Hold the mouse button down as you drag the expanding marquis (dotted line) completely around the entire mountain image (including the snowcaps). Release the mouse button. Once the entire mountain graphic is selected, group it as you did earlier in this exercise (Modify | Group).

l) With the Arrow tool still selected, drag the mountain graphic to the center of the stage.

m) If the mountain range is not long enough to overlap both sides of the stage, do not worry, you will fix this. Make sure the mountain graphic is still selected, and then select the Free Transform tool in the toolbox. Click on one of the scale handles and drag the handle to change the size of the mountain range. Adjust the size of the mountain graphic by clicking and dragging the scale handles. See figure 2-56.

Fig. 2-56. Free Transform tool and scale handles on object.

·T/P·

If you click and drag a scale handle on either the top or bottom, you will change the height without affecting the width. If you click and drag on either side, you will change the width without affecting the height. If you click and drag one of the corner scale handles, you will change both height and width at the same time.

n) Drag the mountains up so that they overlap the sky. When you are finished, your graphic should look similar to that shown in figure 2-57.

Fig. 2-57. Mountain range scaled and in place.

5. Now you have the sky, sun, and mountains. Now let's create the ground.

 a) Select the Rectangle tool from the toolbox. In the Properties panel, click on the Stroke color picker and select a dark green color. Set the stroke width to 5 using the slider. Click on the Fill color picker and select a medium green from the palette.

 b) Click and drag the Rectangle tool to draw a rectangle in the work area, one that is large enough to cover the bottom third of the stage. If you cannot see the work area, select View | Work Area.

 c) Select the Arrow tool from the toolbox. As you move the Arrow tool over the fill area of the rectangle, note the four-headed arrow symbol. This symbol indicates that if you click and drag now you will move the fill.

 d) Position the cursor on the top of the top line (the stroke) of the rectangle. With the cursor positioned over the stroke, a curved line symbol appears next to the Arrow cursor. See figure 2-58. This indicates that you can now push and pull the line to change its curvature.

Fig. 2-58. Arrow cursor symbol indicating ability to alter the curve of the stroke.

 e) Click and drag the stroke upward to form a hill. See figure 2-59.

·**T/P**·

When working with multiple objects, you may find it easier to draw and assemble objects off stage in the work area and then when ready, drag them onto the stage. If you are working with objects that overlap, you may find this technique especially helpful. However, this "off-stage construction" is definitely not necessary. You may prefer to create on the stage. If there isn't enough room to draw on the side of the stage, you can always use the scroll bars at the bottom or side of the Stage window to adjust your view. Once you start animating objects in later chapters, you can also use the work area to position objects off the stage in certain frames.

·**T/P**·

If you position your Arrow tool over the corner of the rectangle, you will get an angle symbol instead of a curve. This will allow you to push and pull the right angle of the rectangle without altering the curvature of the lines.

Fig. 2-59. Beginning of the ground.

Shortcut

The keyboard shortcut for grouping objects is:
Ctrl + G (PC)
Cmd + G (Mac)

f) Double click on the hill graphic and group it as you have done previously.

g) Drag the hill graphic onto the stage. If necessary, click on the Free Transform tool in the toolbox and adjust the size of the hill graphic, as you did for the mountains. Great! This landscape now has some land! See figure 2-60.

Fig. 2-60. Hill in place on the stage.

6. Now let's add a few trees to finish it up. Perform the following steps.

a) Select the Pencil tool from the toolbox. In the Properties panel, select the Stroke color picker and then select a dark green from the palette. Change the size of the stroke width to 3.

b) From Pencil options, select Smooth. To the side of the stage, click and drag the Pencil tool to draw a tree shape. Do not be too concerned with what it looks like at this point.

c) Select the Arrow tool from the toolbox. Use the Arrow tool to "spruce up" the tree shape. If you want to change an angle, click and drag the angle until looks the way you want it to look. To adjust a curve, click and drag a line in the center until the curve is more appealing. You can also select the Subselection tool to edit individual anchor points in the tree shape. See figure 2-61.

Fig. 2-61. Tree before and after use of the Arrow tool.

d) Select the Paint Bucket tool from the toolbox. Click on the Fill color picker and select a medium green (lighter than the tree stroke but darker than the hill fill).

e) Click inside the tree shape to assign the color.

f) Select the entire tree graphic and group it.

7. Perform the following shortcut to create a forest out of this one tree!

a) While holding down the Alt key (Mac, Option), click and drag the tree graphic, and then release the mouse button. You have just created a duplicate of the tree graphic! Repeat this step until you have five trees.

b) Using the Arrow tool and the Free Transform tool, change the scale, height, and width of the individual trees so that each appears a little different.

c) Arrange the tree graphics into a little grove. Select all of the tree graphics and group them. See figure 2-62.

Fig. 2-62. A grove of trees is easily created using the duplication technique.

d) Click and drag the group of trees onto the left side of the hill graphic. Resize them if necessary by using the Arrow tool and Free Transform tool.

CAUTION

If you select a line by clicking on it, and then click and drag, you will move the selected line instead of adjusting the curve.

Shortcut

You can also use the Edit | Duplicate command to make copies of a selected object. The keyboard shortcut for Duplicate is:
Ctrl + D (PC)
Cmd + D (Mac)

e) With the trees still selected, create a duplicate of them, as previously (PC, Alt and drag; Mac, Opt and drag), and position them on the right side of the hill. Use the Arrow tool and Free Transform tool to make them smaller, and then position them close to the top stroke of the hill graphic to make them appear further away.

8. Save this file as *Exer2.fla* in the *SaveWork* folder you previously created on your hard drive.

CHAPTER

3

Creating

Frame-by-Frame

Animations

Introduction

In a previous chapter you were introduced to the movie or theater production metaphor used in the Flash authoring environment. This movie production theme will become clearer in this chapter, as you work with a fundamental concept in Flash: frame-by-frame animation. Now that you have learned some basic drawing techniques, it is time to start adding some action! In Chapter 2, you learned how to work with the tools that can be used to create objects ("characters" on the stage). Now you need to make these "characters" perform. Let's start by animating simple objects on the stage. By the end of this chapter you will be able to:

- *Add and delete frames in the timeline*
- *Add an object to specific frames in the timeline*
- *Control the playback of the timeline*
- *Describe the purpose of the timeline*
- *Change document properties*
- *Describe and use keyframes*
- *Create a basic frame-by-frame animation*
- *Preview your movie*
- *Use the onionskin tools*

Guided Tour 3A: The Controller and Playhead

In this Guided Tour you will open an existing Flash movie and learn how to preview it using the controller and the playhead on the timeline. These tools allow you to preview frames in the timeline of a movie as it is being developed. By the time you complete this tour you will have a better understanding of how these features help you preview a Flash movie, and how you can step through the individual frames of a movie. To work with the controller and the playhead, perform the following steps.

 CD-ROM

1. Open the file *Lesson3.fla*, located in the *Chapter03* folder on the companion CD-ROM.
 a) Select File | Open.
 b) For PC: In the dialog window that opens, use the pull-down browse function within the Look In field to locate and select the CD-ROM drive. For Mac: Use the pull-down browse function to navigate to the CD-ROM.
 c) Locate, select, and look inside the *Chapter03* folder.
 d) Locate, select, and open the *playback.fla* file by either double clicking on the file name or by selecting it and then clicking on the Open button.

2. Take a moment to examine the file. The stage is shown in figure 3-1, and the timeline in figure 3-2.

Fig. 3-1. The stage.

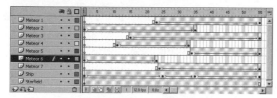

Fig. 3–2. The timeline.

3. Let's use the controller and the playhead to step through the completed movie file. First, you need to open the controller, as follows.

 a) If you are using a Mac, with the *playback.fla* file still open on the stage, open the controller by selecting Window | Controller.

 b) If you are using a PC, with the *playback.fla* file still open on the stage, open the controller by selecting Window | Toolbars | Controller.

4. You were first introduced to the controller in Chapter 1. As a review, the controller buttons look very similar to a VCR's buttons, and serve the same functions in the Flash environment. See figure 3-3.

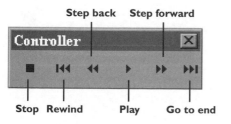

Fig. 3-3. The controller.

·T/P·

The controller is a floating panel that can be moved and positioned anywhere on the screen.

a) Press the Play button on the controller to run through the entire time-line of the movie until it reaches the last frame and stops. Note that the playhead in the timeline moves through each frame of the movie in sequence, displaying the content of every frame on the stage.

b) Press the Rewind button and then play the movie again. This time, press the Stop button before the playhead reaches the end of the timeline. See figure 3-4.

Rewind button　　　　　　**Stop button**

Fig. 3-4. Rewind and Stop buttons.

c) Use the Step Back and Step Forward buttons (shown in figure 3-5) to step through individual frames in the movie timeline. Note that the playhead moves in sequence with any action in the controller.

Step back button　　　　　　　　　　**Step forward button**

Fig. 3-5. Step Back and Step Forward buttons.

Shortcut

If you want to play through all frames of your movie without using the controller, press the Enter key. The playhead will move down the time-line and stop at the last frame. Press Enter again to start the movie from the beginning.

5. Instead of using the controller, move through each frame by dragging the playhead to the left or right along the timeline. As the playhead (shown in figure 3-6) moves, the red line descending from the playhead shows you which frame you are on in each layer of the timeline.

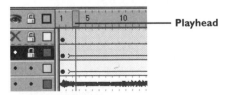

Playhead

Fig. 3-6. The playhead.

6. You can modify the playback of your movie by using Control menu options. To use these options you must also play the movie by selecting Control | Play.

 a) To play the movie in a continuous loop, select Control | Loop Playback.

 b) To play all scenes in a movie, select Control | Play All Scenes.

 c) To play a movie without sound, select Control | Mute Sounds.

7. You are finished here, let's move on. Leave this file open, as you will use it in the next Guided Tour.

The Timeline

By now you probably realize that the timeline is the central controlling element in a Flash movie. The stage displays all objects and elements in a movie that the viewer sees. However, any action that takes place on the stage is controlled by what happens in the timeline. In the previous Guided Tour, as you moved the playhead along the movie timeline, you saw how individual frames triggered events displayed on the stage. When working with the timeline in Flash, objects, actions, or animations will be activated by the content of these individual frames in the timeline.

Flash provides the capability to include multiple layers in the timeline so that you can create very complex movies with many different animated objects. In addition, by using symbols you can also place a sub-timeline (timeline within the main timeline). In other words, you can nest timelines within other timelines. This is an advanced feature of Flash, which you will examine later in the book, as it is one of the features of Flash that makes it so versatile and powerful.

The basic concept and structure of the timeline is rooted in the way traditional frame-by-frame animation was created in the early days of the movie industry. When animators first started creating cartoons, each frame of action in the movie was drawn by hand. After the first frame was drawn, animators placed translucent paper (onionskin paper) on top of the first frame so that they could see the previous frame and draw incremental changes on this second sheet of onionskin. Putting hundreds – or thousands – of these sheets together eventually made up an animated scene.

In a similar way, as children, many of us created our own "cartoons" by drawing a simple figure on the edge of many pages of a book, with each page containing a small change in the figure. When you "flipped" through these pages, you saw an animation of the figure. Although a crude form of animation, these "flip-books" use the same concept as traditional frame-by-frame animation.

Although the timeline interface for Flash is based on this traditional frame-by-frame concept, Flash also has built-in features that allow you to work much faster than early animators. The tweening features in Flash make it easier to create animation by taking the tedium out of creating each frame within the ani-

mation. With the Tweening feature, you create the "beginning" and "end" figures, and let Flash create the frames "between," saving you a lot of time and effort.

A simple example might clarify the difference between frame-by-frame animation and tweening. In the example that follows, the effect you want to create is to make it appear that a large ball is moving away from you on a diagonal path. The "start" (or first frame) and the "end" (last frame) for both frame-by-frame and tweening will be exactly the same. For example, see figures 3-7 and 3-8.

Fig. 3-7. First frame.

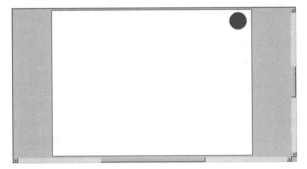

Fig. 3-8. Last frame.

In the first frame of the animation there is a large ball located in the lower left-hand side of the stage. In the last frame, the ball is much smaller and is located in the upper right-hand corner of the stage. In this example, let's assume that there will be 20 frames between the first frame and the last frame.

With frame-by-frame animation you would need to make modifications in the second frame, and in all subsequent "between" frames. In each frame you would need to draw the ball just a little bit smaller and move it slightly to the upper right. In other words, you end up drawing the ball in all 22 frames.

With tweening, you draw the first and last frames and use the Properties panel to have Flash automatically create the necessary changes to all frames between

the first and last frames. The term tween is derived from between. In a subsequent chapter you will explore the details of motion and shape tweening, including a lot of hands-on practice with tweening.

Playback Speed

The playback speed of a Flash movie is controlled by the frame rate chosen in the Properties panel for the document. You can think of this as setting a "speed limit" of how fast the playhead runs through the length of the movie. Flash measures the speed of a movie in terms of frames per second (fps). If the frame rate is set to 30, Flash displays 30 fps. By increasing the fps, you affect a movie in two ways. First, the animation will play faster. Second, the animation will play more smoothly (assuming your computer's processor is fast enough to handle the faster fps). It is important to understand that the frame rate does not control factors such as slow Internet connections or processor speed.

What frame rate is best for your application? There really is no "correct" answer that will work for every situation. There are several factors, however, that influence how well your Flash movie will play back. These factors include the user's computer CPU speed, the user's graphic card/monitor, the delivery medium (CD-ROM, Internet modem connection, Internet broadband connection, intranet broadband connection, and so on), the animation itself (i.e., the size of the objects and complexity of motion), and whether additional media elements (audio/video) are involved in the presentation. Faster, newer computers will be able to handle higher frame rates.

Whatever frame rate you select, it should accommodate the typical user you expect will access and view your application. You may find that a frame rate between 8 and 12 will serve as the best "lowest common denominator" for your target audience if you are working on a web-based application. However, the best advice is to experiment with various frame rates while you "test" these rates with various computers and connections typically used by your viewers.

Examine figure 3-9. The frame rate is displayed at the bottom of the layers in the timeline. This portion of the timeline is called the status bar because it displays the vital statistics of the current movie. When your movie begins to play, the status bar will tell you if the actual frame rate dips below the fps setting because of complex animation that taxes your computer. Information such as the current frame number, fps, and estimated current runtime of the movie is displayed in this area.

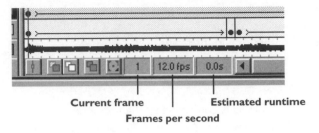

Current frame | Frames per second | Estimated runtime

Fig. 3-9. Status bar showing current frame, frame rate, and runtime.

Guided Tour 3B: Document Properties

This Guided Tour shows you how to control the basic elements of a movie by modifying the document properties. These document properties can be accessed with the use of the menu option Modify | Document or with the use of the Properties panel associated with the document. It is important to remember that these settings are applied globally to the timeline of the current movie and are used only within the document in which they are set. To explore document properties, perform the following steps.

1. In this Guided Tour you will continue to use the *playback.fla* file you first opened in Guided Tour 3A. If you do not currently have the *playback.fla* file open, see Guided Tour 3A and follow the instructions there to open the *playback.fla* file.

2. Let's change the document properties of this Flash file. Open the Document Properties window by selecting the menu option Modify | Document. The Document Properties window now opens. This window displays several options for customizing your movie and stage settings. See figure 3-10.

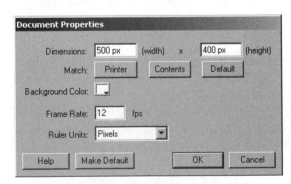

Fig. 3-10. The Document Properties window.

·T/P·

The higher the number in the Frames Per Second setting, the faster the movie will play. It is important to remember that slow processor speeds and a slow Internet connection may cause the movie to pause, render slowly, or skip frames.

3. In the middle of the window, you will see the Frame Rate field. Click you cursor in this field and type in 45. This will significantly speed up the rate at which the playhead moves through the movie.

4. The Document Properties window also allows you to change the pixel dimensions of your movie. Click your cursor in the width and height fields (respectively) and change the pixel dimension to 300 x 300. This setting changes the physical size of the stage. You can also use the Ruler Units pull-down to change the unit of measurement from the default setting of pixels to inches, points, centimeters, or millimeters. For web or on-screen work, pixels is the appropriate measurement.

5. Customize your stage further by changing the color of the background. Click on the Background Color picker to bring up the Color Well. Select any color from the Color Well as your background color. See figure 3-11.

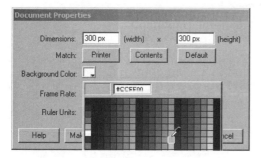

Fig. 3-11. Color Well.

6. Click on OK once you are finished editing the Document Properties settings. Click on the Play button on the controller to see the changes to the playback rate.

Guided Tour 3C: Frames, Keyframes, and the Timeline

Think again about the movie metaphor used in Flash. When you sit down to watch a movie, everything takes place within a certain period of time. Each second of a movie you see at home or in the theater was filmed frame-by-frame. When you create a Flash movie, everything that happens on the stage is scripted in the timeline and is contained within a certain number of frames, just like a conventional movie.

For many new users, the most difficult part of Flash is getting used to working within the convention of a timeline-based program. Sometimes this concept can be confusing when you first begin moving between frames in the

·T/P·

As you are creating your movie, you may wish to alter the size of the stage and make your movie dimensions smaller or larger. It is important to understand how Flash resizes the stage in order to avoid long production delays that can arise from this situation.

When you resize the stage, Flash uses the top and left as constant edges. Any pixels added or subtracted from the stage will be taken from the bottom or right edge.

For example, if you make the dimensions of your movie smaller, anything on the right or bottom that extends past the new dimensions will no longer be on the stage. If you are unsure of the final dimensions of your movie, use the top and left as fixed sides of your movie.

timeline. Let's take a closer look at the timeline and examine the various types of frames in Flash, and then see how to control the length of your movie. This will help you better understand how to create a frame-based movie.

1. Open a new file by selecting File | New. Take a look at the timeline on your screen, as well as the one shown in figure 3-12.

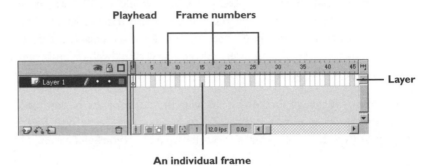

Fig. 3-12. Timeline for new file.

 a) Note the layer (the horizontal row of white and gray blocks), the frame numbers (the top row of numbers, 10, 20, 30, and so on), and the playhead (the red square and red line below it). Paying attention to the playhead and the frame numbers can be very helpful as you create your movies, as they provide visual clues as to where you are.

 b) As you begin to design and create your own Flash movies, it is very important to place content in particular frames. Learning how to read the location of the playhead and recognize frame numbers will help you avoid trouble.

 c) The red line that vertically extends from below the playhead becomes even more helpful when you have multiple layers in your movie. This will help you keep track of where you are in the movie timeline – with one glance.

2. It is easy to add frames to the timeline. All new Flash files start with one layer and one frame in the timeline. The playhead of your movie should now be directly above the first frame, as shown in figure 3-12.

 a) Select Insert | Frame to add frames to layer 1 in the timeline. See figure 3-13. Go ahead and try it.

 b) You started with one frame and have now added another frame.

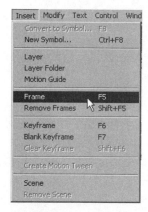

Fig. 3-13. Inserting a frame.

3. You can also add several frames at once to the timeline, as follows.
 a) Highlight the section of the timeline where you want to insert frames. Click and drag across layer 1, from frame 3 to frame 25, as shown in figure 3-14. You can tell that frames are selected when they are highlighted in blue.

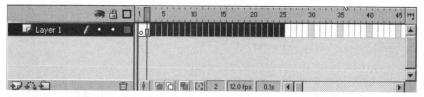

Fig. 3-14. Selecting frames 3 through 25.

 b) Select Insert | Frame to insert multiple frames at once. See figure 3-15.

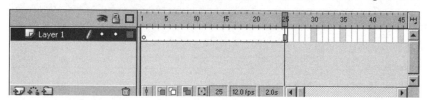

Fig. 3-15. New frames added to the timeline.

4. Deleting frames is a very similar procedure to adding them. You can select individual or multiple frames and then use the Insert menu to delete the selected frames, as follows.
 a) Highlight frames 21 through 25 by clicking and dragging the cursor across these frames. Select Insert | Remove Frames, as shown in figure 3-16.

·T*i*P·

Another way to easily select multiple frames is to hold down the Shift key and click in the first and then the last frame you want to select. This will select all frames between these two frames without having to drag across all of them. This trick also works with multiple layers. Let's say you want to select frames 1 through 20 on four layers in the timeline. Hold down the Shift key and select frame 1 in layer 1. Then click on frame 20 in layer 4. All frames between will be highlighted. To quickly select all frames in a layer, double click on any frame in the specified layer to highlight every frame in that layer.

Shortcut

There are some handy keyboard shortcuts for adding and deleting frames in the timeline. You will use these shortcuts often, and learning them will greatly speed up your production time.

Insert Frame – F5

Delete Frame – Shift + F5

Fig. 3-16. Removing frames.

b) Your timeline should now look like that shown in figure 3-17, with only 20 frames.

Fig. 3-17. Timeline with 20 frames.

c) Select frame 10 by clicking on it. Note that in figure 3-18 frame 10 is selected. When a frame is selected, it is highlighted in black and the playhead moves to the corresponding frame number on the timeline.

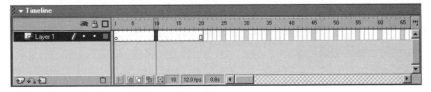

Fig. 3-18. Frame 10 selected in the timeline.

5. Note that a thin black line surrounds all frames on the bottom and right edges. See figure 3-18. As you add frames to the timeline, this line expands to the right to include the new total number of frames. Note that the available frames look different from the empty timeline. All available frames (within the black lines) no longer have a solid gray line dividing each unit from another. Instead, they have small hash marks separating frames. In the empty timeline, every fifth empty unit is a solid gray box,

whereas all frames are solid white. These visual cues allow you to glance at the timeline and know how many frames you have in it.

6. Flash also differentiates between basic frames and another type of frame, the keyframe. Keyframes are an important concept in Flash, and will be used extensively in most of your movies. A *keyframe* is a frame in which some type of action, animation, or event begins, ends, or changes. When you see a keyframe in your timeline, it indicates that some type of change is about to occur.

7. In Flash 5, keyframes were by default invisible. This was a change from previous versions of the Flash program. In Flash MX, keyframes are again visible by default. To help you unlock the mysteries of using keyframes, you are going to take a look at how to recognize keyframes in the timeline.

 a) Keyframes are represented by two different symbols. Blank keyframes (keyframes with no content in them) are indicated by a white circle. Examine figure 3-19, which shows that the first frame in each of two layers is a blank keyframe. The first frame of every layer automatically has a blank keyframe inserted into it.

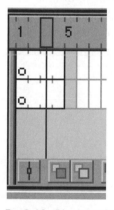

Fig. 3-19. Blank keyframes are represented by a white circle.

 b) A black circle represents keyframes with content in them. Examine figure 3-20, which shows that the first frame in each of these two layers contains content.

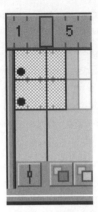

Fig. 3-20. Keyframes with content are represented by a black circle.

8. As you will see in a later chapter, you can add layers to the timeline to keep objects separated, or to add multiple layers of animation. When you add frames to one layer, you must also add them to all other layers if you want the animations on each layer to run the same length of time. Let's add a layer and see if the number of frames matches. You will learn more about customizing layers in a later chapter.

 a) Insert a new layer by selecting the Insert Layer icon, located in the lower left of the Timeline window. See figure 3-21.

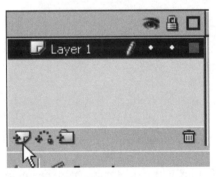

Fig. 3-21. Insert Layer icon.

 b) Because you previously added frames to layer 1 (with a total of 20 frames), the new layer automatically takes on the same number of frames. See figure 3-22.

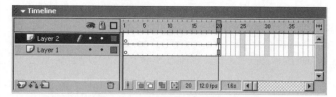

Fig. 3-22. Two layers, each with 20 frames.

9. If you want to simultaneously add frames to more than one layer of the timeline, you must first select frames in each layer. You can simultaneously add frames to as many layers as you like in Flash MX. Let's try it out.

 a) Select frame 21 in layer 2 by clicking on it. Click and drag from this location to frame 25 in layer 1.

 b) Select Insert | Frame and note that five (5) frames are added to each layer at the same time. See figure 3-23.

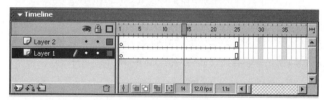

Fig. 3-23. Two layers, each with 25 frames.

10. Let's now consider inserting and deleting keyframes. The procedure for inserting and deleting keyframes is basically the same as for inserting and deleting empty frames in the timeline, as follows.

 a) Click on frame 10 in layer 1. Select Insert | Keyframe. Click on frame 15 to move the playhead. Note that the new keyframe contains a white circle. A solid black line appears between the keyframe and a white rectangle. See figure 3-24. This white rectangle is a visual marker indicating the last frame in the timeline, or the last static frame before a new keyframe appears.

Fig. 3-24. New keyframe 10, with the playhead in frame 15.

Shortcut

The following are useful keyboard shortcuts for adding and deleting keyframes in the timeline. You will use these shortcuts often, and learning them now will greatly speed up your production time.

Insert Keyframe – F6
Insert Blank
Keyframe – F7
Clear (Delete)
Keyframe – Shift + F6

b) To practice deleting a keyframe, select keyframe 10 in layer 1, and then select Insert | Clear Keyframe. This will not delete the frame where the keyframe resides or shorten the timeline, but it will remove the keyframe marker so that the frame becomes a normal frame.

This concludes the tour of frames and the timeline. You are ready to get to work on an exercise.

Practice Exercise 3-1: Creating a Frame-by-Frame Animation

Description

In this exercise you will apply what you have already learned about frames to create a simple frame-by-frame animation. By changing a graphic in each keyframe, you will create a looping animation of a light bulb turning on and off. In this exercise you will:

- *Insert keyframes in appropriate places on the timeline*
- *Alter artwork in various keyframes to create a simple animated effect*
- *Work with objects on different layers*
- *Learn to loop playback for a continuous animation*
- *Learn to use the Enter (Return) key for a quick preview of animation*

Take a Look

CD-ROM

Before beginning the exercise, let's take a look at the exercise in its completed state so that you can clearly see what it is you are about to build.

1. Select File | Open and locate on the companion CD-ROM the folder named *Chapter03* and the file within it named *Lesson3.fla*. Double click on *Lesson3.fla* to open the file.

2. The Controller panel should already be open. If not, select Window | Toolbars | Controller.

3. Click on the Play button in the Controller and watch the animation.

4. When finished, click on the Stop button.

5. The file *Lesson3.fla* should now appear in your copy of Flash. Note the following properties of this completed exercise.
 a) Keyframes are necessary in order to change the artwork or symbol instances within the timeline.
 b) Multiple frames are necessary to create an animated effect.
 c) Animation is not restricted to motion effects.

Storyboard: On Screen

Figure 3-25 shows you what the stage will look like when you finish this exercise.

Fig. 3-25. Stage when complete.

Storyboard: Behind the Scene

Figure 3-26 shows you what the stage and timeline will look like once you finish your frame-by-frame animation.

Fig. 3-26. Stage and timeline when complete.

Step-by-Step Instructions

To create a frame-by-frame animation, perform the following steps.

1. So that you do not have to create the basic lightbulb artwork, let's make use of a file located on the companion CD-ROM. Perform the following.

CD-ROM

Go Solo

a) Select File | Open and use the browse function to locate the *Chapter03* folder on the companion CD-ROM. Locate, select, and open the file *lightbulb.fla*.

b) Select File | Save As to save a copy of the file as *my_lightbulb.fla* in the *SaveWork* folder on your computer.

c) Take a look at the layers and timeline in this file. Right now, there is one frame with two layers, named *Radial Fill* and *Bulb Layer*. See figure 3-27.

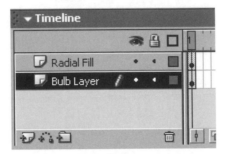

Fig. 3-27. Timeline showing two layers.

2. To create the illusion of a light bulb turning on and off, you need to add some frames and change the yellow fill in the light bulb, as follows.

a) You first need to highlight the frames you want to add. Click and drag from frame 2 to frame 50, which will highlight the empty frames in both layers. See figure 3-28.

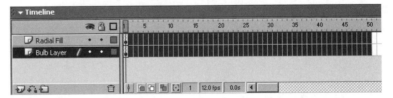

Fig. 3-28. Frames 2 through 50 and both empty layers highlighted.

b) Select Insert | Frame to add the frame numbers you have selected to the timeline. You should have 50 frames in each layer. See figure 3-29.

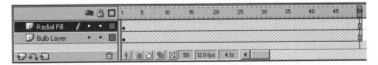

Fig. 3-29. Timeline with 50 frames in each layer.

3. Add a keyframe, as follows.

a) Select frame 5 in both layers by holding down the Shift key as you click on frame 5 in each layer. See figure 3-30.

Fig. 3-30. Frame 5 selected in both layers.

b) Select Insert | Keyframe to turn frame 5 in both layers into a keyframe. Note that there is now a black circle in frame 5 of both layers. See figure 3-31.

Fig. 3-31. Keyframes inserted in frame 5 of both layers.

c) Repeat steps a and b to insert keyframes in frames 10, 15, 20, 25, 30, 35, 40, 45, and 50. See figure 3-32.

Fig. 3-32. Timeline with all keyframes inserted.

4. Now let's make some changes to the light bulb so that it appears to turn off, as follows.
 a) Click on frame 5 of the Radial Fill layer, and the yellow fill will be automatically selected on the stage. The yellow fill is a grouped object that when selected will look like that shown in figure 3-33.

·T/P·

You can recognize groups by the rectangular bounding box that appears around the object when the object is selected. Conversely, when an object is ungrouped and then selected, the fill and stroke take on a "speckled" appearance.

If you have trouble selecting small fill areas, do not forget to use the Magnifying Glass tool in the tool-box to enlarge detailed areas. To zoom in (get closer) to objects on the stage, select the Magnifying Glass tool and click on the object on the stage. To zoom out (get farther away) from the object on the stage, select the Magnifying Glass tool and hold down the Alt key (PC) or the Opt key (Mac). A minus sign will appear in the Magnifying Glass cursor and you can then click and zoom out on the object.

Shortcut

As you have seen in step 4e, you do not have to select the Paint Bucket tool to change the color of an object. Just select the object with the Arrow tool and select a new fill or stroke color in the Color Well in the tool-box to change it auto-matically. Be sure to deselect the object to see the color change.

Fig. 3-33. *Yellow bulb color selected.*

 b) Ungroup this shape by selecting Modify | Ungroup.

 c) Change the fill to white using the Fill color selector in the toolbox. See figure 3-34.

Fig. 3-34. *Bulb fill changed to white.*

 d) Hold down the Shift key and select the remaining yellow fill inside the filament area of the bulb. You will have to click several times to select all of the yellow fill. You can hold down the Shift key to facilitate adding the selection with each click.

 e) Change the fill to white by now using the Fill color selector in the toolbox.

 f) Repeat steps a through e in frames 15, 25, 35, and 45.

5. Get the popcorn! It's time to preview the movie.

 a) Drag the playhead to frame 1 of the timeline.

 b) Select Window | Toolbars | Controller. (On a Mac, select Window | Controller).

c) Select Control | Loop Playback.

d) Click on the Play button on the controller to play through the movie. Because the controller is set to loop, it will continue to play until you stop it.

e) Click on the Stop button on the controller to stop the movie.

f) Drag the playhead back to frame 1 and press the Enter/Return key to play through the movie timeline just once.

g) Save the file in your *SaveWork* folder on your hard drive.

Onionskinning

Although it sounds like a culinary term, onionskinning is actually a very old technique used by traditional cell animators back in the days when each frame of a cartoon was drawn by hand. To create realistic, fluid movement between each frame of a cartoon, animators needed a way to see what they had drawn in the previous frame while drawing the next movement. They used something called onionskin paper – a thin, translucent paper that allowed animators to see through to the sheet underneath. These sheets are very thin – like an onion skin. Animators found that they could stack many of these sheets on top of each other, and because of the translucence, they could see multiple layers of a drawing. This allowed them to create a real sense of the fluidity of movement from frame to frame.

Guided Tour 3D: The Onion Skin Tools

Flash uses its own form of digital onionskinning. Unlike the previous exercise, some forms of frame-by-frame animation will actually require slight changes to a drawing in order to create movement, or a transition. This is not an easy task to accomplish if you cannot see the drawing in the previous frame. Let's explore the onionskinning options in the Flash timeline and see how they can be used.

1. Select File | Open.

2. Locate the *Lesson03* folder on the companion CD-ROM and open the file *Onionskin.fla*.

3. Take a look at the timeline on your screen, as well as the one shown in figure 3-35.

4. Press the Enter/Return key to see the minute hand of the clock run.

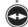

Shortcut

You can use the Enter/Return key as a shortcut to play through the frames of your movie anytime during the development. Press the Enter/Return key and the playhead will start from the currently selected frame and move frame by frame through your movie, stopping at the last frame. Press Enter/Return again and the movie will begin again from frame 1.

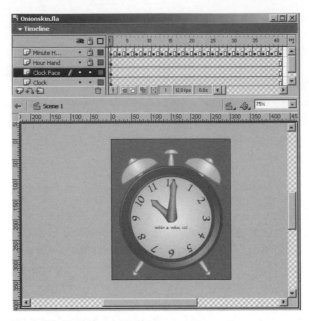

Fig. 3-35. Timeline and the stage.

5. Note at the bottom of the timeline (below frames 1 through 12) that there are four blue-and-white icons. These are the Onion Skin tools. From left to right they are Onion Skin, Onion Skin Outlines, Edit Multiple Frames, and Modify Onion Markers. See figure 3-36.

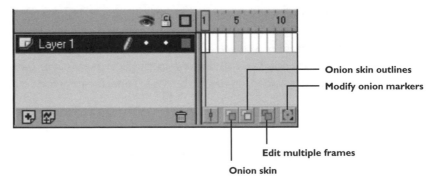

Fig. 3-36. The Onion Skin tools.

6. Return the playhead to frame 1. Click on the Onion Skin button. See figure 3-37. Note the highlighted handles that appear at the top of the timeline, along the frame numbers. This is the Onion Skin marker. You can expand or contract this marker to see any number of frames in the timeline by simply dragging the right handle of the Onion Skin marker. Try it.

Onion skin marker

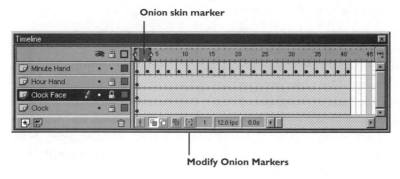

Modify Onion Markers

Fig. 3-37. Onion Skin marker.

7. The Modify Onion Markers tool allows you to quickly toggle between several Onion views without dragging the marker handle. Click on the Modify Onion Marker tool and a pull-down menu will appear. Select Onion All to view all frames in the timeline using an Onion Skin option. You must have one of the Onion Skin options turned on in order to view Onion All, Onion 2, or Onion 5. Onion 2 and Onion 5 turn on 2 and 5 frames on either side of the selected frame.

8. Drag the left side of the Onion marker so that it extends farther down the length of the timeline, as shown in figure 3-38. Note that you can see on stage the progression of the minute hand on the clock.

Fig. 3-38. The Onion Skin feature revealing multiple frames in the timeline.

9. Turn off the Onion Skin button by clicking on it again.

10. For some, turning the Onion Skin view on can be distracting, because you see the fills and outlines of all objects in each frame. Most traditional animators actually start with line drawings when creating frame-by-frame animation. With Flash you can have the best of both worlds. You can go ahead and add all fills to objects on the stage, and then choose to display only the onionskin outlines when working on frame-by-frame animation.

 a) Click on the Onion Skin Outlines tool (two white squares). Note that the minute hands in onionskin frames turn to outline instead of a solid shape. See figure 3-39.

Fig. 3-39. Onion Skin Outlines tool reveals outlines of shapes.

 b) Move the Onion marker along the timeline so that you can see as many frames as possible. Note that this is very similar to the Onion Skin tool you worked with earlier. However, here all you see are outlines!

 c) Turn off the Onion Skin Outlines tool by clicking on it again.

11. Now for something really exciting. The Edit Multiple Frames tool not only allows you to see all frames you choose in your timeline but also allows you to edit all frames simultaneously – as if all objects were in one frame! Let's try it.

 a) Turn on the third Onion Skin tool – the Edit Multiple Frame tool (two blue squares). Drag the Onion marker over the frame numbers so that you can see most of the frames in the timeline. Note that the objects are not grayed out or in outline form. You can see them in full color! See figure 3-40.

Fig. 3-40. Edit Multiple Frame tool reveals multiple frames simultaneously.

b) Try to edit the minute hands on the screen. Note that no matter what frame those objects are in, you can still edit them. All other layers in the file are locked, so you will not be able to edit anything other than the Minute Hand layer unless you unlock the other layers.

C H A P T E R 4

Application

Chapter: Getting

Started with the

Application Project

Introduction

Throughout this book you will find a number of application chapters. These chapters differ from the others in that they will challenge you to combine the knowledge and techniques acquired from several previous chapters and apply these skills to create part of a "real-world" web site.

The application exercises found in these chapters differ from the practice exercises found in other chapters, in that they provide a listing of the general tasks that need to be accomplished but do not provide the step-by-step instructions on how to accomplish those tasks. In this way you are given the opportunity to "test" your understanding of the material covered in preceding chapters.

Each application chapter, of which this is the first, focuses on creating one of nine application exercises that combined constitute a fully functional application project named *Route 67 – America's Other Scenic Highway*. Each application exercise is a separate and distinct element of the overall application project. Each exercise, in its completed form, can be found on the companion CD-ROM. In this way, you can choose to complete an application exercise or a combination of application exercises and integrate your work with the completed exercises supplied. Alternatively, you can complete any or all of the application exercises on your own. The choice is yours.

We have designed the overall application project, *Route 67 – America's Other Scenic Highway,* and all of the component exercises found in each of the application chapters to reflect real-world structures and project objectives. These are the types of structures you would likely find if you worked in a web design firm creating web-based applications for corporate business customers.

More and more companies are using Flash for marketing, advertising, informational, and educational purposes. So, after you have completed the entire application project, you will have a "portfolio project" that is typical of a Flash application created in the real world of web development. It is hoped that you will find the application project to be a valuable opportunity to practice what you have learned, while having some fun along the way. By the end of this chapter you will be able to:

- *Modify Document Properties including stage size, color and frame rate*
- *Modify the size and location of graphic images by using the Properties panel*

Application Project Description

The application project involves creating a web site for an online travelogue touting the beauty and character of an imaginary highway through the American southwest: Route 67 (America's "other scenic highway"). All towns, names, and events described are obviously fictitious. Any resemblance to any real town, person, or event is completely unintentional and purely coincidental.

This web site is meant to be playful, so be aware that it pokes a little fun at those horribly long vacation drives many of us endured as children. Remember the billboard signs that promised "Amazon Wildlife" at such-and-such an exit and it turned out to be nothing more than a grass snake in a dirty aquarium? This site is our homage to misdirected and "underwhelming" roadside exits everywhere. Welcome to Route 67!

Route 67 – America's Other Scenic Highway

Historic Route 67 is a scenic drive through America's beautiful and rugged Southwest. It was originally conceived as a coast-to-coast highway that would open a new corridor to travel and commerce. Unfortunately, the project came to a halt when someone in Washington decided it bypassed all of the so-called "interesting" features of the Southwest. Take our word for it, there is a lot to be excited about on Route 67! You will build a travel site that offers information on the locations described in the following sections.

Bulldozer, Texas

In August of 1978, Sissy Glabella entered a dish at the annual town fair that started the culinary movement known as "Texahoma cuisine." Stop and enjoy such delectables as Fried Meat Tidbits with Salt, Cheesy Noodle Bake, No-Fuss Cheesecake, and the dish that started it all, Sissy's Steamed Squash Medley on Rice. When you say Bulldozer, you've said "Good eating."

Wagonrut, New Mexico

Come face-to-face with wild animals at Colonel Steve's Wild Game Preserve! Colonel Steve has scoured the earth to gather the most exotic and incredible animals ever assembled in north/northeastern New Mexico. Your children will no doubt gain valuable natural insights that will make them much more intelligent and successful in their adult lives!

Chikapee, Arizona

Bring the family to Chikapee for a trip to the mysterious Invisible Ocean, discovered in 1952 by Lester "Tequila" Hopkins. Stay awhile and marvel at the aerobatic hijinks of Lester Hopkins (the Third) and his Flying Cropduster Circus! Lester has been known to let lucky children fly his plane while he shouts authentic flight instructions from the ground.

Underdale, Nevada

The town motto here is "Too close to be far; too far to be convenient!" Even on the blackest night the glowing lights and the jingling sounds of Las Vegas will not bother you. Your family will grow closer as you forage for food and shelter when you explore the Underdale Family Fun Wilderness Trail, a former Desert Survival Training Area for the U.S. Army!

An Overview of the Application Exercises

The sections that follow describe the application exercises.

Chapter 4: Establishing the Document Foundation

In this first exercise you will start into the application project slowly. You will establish the foundation properties for the document and will modify properties pertaining to the stage as well as the background graphic image.

Chapter 9: Designing the Interface and Creating Reusable Symbols

In this application exercise you will build the interface elements and add the descriptive text that will be used throughout your web site. You are creating an online travel experience where these elements are used for scenery along the way and for each "stop" of your online travelogue.

Chapter 11: Adding Animation

In Chapter 11's application exercise you will go back and add some animated effects to your main movie interface by applying what you have learned about motion and shape tweens.

Chapter 15: Movie Clip and Button Content

In this application exercise you will create the buttons for your movie interface. You will also create some additional movie clips that will be used elsewhere in the site.

Chapter 17: Creating Sound Effects

After you have your interface built, along with most of your attractions, you will add sounds for your buttons in this application chapter.

Chapter 19: Setting Up Scenes

This application exercise allows you to play "director" and add a couple of scenes that will enhance the feel and function of the site. When you finish this exercise, you will have the basis of a connected web site.

Chapter 21: Building a Preloader

In this application exercise you will learn how to add a preloader to your main movie site. This exercise teaches you how to use frame actions to control how your movie is initially loaded and displayed.

Chapter 24: Information Form

After you have the bulk of your site built, you can add some bells and whistles. Here, you will first build a form for the visitors to your site to fill out, and then you will add it to your movie.

Chapter 25: Publishing the Site

Finally, you will put it all together and publish your site. You will also simulate posting your movie and the accompanying HTML file to a server.

Application Exercise: Establishing the Document Foundation

Description

The foundation task of every Flash movie is to establish the size, color and frame rate of your movie. These document settings affect every frame of each movie that you create. A consistent background is also essential to the overall unity of all frames within a site.

In this first application exercise, you will establish the document settings for the web site that you create throughout the application exercises. These document properties include size of the stage, stage background color, and frame rate. You will also adjust the size and location of the primary graphic image.

Take a Look

Before beginning the exercise, let's take a look at the exercise in its completed state so that you can clearly see what it is you are about to build.

1. Select File | Open and locate on the companion CD-ROM the folder named *Chapter04* and within it the file named *application_4.fla*. Double click on *application_4.fla* to open the file.

2. Verify that the file *application_4.fla* appears in your copy of Flash.

3. Take a moment to examine the file.

4. You may want to use the Magnification pull-down menu to reduce the stage size to 75% or 50% so that you can see the entire stage without scrolling.

Storyboard: On Screen

Figure 4-1 shows what will be seen on stage when the exercise is complete.

Fig. 4-1. Completed stage.

Storyboard: Behind the Scene

Figure 4-2 shows how the timeline will look when the exercise is complete.

Fig. 4-2. Completed timeline.

Step-by-Step Instructions

Complete this exercise on your own, using the following steps as a high level listing of the tasks that need to be accomplished. These steps do not include the details of how to accomplish these tasks, as the "how to" has been covered in earlier chapters. Keep in mind also that you can refer to the completed example referenced in the "Take a Look" section for further guidance.

NOTE: The following steps are intended as a guide, but this is your project, so feel free to make whatever variations you would like.

1. Open the file *application_start.fla* found in the *Chapter04* directory on the CD-ROM that accompanies this book.

2. Using a menu option, modify the document properties so that they are as follows:

 W: 640 pixels

 H: 480 pixels

 Frame rate: 12 fps

 Background color: White

3. Rename the existing layer 1 so that the new layer name is **Background**.

4. Select the background image on the stage.

5. Using the Properties panel, modify the settings for the background image so that the new size is as follows:

 W: 640 pixels

 H: 480 pixels

6. Using the Properties panel, modify the settings for the background image so that the new image alignment is as follows:

 X: 0

 Y: 0

 In other words, it should fit perfectly over the stage with no overlapping.

7. Use the Magnification pull-down menu to reduce the stage by 50%, so that you can view the entire stage without using the scroll bar.

8. Save your file as *application_04.fla* in the *SaveWork* folder on your computer's hard drive.

5

Importing

Artwork

into Flash

Introduction

In Chapter 2 you learned how easy it is to draw in Flash. Although Flash is a vector-based program, you can still use bitmap images generated in popular programs such as Macromedia's Fireworks or Adobe's Photoshop to add visual interest to your Flash movies. In this chapter you will learn the difference between vector and bitmap images in order to use both graphics types effectively in your Flash movies.

By the end of this chapter you will be able to:

- *Describe the difference between the vector and bitmap graphics formats*
- *Import artwork from other programs*
- *Identify graphics file types that are appropriate for import*
- *Convert bitmap images to vector graphics using Flash's Tracing feature*
- *Use a bitmap image as a fill pattern*

Importing Files from Other Programs

The drawing and paint tools in Flash make it possible to create any artwork you need for your movies without the aid of other graphics programs. However, the Import feature in Flash also allows you to bring in vector artwork from illustration programs such as Macromedia's FreeHand, as well as bitmap images from image editors such as Macromedia's Fireworks and Adobe's Photoshop. Video and audio file formats can also be imported into Flash. These are covered in a later chapter.

Image File Formats Valid for Import into Flash

The following image file formats can be imported into Flash on both the Mac and PC platforms, even if QuickTime is not installed.

- *Adobe Illustrator (.ai):* The Adobe Illustrator format. This format can also be used to export files from FreeHand.
- *AutoCAD DXF (.dxf):* This file format is used to export files created with CAD software.
- *Flash Player (.swf):* Shockwave Flash format. The standard format for exporting Flash movies. Files exported from Flash can be imported into a new Flash movie as long as they were not protected when published. This means that Flash movies on the Web can potentially be downloaded and edited by other users.
- *FreeHand (.fh7, .fh8, .fh9, .fh10):* Files imported from FreeHand versions 7, 8, 9, and 10 can be imported directly into a Flash movie with layers and groups intact.

- *FutureSplash Player (.spl):* FutureSplash was the precursor of Macromedia's Flash. You can still import FutureSplash files for use in Flash 5.

- *GIF and animated GIF (.gif):* The Graphics Interactive Format is a proprietary compression format from CompuServe. GIF and JPEG images are the two most common file formats used on the Web, and are supported by both major browsers. The GIF format is commonly used for images with less than 256 colors, or for images that require transparency. GIF files also support multiple frames for animation, as well as interlacing. GIF supports only one level of transparency.

- *JPEG (.jpg):* The Joint Photographic Experts Group is a compression format that contains continuous-tone image coding. The JPEG format is typically used for 24-bit color images, such as photographs. GIF and JPEG images are the two most common file formats used on the Web, and are supported by both major browsers. JPEG is considered a "lossy" compression formula. It does not support transparency, although it does support progressive downloads.

- *PNG (.png):* A file compression format originally developed by Adobe. Although it is not used or supported as frequently as GIF or JPEG, this format is also used on the Web. PNG is also the native file format for files created in Macromedia's Fireworks. PNG files combine the characteristics of GIF and JPEG files and support multiple levels of transparency.

The following file formats can be imported into Flash on only the PC platform.

- *Bitmap (.bmp):* This image format can be exported from a wide variety of image editing programs, and is considered the native file format for Windows users. It can also be imported on the Mac if QuickTime is installed.

- *Enhanced Windows Metafile (.emf):* Common Windows file format in 32-bit applications created to replace Windows metafiles *(.wmf).*

- *Windows Metafile (.wmf):* Common Windows 3.x file format.

The following file format can be imported into Flash on only the Mac platform.

- *PICT (.pct, .pic):* This bitmap format can be exported from a wide variety of image editing programs and is considered the native file format for bitmaps generated on a Macintosh (originally QuickDraw).

The following file formats can be imported into Flash only if QuickTime 4.0 or later is installed.

- *MacPaint (.pntg):* Images created in the MacPaint program can be imported directly into Flash movies.

- *Photoshop (.psd):* Images created in Photoshop can be imported directly into Flash movies without saving to other forms (e.g., bitmap or JPEG) first.

- *PICT (.pct, .pic):* This bitmap format can be exported from a wide variety of image editing programs and is considered the native file format for bitmaps

generated on a Macintosh. With QuickTime 4.0 installed, PICT files can be imported into Flash 5 on the PC as a bitmap.

- *QuickTime Image (.qtif):* QuickTime format used for compressed still images.
- *Silicon Graphics (.sai):* Images created on a Silicon Graphics platform can be imported directly into a Flash 5 movie.
- *TGA (.tgf):* Also known as TARGA. This widely used file format is used for storing 24-bit color images.
- *TIFF (.tiff):* Stands for Tagged Image File Format. It is a raster format often used for exporting high-resolution images in desktop publishing.

Importing Artwork from FreeHand

Seasoned designers who depend on a vector-based illustration program such as Macromedia's FreeHand or Adobe's Illustrator may still want to create their artwork in the previously listed more full-featured design programs, rather than using the Flash drawing tools. With Flash's import capability, bringing these other file formats into Flash is a simple process. In addition, if you use the Layers panel in FreeHand to separate elements of complex illustrations, Flash will import those layers intact and add them to its own Layers panel. Illustrator users also have these capabilities.

Practice Exercise 5-1: Importing Artwork from FreeHand

Description

In this exercise you will import artwork created in FreeHand and place it into your Flash movie. In this exercise you will:

- *Import a vector graphic*
- *Use the Hide Layer icon and Lock Layer icon*

Take a Look

Let's take a look at the particulars of this exercise so that you can more clearly see what it is you are about to build. Perform the following steps.

1. You first need to open a file located in the *Chapter05* folder on the companion CD-ROM, as follows.
 a) Select File | Open.
 b) In the dialog window that opens, use the pull-down browse function within the Look In field to locate and select the CD-ROM drive.
 c) Locate, select, and look inside the *Chapter05* folder.

CD-ROM

d) Locate, select, and open the *Lesson5_vector.fla* file by either double clicking on the file name or by selecting it and then clicking on the Open button.

2. Take a moment to examine the file. Note the following property as you complete this exercise.
 • *Imported vector graphics maintain their layering capability.*

Storyboard: On Screen

Figure 5-1 shows how the file will look once you have completed this exercise.

Fig. 5-1. Completed exercise on screen.

Storyboard: Behind the Scene

Figure 5-2 shows what happens to the layers within the timeline once the FreeHand file is imported.

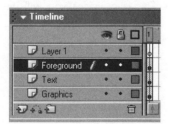

Fig. 5-2. Layers within the timeline after import.

Step-by-Step Instructions

To import artwork from FreeHand, perform the following steps.

1. Import vector artwork from FreeHand, as follows.
 a) Select File | New.
 b) Select File | Import. Select the file named *flowers.fh10* from the *Chapter05* folder on the companion CD-ROM. Click on the Open button.

Go Solo

c) The FreeHand Import window will open. See figure 5-3. Under Mapping, select the radio button next to Scenes and Layers. This will keep the *Layers in FreeHand* file intact. If you were to select Flatten, the layers would not be imported.

Shortcut

The keyboard shortcut
for Import is:
Ctrl + R (PC)
Cmd + R (Mac)

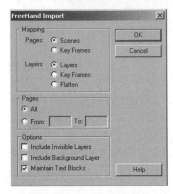

Fig. 5-3. FreeHand Import window.

d) Select All Pages. If your document has more than one page, you can bring pages in one by one.

e) Place a check mark next to Maintain Text Boxes, and uncheck the other options. Click on OK.

f) Take a look at the layers in the timeline. When you imported the FreeHand artwork, Flash recognized the layers and kept them separate for you.

2. Now let's work with the layers, as follows. The layer icons you will be working with are shown in figure 5-4.

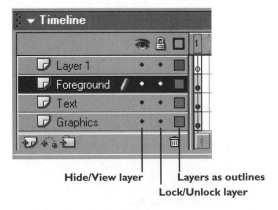

Hide/View layer Layers as outlines
Lock/Unlock layer

Fig. 5-4. Layers in the timeline.

a) Use the Magnification pull-down menu to reduce the stage to about 50% so that you can see the entire graphic without scrolling.

b) Click on the Hide/View Layer icon on the *Text* layer. Everything on the *Text* layer has been hidden, leaving the *Graphics* layer visible.

c) Click on the Hide/View Layer icon on the *Text* layer once again and this layer will become visible again.

d) Click on the Lock/Unlock Layer icon to lock the *Graphics* layer.

e) Click on the Paint Bucket icon from the toolbox.

f) Select the Fill picker and select a medium blue. Click anywhere within the graphic and try to change the color. Why doesn't this work? You cannot change the color (or make any other modifications, for that matter) because this layer has been locked. This is a great way of protecting your completed layers from unintentional changes.

g) Close the file (without saving it) by selecting File | Close.

Bitmap Versus Vector

In Chapter 2 you learned that vector graphics consist of paths defined by lines and curves. You also discovered that some of the benefits of using vector graphics are smaller, more efficient file sizes and scalable graphics. In this chapter you have worked with vector graphics imported from other programs, such as Macromedia's FreeHand. However, you will now discover how to work with the most common file type on the Web — bitmap graphics.

Bitmap graphics are fundamentally different from vector graphics. Bitmaps do not consist of paths that define an object. Instead, bitmaps consist of tiny blocks called pixels. In a previous chapter you learned that each pixel contains specific color information about that particular part of the image. These pixels fit together to create a complex pattern that forms a recognizable image to the human eye. Figure 5-5 shows a digital image of a duck, as you would normally view it.

Fig. 5-5. Digital image of duck.

Figure 5-6 shows a magnification of this same image, whereby you can see the pixels that blend to create the image.

Fig. 5-6. Magnification of digital image of duck.

Common Bitmap File Formats and Scaling Bitmap Images

The term *bitmap* refers to a wide variety of file formats. Bitmap file formats include GIF, JPEG, PICT, TIFF, BMP, PNG, and PCX. Originally these file formats were developed for different types of applications. GIF and JPEG are the graphics formats most commonly found on the Web. The BMP format was first made popular within Windows-based "paint" programs. Although these formats were developed for different purposes, the common thread tying them together is that they all create images via use of pixel-based graphic information.

Vector graphics can be scaled to any size without loss of image quality. This is handy if you are creating a corporate logo or other design that must be enlarged or reduced to various sizes. With bitmaps, however, the same rules do not apply. Figures 5-7 through 5-10 compare the quality of bitmap and vector graphics scaled to 300% of normal size. A circle is used as the "content" to more dramatically point out the differences.

Fig. 5-7. Vector graphic of circle at normal size.

Fig. 5-8. Vector graphic of circle enlarged to 300% of normal size.

Fig. 5-9. Bitmap image of circle at normal size.

Fig. 5-10. Bitmap image of circle enlarged to 300% of normal size.

These images demonstrate what happens to a bitmap image when it is resized and scaled beyond its original size. As you learned in a previous chapter, as a bitmap image is scaled larger, an effect known as pixelation occurs. This term refers to the jagged edges that appear on the enlarged circle image, as seen in figure 5-10. The reason for this distortion is that the computer is forced to add pixels to an image when it is enlarged. In the absence of data that identifies what these pixels should look like, the computer must "make up" the

information to fill in gaps. Thus, the pixels added do not correspond to the actual image. Because vector graphics are not based on the pixel formula, they can be enlarged without dependence on the supply of missing information.

Practice Exercise 5-2: Importing and Converting Bitmap Images

Description

In this exercise you will import a bitmap image created in Adobe's Photoshop. Although bitmap images can be used as-is in Flash, you can also convert bitmap images into vector graphics. This exercise includes the conversion process. Bitmap images created in Fireworks can also be easily imported into Flash. In this exercise you will:

- *Import a bitmapped graphic*
- *Make a copy of the graphic*
- *Use the Trace Bitmap option*

Take a Look

Let's take a look at the exercise in its completed state so that you can clearly see what it is you are about to build.

CD-ROM

1. You first need to open a file located in the *Chapter05* folder on the companion CD-ROM.
 a) Select File | Open.
 b) In the dialog window that opens, use the pull-down browse function within the Look In field to locate and select the CD-ROM drive.
 c) Locate, select, and look inside the *Chapter05* folder.
 d) Locate, select, and open the *Lesson5_bitmap.fla* file by either double clicking on the file name or by selecting it and then clicking on the Open button.

2. Take a moment to examine the file. *Note the following properties as you complete this exercise.*
 - *The new image is automatically added to the library as you import it.*
 - *The original bitmapped image and the "traced" image appear quite different.*

Storyboard: On Screen

Figure 5-11 shows what the stage area will look like once you have completed this exercise.

Fig. 5-11. Completed stage.

Storyboard: Behind the Scene

Figure 5-12 shows an example of what the layers within the timeline looks like after a bitmap image has been imported and converted.

Fig. 5-12. Layers within the timeline after importing bitmap.

Step-by-Step Instructions

To import and convert bitmap images, perform the following steps.

1. Let's see how to convert bitmap images to vectors. Perform the following.
 a) Select File | New.
 b) Select File | Import.
 c) Select and open the file named *duck.bmp* from the *Chapter05* folder on the companion CD-ROM.
 d) Note the thin dotted outline around the duck image. This indicates that the image is already selected after you imported it.
 e) While holding down the Alt key (PC), or the Opt key (Mac), click and drag the duck image to create a duplicate image. Position the two images side by side. You will keep one copy of the duck as is, so that

Go Solo

Take a look at the
library of your movie
after you import the
bitmap graphic. Open
the library by selecting
Window | Library. The
new image was added
to your library auto-
matically when
imported. Even if you
modify the image on
stage, you can always
drag another copy of
the original onto the
stage, in that it is now
stored in the library.

You do not have to
convert bitmap images
to vector to use them
in your movies. You can
use them as-is without
applying the Trace
Bitmap command. Just
remember that they
will not be as scalable
as vector graphics
are, and they may
add to the file size
of your movie.

you can compare it to the result of converting the other copy to a
vector graphic.

f) Make sure one of the duck images is still selected. Select Modify |
Trace Bitmap (this option will only work on the selected image). The
Trace Bitmap window now appears. See figure 5-13.

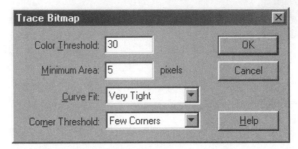

Fig. 5-13. Trace Bitmap window.

g) Set Color Threshold to 30, Minimum Area to 5 pixels, Curve Fit to
Very Tight, and Corners to Few Corners.

h) Click on OK. The Tracing Bitmap progress indicator now appears.
When the tracing is finished, deselect the freshly "vectorized" duck
to see the results and compare it to the original duck bitmap. You
might conclude that the duck bitmap looks like a photograph,
whereas the duck vector looks more like a painting, as shown in fig-
ures 5-14 and 5-15.

Fig. 5-14. Duck as a bitmap.

Fig. 5-15. Duck as a vector after tracing.

2. Now that you have imported the bitmap and learned to convert it to vector, let's use the original bitmap image as a fill pattern, as follows.

 a) Select Edit | Select All to select both duck images on the stage. Press Delete.

 b) Select the Oval tool from the toolbox. Draw a large oval on the stage with a black stroke and a light blue fill.

 c) Using the Arrow tool, select the blue fill in the oval.

 d) The Color Mixer panel may already be open, but if not, select Window | Color Mixer. In the Color Mixer panel, select Bitmap from the Fill pull-down menu, as shown in figure 5-16.

Fig. 5-16. Color Mixer panel.

 e) Verify that the oval is now filled with the image of the duck, as shown in figure 5-17.

If you do not want to use the Trace Bitmap command but want to modify part of a bitmap image in Flash, try out the Break Apart command. Even without converting the bitmap, by breaking it apart you can use the Eraser and Lasso tools to modify the image. With a bitmap image selected, select Modify | Break Apart to apply this command.

Fig. 5-17. Bitmap used as a fill.

f) With the duck fill still selected, press Delete to clear the fill.

g) Select the Paint Bucket tool and click in the oval to fill it with the bitmap. What a difference! Instead of one large duck, a repeated wallpaper pattern of small duck images fills the oval, as shown in figure 5-18.

Fig. 5-18. A bitmap fill applied with the Paint Bucket tool.

h) Close the file without saving it by selecting File | Close.

6

Organizing Movies with Layers and Groups

Introduction

As you move through the exercises in this book, you will become more comfortable drawing and customizing simple objects for your movies. In addition to learning how to use the drawing tools, another critical aspect of creating complex applications in Flash is learning to organize the elements in your movie. In this chapter you will begin to work with groups and layers. Understanding how to work with layers will allow you to create movies with many animated objects that interact with one another.

By the end of this chapter you will be able to:

- *Group individual shapes*
- *Create nested groups*
- *Modify grouped objects*
- *Arrange items on a layer*
- *Set up new layers*
- *Add objects to layers and move objects between layers*
- *Change the stacking order of layers*

Guided Tour 6A: Advantages of Grouping Objects

In Chapter 2 you first encountered the "cookie cutter" problem associated with objects within Flash. The problem is that ungrouped objects, when placed on top of each other, will actually merge and become part of a larger composite graphic. When you try to move what used to be a separate object, you discover that whatever used to be underneath is lost in the merger. If you attempt to move one of the objects, a hole appears, or you break apart the merged object.

Let's review this problem. You can (1) open Flash and follow along by drawing and moving the objects or (2) read through the steps and refer to each illustration. Perform the following steps.

1. Draw a circle and a square on stage, using the same color and stroke for both objects. See figure 6-1.

Fig. 6-1. Circle and square drawn on the stage.

2. Double click on one object to select both the stroke and the fill and then move this object until it overlaps the other object. Click in a blank area of the stage to deselect the objects. At this point the objects have "joined" to become one shape that consists of the combination of a circle and a square. Once these individually drawn shapes come in contact with each other and join, it becomes impossible to select the individual shapes again. See figure 6-2.

Fig. 6-2. Circle and square joined as o single object.

3. If you double click on the rectangle (selecting both the fill and the stroke) and move it, you separate the joined image, but the images are not what you originally started with. See figure 6-3.

Fig. 6-3. Images separated.

Using Modify | Group to group each object by itself, you will be able to overlay multiple objects without losing the properties of individual objects. This makes it much easier to move individual objects around on the stage, change the layout in your movie, and keep shapes independent of one another.

Artwork imported from other vector-based programs, such as FreeHand, is automatically grouped when placed on stage. To modify these imported objects in Flash, you use the Ungroup option, which you will work with in the next Practice Exercise.

·T*i*P·

If your shapes do not have a stroke around them when merged, you will not be able to isolate the rectangular shape when you double click.

Shortcut

The keyboard shortcut for Group is:

Ctrl + G (PC)

Cmd + G (Mac)

The keyboard shortcut for Ungroup is:

Ctrl + Shift + G (PC)

Cmd + Shift + G (Mac)

Modifying Grouped Objects

Manipulating artwork in Flash is very different from manipulating artwork in other vector-based programs, such as FreeHand. Instead of being confined to editing anchor points, you can modify the shape of objects by pushing and pulling on the outlines, without manipulating anchor points.

However, you will discover that after you have grouped an object, you are no longer able to change the shape, fill, line, or any other artistic attribute, with the exception of scale or rotation. A grouped object cannot be edited in the normal editing mode of the stage.

Group Editing Mode

Flash provides an easy to use Ungroup function that breaks a group into separate objects. Each object can then be modified with the drawing and paint tools. However, an alternative to the grouping and ungrouping processes is provided by Group Editing mode. Instead of using the Ungroup option to break a group into its original objects (to modify the fill, stroke, or shape), you can double click on the group to activate Group Editing mode.

Guided Tour 6B takes you through the process of entering and exiting Group Editing mode. Although at times it may seem that you are still working in the main stage area, you will actually be entering an alternative editing mode that allows you to modify a group without breaking that group apart, and without altering any other elements on the main stage.

The ability to recognize when you are leaving one editing mode and entering another is an important concept in Flash. Throughout this book you will practice switching editing modes, which will increase the efficiency of your work.

Guided Tour 6B: Group Editing Mode

One of the quickest ways to become sidetracked when first working within the Flash workspace is to accidentally double click on a grouped object. Suddenly, the screen changes appearance: some of the artwork appears selected, whereas the rest appears to be dimmed and is impossible to select or manipulate. What happened? When you double click on a grouped object, Flash enters Group Editing mode. Examine figures 6-4 and 6-5.

Fig. 6-4. Normal Flash interface.

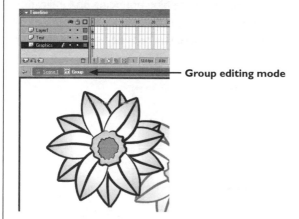

——— **Group editing mode**

Fig. 6-5. Group Editing mode.

There are a couple of visual cues that will help you to more easily recognize when you enter Group Editing mode. Note the following, evident in figure 6-5.

• *There is a new Tab titled Group at the top of the stage.*

• *The object you double clicked on appears to be both ungrouped and selected (a speckled appearance).*

• *All other objects appear dimmed and are not selectable or editable.*

Let's take a quick tour of the Group Editing mode to understand it more completely.

1. Select Edit | Select All and the press the Delete key to clear the stage.

2. Let's first draw something to group, as follows.
 a) Select the Rectangle tool from the toolbox.

b) Using the Stroke and Fill color pickers, assign a black stroke and a yellow fill.

c) Draw a small rectangle on the stage.

d) Select Edit | Select All.

e) Select Modify | Group. Notice there is now a blue bounding box around this object. This indicates that this is now a grouped object.

f) Select Edit | Deselect All.

g) Select the Oval tool from the toolbox. Using the Stroke and Fill color pickers, assign a black stroke and an light blue fill.

h) Draw a small oval on the stage, making sure not to overlap the rectangle.

i) Select the Arrow tool from the toolbox.

j) Double click the light blue fill within the Oval tool to select the fill and stroke.

k) Select Modify | Group. Again, notice the blue bounding box indicating that this is now a grouped object.

l) Select Edit | Deselect All. You now have two grouped objects to work with, as shown in figure 6-6.

Fig. 6-6. Two grouped objects.

3. Let's take a closer look at the overlap issue, as follows.

a) With the Arrow tool still selected, drag the oval until it overlaps the left side of the rectangle. Note that one object now is on top of the other, appearing as if it is a separate layer instead of "merging" with the other object as we saw earlier.

b) Note that the oval is on top of the rectangle. This is because it was grouped after the rectangle. The most recently grouped object will always lie on top of previously grouped objects.

c) Double click on the rectangle and note the following changes within the work area. See figures 6-7 and 6-8.

• *There is a new tab titled Group at the top of the stage.*

• *The rectangle appears to be both ungrouped and selected.*

- *The rectangle now appears to lie on top of the oval.*
- *The oval appears dimmed and is not "clickable" or editable.*

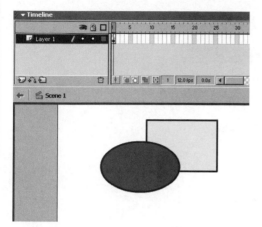

Fig. 6-7. Flash interface in normal editing mode.

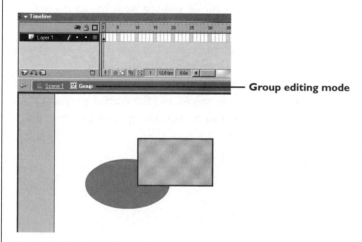

— **Group editing mode**

Fig. 6-8. Flash interface after changes via Group Editing mode.

d) You are now in Group Editing mode. This will allow you to isolate a particular object and manipulate it as though it were ungrouped, with the grouped objects protected from accidental changes. Use the Arrow tool and click anywhere on stage to deselect the rectangle.

e) Using the Arrow tool, click and drag on the right side (stroke) of the rectangle to change its shape. See figure 6-9.

As the Arrow tool moves over the stroke, the cursor changes from its normal appearance to an arrow with a curved line appendage – indicating that the stroke (line) can be modified.

Fig. 6-9. Rectangle with changed shape.

 f) Click and drag the yellow fill to another part of the stage so that it is no longer within the stroke.

 g) Let's return to normal editing mode and see what has happened.

 Select the Scene 1 tab next to the Group tab (or double click anywhere on the stage). You will notice that the oval is back where you positioned it previously – back on top of the rectangle.

 h) Select the altered rectangle. Note that it behaves like a grouped object once again. Even though the fill and the stroke are separated, if you move one, the other also moves. The fill and the stroke are grouped objects. See figure 6-10.

Fig. 6-10. Completed group editing.

 i) Close the file without saving the artwork.

Creating Nested Groups

Grouping is not limited to individual objects. You can also create groups with previously grouped objects, essentially forming one large group that contains multiple subgroups. You can think of these as groups nested within groups. This is a handy feature when it is necessary to select and move many items around on the stage, or when you want to scale or rotate everything on a layer all at once. You will notice, however, that in order to ungroup subgroups on a layer, you may have to select the Ungroup option several times in order to break apart all grouped objects so that they return to their original single-object states.

Layers Versus Groups

In previous chapters you worked with files that contained multiple layers, but only drew objects on one layer. By creating multiple layers in Flash, you can separate objects on the stage so that each has its own position in the stacking order of your movie. Using multiple layers also means that each object can be modified separately from other objects on the stage. This has the same effect as grouping objects, but has even greater importance in regard to details of the animation features of Flash.

Layers allow you to animate multiple objects in Flash by giving each its own layer within the timeline. The other benefits of layers are explored in greater depth later in the chapter. However, for the first practice exercise you will concentrate on organizing objects by grouping them while working in only one layer.

Arranging Objects on a Layer

Multiple objects drawn on a single layer are stacked (back to front) in the order they were drawn. This means that the last object drawn within a single layer will always appear on top. Try visualizing it this way: imagine you have a deck of playing cards and are placing them in a stack on a table, one card at a time. The first card put down on the table will always end up as the bottom card in the stack, whereas the most recent card placed on the stack will always appear on top. See figure 6-11.

·T/P·

You can also break down all objects in a group into vector artwork that can be modified by using the Break Apart option found under the Modify pull-down menu. For grouped objects with many nested subgroups, you may have to apply this option more than once. Break Apart is most often used to break apart text and bitmap images, but can also be used in place of the Ungroup option.

Shortcut

The keyboard shortcut for Break Apart is:

Ctrl + B (PC)

Cmd + B (Mac)

Fig. 6-11. Stacking order of layers.

It is exactly the same with objects drawn in Flash. Whatever you draw first will always end up being at the bottom of the stacking order within a single layer. If these objects are placed on top of one another, whatever object was created or imported last will appear in front of whatever objects it overlaps. Remember, objects drawn in Flash that are not grouped will be "merged" if they overlap.

Shortcut

The keyboard shortcut for Bring to Front is:

Ctrl + Shift + Up Arrow (PC)

Opt + Shift + Up Arrow (Mac)

Once an object is grouped, it will appear on top of any ungrouped objects that are present or that are subsequently added. However, by using the Arrange option found under the Modify pull-down menu, you can make grouped objects appear in front of or behind other grouped objects. Figures 6-12 and 6-13 show you the before and after effect of the Modify | Arrange | Bring to Front function.

Fig. 6-12. Before: Circle appears underneath.

Fig. 6-13. After: Circle moves to the foreground.

Practice Exercise 6-1: Grouping, Ungrouping, and Adding Objects to Layers

Description

This Practice Exercise begins with the basics of grouping and ungrouping objects. You will soon see the benefits of grouping even single objects. You will then create nested groups of multiple objects located in the same layer. Creation of artwork here is limited to just enough time to give you some extra practice working with the tools. You can spend more time on your own later to create more refined artwork. In this exercise you will:

- *Learn to group and ungroup objects*
- *Practice creating and editing layers*
- *Change the stacking order of layers*
- *Move objects from one layer to another*

Take a Look

Before beginning the exercise, let's take a look at the completed exercise so that you can see what you are about to build. The artwork has been previously created, so that you can focus on the concepts of groups and layers. Once you have completed the exercise, try recreating the entire project from scratch. Perform the following steps.

1. Select File | Open and locate the *Lesson6.fla* file in the *Chapter06* folder on the companion CD-ROM. Open the file.

2. The *Lesson6.fla* file should now appear in your copy of Flash. Note the following properties of this completed exercise. You may want to use the Magnification pull-down menu to reduce the stage to 50% so you can see the entire stage without scrolling.

 - *The artwork on the stage consists solely of grouped elements.*
 - *Each grouped element can be repositioned without affecting the other elements.*
 - *The stacking order of each group is dependent on the stacking order of the layers.*

Storyboard: On Screen

Figure 6-14 shows what the Flash movie will look like once you have completed the exercise.

 CD-ROM

Fig. 6-14. Completed stage.

Storyboard: Behind the Scene

Figure 6-15 shows the completed stage and timeline for the completed exercise.

Fig. 6-15. Completed stage and timeline.

Step-by-Step Instructions

To group, ungroup, and add objects to the stage, perform the following steps.

1. First things first. Let's set up the workspace, as follows.
 a) Select File | Open.
 b) Locate the *Lesson6group-layer.fla* file in the *Chapter06* folder on the companion CD-ROM.
 c) Open the file.
 d) You may want to use the Magnification pull-down menu to reduce the stage to 50% so you can see the entire stage without scrolling.

2. Now you are ready to get busy! Let's get the groups together! Perform the following.

Go Solo

a) Select the Arrow tool from the toolbox.

b) Click the Arrow tool on the stage slightly above and to the left of the set of three portholes. Hold the mouse button down as you drag the selection marquee down to the lower right-hand side of the port-holes. Figure 6-16 illustrates the selection marquee surrounding the three portholes. Let go of the mouse button. You should now see that all three portholes have been selected.

Fig. 6-16. Selection marquee surrounding three portholes.

c) Select Modify | Group. Note the blue bounding box around the three portholes.

d) Select Edit | Deselect All.

e) Click the Arrow tool on the stage slightly above and to the left of the hull of the boat. Hold the mouse button down as you drag the selection marquee down to the lower right-hand side of the hull. Let go of the mouse button. You should now see that the hull has been selected.

f) Select Modify | Group. Note the blue bounding box around the hull.

g) Select Edit | Deselect All.

h) Click the Arrow tool on the stage slightly above and to the left of all the cabin objects for the boat. Hold the mouse button down as you drag the selection marquee down to the lower right-hand side of the cabin. Let go of the mouse button. You should now see that the cabin objects have been selected.

i) Select Modify | Group. Note the blue bounding box around the cabin.

j) Select Edit | Deselect All.

k) In a similar manner, drag a selection marquee around the flag and flagpole.

l) Select Modify | Group.

m) Select Edit | Deselect All.

n) Use the Arrow tool to position the grouped elements. You will also need to use the Modify | Arrange | Bring to Front and Modify | Arrange | Send to Back commands to position the elements in the correct stacking order.

3. Suppose now that you want to change a group (the portholes, for instance) without affecting the stacking order. Let's see how Group Editing mode will facilitate making edits without unnecessary risk.

a) If necessary, select the Arrow tool from the Tools toolbox.

b) Double click on the Portholes group.

c) Note that you now have a Group tab along the top of the stage, the portholes are behaving like ungrouped objects, and the other artwork is dimmed out and uneditable.

d) Click on a blank area of the stage to deselect the portholes.

e) Select the Paint Bucket tool from the toolbox.

f) Select a bright blue color from the Fill color picker and then click inside any porthole to change the color from a gradient to a solid color.

g) Click on the Scene 1 tab to return to the main work area. Note that the portholes are still grouped and in their proper stacking order.

4. Create a few layers and distribute the artwork, as follows.

a) Click on the New Layer icon three (3) times, so that you end up with a total of four (4) layers.

b) Rename the layers, in order from top to bottom, *Portholes, Hull, Cabin,* and *Flag,* as shown in figure 6-17.

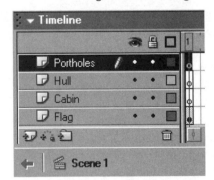

Fig. 6-17. Renamed layers after inserting three new layers.

c) Select the Portholes group and the select Edit | Cut.

d) Select the *Portholes* layer and then select Edit | Paste.

e) Select the Hull group and then select Edit | Cut.

f) Select the *Hull* layer and then select Edit | Paste.

g) Select the Cabin group and then select Edit | Cut.

h) Select the *Cabin* layer and then select Edit | Paste.

5. Let's look at the layers, as follows.

a) Drag the *Cabin* layer to the top of the layer stacking order in the timeline. Note that the stacking order of the layers determines the visibility of an object.

b) Drag the *Cabin* layer back to the bottom of the stacking order.

c) Select the Portholes group and ungroup them (Modify | Ungroup).

d) Select Edit | Deselect All. Note that an ungrouped object can remain visible in front of a grouped object if it is placed in a layer above the grouped object.

Working with Layers

You were introduced to layers in Chapter 1. In Flash, layers work in a fashion similar to many other programs. The Layers feature is often used to organize complex images, or in the case of Flash, complex animated movies. Layers can be given specific names (or labels) that correspond with the objects placed in them. Another handy aspect of the Layers feature is that items placed in layers cannot be affected by items placed in other layers.

It might be helpful to think of the stage not as a 2D surface, as it appears on your flat computer screen, but instead as more like the 3D stage of a playhouse theater, demonstrating width, height, and depth (from stage front to stage back and stage left to stage right). By visualizing the Flash stage with depth, you can think of layers as actors and props located at various positions (relative to stage front and stage back and stage left to stage right), all within the curtains located on the sides and top.

By placing objects in different layers, you can organize the elements in your movies much more effectively. In addition, using layers will give you a much more complex and textured animated movie. As an example of this, note in figure 6-18 that each "boat part" corresponds to a layer in the timeline.

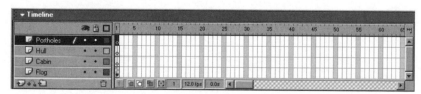

Fig. 6-18. Each boat part as a layer within the timeline.

·T*I*P·

Remember that to change the stacking order of a layer all you have to do is click on the layer you want to move and drag it to its new position. Watch for the thin black horizontal line that appears as you drag the layer. This line indicates where the layer will be moved to if you let go of the mouse button.

In Flash, unlike other graphics programs, layering capabilities extend far beyond using them to organize graphics or create complex images with special effects. In Flash, layers have the added dimension related to movement. Multiple layers corresponding to the timeline can be used to create animations that take place on discrete layers within the boundaries of the stage. Potentially, you can have multiple layers, with multiple animations, taking place in the same frames, on each layer in the timeline. You will work with layers extensively as you continue through the exercises in this book.

CHAPTER

7

Text and

Layout Tools

Introduction

In previous chapters you practiced using the drawing and paint tools in Flash and learned to create simple frame-by-frame animations. All of these basic skills have given you a glimpse of the breadth and depth of Flash MX's capabilities. We will continue to explore more of Flash's design features in this chapter by working in depth with text. Within the exercises in this chapter, as you learn to insert and format text, you will also be introduced to some of Flash's layout and guide tools. By the end of this chapter you will be able to further customize your movie by using:

- *Text Tool modifiers to apply fonts, colors, alignment, and paragraph formatting*
- *The Antialias Text command*
- *The Info panel*
- *The Break Apart command*
- *Rulers, grids, and guides for layout*
- *The View menu*

Control of Text in Flash

When working with text in Flash there are several points to remember. First, the characteristics of standard text in Flash are very different from standard text found on most web pages written with HTML. In fact, text in Flash has more in common with the appearance, characteristics, and control of text in a page layout program (such as PageMaker or QuarkXPress) because of the degree of precise control you have over the appearance and placement of text.

As you will see in this chapter, text in Flash can also be treated as a graphic element. Those of you who have worked with FreeHand or Illustrator are familiar with converting text to paths so that the letterforms can then be manipulated as graphic objects. Flash allows you to treat text in a similar manner by breaking down the letterforms into vector objects.

However, these are not the only text options available in Flash. Text in Flash can be inserted and formatted using all of the tools available to designers when laying out pages for print publications. Flash allows control over typical elements such as font, font size, and text alignment, and styles such as bold and italic. The Properties panel with the Text tool selected (as shown in figure 7-1) also gives you control over typographic elements such as leading (the space between lines of text), left and right paragraph margins, and line indentation. Additionally, the Kerning option allows you to control the space between letters.

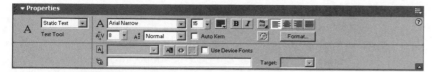

Fig. 7-1. Text Properties panel.

In Flash MX, you can also use HTML tags to format text that appears in your Flash movie. If you are familiar with HTML, you know that these tags allow you to apply preset attributes to text in an HTML document. These tags give web developers a certain amount of control over text elements on their web pages. You will take a closer look at some of these tags in Guided Tour 7A. Now let's take a closer look at the different text options in Flash.

Guided Tour 7A: Text Options in Flash

There are two general types of text fields that you can create in Flash: static text fields and editable text fields. To understand the difference between these two, let's explore the Properties panel more closely. Working with elements such as text has been greatly simplified in Flash MX. Instead of having individual panels for things like character settings and text options, the Properties panel consolidates the many separate panels that previously existed in Flash 5. The Properties panel allows you to set parameters for the text boxes you insert in your Flash document.

1. Let's take a look at the Text Properties panel.
 a) Select the Text tool in the toolbox.
 b) In the Properties panel, take a look at the pull-down menu in the Text type field, located in the upper left-hand corner of the panel and note the three types of text you can choose from: Static, Dynamic, and Input. See figure 7-2.

Fig. 7-2. Text options in the Text type field in the Properties panel.

 c) Select Static Text from the pull-down menu. Static text is one of the most commonly used text forms in Flash applications that do not require dynamically updated information or input from the user. The

Static Text option sets up a text field that contains specifically for-matted text, similar to the text found in a page layout program. Unlike text formatted with HTML, in Flash you can choose from a large variety of fonts that can be embedded into the final SWF file you export. This embedding process preserves the original outlines of the font you have applied to your text and ensures that the font will display accurately in the user's Flash Player. Those of you who have designed HTML pages and have wrestled with the varied (and frequently undesired) ways your text displays on different computers will appreciate the control that embedded text gives you over the display of text elements in Flash.

d) Look in the middle of the Text Properties panel and turn on the Use Device Fonts check box, and click on the Selectable button, shown in figure 7-3. Checking Use Device Fonts allows you to override the Embed Fonts options when you publish your final SWF file. Instead of embedding the outlines of a font in your Flash movie, choosing Use Device Fonts directs your movie to pull the fonts that most closely resemble the Device Fonts specified in your movie. As you can imag-ine, using Device Fonts can reduce your file size because you do not have to embed the font outlines in your published SWF file. But, you will also run the risk that the font your user ends up with may not look exactly as you originally planned.

Selectable Use device fonts

Fig. 7-3. The Use Device Fonts setting and the Selectable button.

e) The Selectable button allows you to specify that text can be selected, copied, and then pasted into another document by a user viewing your movie on the Web.

2. The Font pull-down menu in the Properties panel allows you to see the device fonts that can be specified for use in your movie file. This pull-down menu allows you to specify a particular font to apply to selected text in your movie, as in figure 7-4.

·T*i*P·

Embedding fonts in your exported Flash movie is a great option. However, be aware that not all font outlines can be exported. To find out if the font you are using can be exported, select the menu option View | Antialias Text. If this option does not smooth out the edges of the font you selected, Flash cannot correctly export the outlines of that partic-ular font.

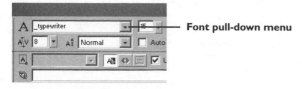

Fig. 7-4. The Font pull-down menu with a Device Font option selected.

As you select a Font, an attached floating window will show you an example of what the selected font looks like. There are three device fonts that are installed with Flash MX from which you can choose, as illustrated in figure 7-5. At the top of the Font pull-down menu you will see *_sans*, *_serif*, and *_typewriter*. Note that these Device Font options all begin with an underscore. The following device fonts resemble certain commonly used fonts.

_sans	Arial, Helvetica
_serif	Times
_typewriter	Courier

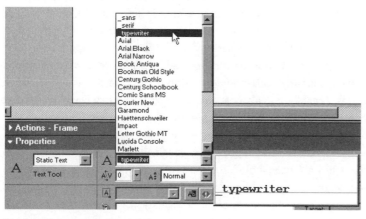

Fig. 7-5. Preview of selected font.

3. As we mentioned earlier in this Guided Tour, there are two types of text fields in Flash: static and editable. You were just introduced to the Static Text field. Now let's take a look at the first editable text field, Dynamic Text.

 a) Select the Text tool and click anywhere on the stage. When the cursor starts blinking on the stage, type in some sample text. From the Text Properties panel, select Dynamic Text. Once you type in some text on the stage, Dynamic Text gives you the following options: Line Type, Variable, Render Text as HTML, Border, and Selectable. With the

Render Text as HTML option turned on, the URL Link field also becomes active. See figure 7-6.

Fig. 7-6. The Dynamic Text options in the Properties panel.

b) To the right of the fields you just looked at, you will find the Variable field. The Variable field may help you understand why dynamic text is considered an editable text field. Normally, when we think of editable text fields we think of the user typing in information, such as text fields on a form. This is not the case with dynamic text. Dynamic text can be updated by information from a server-side application that feeds new information to the text field. This is useful in applications where frequently updated information is valuable, such as with stock quotes. Variables can also be used to update text in a Flash movie that is generated from a basic text file found on a server. This allows you to make text changes without editing and republishing your Flash movie. Dynamic text is updated by specifying certain variables. A variable is like a "cubby-hole" in Flash's memory that stores information specific to it. The "cubby-hole" is labeled with a specific name and stores the changing values of this information. In our earlier example, these changing values might be the numbers for stock quotes that are constantly being updated, or fed to the Dynamic Text field.

c) Use the Single-Line or Multi-Line option from the pull-down menu in the Line Type field to choose how many lines your Dynamic Text field will contain. This obviously depends on the type of content you will be updating.

d) The last option under Dynamic Text that we will look at is Render text as HTML. Flash allows you to format your text using standard HTML tags. This is especially useful if you are updating this information from a server-side application. That way, HTML tags such as BOLD, or can be used to format the text in a

document that will be displayed in a Dynamic Text Field. Figure 7-7 shows an example of HTML tags applied to text in a web document.

> When writing in HTML, it is important to remember to use your BOLD TAGS when necessary.

Fig. 7-7. HTML tags to begin and end bold style.

4. Now that you have seen the first editable text field, Dynamic Text, let's take a look at Input Text.

 a) From the Text Properties panel, select Input Text from the Text type field. See figure 7-8. Input Text gives you most of the same options as Dynamic Text with an additional field, Maximum Character.

Maximum Characters field

Fig. 7-8. Additional Input Text option, Maximum Characters

 b) Input Text is the second type of editable text field in Flash. However, Input Text allows you to set up text fields that require user interaction. So, instead of editing the text field from a server-side application, the visitors to your site have an opportunity to give feedback using forms, buy products (e-commerce), and otherwise interact by typing information into these text fields.

 c) Take a look at the Password option in the Line Type field pull-down menu. This allows you to set an editable text field so that users are required to submit a specified password.

 d) Now, let's take a look at the Max Char (Maximum Character) option on this panel. With this field you can specify a limit to the number of characters that can be typed into this text field by the user. You might use this option if you are asking for things such as phone numbers that have 10 digits.

Practice Exercise 7-1: Formatting and Inserting Text

Description

This exercise will show you how to insert and format text in Flash. Using files found on the companion CD-ROM, you will cut text from a plain text file and paste it into your Flash document. You will also learn to type text directly into your document and format it accordingly. In this exercise you will:

- *Copy and paste text from an external file*
- *Create your own text within Flash*
- *Modify and distort text*
- *Change font characteristics*
- *Turn text into hyperlinks*
- *Learn to use the Resizing handle to create single-line and paragraph text*
- *Learn to use the Paragraph panel*
- *Convert text into editable vector paths*

Take a Look

CD-ROM

Before beginning the exercise, let's take a look at the exercise in its completed state so that you can clearly see what it is you are about to build.

1. Use the menu option File | Open and locate on the CD-ROM the *Chapter07* folder. Locate and select the file named *Lesson7.fla*. Double click on *Lesson7.fla* to open the file.

2. The file *Lesson7.fla* should now appear in your copy of Flash. Note the following properties of this completed exercise.

 • *Text can be copied and pasted from files created in other programs.*

 • *Text can be formatted in many ways within a single paragraph.*

 • *You can easily adjust the size of text boxes.*

Storyboard: On Screen

Figure 7-9 shows you what the completed stage will look like on screen.

Of course in retrospect it all seems awash with bits of flotsam and jetsam, with exception, of course, to the extcurptics noodlings of those vague vessels. How incredible! Naturally we couldn't wait to place them within our eager lunch-pails and carry them off to some fantastic conclusion. How Mother and Uncle Bannister would chortle with effluvient glee as we conjoined ourselves to the dusty Chesapeake trails. Ahh... the pelusive memories of a complete and hippocratic adolescence. What joy we had at the time. But time *is* fleet footed.

Fig. 7-9. The completed on stage.

Storyboard: Behind the Scenes

Figure 7-10 shows you what the stage and timeline will look like when the exercise is completed.

Fig. 7-10. The completed stage and timeline.

Step-by-Step Instructions

1. First, let's do a little preparatory work and copy some text from a text file.

 a) Use your computer's browse function to locate the file named *Sample_Text.txt* in the *Chapter07* folder on the CD-ROM. Double click on the file to open it in your computer's default text/word processor. Select Edit | Select All from the menu, and then Edit |

Go Solo

Copy. You have just copied the text you want to use into your computer's clipboard. Close the text/word processor.

b) Now open Flash and create a new movie by selecting the menu option File | New.

2. Now let's get down to business!

a) Select the menu option Edit | Paste to paste the text stored in the clipboard onto the stage. Make sure the font type in the Properties panel is set to Static Text. Set the magnification so that you can see the entire stage without scrolling.

b) Select the Free Transform tool from the toolbox.

c) Click and drag one of the scale handles (black squares) to the right.

d) Release the handle. Notice how the text has been distorted!

e) Select the menu option Edit | Undo.

f) Select the Text tool from the toolbox.

g) In the Properties panel, change the Font Selection to _typewriter. Click the check mark next to Use Device Fonts, in that you have selected a device font.

h) Change the Font Size option to 10.

i) In the Properties panel, click on the Format button. Change the Line Spacing option to 0.

j) With the Text tool, click anywhere within the paragraph. You will notice a few changes in the appearance of the text block, as follows.

• The text no longer has a smooth, antialiased appearance.

• There is a little square in a corner of the text box.

3. Antialiasing is automatically turned off as you edit text. This is to conserve your system's memory resources. The little square in the corner is the Resizing handle. See figure 7-11. When the Resizing handle is present, it indicates that the text will always break at this point in the paragraph and will "wrap" to the next line. In other words, the paragraph will never be wider than is indicated by the Resizing handle. However, by dragging the Resizing handle, you can change the width of the paragraph.

Fig. 7-11. The Resizing handle.

4. Let's take a moment to experiment with this. Double click on the Resizing handle. This will turn the paragraph of text into single-line text. Single-line text is indicated by a circular handle (which at this point, is off screen to the right). See figure 7-12. Single-line text eliminates "word-wrap." This means that text will go on forever (or thereabouts) to the right as you type until you press the Enter/Return key. An Enter/Return will drop the cursor down a line so that you can continue typing text below the previous line (just like the carriage return on an old-fashioned typewriter!). Dragging the single-line text Circular handle will convert it to the Resizing handle. Select Edit | Undo to convert your text block back into wrapped text format.

Fig. 7-12. The single-line text Circular handle.

Each of these changes has had a global effect on all of the text in the text block. You can also make selective changes to text within the paragraph by using the Text tool to highlight and apply changes to particular letters, words, or phrases (similar to how you might do it in a word processor).

5. So let's get specific. Before you begin, if your text to this point is still readable, continue with the following steps. If, on the other hand, you would like to start "fresh," you can delete the existing text block, paste in a "fresh" copy of the text, and then continue.
 a) Use the Text tool to select the first sentence of the paragraph (click and drag to highlight – just like in a word processor). Select the Bold button in the Properties panel to make the text bold.
 b) Use the Text tool to select the last sentence of the paragraph. Click on the Italic button in the Properties panel to italicize the text.
 c) Use the Text tool to select all text between the first and last sentences. Select the Properties panel and select Red to change the Font Color option to red.

6. We're not finished yet! Let's add a hyperlink to our text block.
 a) Select the Text tool and click at the end of the paragraph. Press the Enter/Return key to move the cursor to a new line.
 b) Type in the following text: *This web site was created with Macromedia Flash MX.*
 c) Once you finish typing, highlight the words *Macromedia Flash.*

·TIP·

If you need to enlarge the text to see it better, use the Magnification pull-down in the upper right corner of the stage, or use the Zoom tool in the View section of the toolbox.

d) In the Properties panel, in the URL field, type the web address *http://www.macromedia.com* (as illustrated in figure 7-13). Press the Enter/Return key to set the hyperlink.

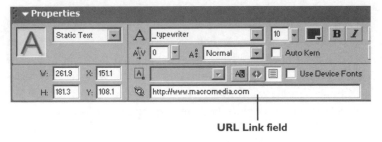

URL Link field

Fig. 7-13. The URL Link field in the Properties panel.

e) Select the menu option Edit | Deselect All. Your text should have a dashed line under it signifying that it is a hyperlink.

f) If you are connected to the Internet, select the menu option Control | Test Movie.

g) When you click on the text *Macromedia Flash*, your default browser will launch and you will be taken to the Macromedia web site.

7. Now, let's make some changes to the paragraph alignment.

a) With the Arrow tool selected, select the text block you have been working with.

b) In the Properties panel, click on the Center Alignment icon. If you are not sure which icon this is, take a look at figure 7-14.

Fig. 7-14. Alignment options in the Text Properties panel.

c) By selecting the entire text block, you can change the alignment of all text in a text block, all at once!

d) To change the alignment of one paragraph, select the Text tool and insert your cursor anywhere within the line that reads *This web site was created with Macromedia Flash*.

·T/P·

When users see your movie, the hyperlink will not appear underlined, as it does on the stage. If you want to indicate that this is a hyperlink, try changing the font color.

e) Select the Center Alignment icon on the Properties panel. This centers that specific paragraph while leaving the other paragraphs left-aligned.

8. The Properties panel also contains the a button for Format options. Clicking on this button opens a window that provides the opportunity to change indentation, line spacing, left margin and right margin. See figure 7-15.

Indentation ——
Line spacing (leading) ——
Left margin ——
Right margin ——

Fig. 7-15. The Indent, Line Spacing and Margin fields in the Format Options window.

a) With the Arrow tool, select the Text tool and set the entire text block to left-alignment.

b) In the Properties panel, click on the Format button. Indent the left margin of the text block 20 pixels by typing in *20* in the Left Margin field. Press the Enter/Return key and watch as the left margin of the entire text block moves 20 pixels to the right.

c) To indent only the first line of text, type in *10* (pixels) in the Indent field.

d) Now, let's change the right margin of the text block. Click on the Down arrow to the right of the Right Margin Indent field and use the slider bar to change the pixel number to 50.

e) Finally, let's change the line spacing on this text block. To decrease the space (or leading) between each line, click on the Down arrow to the right of the Line Spacing field and use the slider bar to change it to –5 points. To increase the space (or leading) between each line, let's use the other method, by just typing in *20* and pressing Enter/Return. When you are finished formatting your text block, click on Done to apply the changes, and close the Format window.

9. Time to finish up.

a) With the Text tool selected, click on a blank (nontext) area of the stage.

b) A small bounding box appears with the Single Line Text handle (the circle) and a blinking cursor. Type in: *All work and no play makes Joe sleepy.* You can then adjust the text as we have previously discussed. Great job!

c) No need to save this exercise, unless you would like to.

Guided Tour 7B: Text as Graphic Elements

The Text tools in Flash allow considerable typographical control over the placement and formatting of text in your movies. In addition to normal text objects, however, text can be converted to graphic elements by using the Break Apart option. Be aware that after breaking apart letterforms, the Text tool cannot be used for editing them any longer because the letters have been converted to outlines, or vector objects. However, as a graphic object, all the drawing and paint tools can now be used on the converted text, and the letter paths can be modified to any shape. Let's give it a try.

1. We will start with a new file.
 a) Select the menu option File | New.
 b) Select the Text tool in the toolbox. In the Properties panel, select a font you like and make the Font Size option at least 48 or 60 points.
 c) Click anywhere on the stage and type in your name.
 d) Select the Arrow tool in the toolbox. There should be a blue rectangle around the text object indicating that it is selected.
 e) Select the menu option Modify | Break Apart to convert your name from text into graphic objects. You might need to select Modify | Break Apart more than once to break down and ungroup the letterforms. You will be able to tell that the letters have been broken down into individual paths when each letterform has a dotted pattern and looks like that shown in figure 7-16.

Fig. 7-16. The Break Apart command applied to text.

·T/P·

Use the Magnifying Glass icon in the toolbox to zoom in and out on objects on the stage, or use the Percentage menu at the bottom left of the stage to toggle between magnifications.

2. You may want to zoom in for the rest of this step.
 a) With the Arrow tool still selected, click anywhere on the white portion of the stage to deselect the letters and turn off the dotted pattern. Move the cursor to the edge of a letterform. The half-moon or angle symbol will appear next to the letter, indicating that you can edit the "letter" shape (they are shapes that have the form of a letter, but they are no longer true, editable letters).
 b) Because the text has been converted into graphic elements, you can now manipulate them as any other graphic element. Try selecting the Subselect tool and clicking on the outline of the letters to edit the

shape of the outline using the anchor points. Use the Paint Bucket and Ink Bottle tools to change the Fill and Stroke option colors of each letter. See figure 7-17. Experiment and have fun!

Fig. 7-17. Text converted into a graphic element.

Shortcut

Double click on the Magnifying Glass icon in the toolbox to return to 100% magnification.

The View Menu

The View menu contains four options options (Outlines, Fast, Antialias, and Antialias Text) that control the display quality of objects on the screen, including text. The View menu allows you to change these display qualities so that as you are working on items, they can be redrawn on screen more quickly. These settings do not affect the final Export settings in the movie. Essentially, these options help you work faster and view objects on the stage in a variety of helpful ways.

The highest-quality display for objects and text is the Antialias or Antialias Text view. Computer displays are defined by tiny squares called pixels. As we discovered in an earlier chapter, when a bitmap image is scaled to a larger size, an effect known as *pixelation* occurs. This term refers to the jagged edges of the enlarged images that appear on screen. These jagged edges show the building blocks – or pixels – that make up the images. To simulate curves on the computer screen, a technique called antialiasing is used. A gradation of pixels is used to make the lines appear smoother to the human eye, and in the case of text, more readable. The four display views are:

- *Outline view: Converts all objects on the screen to lines (outlines) with transparent fills. This option allows you to see the outlines of objects that are stacked on top of each other.*
- *Fast view: Shows all lines and fills of objects and text on the screen, without any antialiasing.*
- *Antialias view: Creates a smoother edge on all objects (except text) on stage.*
- *Antialias Text view: Creates a smoother edge on all elements on stage, including text.*

Guided Tour 7C: Controlling the Display View

1. Let's take a closer look and try out these different View options.
 a) Select the menu option File | New.
 b) Select the Text tool from the toolbox.
 c) Click on the stage and type in your name. Using the Properties panel, change the Font Size option to 36.
 d) Select the menu option Edit | Deselect All.
 e) Select the Oval tool from the toolbox and draw an oval below your name.
 f) Select the menu option View | Outlines. Objects on the stage appear as outlines. See figure 7-18. The Outline view uses minimal memory to show you the images on-screen, and can be helpful when you have many objects to work with. Anything that is on the stage can still be edited in the Outline view.

Fig. 7-18. Outline view.

 g) Select the menu option View | Fast. Both the text and the object appear in full color but have jagged edges. This is because their edges are not being antialiased (or "smoothed") by the computer. By not antialiasing the view, your computer can redraw and refresh the view on the screen much faster than when it applies antialiasing. See figure 7-19.

Fig. 7-19. Fast view

h) Select the menu option View | Antialias. The object's edges appear smooth (antialiased) but the text does not. This is just another option to conserve memory! See figure 7-20.

Fig. 7-20. Antialias view.

i) Select the menu option View | Antialias Text. Both the text and the object appear smooth and antialiased. This particular view gives you the most appealing display and is great to work in – if your system resources will allow it. See figure 7-21.

Fig. 7-21. Antialias Text view.

The Info Panel

As the name implies, the Info panel (Window | Info) gives you basic information about selected objects on the stage of your movie. As shown in Figure 7-22, you can use this panel to view the dimensions of an object, to change the dimensions of an object, to get RGB and alpha values, and to view and move the placement of objects on the stage.

The Info panel can be used for controlling placement of objects on the stage area by typing in the X and Y coordinates into the corresponding areas of the Info panel. These coordinates represent the placement of the selected object in relation to the horizontal (X) and vertical (Y) edges of the stage area. These coordinates can be measured from the top leftmost edge of the object, or

from the center point of the object, depending on the settings established in the Info panel. You can also use the Flash layout tools to help arrange text elements and graphics on a page, as you will see in Guided Tour 7D.

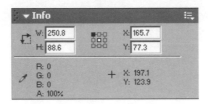

Fig. 7-22. The Info panel.

Guided Tour 7D: Working with Rulers, Guides, and Grids

When working on the stage, layout tools such as Rulers, Guides, and Grid lines will help you place items in precise positions. All three of these functions can be used together to align elements, to draw objects with specific sizes, and to create a guiding framework for laying out elements on the stage. Let's take a closer look.

1. Rulers are helpful additions to the stage because they provide a visual reference for positioning your graphic or text elements. Let's put a simple graphic on stage and see how the Rulers option can help us to work more efficiently.

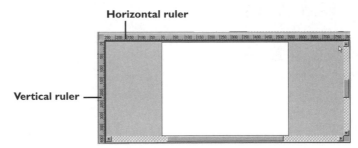

Fig. 7-23. Stage with rulers visible.

 a) Select the menu option File | New.
 b) Select the menu option View | Rulers.
 c) Select the Oval tool from the toolbox. Without clicking, move the cursor around the desktop. Notice how the horizontal and vertical rulers track the position of the cursor with a black line that moves up and down the rulers.
 d) Since the Oval tool is selected, let's draw a simple oval anywhere on stage.

e) Select the Arrow tool from the toolbox and double click the oval you just drew. Just to avoid any potential accidents, select the menu option Modify | Group.

f) With the Arrow tool still selected, click and drag the oval around the stage. Each ruler now has two lines that track the position of the active object. The vertical ruler on the left of the stage tracks the top and bottom edges of the object, whereas the lines in the horizontal ruler track the left and right edges of the object. With the use of this function, we can very precisely position graphics and text on stage.

g) To change the unit of measurement used by the rulers, select the menu option Modify | Document and then change the unit in Ruler Units. See figure 7-24.

Shortcut

The keyboard shortcut for turning rulers on and off is:

Ctrl + Alt + Shift + R (PC)

Option + Shift + Cmd + R (Mac)

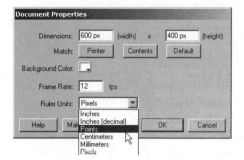

Fig. 7-24. Changing the Ruler Units option in the Document Properties dialog window.

h) To hide the rulers, simply select View | Rulers from the menu once again (this option acts like an on/off switch).

2. Another benefit of the Rulers option is using rulers to create guides. Guides are of great value if you would like to establish boundaries for your artwork. Let's take a look at the guides as shown in figure 7-25.

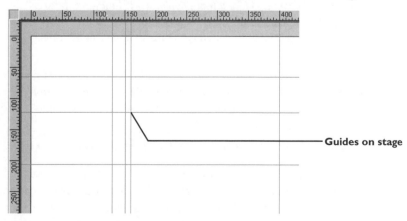

Guides on stage

Fig. 7-25. Guides on the stage.

a) Your rulers must be visible in order to create a guide. If your rulers are not visible, select the menu option View | Rulers. The rulers will track the vertical or horizontal position of the guide, depending on whether it is a vertical or horizontal guide.

b) Click on the vertical ruler and drag a vertical guide onto the stage.

c) Release the mouse button to place this guide.

d) Click on the horizontal ruler and drag a horizontal guide onto the stage.

e) Release the mouse button to place this guide.

f) Once you have dropped a guide in place you can reposition it by placing your cursor over the guide and then clicking and dragging the guide to a new position. Try it!

g) Using your Arrow tool, drag the oval you created earlier and position its top and left edges with your guides.

h) There are also a number of options available for guides. They are accessed by selecting the menu option View | Guides | Edit Guides. The options are as follows:

- *Guide Color: Changes the color of the guides (a blue guide does you no good against a blue stage, as you have to see it to use it).*

- *Show Guides: Toggles guide visibility. You can temporarily hide the guides if you want them out of the way for a moment but do not yet want to clear them for good. Show Guides is also available by selecting the menu option View | Guides | Show Guides.*

- *Snap to Guides: Will "snap" your artwork to line up with the guides you have placed on the stage. This allows for accurate positioning of your artwork. Snap to Guides is also available by selecting the menu option View | Guides | Snap to Guides. Try aligning your oval with the guides while this option is active and watch how it will "snap" to the guides.*

- *Lock Guides: Is of utmost importance once you have placed your guides and want to avoid accidental repositioning. This command "freezes" your guides in place so they are no longer affected by the mouse. Lock Guides is also available by selecting the menu option View | Guides | Lock Guides.*

- *Snap Accuracy: Allows you to control how much "pull" the guides have when the Snap to Guides option is in effect. You essentially control how close the selected object must be to the guide before it will "snap" to it (Close, Normal, or Distant).*

- *Clear All: Is the one-step method of getting rid of all guides on the stage.*

3. Grid is another option available to help you align and orient artwork on the stage. It is essentially an interwoven series of guides that form an intersecting pattern of horizontal and vertical lines that cannot be adjusted individually, only together as a unit. See figure 7-26.

Shortcut

The keyboard shortcut for turning guides on and off is:

Ctrl + ; (PC)

Cmd + ; (Mac)

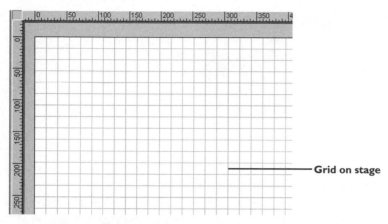

Grid on stage

Fig. 7-26. Grid on the stage.

 a) As with the guides, there are also a number of options available for grids. They are accessed by selecting the menu option View | Grid | Edit Grid. The options are as follows:

- *Grid Color: Changes the color of the grid (a blue grid does you no good against a blue stage, as you have to see it to use it).*

- *Show Grid: Toggles grid visibility. You can temporarily hide the grid if you want it out of the way. Show Grid is also available by selecting the menu option View | Grid | Show Grid.*

- *Snap to Grid: Will "snap" your artwork to the grid when it is visible on the stage. This allows for accurate positioning of your artwork. Snap to Grid is also available by choosing View / Grid / Snap to Grid from the menu. Try aligning your oval to the grid while this option is active and watch how it will "snap" to the grid.*

- *Horizontal and Vertical Gap: Increments can be set in their respective fields. The unit of measurement is dependent upon the Ruler Units set- ting. Ruler Units are changed in the Document Properties Dialog window and are accessed by selecting the menu option Modify / Document.*

- *Snap Accuracy: Allows you to control the "snapping power" of the grid when the Snap to Grid option is in effect. With this option, you can con- trol how close the selected object must be to the grid before it will "snap" to it (Close, Normal, Distant, or Always).*

 b) Use the oval we created earlier to try out these grid options.

4. The Info panel provides a few more options for the placement and manipu- lation of text and graphics, as well as a wealth of information concerning cur- sor position and graphic elements. You will be able to use the Info panel to help you with precise movements during the animation process.

Shortcut

The keyboard shortcut for turning the grid on and off is:

Ctrl + ' (PC)

Cmd + ' (Mac)

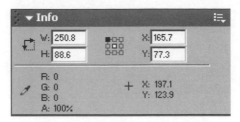

Fig. 7-27. The Info panel and attributes.

a) Go ahead and open the Info panel by selecting the menu option Window | Info.

b) With the Info panel visible, select the oval on stage. The Info panel becomes active for the selected object (in this case, the oval).

c) Change the size of the oval by typing new numbers into the Width and Height fields. Their unit of measurement is dependent on the Ruler Units setting. (Ruler units are changed in the Document Properties dialog window and are accessed by selecting the menu option Modify | Document.)

d) Change the position of the oval by typing new numbers into the X Location and Y Location fields. The unit of measurement is dependent on the Ruler Units setting. (Ruler units are changed in the Document Properties dialog window and are accessed by selecting the menu option Modify | Document.) An additional feature of these fields is that you can specify whether you change position relative to the center of the object or to the top left of the object. This is achieved by clicking on the appropriate icon adjacent to the X Location and Y Location fields.

e) With the oval selected, select the menu option Modify | Break Apart.

f) Select the menu option Edit | Deselect All.

g) Place your cursor over the center of the oval. The Info panel gives you the RGB color value and alpha (opacity) of the fill, as well as the position of the cursor.

h) We are finished here. Save your work – only if you want to.

C H A P T E R **8**

Symbols,

Instances,

and Libraries

Introduction

The Flash library functions somewhat like an electronic library, where we can check out copies of objects instead of books. Flash's library is a place where an original object is stored, allowing a "reference copy" to be "checked out" and placed in different frames of the timeline. The object really only physically exists in one place — in the library. Each time the object is placed and appears in the timeline, it is called an instance and it actually only references (and reuses) the original object stored in the library. In this way, library objects can be reused many times, helping the development process become much more efficient, organized, and streamlined. The use of objects in the library also significantly reduces file size and improves performance. By the end of this chapter you will be well on your way to creating more complex Flash movies by taking advantage of symbols and instances. By the end of this chapter you will be able to:

- *Briefly describe the purpose and structure of the library*
- *Add symbols to the library*
- *Use the common libraries in Flash*
- *Create and modify symbols*
- *Briefly describe all three symbol behaviors*
- *Define an instance of a symbol*
- *Modify an instance of symbol*

Guided Tour 8A: Exploring the Library

The library is a general storage area for media elements used in your Flash movies. The library is mainly used for storing specialized elements called symbols, the function and purpose of which are discussed in detail later in this chapter. In short, symbols are objects created in Flash that are added to the library and designated with different behaviors. There are three main types of symbols: movie clips, graphics, and buttons. Each one of these symbols has certain characteristics or behaviors that dictate how these symbols operate, what they can do, and how they should be used in your movie timeline. While symbols are the most common media element stored in the Flash library, they are not the only objects stored there. Other items (such as bitmaps, sound files, and digital videos that have been imported into Flash) are also automatically added to the library.

The purpose of the library goes way beyond the storage and organization of elements in your movies, although these are helpful features of the library. In Flash, the library also plays an important role in the efficient functioning of

your Flash movie. Once a symbol is stored in the library, it can be used over and over again in the frames of your movie. Each time an instance of the symbol appears in the timeline, it actually references (and reuses) the original object stored in the library. By creating copies of library objects – instead of creating a new object for each frame – the file size is kept far smaller and the download performance is significantly improved. Let's take a quick tour of the library to understand it more completely.

1. Let's start by opening the library.
 a) Select File | New to create a new file.
 b) Select the menu option Window | Library.
 c) If you have a blank document open and have not added anything to your library, your library will look like the empty library illustrated in figure 8-1.

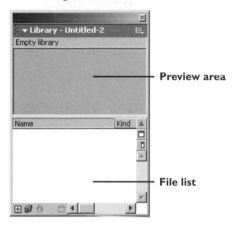

Fig. 8-1. An empty library.

2. Notice that the library is divided into two areas: the Preview Area (the gray area at the top of the library) and the File List (white area) that shows the Name, Kind, Use Count, Linkage, and Date Modified parameters of the symbol stored in the library.

3. The following is some useful background information about libraries that you should digest.
 a) Every new Flash file has an empty library associated with it. As you build your movie you can create new graphics or import existing graphics, and Flash automatically places them in the library.
 b) You can open libraries you have already created and reuse these objects in other movies.
 c) You can include symbols in a shared library and link to items in the shared library from any Flash movie.

Shortcut

The keyboard shortcut for Window | Library is:

Ctrl + L or F11 (PC)

Cmd + L or F11 (Mac)

·TIP·

To see all columns of information available to you in the library (Name, Kind, Use Count, Linkage, and Date Modified), you may need to scroll (to the left or right in your File list) or make your Library window larger.

 d) You can create font symbols in Flash that allow you to link to movies containing font symbols so you do not have embed a particular font in all exported movies.

 e) Once you export your Flash movie, the library will be exported as well.

 f) As mentioned earlier, keeping objects in the library helps to keep the file size down. Using the library can also help you stay organized. You can set up collapsible folders within the library to keep different types of symbols used in your movie separate from each other. These folders are similar to the folders you use on your computer's hard drive. They can be named and organized in any way, and can be nested inside one another.

4. Let's create a new folder within the library.

 a) Click on the New Folder icon on the bottom left edge of the Library window to insert a new folder, as illustrated in figure 8-2.

New folder icon

Fig. 8-2. Inserting a new folder.

 b) Notice that there are several icons found on the bottom border of the Library window. These are discussed in material to follow.

5. Folders in the library can be expanded or collapsed when they contain items. To hide or reveal the content of a folder, double click on a folder icon in the File list.

6. Let's look at a library example of folders and objects within those folders. To do so, we will look at one of the common libraries that Macromedia supplies with Flash MX. These libraries include numerous objects you may find useful.

 a) Select Window | Common Libraries | Buttons.

b) Note that you now have two libraries open. The first is associated with the new file you opened and currently is untitled. The second library you opened provides many objects that have already been created and are provided by Macromedia.

c) Double click on the Arcade Button folder in the open Buttons library.

d) You are now looking at the Arcade Button folder in an expanded format. See figure 8-3.

Fig. 8-3. Buttons library with multiple folders and one folder expanded.

e) Now single click on the arcade button, *blue*. A preview of that object now appears in the top portion of the library panel.

f) Next single click on the arcade button, *red*. You get the idea.

g) Double click on the Arcade Button folder to close the expanded format.

7. Symbols can be added to the library using various methods. You'll get some hands-on experience doing this in the exercises that follow.

a) Symbols are easily added directly into a folder just by dragging and dropping them on top of the folder.

b) Blank symbols are easily added to the library by clicking on the New Symbol icon. See figure 8-4.

c) Folders and symbols can also be added by using the Options pull-down menu located on the upper right-hand corner of the Library window. (It looks like three lines with an arrow pointing down. See figure 8-4.) From the pull-down menu, select New Symbol. The Option menu gives you a list of commands that can be used to control the way your library symbols and folders behave. Among these commands are: Edit, Delete, Duplicate, and Rename Symbols.

CAUTION

An important thing to remember about deleting symbols is that this action *cannot* be reversed using the Undo command. Think twice before deleting.

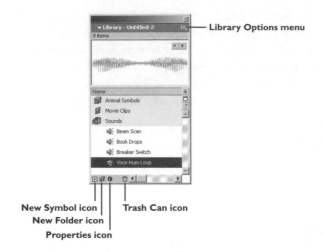

Fig. 8-4. Library panel with labeled icons.

8. Let's look at the other Library window icons.
 a) *The Trash Can icon:* As illustrated in figure 8-4, allows you to delete symbols and entire folders from the library. Just highlight the item you want to discard and click on the Trash Can icon. You can also delete symbols and folders using the Options menu located on the Library panel.
 b) *The Properties icon:* This icon is shown in figure 8-4. By clicking on this icon (which looks like a lowercase i) you can look at or change the properties of each symbol in your library. When you highlight a symbol in the library and click on the Properties icon, the Symbol Properties dialog window appears. This window allows you to designate what type of symbol you want to add to the library and to change a symbol's properties.
9. Later in this chapter you will learn more about the different types of symbols that can be stored in the library.

Symbols

In Chapter 2 you learned that the graphics created in Flash are vector graphics. Just to refresh your memory, one of the benefits of vector graphics is that they tend to have smaller file sizes and usually perform faster (write-to-screen time) than their bitmap cousins. This is because the information in a vector graphic only contains the object's path (outline), rather than large amounts of data describing each individual pixel. As any web user knows, the smaller and more efficient the file size, the quicker it downloads over the Internet.

Streaming Media

Streaming media is a term currently often used in relation to Internet technology, especially referring to large files containing multimedia (video and audio). With traditional file downloading procedures, the entire file must be downloaded before it can be accessed or played. With very large files, this is a very long process that tends to rapidly discourage many Internet users.

With streaming technology, instead of waiting for the entire file to download, you can view/hear the media as it is downloaded "in chunks." As soon as enough data gets through the Internet pipeline with a streamed file, it immediately starts playing and continues to download the rest of the information in the background as you watch.

This process is not always seamless, as anyone who has viewed streaming video or audio with QuickTime or RealPlayer knows. Occasionally, you get pauses when Internet traffic is heavy, if you have a slow connection or if you have a slow internal processor.

Using Symbols

Flash also has another way of keeping file sizes smaller by using symbols. Symbols are one of the primary reasons web sites and applications built with Flash are such efficient examples of streaming media. A symbol is like an electronic "original" file stored in the library that can be copied and placed on the timeline anywhere and as many times as you wish. Each copy of the symbol on the timeline is called an instance and is linked to the original symbol stored in the library. As we mentioned earlier in this chapter, the library is a media storage area where these "original" objects or symbols are kept. Symbols stored in the library carry the bulk of the file size, whereas the instances (copies) of the symbols add only a negligible amount to your file. Symbols also have predefined behaviors. There are three types of symbols: movie clips, buttons, and graphics. You will learn more about the characteristics of each of these in material to follow.

Using symbols is a fundamental step in creating efficiently built Flash projects. In contrast to Flash's streamed delivery, you probably have waited for other types of pages to load into your browser window, watching items appear one by one on-screen as they download. Frequently graphics placed on a web page will be represented on the page by image placeholders until they are completely downloaded from the server. See figure 8-5.

·T/P·

As you browse through different web pages, you may have noticed that when you go back to pages you have already viewed the download time is typically shorter. This is because most browsers temporarily store pages that have been previously viewed. This cache, or temporary storage, is purged periodically when it reaches a certain size. In Netscape and Internet Explorer, the user can customize the cache settings and set up the parameters for when the cache should be purged or updated.

Fig. 8-5. An image placeholder.

Using Symbols from the Library

The library acts as storage for graphics, buttons, animation, sound, fonts, imported bitmaps, and other media elements you will use in your Flash movie. As you continue the development of your movie, you will place copies of these symbols in different frames in the movie timeline.

Placing Symbols on the Stage from the Library

In your File list, highlight the symbol name you would like to add and drag the symbol from the Library window directly onto the stage. Alternatively, drag and drop the symbol from the Preview area of the library directly onto the stage. Let's work with one of the buttons from the common library.

1. In the previous guided tour, you opened the common library called Buttons. If this library is still open, skip to step 3.

2. Select the menu option Window | Common Libraries | Buttons.

3. Double click on the Arcade buttons folder to expand this folder. Now click on and drag the arcade button, *blue symbol,* from the library and drop it anywhere on the stage.

4. Once the Button symbol is added to the stage, select the menu option Window | Library to open the library associated with this movie, if you do not already have it open. You may have to click on the arrow next to the library name to expand the library.

5. You can tell which library belongs to the current movie because of the name found at the top of the Library panel. Notice that the button you just inserted from Flash's common library has been automatically added to the current movie's library.

Instances

An instance is a copy of a symbol that has been dragged from the library and placed in the movie timeline. Every time you drag a symbol from the library

·T/P·

Although the elements in the common libraries can be used in any of your movies, after a symbol has been placed on stage, this object is copied and stored in the current movie's library.

to the stage you have created a new instance (copy) of that symbol. If you reuse a symbol frequently, you will have multiple instances of that symbol in your movie timeline. In the library, you can keep track of how many instances of a symbol you have in your movie by looking at the column titled Use Count in the Library panel. You may need to use the scroll bar to scroll to the right to see the Use Count column. See figure 8-6.

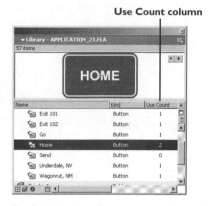

Use Count column

Fig. 8-6. The Use Count column in the library.

The relationship between a symbol and its instances is analogous to printing multiple photographs from a single positive transparency. The original transparency contains all the information needed to print a photograph. Each print is basically a copy of the information stored on the transparency.

Whenever the playhead encounters an instance ("print") in the timeline, Flash always refers to the symbol ("transparency") stored in the library. The fact that the library stores the single original becomes especially handy if you decide to change a symbol. If you edit the symbol stored in the library (the "transparency"), Flash will automatically update each instance (replace each "print" based on the updated "transparency") throughout your entire movie, to reflect the changes you made. In this case you are actually changing the original (or "transparency") in the library.

But what if you want to make a small change to a particular instance of a symbol (change a particular "print") without affecting the image in the library? For example, let's say you have a symbol ("transparency") of a medium-size red circle stored in your library. What if you want one instance of this circle ("a print") to be blue instead of red, and the size reduced 50%. Does this mean you have to create an entirely new symbol? The answer is no!

Let's go a little further with our transparency and print analogy. In the dark-room, we can overexpose/underexpose a particular print, use special filters,

and reduce/increase the image size during the printing process to alter the way a particular print will look. You can apply all of these special effects without altering the original transparency.

In Flash, you can also apply effects that change the look of a particular instance, without affecting the symbol stored in the library. Symbols are so flexible that you can make cosmetic modifications to an instance of a symbol and still maintain the link between that particular instance and the original symbol in the library. In a practice exercise later in this chapter you will get hands-on experience doing this, as you modify an instance of a symbol that you will create.

Symbols and Behaviors

There are three types of symbols that can be stored in a library: movie clips, buttons, and graphics. Each symbol is represented in the library by a different icon, as you will see in material to follow. The name of each symbol type is important because it is descriptive of the behaviors attributed to each type of symbol.

Movie Clips

Movie clips are mini-movies stored as symbols in the library. See figure 8-7. Movie clips are perhaps the most versatile type of symbol and are frequently used by Flash developers. Movie clips have their own timeline, which is independent from the timeline of the main movie. This means you can have animations that are not tied to the main movie's timeline. As the name implies, adding a movie clip to the timeline of your main movie is like making a movie within a movie (i.e., nesting a movie clip within the timeline).

Fig. 8-7. The Movie Clip icon in the library.

Any time a symbol in a library contains more than one frame (as does a Movie symbol that contains its own separate timeline), a Play and Stop button will appear in the upper right-hand corner of the Preview window. See figure 8-8. If you click on this Play button in the Preview window, you will be able to view all frames of that movie clip (or button or graphic symbol). These buttons allow you to play through the frames within button symbols, graphic symbols, or sounds stored in the library.

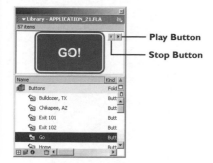

Play Button

Stop Button

Fig. 8-8. Play and Stop buttons in the Preview window.

Movie Clip Characteristics

Movie clips exhibit the following characteristics.

• *Movie clips have their own timeline, which is completely independent of the main movie timeline.*

• *Movie clips are mini-movies that can have any of the features you might include within a "main" movie created in Flash.*

• *An instance of a movie clip can include interactivity.*

• *Movie clips can be nested inside other symbols.*

The way movie clips play or behave can be controlled by Flash ActionScripts incorporated in the main movie timeline.

Guided Tour 8B: Movie Clip Symbols

Let's set up a movie clip and add it to the library.

1. Open the library (if it is not already open) by selecting the menu option Window | Library.

2. Click on the New Symbol icon (looks like a plus sign) at the lower left-hand corner of the library. Review the Library icons illustrated in figures 8-3 and 8-4 if you need to.

3. The Symbol Properties window has now opened. Select the radio button next to Movie Clip, and in the Name field type in *My Movie Clip*. Click on OK.

4. Take a look at your library. You have just added a new movie clip symbol to the library! See figure 8-9. When you click on the *My Movie Clip* symbol in the Library list, there is no preview because it is an empty symbol.

·T*i*P·

You can easily change the behavior associated with a symbol after it has been added to the library. In the Library panel, click on the Properties icon (the *i* icon), and then click on the appropriate radio button in the Symbol Properties window.

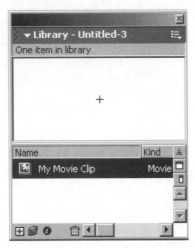

Fig. 8-9. **My Movie Clip** *symbol added to the library.*

Button Symbols

Button symbols are a fast and easy way to create reusable buttons in your movies. When you add a button to the library, the Button timeline automatically has only four frames. This is very different from the timeline for both the graphic symbol and the movie clip symbol. The button's four frames are labeled Up, Over, Down, and Hit. These frames correspond to four different mouse actions (button states). For example, when your mouse moves over an instance of a button symbol, it will show the content of the Over frame and will play any associated sounds. Up corresponds to the normal up position of a button. Down corresponds to the normal down position of a button when pressed. Hit corresponds to the "target" or "hot spot" area that is activated by the mouse action. The Hit frame is invisible to the user.

Button Symbol Characteristics

Button symbols exhibit the following characteristics. See figure 8-10.

• *ActionScripts can be attached to button instances to control the instance's behavior.*

• *Sounds can be added to different button states (you can hear a "click" as a button is depressed or as a user mouses over a button).*

• *Movie clips can be nested in button frames to animate the button (it will have animation associated with a mouse action).*

• *The Hit frame is an invisible frame that defines the button's "hot area" (i.e., the area that responds to mouse activity).*

Fig. 8-10. The Button Symbol icon in the library.

Guided Tour 8C: Button Symbols

Let's set up a button symbol and add it to the library.

1. Open the library by selecting the menu option Window | Library. (It may already be open.)

2. Click on the New Symbol icon at the bottom of the library.

3. The Symbol Properties window has now opened. Select the radio button next to Button, and in the Name field type in *My Button*. Click on OK.

4. Take a look at your library. You have just added a new button symbol to the library, along with the *My Movie Clip* symbol you created earlier! See figure 8-11. When you click on the *My Button* symbol in the Library list, there is no preview because it is an empty symbol. You will add objects to these symbols in later exercises.

Fig. 8-11. **My Button** *symbol added to the library.*

Graphic Symbols

Graphic symbols can consist of either static images or simple animations that are reused throughout a movie. An example might be something like a company logo that is reused frequently, but graphic symbols are generally not used for lengthy animations with interactive elements (this is what movie clip symbols are for).

Graphic Symbol Characteristics

Graphic symbols exhibit the following characteristics. See figure 8-12.

- *The Graphic Symbol timeline is dependent on the main movie timeline and unlike movie clips will not play beyond the end of the main movie.*
- *ActionScripts do not work within a Graphic Symbol timeline.*
- *Sounds on the Graphic Symbol timeline cannot be activated from the main movie timeline.*

Fig. 8-12. The Graphic Symbol icon in library.

Guided Tour 8D: Graphic Symbols

Let's add a graphic symbol to our list in the library.

1. Open the library by selecting the menu option Window | Library. (It may already be open.)

2. Click on the New Symbol icon at the bottom of the library.

3. The Symbol Properties window has now opened. Select the radio button next to Graphic, and in the Name field type *My Graphic*. Click on OK.

4. Take a look at your library. You have just added a new graphic symbol to the library, along with the *My Button* and *My Movie Clip* symbols! See figure 8-13. When you click on the *My Graphic* symbol in the Library list, there is no preview because it is an empty symbol.

·T/P·

Once you have added a lot of symbols to your library, you might want to create some folders to organize the symbols into categories. Select the Folder icon in the Library window and then give your folder a new name. You can now drag symbols on top of the folder to put them inside. Double click on the folder to expand or collapse the folder's content.

Fig. 8-13. **My Graphic** *symbol added to the library.*

Symbol Editing Mode

Once you create a symbol, you can take full advantage of a unique editing mode that allows you to modify and make global changes to every instance of a particular symbol in your movie. Because movie clips, graphic symbols, and button symbols have their own timelines, using Symbol Editing mode opens a new stage and a new timeline, devoted strictly to the selected symbol.

In an earlier chapter you worked with another alternate editing mode, Group Editing. Symbol Editing mode is very similar in concept. The difference is that when you are working with symbols you actually open a new stage and a new timeline.

What is often confusing to novice Flash users is that Symbol Editing mode looks very much like the main movie stage and timeline. Timeline, stage, panels, and tools are all available for use in Symbol Editing mode, just as they are in the main movie. It is easy to lose your bearings. The best way to tell whether or not you are in Symbol Editing mode is to look below the timeline at the tabs. If you are in the main movie timeline, the only tab visible will be Scene, even if you have more than one scene in your movie. If you are in Symbol Editing mode, you will see a tab with the name of the symbol and the icon to match the symbol behavior: Movie Clip, Graphic, or Button icon. See figure 8-14.

⚠ CAUTION

It is easy for new Flash users to lose their bearings and confuse Symbol Editing mode with the main movie stage and timeline. Pay attention to the tabs that appear below the timeline. These tabs will help orient you as to what mode you are in.

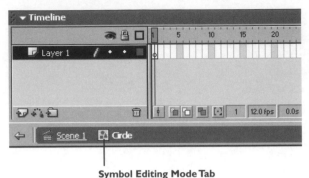

Symbol Editing Mode Tab

Fig. 8-14. The Symbol Editing mode tab for the graphic symbol, Circle.

Exiting Symbol Editing mode is easy. Simply click on the Scene 1 tab to return to your main movie.

Practice Exercise 8-1: Creating and Editing Symbols

Description

In this exercise you will see how to add and modify symbols in your library. You will then convert existing graphics to symbols. In this exercise you will:

- *Add a symbol to the library*
- *Edit a symbol*
- *Rename a symbol*
- *Detach an instance from a symbol*

Go Solo

Take a Look

Before beginning the exercise, let's take a look at the exercise in its completed state so that you can clearly see what it is you are about to build.

1. Use the menu option File | Open and locate on the companion CD-ROM the folder named *Chapter08*. Locate the file named *Lesson08.fla*. Double click on *Lesson08.fla* to open the file.

2. The *Lesson08.fla* file should now appear in your copy of Flash. Take a look around. Note the following properties of this completed exercise.

 - *Symbols are stored in a library.*
 - *Instances of a symbol are what you work with on the stage.*
 - *Changes to a symbol in the library are updated in all of its instances.*
 - *Instances can be detached from symbols in the library.*

Storyboard: On Screen

Figure 8-15 shows you how the stage will look once you have finished this exercise.

Fig. 8-15. The completed stage.

Storyboard: Behind the Scenes

Figure 8-16 shows you what the library will look like after you have added symbols to it.

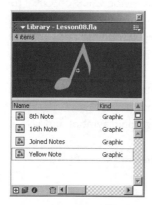

Fig. 8-16. The completed library.

Step-by-Step Instructions

1. First things first. Let's set up the workspace.
 a) Select the menu option File | Open.
 b) Locate the *music.fla* file in the *Chapter08* folder on the companion CD-ROM.
 c) Open the file.
2. Let's take a look at the file's content (what you are starting with).

Go Solo

a) Take a look around the *music.fla* file. Notice that there are two layers in the timeline: *Music Notes* and *Background*. The *Background* layer is locked.

b) Select the Arrow tool from the toolbox. Click on the *Music Notes* layer.

c) The three notes drawn on the *Background* layer are selected. Note that they are ungrouped objects. You know this because when selected they are filled with a hatched pattern instead of bounded by a rectangular selection box.

d) Click anywhere on the background on the stage to deselect the notes.

3. Now let's add some symbols to the Library.

a) Open the library with the keyboard shortcut Ctrl + L (Mac: Cmd + L). Notice that the library is empty.

b) With the Arrow tool, click to select the green notes on the left-hand side of the stage.

c) You are going to convert this object into a symbol. Select the menu option Insert | Convert to Symbol, or use the keyboard shortcut F8.

d) The Convert to Symbol dialog window appears. Name the symbol *Joined Notes*, and give it a graphic symbol behavior. Click on OK. The *Joined Notes* symbol has been added to the library.

e) Select the blue note on the stage. Let's try something different this time. Click on and drag the object onto the File list (white area) in the library and then drop it there.

f) The Convert to Symbol dialog window appears. Name the symbol *16th Note* and give it a graphic symbol behavior.

g) Convert the remaining orange note to a graphic symbol and give it the name *8th Note*.

h) Your library should now look similar to that shown in figure 8-17.

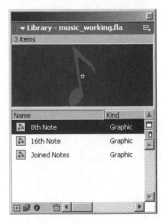

Fig. 8-17. Library with three converted symbols.

·T/P·

The crosshairs that appear in the middle of the stage mark the center point of the symbol. You can move the symbol's position on the stage to alter the location of the center point. This can be helpful if you want to rotate an instance of the symbol by the center point and alter where that point rests.

4. Now that you have created some symbols, let's add another instance of these symbols to the stage.

 a) Select the *8th Note* symbol in the library.

 b) Click and drag the *8th Note* symbol from the library onto the stage and drop it there. You now have two instances of the same symbol on the stage. The first instance is the orange note you converted into a symbol. The second instance is the note you dragged onto the stage from the library. In the next exercise you will learn how to modify the instances of these symbols individually.

5. The notes are very large and take up a lot of space on the stage. To eliminate this problem, let's edit the *8th Note* symbol in the library using Symbol Editing mode.

 a) Select the *8th Note* symbol in the library. Using the Library Options menu (located in the upper right-hand corner of the Library panel), select Edit from the list.

 b) You have now entered Symbol Editing mode. Notice that the other instance of this symbol, along with the rest of the objects on the stage, have disappeared. Also, a tab labeled *8th Note* with the Graphic Symbol icon has been added below the timeline. See figure 8-18.

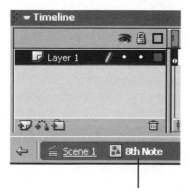

Symbol Editing Mode Tab

Fig. 8-18. Symbol Editing mode tab labeled **8th Note.**

 c) Your note should be selected. If your note is not selected, click on the Arrow tool and use this tool to select the note.

 d) Let's now change the size of the note by scaling it. You could use the Free Transform tool, but instead let's use a menu command that will allow us to scale the note with more precision.

 e) Use the menu option Modify | Transform | Scale and Rotate. In the Scale and Rotate window, type *70* in the Scale field and click on OK. See figure 8-19.

Fig. 8-19. The Scale and Rotate window.

 f) The note has now been scaled to 70% of its original size.

 g) Now let's exit Symbol Editing mode and return to the main movie stage and timeline. Click on the Scene 1 tab at the bottom left of the timeline to return to the main movie stage.

6. Take a look at the changes that have been made to the instances of the *8th Note* symbol on your stage. Both instances are now smaller. Imagine you had a symbol that was used many times throughout a movie. By editing the symbol in the library, it is a snap to globally change each instance of the symbol.

7. Now that you have learned to edit a symbol, let's rename it in the library.

 a) Select the *8th Note* symbol in the library.

 b) Double click on the *8th Note* text. A blinking cursor will appear. See figure 8-20.

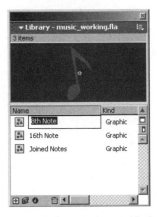

Fig. 8-20. Renaming a symbol in the library.

 c) Type in the name *8th Note Small* in place of *8th Note*.

 d) Press the Enter/Return key to complete the renaming of the symbol.

8. Let's make a copy of this symbol. Symbols can be duplicated in the library so that you do not have to recreate objects with similar shapes.

 a) Select *8th Note Small* in the library.

b) Right click (Mac: Ctrl + Click) on the symbol name. From the pop-up menu, select Duplicate.

c) The Duplicate Symbol dialog window now appears. See figure 8-21. Change the name of the symbol to *Yellow Note* and click on OK.

Fig. 8-21. Duplicating a symbol in the library.

d) Enter Symbol Editing mode by double clicking on the Graphic Symbol icon next to *Yellow Note* in the library.

e) With *Yellow Note* selected, change the Fill picker in the toolbox to an orangy yellow. This will automatically change the color as long as an object is selected.

f) Select the Free Transform tool and rotate the note clockwise so that is tilted to the right.

g) Click on the Arrow tool to release the Free Transform tool. You have now changed the orientation of *Yellow Note* in the library.

h) Exit Symbol Editing mode by clicking on the Scene 1 tab above the timeline.

i) Drag a copy of the *Yellow Note* symbol to the stage.

9. Now that you have learned to edit a symbol, let's see how to detach an instance of a symbol from the symbol in the library so that it is protected from any further editing, and so that it becomes an independent graphic.

a) Select a copy of the *8th Note* symbol already on stage.

b) Take a look at the Properties panel. See figure 8-22. The Properties panel indicates that a graphic symbol is selected, and the symbol is an instance of the *8th Note* symbol.

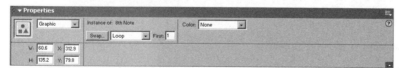

Fig. 8-22. The Properties panel with a graphic symbol selected.

c) To detach this instance of *8th Note* from the symbol in the library, select the menu option Modify | Break Apart. As you do this, keep an eye on the Properties panel. Once the option is applied, the name of the graphic symbol disappears, and is replaced by the name *Shape* (along with the Shape icon). Now that you have broken the symbol apart, it is no longer attached to the symbol in the library.

Shortcut

The Break Apart keyboard shortcut is:

Ctrl + B (PC)

Cmd + B (Mac)

d) Select the remaining *8th Note* symbol on the stage. Double click on this symbol on the stage to enter Symbol Editing mode.

e) Select the note, and then select the Free Transform tool from the toolbox. See figure 8-23.

Fig. 8-23. The Free Transform tool in the toolbox.

f) Use this tool to rotate the note until it is completely upright. If you have trouble controlling the rotation precisely, this could mean that Snap to Objects is turned on. Select the menu option View | Snap to Objects to uncheck this option and turn it off.

g) Exit Symbol Editing mode by clicking on the Scene I tab below the timeline. The remaining instance of the *8th Note* symbol that is still linked to the symbol in the library has been rotated. However, notice that the *8th Note* instance on which you used the Modify | Break Apart option to detach it from the symbol in the library has not been altered!

h) Select the menu option File | Save As. Use the browse function to locate and select the *SaveWork* folder on your local computer. Type in the name *Ex8_1*. You will use this in the next exercise.

Practice Exercise 8-2: Modifying Instances of a Symbol

Description

Let's see how we can modify an instance of a symbol in other ways.

In this exercise you will:

- *Modify an instance of a symbol.*

- *Make changes using the Brightness, Alpha, and Tint options.*

Take a Look

CD-ROM

Before beginning the exercise, let's take a look at the exercise in its completed state so that you can clearly see what it is you are about to build.

1. Use the menu option File | Open and locate the *Chapter08* folder on the companion CD-ROM. Find the file named *Lesson08_instance.fla*. Double click on *Lesson08_instance.fla* to open the file.

2. The file *Lesson08_instance.fla* should now appear in your copy of Flash. Take a look around.

3. Note the following properties of this completed exercise.

 • *You can modify an instance of a symbol without affecting the actual symbol.*

 • *Changes to a symbol will not affect altered instances when effects have been applied.*

Storyboard: On Screen

Figure 8-24 shows you what the stage will look like once you have finished this exercise.

Fig. 8-24. The completed stage.

Storyboard: Behind the Scenes

Figure 8-25 shows you what the library will look like once you have finished this exercise.

Fig. 8-25. The completed library.

Step-by-Step Instructions

1. Let's pick up where we left off in the last practice exercise. Open the file you were working on in the last practice exercise (*Ex8_1* located in your SaveWork directory). Alternatively, open the *Lesson08.fla* file in the *Chapter08* folder on the companion CD-ROM.

2. In the last exercise, you converted some objects on the stage to symbols and learned to drag a symbol from the library to the stage to make copies (instances) of that symbol. You also learned how to make global changes to a library symbol. Now it is time to learn how to modify an instance of a symbol without affecting the original symbol in the library.
 a) Delete all music notes from the stage, except the blue note, to make some room.
 b) Open the library (Window | Library).
 c) Drag two copies of the *16th Note* symbol from the library onto the stage and position them in a manner similar to that shown in figure 8-26.

Fig. 8-26. Three instances of the 16th **Note** *symbol positioned on the stage.*

The color effects in the Properties panel allow you to control the appearance of an instance using four attributes: Brightness, Tint, Alpha, and Advanced.

3. Select the instance of the *16th Note* to the far left on the stage.
 a) In the Properties panel, select Brightness from the Color pull-down menu.
 b) Using the Brightness slider, select -50%, or type in *-50*. See figure 8-27. This will darken the color of your image. Notice that when you make this change the brightness of the other instances of this symbol remain unchanged.

Fig. 8-27. Brightness slider on the Properties panel.

4. Let's take a look at an instance's alpha (i.e., opacity) attribute.
 a) Select the *16th Note* instance in the middle of your stage.
 b) On the Properties panel, select Alpha from the Color pull-down menu.
 c) Use the Alpha slider to change the opacity of this instance to 30%, or type *30* in the Alpha field.
 d) Because this instance is now semitransparent, you can see the textures in the background through this note.
 e) Notice once again that when you make this change the alpha of the other instances of this symbol remain unchanged.

5. Now let's change the overall color of an instance.
 a) Select the remaining instance of the *16th Note* symbol and select Tint from the Color pull-down menu in the Properties panel.
 b) Take a look at the Tint options. See figure 8-28. You can select a new color from the Color Well or from the Color Spectrum. You can also type in specific RGB values.

Fig. 8-28. Tint options in the Properties panel.

 c) Select a red from the pop-up Color Well. You can use the Percentage slider to change the saturation of this tint as well. Great! You have just changed the color of an instance without editing the symbol in the library!

6. Now let's see what happens to the changes you made when you modify the original *16th Note* symbol in the library.
 a) Double click on the icon next to the *16th Note* symbol in the library to edit the symbol in the library.
 b) Using the Properties panel, change the Fill option of your shape to Hot Pink.
 c) Using the Free Transform tool, rotate your symbol slightly clockwise so that the note tilts to the right, and then reduce the size of the note so that it is similar to that shown in figure 8-29.

Fig. 8-29. Modifying the symbol.

 d) Exit Symbol Editing mode by clicking on the Scene I tab.

7. Take a look at what happened to each copy of the library symbol. Each instance of the symbol has been rotated and scaled to a smaller size. However, the Brightness, Alpha, and Tint option modifications that were made to each instance remain unchanged.

 a) Select the middle instance of the *16th Note* and use the Free Transform tool to rotate the note upright and change the scale so that the note looks larger.

 b) Try dragging some other symbols out of the library and adjusting their size, rotation, and color effects as well.

8. Select the menu option File | Save As. Use the browse function to locate and select the *SaveWork* folder on your local computer. Type in the name *Ex8_2*.

CHAPTER **9**

*Application
Chapter: Designing
the Interface and
Reusable Symbols*

Introduction

In this chapter you will continue the application project by building the pieces of our site's interface, as well as some of the symbols that will be reused in many parts of the site. It is important to spend the time planning and creating these symbols in the initial design phase of any project because the efficient use of symbols in your movie can significantly improve how well your movie plays back over the Internet.

Remember that symbols are a fundamental reason Flash movies are considered such efficient streaming media. Even though you may have many instances of a symbol appearing in your movie timeline, the "physical" symbol only exists once (in the library) and thereby significantly reduces file size and download time. Therefore, what may seem like a long pre-production process will actually pay off with better performance when the movie is accessed and played.

By the end of the chapter you will be able to:

- *Create an interface with multiple layers*
- *Add graphic symbols to the timeline*
- *Modify instances of symbols on the timeline*
- *Use tools to create basic graphic shapes*
- *Create new graphic symbols*
- *Create text within the timeline using specific text properties*
- *Position text using X,Y coordinates*

Application Exercise: Designing the Interface and Reusable Symbols

Description

In this application exercise you will build the interface elements and add the descriptive text that will be used throughout your web site. You are creating an online travel experience where these elements are used for scenery along the way and for each "stop" of your online travelogue. Finally, you will add basic frame-by-frame animation to some of the graphic symbols.

Take a Look

CD-ROM

Before beginning the exercise, let's take a look at the exercise in its completed state so that you can clearly see what it is you are about to build.

1. Use the menu option File | Open and locate on the companion CD-ROM the folder named *Chapter09*. Locate the file named *application_09.fla*. Double click on *application_09.fla* to open the file.

2. The file *application_09.fla* should now appear in your copy of Flash.

3. Preview the movie. Take a moment to look around.

Storyboard: On Screen

Figure 9-1 shows what will be seen on stage when the program file is complete.

Fig. 9-1. The completed stage.

Storyboard: Behind the Scenes

Figure 9-2 shows how the timeline will look when the exercise is complete.

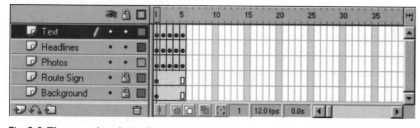

Fig. 9-2. The completed timeline.

Application Project Steps

Complete this exercise on your own, guided by following the general steps. These steps do not include the details of how to accomplish these tasks, as the "how to" has been covered in earlier chapters. You can always refer back to the completed example you viewed in the "Take a Look" section of this exercise.

NOTE: The following steps are intended as guidance. This is your project, so please feel free to make whatever variations you would like.

Designing the Interface

1. In the *SaveWork* directory on your computer's hard drive, open the file *application_04.fla*. Or if you prefer, you can use a file with the same name from the *Chapter04* directory on the companion CD-ROM.

2. Rename scene 1 as *Index*

3. Select frame 1 of the *Background* layer.

4. Now drag a copy of the *Highway Graphic* symbol out of the *Graphic Images* folder and position it at X=213.7, Y=324.6.

5. Add four (4) more frames to the *Background* layer, for a total of five (5) frames.

6. Lock the *Background* layer.

7. Add a new layer and name it *Route Sign*.

8. Select frame 1 of the *Route Sign* layer. Drag a copy of the *Road Sign Graphic* symbol out of the *Graphic Images* folder and onto the stage.

9. Resize the *Road Sign Graphic* symbol to W=208.8 and H=483.5. Position it at X=112.3, Y=221.2.

10. Lock the *Route Sign* layer.

11. Add a new layer, name it *Photos*, and position it above the *Route Sign* layer.

12. Add a blank keyframe to frames 1 through 5 of the *Photos* layer.

13. Select frame 1 of the *Photos* layer.

14. Drag an instance of the *PD Truck* symbol out of the *JPEG Images* folder in the library. Resize it to W=88.2 and H=88.2. Position it at X=231.8, Y=158.3.

15. Drag an instance of the *PD Road* symbol out of the *JPEG Images* folder in the library. Resize it to W=136.0 and H=90.0. Position it at X=348.3, Y=177.2

16. Drag an instance of the *PD Stop* symbol out of the *JPEG Images* folder in the library. Resize it to W=91.0 and H=91.0. Position it at X=516.6, Y=137.7.

17. Select the Rectangle tool from the toolbox. Set the fill color to white, the stroke color to #333333, and the stroke height to 4. Make sure that Snap to Objects is selected.

18. Draw a rectangle over each of the photographs in frame 1 of the *Photos* layer, making sure that each rectangle is the same size as the photograph it is drawn over.

19. Select frame 2 of the *Photos* layer.

20. Drag an instance of the *Underdale 1* symbol out of the *JPEG Images* folder in the library. Resize it to W=154.0 and H=108.0. Position it at X=259.0, Y=151.9.

21. Drag an instance of the *Underdale 2* symbol out of the *JPEG Images* folder in the library. Resize it to W=140.0 and H=94.0. Position it at X=435.9, Y=173.9.

22. Select the Rectangle tool from the toolbox and use the same settings from the previous steps.

23. Draw a rectangle over each of the photographs in frame 2 of the *Photos* layer, making sure that each rectangle is the same size as the photograph it is drawn over.

24. Select frame 3 of the *Photos* layer.

25. Drag an instance of the *Chikapee 1* symbol out of the *JPEG Images* folder in the library. Resize it to W=89.0 and H=134.9. Position it at X=300.0, Y=209.5.

26. Drag an instance of the *Chikapee 2* symbol out of the *JPEG Images* folder in the library. Resize it to W=178.0 and H=119.3. Position it at X=476.4, Y=210.9.

27. Select the Rectangle tool from the toolbox and use the same settings from the previous steps.

28. Draw a rectangle over each of the photographs in frame 3 of the *Photos* layer, making sure that each rectangle is the same size as the photograph it is drawn over.

29. Select frame 4 of the *Photos* layer.

30. Drag an instance of the *Wagonrut 1* symbol out of the *JPEG Images* folder in the library. Resize it to W=130.0 and H=86.0. Position it at X=286.0, Y=232.9.

31. Drag an instance of the *Wagonrut 2* symbol out of the *JPEG Images* folder in the library. Resize it to W=131.0 and H=83.2. Position it at X=429.5, Y=186.6.

32. Drag an instance of the *Wagonrut 3* symbol out of the *JPEG Images* folder in the library. Resize it to W=110.0 and H=86.0. Position it at X=563.0, Y=203.9.

33. Select the Rectangle tool from the toolbox and use the same settings from the previous steps.

34. Draw a rectangle over each of the photographs in frame 4 of the *Photos* layer, making sure that each rectangle is the same size as the photograph it is drawn over.

35. Select frame 5 of the *Photos* layer.

36. Drag an instance of the *Bulldozer 1* symbol out of the *JPEG Images* folder in the library. Resize it to W=167.0 and H=108.0. Position it at X=314.0, Y=200.9.

37. Drag an instance of the *Bulldozer 2* symbol out of the *JPEG Images* folder in the library. Resize it to W=149.0 and H=101.2. Position it at X=501.9, Y=216.6.

38. Select the Rectangle tool from the toolbox and use the same settings from the previous steps.

39. Draw a rectangle over each of the photographs in frame 5 of the *Photos* layer, making sure that each rectangle is the same size as the photograph it is drawn over.

40. Add a new layer and name it *Headlines*. Position it above the *Photos* layer.

41. Add a blank keyframe to frames 1 through 5 of the *Headlines* layer.

42. Select frame 1 of the *Headlines* layer.

43. Drag an instance of the *America's Other Headline* symbol out of the *Graphic Images* folder in the library. Position it at X=207.2, Y=96.0.

44. Select frame 2 of the *Headlines* layer.

45. Drag an instance of the *Underdale Headline* symbol out of the *Graphic Images* folder in the library. Position it at X=419.1, Y=108.8.

46. Select frame 3 of the *Headlines* layer.

47. Drag an instance of the *Chikapee Headline* symbol out of the *Graphic Images* folder in the library. Position it at X=396.3, Y=108.6.

48. Select frame 4 of the *Headlines* layer.

49. Drag an instance of the *Wagonrut Headline* symbol out of the *Graphic Images* folder of the library. Position it at X=391.9, Y=108.8.

50. Select frame 5 of the *Headlines* layer.

51. Drag an instance of the *Bulldozer Headline* symbol out of the *Graphic Images* folder in the library. Position it at X=383.6, Y=108.7.

52. Save your file as *application_09.fla* in the *SaveWork* folder on your computer's hard drive.

Creating Re-usable Symbols

1. Create a new graphic symbol named *Yellow Glow*. In its Symbol Editing window, draw a circle (W=9.5, H=9.5) using any radial gradient as the fill color and using a black stroke (Stroke Height=2).

2. Change the innermost gradient color to #FFFF33, and the outermost gradient color to #FF0033.

3. Position the complete circle at X=0.0, Y=0.0.

4. Return to the main movie and move the *Yellow Glow* symbol to the *Graphic Images* folder of the library.

5. Create a new graphic symbol named *Exit Sign*. In its Symbol Editing window, draw a rectangle (W=56.5, H=34.0, Radius Corners=5), using a fill color of #006633 and no stroke. Position it at X=0.0, Y=0.0.

6. Draw another rectangle (W=53.3, H=30.7, Radius Corners=3) using no fill color and a white stroke with a height of 1. Position it at X=0.0, Y=0.0 and above the green rectangle you just drew. You will use this symbol extensively when you create buttons in a later chapter.

7. Return to the main movie and move the *Exit Sign* symbol to the *Graphic Images* folder of the library.

8. Add a new layer and name it *Text*. Position it above the *Headlines* layer.

9. Add a blank keyframe to frames 1 through 5 of the *Text* layer.

10. Select frame 1 of the *Text* layer.

11. Assign the following text properties.

Font	_sans
Font Height	10
Bold	selected
Color	Black
Kerning	deselected
Left Justified Paragraph	
Static Text	
Use Device Font	selected

12. Type in the following text, with a hard return at the end of each line.

 Historic Route 67 is a scenic drive through America's beautiful and rugged Southwest. It was originally conceived as a coast-to-coast highway that would open a new corridor to travel and commerce. Unfortunately, the project came to a halt when someone in Washington decided that it by-passed all of the so-called "interesting" features of the Southwest. Take our word for it ... there's a lot to be excited about on Route 67!

13. Position this text at X=360.8, Y=420.9.

14. Select frame 2 of the *Text* layer. Use the same text properties as before and type in the following text, with a hard return at the end of each line.

 Our motto here is "Too close to be far, too far to be convenient!" Even on the blackest night you won't be bothered by the glowing lights and the jingling sounds of Las Vegas. Your family will grow closer as you forage for food and shelter when you explore the Underdale Family Fun Wilderness Trail, a former Desert Survival Training Area for the U.S. Army!

15. Position this text at X=360.8, Y=414.1.

16. Select frame 3 of the *Text* layer. Use the same text properties as before and type in the following text, with a hard return at the end of each line.

 Bring the family to Chikapee for a trip to the mysterious Invisible Ocean, discovered in 1952 by Lester "Tequila" Hopkins. Or, stay awhile and marvel at the aerobatic hijinks of Lester Hopkins the Third and his Flying Cropduster Circus! Lester has been known to let lucky children fly his plane while he shouts authentic flight instructions from the ground.

17. Position this text at X=363.1, Y=414.1.

18. Select frame 4 of the *Text* layer. Use the same text properties as before and type the following text, with a hard return at the end of each line.

 Come face-to-face with wild animals at Colonel Steve's Wild Game Reserve! Colonel Steve has scoured the earth to gather the most exotic and incredible animals ever assembled in north-northeastern New Mexico! Your children will no doubt gain valuable natural insights that will make them much more intelligent and successful in their adult lives!

19. Position this text at X=363.5, Y=414.1.

20. Select frame 5 of the *Text* layer. Use the same text properties as before and type the following text, with a hard return at the end of each line.

 In August 1978, Sissy Glabella entered a dish at the Annual Town Fair that started the culinary movement known as "Texahoma Cuisine." Stop and enjoy such delectables as Fried Meat Tidbits with Salt, Cheesy Noodle Bake, No-Fuss Cheesecake, and the dish that started it all . . . Sissy's Steamed Squash Medley on Rice. When you say Bulldozer, you've said "Good Eating!"

21. Position this text at X=363.5, Y=420.9.

22. Save your file as *application_09.fla* into the *SaveWork* folder on your computer's hard drive.

CHAPTER

10

Shape and Motion Tweens

Introduction

After all that work in Chapter 3 to create a short and very simple frame-by-frame animation, it might seem like a daunting task to build an animation that has complex, fluid movement. Looking at some of your favorite Flash sites that have subtle shape and color transitions as well as complex movement on the screen, you may be asking yourself, "How did they do that?" To help you work more productively and create sophisticated 2D animation, Flash added the Tween command, which allows you to create transitional effects in your time-line without manipulating every frame. What this means in plain English is that tweening will save you tremendous time and effort. By the end of this chapter, you will be able to:

- *Define the concept of tweening*
- *Use the Frame panel*
- *Add animation to a symbol*
- *Create a motion tween*
- *Set up a motion guide*
- *Create a shape tween*

What Is Tweening?

Tweening may sound like a strange term, but once you have seen it in action you will never forget what it is. The easiest way to remember what tweening means is to think of it as the action that takes place "be-tween" keyframes in an animation.

In Chapter 3, you learned how to create frame-by-frame animations in which change occurred only in each keyframe (i.e., the turning on and off of a light bulb). With frame-by-frame animation, in order to move an object a short distance you must incrementally move it in each frame to make the movement seem natural when it is played back. This type of frame-by-frame animation is very time intensive and difficult to edit. In addition, certain types of animated effects cannot be easily achieved with frame-by-frame animation – effects such as fluid movement, morphing of shapes, gradual transitions, and motion on a path.

Shape morphing (e.g., transforming a circle into a square) would be very time consuming to accomplish using the frame-by-frame method. You would have to slowly redraw the circle's shape, guessing at the shape changes in each frame until it has been reshaped into a square. For a fluid transition between these shapes, these changes would have to be very small and would probably stretch over many hundreds of frames.

Working in the fast-paced world of web development requires more efficient methods to reduce the tedious and time-consuming process of frame-by-frame animation. Thankfully, with tweening, Flash does all the work and uses only as many frames as you designate in your timeline. In fact, Flash provides two types of tweening that can be easily applied to objects and symbols: the motion tween and the shape tween.

Motion Tweens

Motion tweens allow you to easily move an object around the stage, make it bigger/smaller, or rotate it on an axis. The process, as follows, is simple.

1. Set up a beginning keyframe and an ending keyframe.
2. Convert the object to be animated into a symbol or a grouped object.
3. Position the object in the first keyframe, indicating where it should first appear on the stage.
4. Position the object in the last keyframe, indicating where it should end up on the stage.
5. Apply motion tweening.

Flash takes the beginning and ending positions, as well as the number of frames that exist between the two keyframes, and automatically creates the incremental movement for these "in-between" frames. The result is a fluid transition from the beginning location to the end location. As the object moves, you can also scale and rotate it at the same time. You will get a chance to try this out shortly.

The timeline in Flash gives you visual clues to what commands have been applied in each frame. When you apply a motion tween between two keyframes, you will see an arrow stretching across all of the frames, highlighted in blue. See figure 10-1.

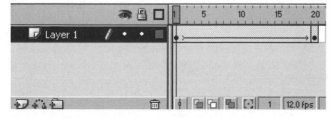

Fig. 10-1. Motion tween between frame 1 and frame 20 (indicated by arrow).

On the other hand, a dotted line indicates that the tween is inactive. See figure 10-2. An inactive tween can result from the following: one of the keyframes is blank, one or both of the objects are ungrouped, or the object has not been converted to a symbol.

When working with motion tweens it is handy to remember the following tips:

- Always insert keyframes for the beginning and ending frames of a motion tween.
- All objects involved in a motion tween must either be grouped or converted to a symbol.

Fig. 10-2. An inactive motion tween, indicated by a dotted line.

Motion Guides

The use of a motion guide is an excellent way to make a more complex path for your objects to follow during a motion tween. You will discover that in an ordinary motion tween, Flash operates by the old axiom "The shortest distance between two points is a straight line." If you want a more complicated or meandering path for your animation to follow, you must use a motion guide. When you add a motion guide, you can draw a specific path for your object to follow, including whatever curves you may want. Motion guides actually reside in a separate layer from the object you are trying to move, but they are linked to the object's layer. Motion guides are inserted by selecting the Add Motion Guide icon on the lower left-hand portion of the Layers window, as illustrated in figure 10-3.

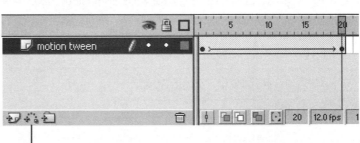

Add Motion Guide icon

Fig. 10-3. Add Motion Guide icon.

A motion guide layer is inserted directly above the layer you currently have selected. When it is inserted, it will have the Motion Guide symbol and will be labeled *Guide: Layer Name*. The *Layer Name* portion of this label changes to the

name of the layer the guide is linked to. See figure 10-4. Once the guide layer is inserted, you can draw a path with any of the drawing tools. This is the path the object will move along. After the path has been created, you then attach the object to the path using its center point. You will get some hands-on practice in doing this during a practice exercise that follows.

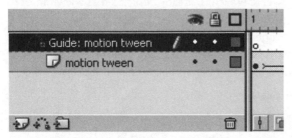

Fig. 10-4. Motion guide layer linked to motion tween layer.

Shape Tweens

A shape tween actually allows you to morph (transform) one object into another. As you will see during an exercise that follows, this can be a very interesting effect that can be used with simple or complex shapes. Shape tweens can incorporate movements, as well as color and alpha (transparency) changes. A shape tween is applied in much the same way as a motion tween. However, unlike motion tweens, you must always either break apart a symbol or ungroup an object in order to apply shape tweening.

As mentioned previously with motion tweening, the timeline in Flash gives you visual clues to what commands have been applied in each frame. When you apply a shape tween between two keyframes, you will see an arrow stretching across all of the affected frames. However, instead of being highlighted in blue, as is the case with a motion tween, the shape tween will be highlighted in green. If your shape tween does not work, this is usually an indication that one of the keyframes is blank, that the objects are grouped, or that the objects have been converted to a symbol and must first be detached from the symbol.

Guided Tour 10A: Frame Properties

The Properties panel is a very important part of using motion and shape tweens. Think of it as "command central" for adding and controlling tween effects. For those of you who are experienced users of Flash, the Properties panel streamlines the animation process. You no longer have to open additional windows to add or edit motion or shape tweens. In addition, editing is a breeze because you can keep the Properties panel open at all times.

1. Let's open the Properties panel and check out its features related to frames and tweening.
 a) Make sure the Properties panel is open. If it is not open, select Window | Properties.
 b) Open a blank document by selecting the menu option File | New.
 c) Select frame 1 in layer 1 (which is already designated as a keyframe) to dynamically change the Properties panel to reflect frame properties. Remember, the Properties panel is context sensitive and changes depending on what is selected. After this selection, take special note of the Tween pull-down menu on the Properties panel. See figure 10-5.

Frame label **Tween selector**

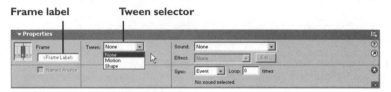

Fig. 10-5. The Properties panel displaying frame properties.

 d) Take a look at the Frame Label field in the Properties panel. See figure 10-6. This field provides you with the capability to label any keyframe with a descriptive label. This feature will come in handy, especially once you start using ActionScripts in later chapters.
 e) Click and hold open the Tween selector pull-down menu in the Properties panel. This is where you will select shape and motion tweens.

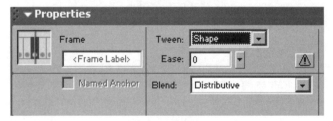

Fig. 10-6. Shape tween settings on the Properties panel.

2. Take a look at the shape tween settings.
 a) In the Tween selector pull-down menu, select the Shape tween. See Figure 10-6.
 b) Click on the Ease pull-down menu. Note that it opens an Easing slider bar. The Easing slider bar allows you to control the rate of acceleration in your animation. Click and drag the handle on the slider bar. Note the corresponding numerical values appearing in the Ease field window. A negative number means a slower start. The

larger, positive number means a more rapid start to the animation. Click anywhere to close the slider bar.

c) Click on the Blend pull-down menu. Note you have two blend options to choose from with shape tweening: Distributive and Angular. The Blend options control the way tweening is applied to the middle frames in your animation. Distributive is generally smoother, and Angular works well with shapes that have straight lines and sharp corners.

3. Now take a look at the Motion tween settings.

a) With the keyframe still selected, select Motion from the Tween selector pull-down menu in the Properties panel. Take a look at the Motion tween settings. See figure 10-7.

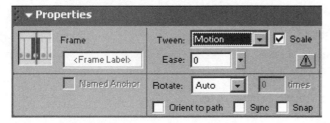

Fig. 10-7. Motion tweening on the Properties panel.

b) The Ease field with a slider bar works the same way as in the Shape tween setting by controlling the rate of acceleration of the motion tween.

c) Select the Rotate pull-down menu. The Rotate option allows you to spin the object being moved during the execution of the motion tween. None does not rotate the object at all. Auto will rotate the object once in the direction requiring the least motion. CW will rotate the object clockwise. CCW will rotate the object counter-clockwise. If you select either CW or CCW, you will note that the Times field becomes active. This field is where you can type a number to specify how many times the object should be rotated.

d) The Scale check mark allows you to apply scaling effects to your tween. This means that if an objects get larger in the last frame, Flash will create the needed transitional effects in the tween frames so that the object looks as if it is getting larger incrementally.

e) Note the remaining options at the bottom of the panel. Place a check mark next to Sync (synchronization) if the number of frames in the animation sequence inside the symbol is not an even multiple of the number of frames the graphic instance occupies in the movie. Place a check mark next to Snap to attach the tweened element to the motion path by its registration point. Orient to Path moves the

·T/P·

You can move the center point of a symbol by entering Symbol Editing mode and moving the graphic in relation to the crosshairs on the stage.

object along a motion guide more naturally by tilting the object at its center point to correspond with the angle of the path.

4. The tour is finished. Let's build something.

Practice Exercise 10-1: Motion Tweens and Motion Guides

Description

In this exercise you will create a motion tween and a motion guide. After creating and animating a symbol, you will see how to apply a motion tween to move this symbol across the screen. You will also draw a path for your symbol to follow by using a motion guide. In this exercise you will:

- *Create a new symbol*
- *Animate your symbol's timeline*
- *Use your symbol in a motion tween*
- *Rotate and scale the motion tween symbol*
- *Add a motion guide*

CD-ROM

Take a Look

Before beginning the exercise, let's take a look at the exercise in its completed state so that you can clearly see what it is you are about to build.

1. Use the menu option File | Open and locate on the companion CD-ROM the folder named *Chapter10*. Locate the file named *motion.fla*. Double click on *motion.fla* to open the file.

2. The file *motion.fla* should now appear in your copy of Flash. Press the Enter/Return key to see a preview of the file. Note the following properties of this completed exercise.

- *Graphic symbols have their own timelines that are tied to the main movie timeline.*
- *Motion tweens can only be applied to symbols or grouped objects.*
- *Motion guides are used to control the path and orientation of an object.*
- *Invisible motion guides are visible when previewed in Flash.*

Storyboard: On Screen

Figure 10-8 shows what the finished exercise will look like on the stage.

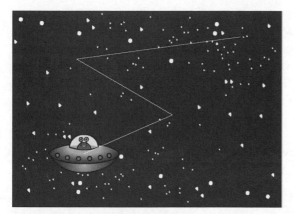

Fig. 10-8. The completed stage.

Storyboard: Behind the Scenes

Figure 10-9 shows your timeline, stage, and library once the exercise is finished.

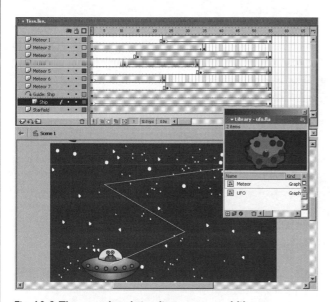

Fig. 10-9. The completed timeline, stage, and library.

Step-by-Step Instructions

1. To begin, let's start with the symbol we want to use in the motion tween. You are going to use a very simple spaceship.

Go Solo

a) Select one of the following. If you want to draw the spaceship your-self, you can look at figure 10-10 as a "model." Select File | New to open a new file. Use the drawing tools and create a simple spaceship. If you do not want to draw the ship, select the menu option File | Open. Use the browse function to locate the *Chapter10* folder. Locate and open the file *spaceship.fla*.

Fig. 10-10. A simple UFO.

b) With either one of the previous choices, save your file by selecting File | Save As, naming the file *motion.fla* and saving it into the *SaveWork* folder on your computer.

c) Using the Arrow tool, select all objects that make up the UFO by clicking and dragging the selection marquee around all objects on the screen, as illustrated in figure 10-11, or by clicking on the UFO.

Fig. 10-11. UFO selected using the Arrow tool to draw a selection marquee.

d) Select the menu option Insert | Convert to Symbol to add the UFO to the Symbol library.

e) Select the Graphic Radio button in the Symbol Properties window and name the symbol by typing in *UFO*. Click on OK.

f) Open your library by selecting the menu option Window | Library, and then select the UFO symbol in the library. Look at the new UFO symbol in the Preview window. See figure 10-12.

Fig. 10-12. UFO in Library Preview window.

2. Now let's edit the symbol to add a short animation before applying the motion tween.
 a) Double click on the UFO graphic icon in the library to enter Symbol Editing mode.
 b) Click on the Insert Layer icon (see figure 10-13) to add a layer to the timeline. Double click on the layer you just added and type in *Running Lights*.

Insert
Layer
icon ———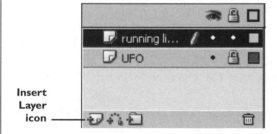

Fig. 10-13. Insert Layer icon.

 c) Rename layer 1 containing the spaceship by double clicking on the layer name and typing in *UFO*.
 d) Lock the *UFO* layer by clicking on the Lock Layer icon (turning the "dot" to a "lock"). See figure 10-14.

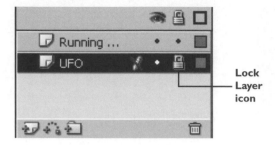

Fig. 10-14. Lock Layer icon.

 e) Select the Circle tool from the toolbox and pick a medium gray fill with a 1.5-point black stroke from the Properties panel.

 f) Select the *Running Lights* layer.

 g) Draw a series of small circles in an arc on the base of the spaceship, as illustrated in figure 10-15.

Fig. 10-15. Running lights added to the spaceship.

 h) Add one frame to both layers by selecting frame 2 in the *Running Lights* and *UFO* layers. Select the Menu option Insert | Frame.

 i) Select frame 2 in the *Running Lights* layer and select the menu option Insert | Keyframe.

 j) With frame 2 still highlighted, select the menu option Edit | Select All to select the circles on the spaceship.

 k) Change the fill in the toolbox to a bright red to automatically change the fill of the selected circles.

 l) To check your work, use the menu option Control | Loop Playback to set the playback to a continuous loop. Press Enter/Return to play through the two-frame timeline. Press Enter/Return again to stop the looping playback.

 m) Exit Symbol Editing mode by clicking on the Scene 1 tab. You have just created a two-frame animation for your symbol that will loop throughout the main movie timeline!

3. Now that you have your symbol set up, you can add the beginning and ending keyframes for your motion tween.

 a) In frame 1 of the *Ship* layer, and drag the *UFO* symbol to the bottom left-hand side of the stage. You might have to drag the *UFO* symbol from the library if it is not already inserted on your stage.

 b) Select frame 55 in the *Ship* layer and select the menu option Insert | Keyframe to add a keyframe to your timeline. This keyframe represents the end of the motion tween you will be creating.

4. Now that you have your keyframes set, you can move your UFO to its end location.

 a) Make sure you have frame 55 in the *Ship* layer selected. Move the UFO from the left side of the screen to the upper right-hand corner of the screen.

 b) Now scrub (drag) the playhead to scroll through the movie frames. Notice that the UFO stays in its initial location until frame 55 and then jumps to the middle of the screen.

5. Now let's apply the Motion tween to make a more fluid movement.

 a) Select any of the frames between 1 and 55 in the *Ship* layer.

 b) In the Properties panel, use the Tween selector pull-down menu and select Motion tween. Make sure that the Scale box is checked. See figure 10-16.

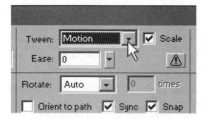

Fig. 10-16. Motion tween selected in Properties panel.

 c) Your frames will be highlighted in blue, and a solid line with an arrow will appear in the *Ship* layer. See figure 10-17.

Fig. 10-17. Ship layer with Motion tween applied.

 d) Press the Enter/Return key to play through the animation. Notice that the *Running Lights* animation set up in the symbol's timeline loops as the UFO moves across the stage.

6. We can also make the UFO larger as it moves.

a) Move the playhead to frame 55 and select the *UFO* instance in frame 55.

b) Open the Transform panel by selecting the menu option Window | Transform.

c) To scale the UFO proportionally without distorting it, check the Constrain box and type in *125* for the width and height. With Constrain turned on, you only have to type *125* in one box . See figure 10-18.

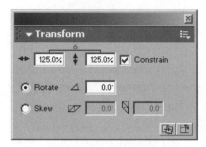

Fig. 10-18. Transform panel.

d) Play through the animation by pressing the Enter/Return key. The UFO gradually gets larger as it moves!

7. Now let's rotate the UFO as it moves.

a) Select any of the frames in your motion tween (highlighted in blue) and take a look at the Properties panel. (If the Properties panel is not open, select Window | Properties.)

b) Select CCW (counterclockwise) from the pull-down menu and type *1* in the times field. See figure 10-19.

Fig. 10-19. Adding rotation to a motion tween.

c) Press the Enter/Return key to play through your animation timeline to watch the UFO spin and scale as it moves across the stage.

8. Let's add a motion guide to control the movement of our UFO more closely.

a) Click on the Add Guide icon to add a guide layer above the *Ship* layer.

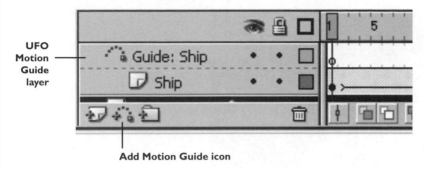

UFO Motion Guide layer

Add Motion Guide icon

Fig. 10-20. **UFO** *motion guide layer.*

b) Select the Pen tool and a white stroke from the toolbox. See figure 10-21.

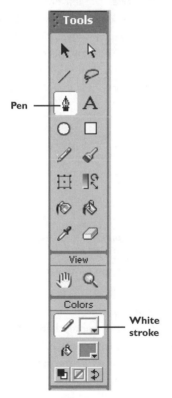

Pen

White stroke

Fig. 10-21. Pen tool.

c) With the motion guide layer selected, draw a zig-zag line that will become the path for your spaceship to follow. See figure 10-22.

Shortcut

The keyboard shortcut for selecting the Pen Tool is:

P (PC)

P (Mac)

Fig. 10-22. Zig-zag motion path.

d) In frame 1 of the *Ship* layer, select the UFO with the Arrow tool.

e) Using the crosshairs as guides, drag the UFO over the left end of the guideline until a hollow circle appears and the object snaps to the end of the guide. Use the menu option View | Snap to Objects to turn snapping on, if you cannot see the hollow circle. You can also turn on Snap to Objects by clicking on the *Magnet* symbol in the Options portion of the toolbox, available when the Arrow tool is selected. See figure 10-23.

Fig. 10-23. Center point of UFO snapping to end of motion guide.

f) Repeat step E in frame 55 of the *Ship* layer, but this time attach the UFO in frame 55 at the other end of the guide line.

9. Let's add a few final touches and then test the movie.

a) Select any frame in the *Ship* layer. In the Properties panel, change the Rotate option to None and check the option Orient to Path. See figure 10-24. Orient to Path will tilt the spaceship at its center point to conform more closely to the shape and angle of the path.

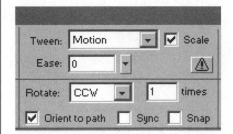

Fig. 10-24. Properties panel with Orient to Path option selected.

b) Preview your movie by pressing the Enter/Return key. Notice that the path drawn for the motion guide layer is still visible. You will learn to hide this later.

c) Adjust the shape of your motion guide until you get your UFO path exactly as you want it.

10. Let's finish up with some special effects!

a) Select frame 25 in the *Ship* layer, and insert a keyframe by using the keyboard shortcut F6.

b) Create another keyframe in frame 35 of the *Ship* layer.

c) Select the *UFO* instance on stage in frame 35 and you will see that the Properties panel changes to reflect the properties of the graphic instance on stage. Now select Alpha from the Color field pull-down in the Properties panel. Use the Alpha slider to set the percentage to 0. This will make the instance of the *UFO* symbol completely transparent.

d) Play through your timeline and notice how the UFO disappears in frame 35.

e) To view the movie as your users would see it (with the guide path invisible), select the menu option Control | Test Movie.

f) A new window will open with the looping animation. Close the window at any time to go back to the Flash movie.

11. Select the menu option File | Save.

Practice Exercise 10-2: Shape Tweens

Description

In this exercise you will learn to morph (transform) one shape into another using a shape tween. This procedure is very similar to adding a motion tween. However, instead of dealing with paths for an object to follow from point A to point B, shape tweens gradually change the physical shape of an object into another shape. You will also notice some special color effects that can be used with shape tweens. In this exercise you will:

·T/P·

When you test a movie, Flash creates a sample .SWF file in the same folder your .FLA movie is located. This is the same type of file you will export later for use in your web page.

·T/P·

If you want to get rid of the motion guide path without testing the movie, just hide the motion guide layer in the timeline! Remember, just click on the dot in the column under the Eye icon.

- *Create two objects for morphing*
- *Break apart text*
- *Apply a shape tween*
- *Apply a distributive blend*

Take a Look

Before beginning the exercise, let's take a look at the exercise in its completed state so that you can clearly see what it is you are about to build.

1. Use the menu option File | Open and locate on the companion CD-ROM the folder named *Chapter10*. Locate the file named *shape.fla*. Double click on *shape.fla* to open the file.

2. The file *shape.fla* should now appear in your copy of Flash. Press the Enter/Return key to see a preview of the file. Note the following properties of this completed exercise.

 • *Motion and color transitions can be applied in a shape tween.*

 • *You cannot apply a shape tween to symbols or grouped objects.*

Storyboard: On Screen

Figure 10-25 shows you what the stage in frame 1 will look like when you finish this exercise.

Fig. 10-25. The completed stage in frame 1.

Storyboard: Behind the Scenes

Figure 10-26 shows you what the stage (frame 1) and timeline will look like when you finish this exercise.

Fig. 10-26. The completed stage (frame 1) and timeline.

Step-by-Step Instructions

1. First, let's open a file for our shape tween.
 a) Select the menu option File | Open and locate the *Chapter10* folder on the companion CD-ROM.
 b) Select the *star.fla* file and double click to open this file in Flash.

2. Now we will insert the first shape to use in the shape transition.
 a) Open the Library panel by using the keyboard shortcut Ctrl + L.
 b) Drag the *Star* symbol from the library to the upper left-hand corner of the stage. See figure 10-27.

Fig. 10-27. Star symbol in the library.

3. Now let's add the second shape for the shape transition.
 a) Highlight frames 2 through 20 and select Insert | Frame.

Go Solo

Shortcut

The Insert | Frame shortcut is F5 for Mac and PC.

b) In frame 20, select Insert | Keyframe to add a keyframe to the last frame of the movie.
c) Delete the star from frame 20.
d) Select the Oval tool in the toolbox.
e) In the Color section of the toolbox, change the Stroke option to No Stroke, and the Fill option to a medium blue. Draw an oval on the bottom right-hand side of the stage.
f) Use the Arrow tool to change the curves in the oval shape to an organic shape similar to that shown in figure 10-28.

Fig. 10-28. Organic shape created from an oval.

4. Now let's apply the shape tween.
 a) Select frame 1 and take a look at the Properties panel.
 b) From the Tween selector pull-down menu, select Shape.
 c) From the Blend selector pull-down menu, select Distributive. See figure 10-29.

Fig. 10-29. Shape tween options in the Properties panel.

d) Press the Enter/Return key to preview your Shape tween. Why does it not work? Recall that to apply a Shape tween the objects cannot be grouped and cannot be symbols. The star in frame 1 is a symbol from our library. Let's fix it.
e) Select the *Star* instance in frame 1. Use the menu option Modify | Break Apart to detach the instance from the library.
f) Now press Enter | Return to preview your Shape tween. Problem solved!

5. Select the menu option File | Save As to save a copy of the file in the *SaveWork* folder on your computer and use the same file name.

Masking

Masking is a technique often used by Flash animators in conjunction with other tweened effects. A mask layer can be applied to another layer in the timeline in order to hide any portions of that layer not included in the mask. Sound complicated? Actually, it is quite a simple effect to create, as you will see in the next practice exercise.

A mask is first created by drawing an object on the stage, and then converting the layer into a mask layer. You can have multiple layers underneath the mask layer attached to it. Once the mask is created, the mask you drew on this layer is now actually invisible to those who view your published movie. The mask only reveals objects on these attached layers that are inside the mask object's borders.

Figures 10-30 and 10-31 illustrate how a layer mask works by showing you two layers before a mask is applied, and the same two layers after a mask is applied. In these figures, the circle layer becomes the invisible mask layer and blocks out anything outside of the circle shape on the square layer underneath. Tweens can also be used on a masked layer to animate the mask and create special effects. Very often, the mask layer is animated so that effects such as "wipes" from side to side can be created.

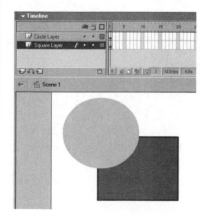

Fig. 10-30. Objects on two layers before a mask layer is created.

Fig. 10-31. Circle layer becomes the mask layer.

Practice Exercise 10-3: Layer Masks

Description

In this exercise you will create a layer mask in order to reveal only a portion of a layer. After you learn to set up a layer mask, you will then apply a motion tween to create a special wipe effect. In this exercise you will:

• *Learn how to set up an object to be masked*

• *Create a layer mask*

• *Animate the mask object*

Take a Look

CD-ROM

Before beginning the exercise, let's take a look at the exercise in its completed state so that you can clearly see what it is you are about to build.

1. Use the menu option File | Open and locate on the companion CD-ROM the folder named *Chapter10*. Locate the file named *mask.fla*. Double click on *mask.fla* to open the file.

2. The file *mask.fla* should now appear in your copy of Flash. Play through the movie by pressing the Enter/Return key. Notice how the *dotComSat* logo appears to be erased by the satellite flying over it. Note the following properties of this completed exercise.

 • *Masks are visible on the stage.*

 • *Masks are invisible when the movie is tested, or when the Show Masking feature is turned on.*

 • *Motion tweens can be applied to masks.*

 • *Masks are only applied to layers directly attached to a mask.*

Storyboard: On Screen

Figure 10-32 shows you what the finished exercise will look like on stage.

Fig. 10-32. The completed stage.

Storyboard: Behind the Scenes

Figure 10-33 shows your timeline and stage once the exercise is finished.

Fig. 10-33. The completed timeline and stage.

Step-by-Step Instructions

Go Solo

1. Let's open a file and get to work.
 a) Select the menu option File | Open. Use the browse function to locate the *Chapter10* folder. Locate and open the file *mask_exercise.fla*.
 b) Press the Enter/Shift key to play through the movie's timeline. Notice that in this file the satellite does not appear to erase the *dotComSat* logo. We are going to create that effect.

2. First, we will create our mask.
 a) Select the *Logo* layer in your timeline.
 b) Use the Insert Layer icon to create a new layer above the *Logo* layer.
 c) Rename this layer *Logo Mask*. Although this is just an ordinary layer right now, we will need to add an object to this layer that will eventually become the mask that creates the erasing effect when animated.
 d) Open the library (Ctrl + L; Mac: Cmd + L).
 e) Inside the library you have two folders, *Graphics* and *Movie Clips*. Double click on the *Graphics* folder to expand it (as shown in figure 10-34) and view its content.

Fig. 10-34. Library with the **Graphics** *folder expanded.*

f) Make sure the *Logo Mask* layer is selected, and drag the *G Mask* symbol out of the library and onto the stage. This inserts the *G Mask* symbol in frame 1 of the timeline.

g) Use the Info panel to position it at X 67.5 and Y 134.4. The *G Mask* symbol appears to cover the logo on the stage.

3. Now let's create our mask layer.

a) With the *Logo Mask* layer selected, right click (Mac: Ctrl + click) on the layer name (make sure you click on the layer name, not frames in the layer). A pop-up menu appears, as shown in figure 10-35.

Fig. 10-35. Layer pop-up menu.

b) Select Mask from the menu.

c) You should notice a big change on your stage and in your Layers panel. In the Layers panel, the *Logo* mask and *Logo* layer now have a blue icon next to them and are locked, as shown in figure 10-36.

Notice that the *Logo Mask* layer and the *Logo* layer are now divided with a dashed line as if to suggest they are connected. The *Logo* layer appears to be indented under the *Logo Mask*.

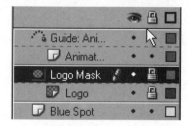

Fig. 10-36. Layer panel with a new mask layer.

d) On the stage, the *G Mask* symbol has disappeared. Do not worry, it is still there. What you are seeing is what your viewers would see – a preview of the masking effect.

e) Press Enter | Shift to play through the timeline. Not very exciting, right? Remember, a mask reveals everything inside the borders of its shape. It also only masks layers that are indented under it and that have the blue mask icon. Therefore, because our mask covers the *dotComSat* logo, and that is all that is on the *Logo* layer, it is working just as it should.

4. Now for some tweening to make this mask effect really interesting.

a) For the finished movie, the satellite will move across the *dotComSat* logo and make it appear to erase from left to right. Because you know that a mask only reveals what is underneath the outline of the mask shape, you can apply a simple Motion tween and move the mask off the screen.

b) Take the playhead and move it to frame 30. In the *Animated Sat* layer, notice that there is a Motion tween between frames 30 and 40.

c) Press Enter/Return to move through the last 10 frames of the movie. It is in these frames that the satellite moves over the logo.

d) Unlock the *Logo Mask* layer and the *Logo* layer. Now you can see the green mask object on the *Logo Mask* layer.

e) Select frame 30 in the *Logo Mask* layer and insert a keyframe (F6). Select frame 40 in the *Logo Mask* layer and insert a keyframe (F6).

f) In frame 40 of the *Logo Mask* layer, hold down the Shift key and move the *G Mask* symbol off the stage to the right until it no longer covers the *dotComSat* logo, as shown in figure 10-37. Be sure to hold down the Shift key so that you can move the *G Mask* symbol in a straight line.

Fig. 10-37. The **G Mask** *symbol moved to uncover the logo.*

g) Right click (Mac: Ctrl + Click) anywhere between frames 30 and 40, and select Create Motion Tween from the pop-up window. Press Enter/Return to play through the timeline.

h) Hey! Why can we not see the masking effect? This is because when you unlocked the *Logo Mask* layer and the *Logo* layer you turned off the Show Masking command. Let's turn it back on.

i) Right click (Mac: Ctrl + Click) on the *Logo Mask* layer name (not frames in the layer). Select Show Masking from the pop-up window.

j) Now try playing through the timeline. As the timeline hits frame 30, the *dotComSat* logo appears to be erased by the satellite because the Motion tween applied to the mask is coordinated with the Motion tween of the satellite. What a neat effect!

5. Select the menu option File | Save As. Use the browse function to locate and select the *SaveWork* Folder on your local computer. Type in the name *mask_exercise.fla*.

C H A P T E R

11

Application

Chapter:

Adding Animation

Introduction

What sets Flash apart from most web design tools is its sophisticated 2D animation tools. For example, the Motion tween and Shape tween features allow you to produce smoother and faster animation, without having to rely on frame-by-frame animation, wherein you must manipulate every frame in your movie. You provide the graphics and the ideas, and Flash does most of the animation work for you.

In this chapter we are still working on the interface elements. However, this time, you will be working on the main movie timeline to set your interface in motion. Try to imagine that you are a choreographer and are designing how the many objects on your stage will interact throughout this movie. Flash sites often have highly dynamic interfaces that draw in and capture the interest of web surfers. It is time to apply these techniques to your own interface and see how interesting you can make this site for your visitors.

Application Exercise: Adding Animation

Description

In this exercise you will go back and add some animated effects to your main movie interface by applying what you have learned about Motion and Shape tweens. You will also add to the movie timeline some of the symbols you created earlier.

Take a Look

CD-ROM

Before beginning the exercise, let's take a look at the exercise in its completed state so that you can clearly see what it is you are about to build.

1. Use the menu option File | Open and locate on the companion CD-ROM the folder named *Chapter11* and locate the file named *application_11.fla*. Double click on *application_11.fla* to open the file.
2. The file *application_11.fla* should now appear in your copy of Flash.
3. Preview the movie. Take a moment to look through the timeline.

Storyboard: On Screen

Figure 11-1 shows what will be seen on stage when the program file is complete.

Fig. 11-1. Completed stage.

Storyboard: Behind the Scenes

Figure 11-2 shows how the timeline will look when the exercise is completed.

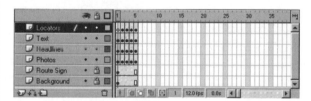

Fig. 11-2. Completed timeline.

Application Project Steps

Complete this exercise on your own, guided by following a high level listing of the tasks that need to be accomplished. These steps do not include the details of how to accomplish these tasks, as the "how to" has been covered in earlier chapters. You can always refer back to the completed example you viewed in the "Take a Look" section of this exercise.

NOTE: The following steps are intended as a guide, but this is your project, so feel free to make whatever variations you would like.

1. Open *application_09.fla*. You can either use the copy you created and saved in the *SaveWork* folder on your computer or the copy in the *Chapter09* folder on the companion CD-ROM.

2. Create a new movie clip symbol named *Locale MC*. In its Symbol Editing window, drag a copy of the *Yellow Glow* graphic onto the stage and posi-

tion it at X=0.0, Y=0.0. Add keyframes at frames 11 and 21 of the *Locale MC* timeline.

3. Rename the existing layer *Yellow Glow*.

4. Select the *Yellow Glow* instance in frame 11 and resize it to W=18.7, H=18.7.

5. Create a Motion tween between frames 1 and 11, and another between frames 11 and 21.

6. Create a new layer above the *Yellow Glow* layer and name it *Actions*.

7. Insert a keyframe at frame 21 of the *Actions* layer and assign the following ActionScript to it: *gotoAndPlay (1)*. (Okay, so we have not gotten into ActionScripts yet, but do not worry. There is not much to do here. You will get into the details of ActionScripts in Chapter 16. Here, it is so intertwined with the animation that some ActionScripting must be included.)

 a) Select the menu option Window | Actions.

 b) Click on the blue *Actions* symbol to expand the category, and then click on the *Movie Control* symbol to expand it as well.

 c) Double click on the *goto* action. The proper ActionScript is assigned automatically!

 d) Take a deep breath. That was not too difficult, was it?

8. Return to the main movie and move the *Locale MC* symbol to the *Movie Clips* folder of the library.

9. Create a new layer above *Text Layer* and rename it *Locators*. Add keyframes to frames 1 through 5 of this layer.

10. Drag an instance of the *Locale MC* symbol to frame 2 of the *Locators* layer and position it at X=218.7, Y=334.1.

11. Drag an instance of the *Locale MC* symbol to frame 3 of the *Locators* layer and position it at X=276.1, Y=353.4.

12. Drag an instance of the *Locale MC* symbol to frame 4 of the *Locators* layer and position it at X=396.1, Y=329.6.

13. Drag an instance of the *Locale MC* symbol to frame 5 of the *Locators* layer and position it at X=499.3, Y=329.5.

14. You do not see the immediate effect of dropping these movie clips into the main movie timeline. Later, once you have set up the navigational controls through the use of buttons and ActionScript, you will see these movie clips play whenever you go to the frame in which they are nested.

15. Save your file as *application_11.fla* in the *SaveWork* folder.

C H A P T E R

12

Working with

Movie Clips

Introduction

Earlier in the book you learned that symbols provide for very efficient reuse of objects and behaviors within Flash. You saw that there are three types of symbols (graphic, button, and movie clip), each with specific functions within Flash.

You have previously worked with graphic symbols. This chapter focuses on the movie clip and actions. The movie clip is like a mini-movie with its own independent timeline. Actions are part of a scripting language that allows you to make your movies interactive. By the end of this chapter you will be able to:

- *Describe the characteristics of movie clips*
- *Describe the difference between a movie clip and a graphic symbol*
- *Create movie clips*
- *Insert movie clips into the timeline*
- *Describe the basic purpose of actions*

Characteristics of Movie Clips

Let's review the characteristics of movie clips that you learned in Chapter 8.

- *Movie clips have their own timeline that is completely independent of the main movie timeline.*
- *Movie clips are mini-movies that can have any of the features of other movies created in Flash.*
- *ActionScripts can be used with instances of movie clips to create interactivity.*
- *Movie clips can be nested (placed) inside other symbols.*

Movie clips have their own timeline and stage, just like graphic symbols. However, an important difference is that a movie clip timeline is completely independent from the main movie in which it is inserted. Movie clips can contain sound, interactivity, and any other feature that can be included in the regular Flash timeline.

There are many common uses for movie clips. In Chapter 14, you will learn to embed a movie clip inside a button symbol in order to make the button appear animated – in response to a user's mouse actions. Later in this book you will also learn how to use movie clips in drag-and-drop interactions. This type of interaction requires that the user click the mouse on an object and then drag it across the screen, to a specified target area. This drag-and-drop interaction is frequently used in gaming, e-commerce, and educational applications.

You can also use movie clips to set up "empty" movies that perform based on the user's actions (you will see more about this in the next chapter). Movie

clips are not limited to animation. They can also be powerful authoring tools to help you more efficiently build and control your project applications.

Movie Clips and Graphic Symbols

Movie clips are inserted into a keyframe in your main movie timeline and will start to play once the movie reaches that particular frame. After a movie clip symbol has been encountered, it plays until it reaches the end of its own timeline, unless an action stops it from playing. In a previous chapter, you created a graphic symbol with a simple frame-by-frame animation. At first, it might be confusing to understand the difference between a graphic symbol and a movie clip symbol. After all, both have their own timelines in which you can add layers, use tweening, and apply many other animated effects.

On the surface, these symbols may seem similar; however, they perform very differently from each other. To see this difference, let's review the general characteristics of graphic symbols, which you learned in Chapter 8.

- *The graphic symbol timeline is dependent on the main movie timeline and, unlike movie clips, will not play beyond the end of the main movie.*
- *ActionScripts do not work within a graphic symbol timeline.*
- *Sounds on the graphic symbol timeline will not play within the main movie timeline.*

When a graphic symbol is inserted into the main movie timeline, it is completely dependent on the frames in the main timeline. A graphic symbol will not move from frame to frame within its own timeline unless there are corresponding frames in the main timeline. Graphic symbols are very useful for creating animations precisely orchestrated to correspond to the actions taking place in the main timeline, or for static images that are reused throughout a movie, such as a company logo. In contrast with this behavior, if a movie clip is inserted into a keyframe, it will play all the way through its own timeline regardless of the length of the main timeline it was inserted into.

Practice Exercise 12-1: Creating a Movie Clip

Description

In this exercise you will create a fairly complex animation. You will work with symbols that look like text, and will use Flash to make them move, to rescale them, to make them fade in and out, and to combine them to make a pretty dazzling animated sequence. Sound tough? Do not worry. Even the most complex-looking animation is easy when you realize that most often a complex animation is simply a large group of smaller, simpler steps. In this exercise you will:

> **CAUTION**
>
> Although you can insert sounds into a graphic symbol timeline and play them in Symbol Editing mode, do not be fooled! Once the graphic symbol is inserted in the main movie timeline, the sound will not play.

- *Create multiple timelines*
- *Animate symbols within their own timelines*
- *Apply tweening to symbols*
- *Adjust scale in an animation*
- *Adjust alpha in an animation*

Take a Look

CD-ROM

Before beginning the exercise, let's take a look at the exercise in its completed state so that you can clearly see what it is you are about to build.

1. Use the menu option File | Open and locate on the companion CD-ROM the folder named *Chapter 12*. Locate the file named *total_sound.fla*. Double click on this file to open it.

2. The file *total_sound.fla* should now appear in your copy of Flash.

3. Press the Enter/Return key to see the movie play back. Note the following properties of this completed exercise.

 - *Each animated element requires its own layer.*
 - *Keyframes are necessary in order to insert artwork or symbol instances within the timeline.*
 - *Multiple frames are necessary to create an animated effect.*
 - *Animation is not restricted to motion effects.*

Storyboard: On Screen

Figure 12-1 shows you what the stage will look like once you have finished this exercise.

Fig. 12-1. Completed exercise on the stage.

Storyboard: Behind the Scenes

Figure 12-2 shows you how the stage and timeline should look when you complete the exercise.

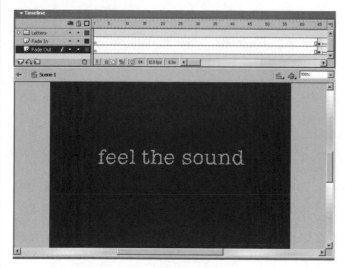

Fig. 12-2. Completed stage and timeline.

Step-by-Step Instructions

Go Solo

CD-ROM

1. Let's get started!
 a) Select the menu option File | Open. Locate and select the file named *sound_new.fla* from the *Chapter12* folder on the companion CD-ROM.
 b) Double click on layer 1 and rename it *F*.
 c) Select frame 1 of the *F* layer.
 d) Select Window | Library to open the Library panel. Drag an instance of the F symbol from the library and drop it anywhere onto the stage.
 e) If the Info panel is not visible, select the menu option Window | Info.
 f) Let's reposition the letter using the Info panel. Type in the following values X=109.7 and Y=169.3.
 g) Select frame 5 in the *F* layer. Press the F6 key to insert a keyframe.
 h) Select frame 10 in the *F* layer. Press the F6 key to insert a keyframe.
 i) Select frame 5 in the *F* layer. Select the instance of the F symbol on the stage.
 j) Using the Info panel, rescale the instance to W=24.4 and H=39.6.

·T*i*P·

We are providing all the X, Y, W, and H values in this exercise so you can focus on learning the techniques and not worry about the "art." In building your own projects, you will also need to figure out "artistically" what X and Y values you will want to use.

·T/P·

If you have your Properties panel open, you can also select Motion from the Tween selector pull-down menu.

·T/P·

Alpha Effect deals with the opacity of an object. The higher the alpha number, the more opaque (or the less transparent) an object. The lower the alpha number, the less opaque (or the more transparent) an object.

·T/P·

If the controller is not visible, use the following respective menu options to open it:

Window | Toolbars | Controller (PC)

Window | Controller (Mac)

Shortcut

To quickly insert a layer without using the Layer icon, right click (Mac: Ctrl + Click) on a selected layer and select Insert Layer. This will insert a layer above the selected layer in the timeline.

k) Using the Info panel, reposition the instance in frame 5 to X= 108.1 and Y=158.7.

l) Right click (Mac: Ctrl + click) anywhere on the *F* layer timeline between frames 2 and 4. Select Create Motion Tween from the pop-up menu.

m) Right click (Mac: Ctrl + click) anywhere on the *F* layer timeline between frames 6 and 9. Select Create Motion Tween from the pop-up menu.

2. Now let's add the alpha effect.

a) Select frame 1 of the *F* layer. Now select the instance of the *F* symbol that you now see on the stage.

b) Take a look at the Properties panel.

c) Click on the Color pull-down and set the Effect Type option to Alpha, and the value of the alpha effect to 0%.

d) Select frame 10 of the *F* layer. Now select the instance of the F symbol that you now see on the stage.

e) Find the Color pull-down in the Properties panel.

f) Click on the Color pull-down and set the Effect Type option to Alpha, and the value of the alpha effect to 75%.

g) Select frame 84 in the *F* layer. Press the F6 key to insert a keyframe.

h) Using the controller (Window | Toolbars | Controller), click on the Rewind button, and then click on the Play button to preview your movie up to this point. See figure 12-3.

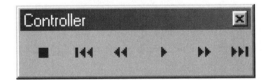

Fig. 12-3. The controller.

i) Save the file in the *SaveWork* folder on your own computer, naming it *sound_final.fla*.

3. Now to set up the rest of the layers.

a) Click on the Insert Layer icon 11 times (that is correct, 11!).

b) Drag the *F* layer to the top of the new layers. You can resize the timeline by clicking and dragging downward on the bottom border. See figure 12-4.

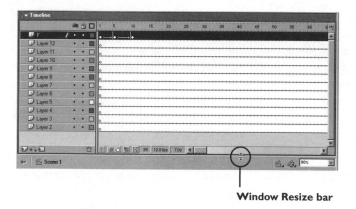

Window Resize bar

Fig. 12-4. Resizing the the Layers panel within the timeline.

c) Starting with the layer directly below the *F* Layer, rename the layers *E1, E2, L, T, H, E3, S, O, U, N, D*.

d) It is generally best to place each animated object on its own layer. Trying to get more than one instance to animate within a single layer frequently produces unpredictable and undesirable results. In addition, you cannot animate more than one instance within the same frames on a single layer.

e) Once you finish creating all new layers, select the topmost layer and use the Insert Folder icon to create a folder.

f) Double click on the folder name and rename it *Letters*.

g) Hold down the Shift key and select all layers with letter names.

h) Once selected, click and drag the layers on top of the *Letters* folder. Once you release the mouse, all layers will be deposited in the folder. The folder can now be expanded and collapsed in the timeline.

4. Now it is time to "spell it out."

a) Select frame 5 of the *E1* layer.

b) Press the F7 key to insert a blank keyframe.

c) Drag an instance of the E symbol from the library and drop it on the stage.

d) Using the Info panel, reposition the instance of the E symbol to X=127.7 and Y=177.9.

e) Select frame 10 in the *E1* layer. Press the F6 key to insert a keyframe.

f) Select frame 15 in the *E1* layer. Press the F6 key to insert a keyframe.

g) Select frame 10 in the *E1* layer of the timeline. Select the instance of the E symbol on the stage.

h) Using the Info panel, rescale the instance to W=27.3 and H=29.9.

·T/P·

You can also change *w*, *h*, and *x, y* coordinates in the Properties panel.

i) Using the Info panel, reposition the instance to X= 125.8 and Y=167.9.

j) Right click (Mac: Ctrl + click) anywhere on the *E1* layer timeline between frames 5 and 9. Select Create Motion Tween from the pop-up menu.

k) Right click (Mac: Ctrl + click) anywhere on the *E1* layer timeline between frames 11 and 14. Select Create Motion Tween from the pop-up menu.

5. Now for the alpha effect.

a) Select frame 5 of the *E1* layer in the timeline. Select the instance of the E symbol that you can now see on the stage.

b) In the Properties panel, click on the Color pull-down and set the Effect Type option to Alpha, and the value of the alpha effect to 0%.

c) Select frame 15 of the *E1* layer in the timeline. Select the instance of the E symbol that you can now see on the stage.

d) In the Properties panel, click on the Color pull-down and set the Effect Type option to Alpha, and the value of the alpha effect to 75%.

6. Use the following guidelines to add animated keyframes to all of the remaining layers (do not forget to tween them!).

a) In layer *E2*:

·T/P·

All the symbols you will need in step 6 can be found in the library. The Info panel and the Properties panel will be used throughout the following steps.

Add a keyframe to frame 10.

Position an instance of the E symbol at X=154.7, Y=177.9, and set the alpha value to 0%.

Insert keyframes in frames 15 and 20.

Change the alpha value in frame 20 to 75%.

Rescale the instance in frame 15 to W=27.3, H=29.9.

Reposition the instance in frame 15 to X=152.8, Y=167.9, and set the alpha value to 100%.

Create motion tweens between keyframes.

Shortcut

To insert a keyframe, you can also right click (Mac: Ctrl + Click) on the appropriate frame and select Insert Keyframe or Insert Blank Keyframe from the pop-up menu.

b) In layer *L*:

Add a keyframe to frame 15.

Position an instance of the L symbol at X=180.8, Y=168.9, and set the alpha value to 0%.

Insert keyframes in frames 20 and 25.

Change the alpha value in frame 25 to 75%.

Rescale the instance in frame 20 to W=17.7, H=39.4.

Reposition the instance in frame 20 to X=179.7, Y=158.4, and set the alpha value to 100%.

Create motion tweens between keyframes.

c) In layer *T*:

Add a keyframe to frame 20.

Position an instance of the *T* symbol at X=209.4, Y=170.4, and set the alpha value to 0%.

Insert keyframes in frames 25 and 30.

Change the alpha value in frame 30 to 75%.

Rescale the instance in frame 25 to W=20.9, H=38.3.

Reposition the instance in frame 25 to X=208.1, Y=159.9, and set the alpha value to 100%.

Create motion tweens between keyframes.

d) In layer *H*:

Add a keyframe to frame 25.

Position an instance of the *H* symbol at X=228.6, Y=168.9, and set the alpha value to 0%.

Insert keyframes in frames 30 and 35.

Change the alpha value in frame 35 to 75%.

Rescale the instance in frame 30 to W=35.5, H=40.1.

Reposition the instance in frame 30 to X=226.3, Y=158.3, and set the alpha value to 100%.

Create motion tweens between keyframes.

Hang in there; you are doing great!

e) In layer *E3*:

Add a keyframe to frame 30.

Position an instance of the *E* symbol at X=259.6, Y=177.9, and set the alpha value to 0%.

Insert keyframes in frames 35 and 40.

Change the alpha value in frame 40 to 75%.

Rescale the instance in frame 35 to W=27.3, H=29.9.

Reposition the instance in frame 35 to X=257.8, Y=167.9, and set the alpha value to 100%.

Create motion tweens between keyframes.

f) In layer *S*:

Add a keyframe to frame 35.

Position an instance of the S symbol at X=301.5, Y=176.5, and set the alpha value to 0%.

Insert keyframes in frames 40 and 45.

Change the alpha value in frame 45 to 75%.

Rescale the instance in frame 40 to W=24.4, H=32.0.

Reposition the instance in frame 40 to X=299.9, Y=166.4, and set the alpha value to 100%.

Create motion tweens between keyframes.

g) In layer O:

Add a keyframe to frame 40.

Position an instance of the O symbol at X=326.7, Y=177.1, and set the alpha value to 0%.

Insert keyframes in frames 45 and 50.

Change the alpha value in frame 50 to 75%.

Rescale the instance in frame 45 to W=26.3, H=29.9.

Reposition the instance in frame 45 to X=325.0, Y=167.2, and set the alpha value to 100%.

Create motion tweens between keyframes.

h) In layer U:

Add a keyframe to frame 45.

Position an instance of the U symbol at X=352.1, Y=177.8, and set the alpha value to 0%.

Insert keyframes in frames 50 and 55.

Change the alpha value in frame 55 to 75%.

Rescale the instance in frame 50 to W=35.3, H=30.1.

Reposition the instance in frame 50 to X=349.8, Y=167.9.

Set the alpha value to 100%.

Create motion tweens between keyframes.

i) In layer N:

Add a keyframe to frame 50.

Position an instance of the N symbol at X=384.1, Y=177.4.

Set the alpha value to 0%.

Insert keyframes in frames 55 and 60.

Change the alpha value in frame 60 to 75%.

Rescale the instance in frame 55 to W=35.8, H=29.9.

Reposition the instance in frame 55 to X=381.8, Y=167.5, and set the alpha value to 100%.

Create motion tweens between keyframes.

j) In layer D:

Add a keyframe to frame 55.

Position an instance of the D symbol at X=417.5, Y=169.1, and set the alpha value to 0%.

Insert keyframes in frames 60 and 65.

Change the alpha value in frame 65 to 75%.

Rescale the instance in frame 60 to W=31.3, H=40.9.

Reposition the instance in frame 60 to X=415.4, Y=158.4.

Set the alpha value to 100%.

Create motion tweens between keyframes..

Your timeline should now look like that shown in figure 12-5. Use the controller to rewind the movie, and then press the Play button to preview your movie up to this point. Looking good! You are well on your way to becoming the envy of your peers! Let's add just a couple of other fading animations to make the movie a little more dynamic.

Fig. 12-5. The timeline in progress.

7. Now to add finesse.

a) Collapse the Letters folder by clicking on the triangle next to the yellow folder icon. Lock the folder by clicking on the dot in the padlock column next the the layer name. Create two new layers and drag them to the bottom of the existing layers. (Do not place them within the Letters folder.) Name them (from top to bottom) Fade In and Fade Out.

b) Select frame 65 in the Fade In layer and press the F6 key to insert a keyframe.

 c) Drag an instance of the Sound MC symbol onto the stage to insert it into frame 65 of the *Fade In* layer. Rescale the instance to W=2082.3 and H=221.9. Position it at X=9.5 and Y=9.7, and then change the alpha value to 0%.

 d) Insert a keyframe (F6) at frame 83 of the *Fade In* layer. Rescale the instance to W=335.0 and H=35.7. Position it at X=109.7 and Y=168.9, and then change the alpha value to 100%.

 e) Right click (Mac: Ctrl + click) anywhere between frames 66 and 82, and select Create Motion Tween.

 f) Select frame 65 of the *Fade Out* layer, and press the F6 key to insert a keyframe.

 g) Drag an instance of the Sound MC symbol onto the stage to place it into frame 65 of the *Fade Out* layer. Position it at X=109.7 and Y=168.9. Keep the alpha value at 100%.

 h) Insert a keyframe (F6) at frame 83 of the *Fade Out* layer. Rescale the instance to W=2082.3 and H=221.9. Position it at X=9.5 and Y=9.7, and then change the alpha value to 0%.

 i) Right click (Mac: Ctrl + click) anywhere between frames 66 and 82, and select Create Motion Tween.

It would be perfectly okay to leave our movie just as it is if this animated sequence were all we wanted to create. But what if there is more to our movie? Do we keep adding frames and layers to the existing timeline? We could do this, but a better approach is to convert the animation we just created into a movie clip symbol and then place the movie clip in the main movie timeline. Let's give it a try.

8. Let's finish this exercise.

 a) Click in frame 1 of the *Letters* folder. Press and the hold the Shift Key down and then click in the Fade Out layer in frame 84 to select all frames.

 b) Select Edit | Copy Frames.

 c) Select the menu option Insert | New Symbol.

 d) Name the new symbol *FinalSound MC*, make sure the symbol behavior is set to Movie Clip, and click on OK.

 e) Select frame 1 of layer 1 in the *FinalSound MC* timeline and select Edit | Paste Frames.

 f) Click on the Scene 1 tab to return to the main movie timeline.

 g) Click on the New Layer icon to add a new layer to your main movie and name the new layer Sound MC. Then drag an instance of the FinalSound MC movie clip symbol onto the stage in frame 1 of the new layer.

h) Use the Info panel to reposition it at X=109.7 and Y=168.9.

i) Now select and delete the Letters folder layer, the Fade In layer and the Fade Out layer using the Trash Can icon.

j) Select Control | Test Movie to preview the result.

9. Select File | Save.

Our new timeline looks much less formidable. That was some work, but well worth it! You have just completed the type of exercise that makes Flash such a valuable tool. Understanding how to structure animation gives you the skills you will need to improve your marketability and value as a designer. Outstanding!

Guided Tour 12A: Testing Movie Clips and Use of the Bandwidth Profiler

Testing and previewing may on the surface seem to be the same function within Flash, but they are actually quite different. When you preview a movie, you are previewing your timeline, while still within Authoring mode on the stage. You will generally press the Enter/Return key to step through your time-line. You can also use your controller to preview your movie on the stage. During a preview, motion guides, grids, guides, and anything in the work area will still be visible as the timeline plays. In general, previewing allows you to check your work but is not an exact representation of what the user will see.

On the other hand, testing your movie allows you to view your movie exactly as the user will see it, without any guides, grids, or anything outside the stage area visible. When you select the menu option Control | Test Movie (or use the keyboard shortcut Ctrl + Enter on the PC or Cmd + Return on the Mac) to test a movie, Flash generates a sample SWF file that will be stored in the same folder as your original FLA movie file. The new window that opens, plays back the movie and allows you to use tools such as the Bandwidth Profiler (which you are going to learn about now), and the Debug tool.

1. Let's test the movie you just completed in the previous exercise.

a) Select the menu option Control | Test Movie. The SWF file should now be open and playing.

b) As the movie is playing, select the menu option View | Zoom In. This will, of course, zoom in closer to the image. Next, select View | Zoom Out to return to a 100% preview size.

c) As the movie continues to play, select the menu option View | Bandwidth Profiler. This very helpful panel displays your movie set-tings and playback settings, and even gives you a graphic representa-tion of the frame-by-frame dataload of the movie. It looks like no frame is larger than 400 bytes in size; not too bad! The lower the data

·T/P·

You cannot preview a movie clip on the stage. You must use the Test Movie option to preview movie clips. Because movie clips have a time-line that is independent from the main movie timeline, they do not respond to normal com-mands (such as using the Enter/Return key or the controller). Select the menu option Control | Test Movie. Or, you can use the keyboard short-cut Ctrl + Enter (Mac: Cmd + Return) to test your movie as your users would see it.

load, the faster the download and playback. Select View | Bandwidth Profiler again to remove the check mark in the menu and the profiler from the screen.

d) As the movie continues to play, select the menu option View | Quality | Low. This will preview the movie with no antialiasing (bitmap smoothing). This maximizes playback speed. Medium will antialias everything except text (actual text, not shapes that look like letters, as we have been using), and High will antialias everything (and can potentially slow down playback as the computer tries to keep up with the movie speed). Try them out!

2. Note that the nested movie clip plays in a continuous looping manner. In Chapter 15 we will explore the Actions panel to see some of the playback commands we could potentially add to our movie clip or main movie.

Guided Tour 12B: The Actions Panel

The Actions panel allows you to quickly add ActionScripts to objects and frames in your movies. As you will discover throughout the rest of this book, ActionScripts are the key to adding interactivity to your Flash applications. In this regard, the Actions panel is like "mission control." In chapters that follow, you will explore the details of the Actions panel, but for now, let's explore the basic structure and features in this very important panel.

1. First, let's open the Actions panel by selecting the menu option Window | Actions. Usually the Actions panel is collapsed directly above the Properties panel when the default panel layout is used. To revert to the default panel layout, use the menu option Window | Panels Sets | Default Layout. Expand the Actions panel by clicking on the white triangle next to Actions.

2. The Actions panel should now be visible on your screen and look similar to that shown in figure 12-6.

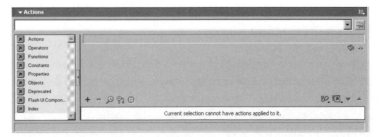

Fig. 12-6. Actions panel.

3. Let's take a look at the basic structure of the Actions panel. On the left side of the panel are various folders that can be expanded or collapsed. Click on the Actions folder to expand it. Inside this folder, you will find subfolders that can also be expanded to reveal various types of actions. We will use some of the actions inside these subfolders in later practice exercises. See figure 12-7.

Expanded Actions folder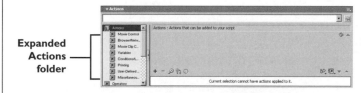

Fig. 12-7. Actions folder expanded to show subfolders.

4. You can also select actions by clicking on the Add New Item icon (plus sign) on the bottom of the panel and making a choice from the resulting pop-up menus, shown in figure 12-8. The Delete Selected Action icon (minus sign) lets you delete actions you have already added to your movie.

Add New Item icon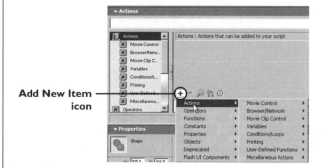

Fig. 12-8. The Add New Item icon and resulting menus.

5. Select frame 1 in the movie timeline. Open the subfolder titled *Movie Control*. Double click on the first action in the list, *Go To*. A line of code appears in the bottom portion of the Actions panel. The Code window actually displays the ActionScript code (the programming language in Flash) that makes interactivity possible. For those of you who are not skilled in programming, do not worry. The folders on the left side of this window contain many actions that allow you to easily double click and add prepared lines of code to your movie.

6. The Actions panel contains two editing modes: Normal and Expert. If you happen to have more advanced programming skills, you can switch to

Expert mode by using the Actions panel menu, as illustrated in figure 12-9. Expert mode allows you to type directly into the Code window, just like a text editor. This gives you ultimate control over your ActionScript – if you need or want it.

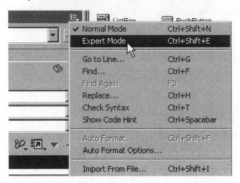

Fig. 12-9. Normal and Expert mode menu options.

Those are the basics of the Actions panel! In the next chapter, you will put what you have learned to good use.

CHAPTER

13

Adding

Interactivity

with Actions

Introduction

The drawing and animation capabilities of Flash make it stand out among web development software. But you might ask how easily does Flash handle interactivity? In the last chapter, you were given a sneak preview of how easy it is to add interactivity, when you were introduced to the Actions panel. In this chapter, we will more fully focus on interactivity as you learn how to use some basic actions in Flash to control how the elements of your movie play. More importantly, you will help the user interact with your application. By the end of this chapter you will be able to:

- *Describe what an ActionScript is and what it does*
- *Apply basic actions from the Actions panel*
- *Describe the differences among frame, button, and movie clip actions*
- *Add labels and comments to your timeline*
- *Add frame actions to your movie*

ActionScripts and Actions

The Flash timeline consists of a series of frames that play like a cinema film — one frame after another. At this point, despite all of the interesting effects you have created with tweening, motion guides, and symbols, all of these previous exercises played in a linear fashion and did not allow the user to interact with the elements on the screen.

The element that has been missing is making the user part of the experience; that is, engaging the user, and allowing the user to interact with the program and decide what to see and do next. In other words, what has been missing in our Flash programs to this point is interactivity and user control.

·T*i*P·

For you nonprogrammers out there, do not panic when you start reading the next few paragraphs. Flash has an easy-to-use solution, discussed in material to follow.

To provide interactivity, user control, and other more advanced functions, most multimedia and web authoring tools make use of various types of programming or scripting languages. These programming/scripting languages provide the capability to write very detailed and exact instructions about actions that need to performed. An authoring tool that includes a "built-in" programming/scripting language will generally be able to provide a programmer with the ability to write lines of instruction (code) to perform just about any function needed within the multimedia/web program.

In Flash, this programming/scripting language is called ActionScript. Flash's ActionScript is the foundation upon which interactivity, user control, and many other functions and capabilities within Flash are made possible. ActionScript is an object-oriented programming language with syntax similar to JavaScript. Those who know JavaScript will find it easier to learn ActionScript.

On one hand, a powerful programming/scripting language offers a powerful authoring tool for those programmers who want to push authoring to its limits to provide increased functionality. On the other hand, a large segment of typical end users of authoring tools do not know, and do not want to know, very much about programming, although they do want increased functionality. In response to trying to be the product that appeals to the broadest potential market, many authoring tools (including Authorware, Director, Dreamweaver, and Flash) not only include the "raw" scripting capability but also "pre-built" functions that can often be used as is, or that can be easily modified for use.

In Flash, these prebuilt functions are called actions. Actions are prewritten chunks of ActionScript that perform specific functions. In previous versions of Flash, actions could be added to frames and objects to provide basic functions, such as Stop, Play, and Go To (among many others). These basic actions were easy to add and very useful. These and other actions provide the ability to add interactive elements and control the display and functioning of elements within a Flash movie. Actions have been, and continue to be, the backbone of adding interactivity to your Flash movies.

The Actions Panel provides the ability to directly edit the ActionScript. This editing feature in the Actions panel makes it easier for programmers to access the ActionScript code and make changes to the functionality of basic and custom-built actions. With some programming knowledge and a familiarity with the JavaScript syntax, you can create a wide range of custom-built actions for your applications.

If you are not a programmer, and do not want to be, do not worry; Flash MX's Action panel has a normal mode for "programming" with a few mouse clicks, an expert mode that allows you to type scripts directly into the panel, and a built-in reference to help you better understand ActionScript. Our intent in this chapter is not to jump right into ActionScript but to start you with exercises to help you learn to use basic actions. We will concentrate on the built-in actions but will also show you features in the Actions panel that can help you develop your own ActionScripts.

As you continue to use actions, you will become more familiar with the scripting language they are based on, and will soon be able to build on your basic knowledge. We will start by working with some of the most frequently used actions, and in later chapters continue with more advanced work with actions. These latter expand the types of interactivity that can be added to Flash applications. We will concentrate on the basics so that you can build on your skills from a strong foundation.

·T*i*P·

JavaScript was created by Sun Microsystems as an easy-to-use offshoot of their programming language Java. Adding JavaScript code to regular HTML pages provides the capability to add animation and interactivity to web pages. These pages can be displayed through Java-enabled browsers. Some of the most frequent uses of JavaScript seen on web pages include mouse-over (rollover) behaviors such as the swapping of images, date and time displays, and simple go-to behaviors that automatically redirect users to other web pages. You will learn how to accomplish a similar (and easier) rollover effect with button symbols, in Chapter 14.

Shortcut

A quick way to open the Actions panel is to click on the Actions button in the Properties panel. Select a Frame or an object on the stage, and then click on the circular blue icon on the upper right-hand side of the Properties panel to open or expand the Actions panel.

·T/P·

Flash MX provides several default layouts that are customized for different possibilities of how you might use Flash, and your monitor resolution. These layouts contain panel arrangements that correspond with the panels most frequently used by designers (animators and artists) and developers (programmers). Use the menu option Window | Panel Sets to look at these choices. Note that when any designer layout is active, the Actions panel is not even on the screen! Use the default layout for now, until you learn more about the basics.

Guided Tour 13A: Movie Control Actions

Let's start slowly by first taking a quick look at some of the frequently used movie control actions included in Flash MX. We can do this easily by looking at the Actions panel.

1. Select File | New. Now open the Actions panel by selecting the menu option Window | Actions, or by expanding the Actions panel if it is already open.

2. The Actions panel is now open. See figure 13-1. As you have seen previously, this panel is like a library, with a list that appears in the left-hand window of this panel. Use the scroll bar to look through the list of folders: *Actions, Operators, Functions, Constants, Properties, Objects, Deprecated Actions, Flash UI Components,* and *Index.*

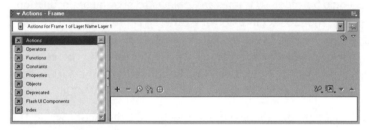

Fig. 13-1. Actions panel.

3. Click on the folder called *Actions* to expand this folder and to reveal the subfolders with categories of actions, as shown in figure 13-2.

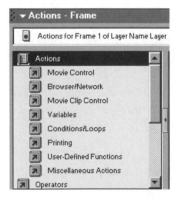

Fig. 13-2. Expanded actions subfolders.

4. Click on the *Movie Control* subfolder in the actions in this list, shown in figure 13-3. The actions are as follows:

- *Go To:* This action instructs the movie to jump to a specific frame or scene on the timeline. You can also specify whether the timeline will play or stop after the Go To action.

- *On:* Allows you to assign a specific mouse event to trigger an action.

- *Play:* Instructs a movie to begin playing.

- *Stop:* Instructs a movie to stop playing.

- *Stop All Sounds:* Halts any sounds currently playing.

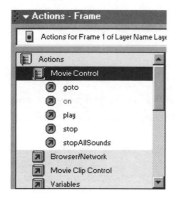

Fig. 13-3. Movie control actions.

5. Click on the *Movie Control* subfolder in the Actions list to collapse this list. Click on the *Browser/Network* subfolder, shown in figure 13-4. The actions are as follows:

- *FS Command:* This Action provides instructions to the Flash Player or other projector playing the movie.

- *Get URL:* Instructs Flash to jump to a web page outside your Flash movie.

- *Load Movie:* Opens other SWF files in place of the current movie, or within the current movie.

- *Load Variables:* Allows you to grab data from a file outside the Flash movie and update values assigned to variable elements in a new movie. These external files are generally things such as a text file, or files generated by ASP, PHP, and similar sources.

- *Unload Movie:* Unloads a movie in your browser, player, or projector.

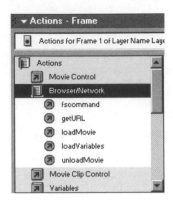

Fig. 13-4. Browser/Network actions.

6. The Actions panel is the "mission control" of authoring and programming in Flash. Within it lies everything you need to make your movies behave the way you want them to.

Frame Actions and Object Actions

Before we continue to work with actions, it is important to understand the distinction between frame actions and object actions. Object actions are actions tied to a specific element, such as a button symbol or a movie clip. In the next chapter, you will learn how to add actions to button symbols when creating a user interface. As you will see, this will be an example of an object action that responds to user events (i.e., mouse events).

Frame actions, on the other hand, are tied to particular frames in your time-line. Actions within frames give instructions that might direct the playhead to advance to a different frame or to stop altogether – without user input. You will use frame actions in the following exercises to control how the timeline plays, whether that means it plays linearly, stops at certain points, or jumps to specific frames based on the actions in individual frames. In the example illus-trated in figure 13-5, we have selected frame 1 in a layer in the timeline. Notice that the text at the top of the Actions panel has changed to the text *Actions for Frame 1 of Layer Name Background*. This phrase indicates that any actions inserted will be applied to a particular frame in a particular layer.

Fig. 13-5. Frame actions.

Frame Labels

When working with actions, you will probably want to use frame labels, and refer to these labels rather than to frame numbers, for two important reasons: (1) to provide a brief description of what the action is doing, and (2) as a specific point of reference for use with actions that won't change if you add or subtract frames.

In the next chapter you will learn to add frame labels when setting up navigational buttons in a practice exercise. Flash recognizes these labels on the timeline so that you can use actions to send the playhead to a specific label – based on a button click, or based on when the timeline reaches the frame location of the insertion of the action.

Flash will even recognize labels found in other scenes of the movie, or in other movies! This means that your user can click on a button to load a new movie and have that movie start at the frame label you specify.

The benefit of using labels instead of frame numbers is that if you inadvertently alter the number of frames in your timeline or move the label, your action does not have to be edited. Flash looks for the label, not the frame number. To add a label to a frame, select the frame you want to label and take a look at the Properties panel. As you know, this panel is context sensitive, and therefore the properties are now frame properties. Type your frame label in the Frame Label field, as illustrated in figure 13-6.

·T/P·

In creating a Flash application, it is quite likely you will add and/or delete frames continually throughout the development process. Using frame labels, independent of frame numbers, will help reduce the amount of recoding you may otherwise have to do because of the adding/deleting of frames.

Frame Label field

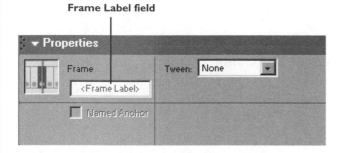

Fig. 13-6. Adding a frame label in the Frame Label field

Once you add a frame label, a red flag will display in that frame, along with the frame label on your timeline. See figure 13-7.

Red flag **Frame label**

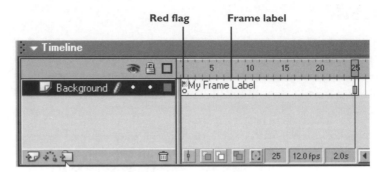

Fig. 13-7. Red flag and frame label.

The frame label will display as long as there is no keyframe nearby that may concatenate the label. See figure 13-8.

Concatenated frame label

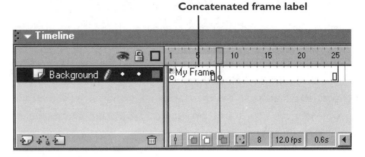

Fig. 13-8. Frame label concatenated.

Practice Exercise 13-1: Using Play, Stop, and Go To

Description

In this exercise you will learn how to use some of the most basic ActionScripts to control and add interactivity to your movie. In this exercise you will:

- *Create an animation that begins playing based on a mouse event*
- *Insert the basic actions for Go, Stop, On MouseEvent, and Go To*

Take a Look

CD-ROM

Before beginning the exercise, let's take a look at the exercise in its completed state so that you can clearly see what it is you are about to build.

1. Use the menu option File | Open and locate on the companion CD-ROM the folder named *Chapter13*. Locate the file named *actions.fla*. Double click on this file to open it.

2. The file *actions.fla* should now appear in your copy of Flash. Save the file under the same file name in your *SaveWork* folder.

3. Select the menu option Control | Test Movie to preview the movie.

4. Move your mouse over the word *GO* to start the animation loop.

5. After 5 seconds or so, click the mouse on *GO* and watch as the pattern changes. Note the following properties of this completed exercise.

 • *The animation begins to play as soon as the mouse enters the target area (GO) and continues to play as long as the mouse remains in the target area.*

 • *The animation stops playing as soon as the mouse leaves the target area.*

 • *A second animation begins (after a mouse is clicked within the target area), and plays through only once.*

Storyboard: On Screen

Figure 13-9 shows how the stage will look once you have completed this exercise.

Fig. 13-9. Completed stage.

Storyboard: Behind the Scenes

Figure 13-10 shows you how the timeline will look when the exercise is completed.

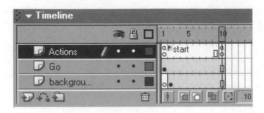

Fig. 13-10. Completed timeline.

Step-by-Step Instructions

1. Let's get started.
 a) Open the file named *basic_actions.fla* in the *Chapter13* folder on the companion CD-ROM.
 b) Save a copy of the file in your *SaveWork* folder on your computer.
 c) Take a look at the timeline. There are two layers. Scroll through the timeline by dragging the playhead.
 d) Before we begin, add a new layer to the timeline. Select the *Go* layer and then click on the Insert Layer icon to add a new layer.
 e) Rename the new layer *Actions*.

2. Now let's add a stop action to pause the movie.
 a) Select frame 1 in the *Go* layer.
 b) Open the Movie library by pressing Ctrl + L (Mac: Cmd + L).
 c) Double click on the Go button in the Library list to enter Symbol Editing mode. Take a look at the button's timeline. There are three layers in this timeline. The *audio* layer contains a sound clip in the Down frame, and the *star* layer contains a nested movie clip in the Over frame. This is the button in frame 1 of the *Go* layer.
 d) Select the Scene 1 tab to leave Symbol Editing mode.
 e) In the *Actions* layer, select frame 1. In the Properties panel, click the cursor in the Frame label field and label the frame by typing in *stop*. A red flag and the label name should now be inserted in the timeline.
 f) Open the Actions panel by selecting Window | Actions or pressing the F9 key.
 g) Click on the *Actions* folder to expand it, and then click on the *Movie Control* subfolder to expand it.
 h) Make sure that frame 1 is still selected in the *Actions* layer, and double click on the stop action in the list. The code added to the bottom right-hand side of the Actions panel should look as follows:

```
stop ();
```
 i) Save your file and the test your movie to make sure the movie stops in the first frame. Select Control | Test Movie.

3. Now let's make the movie play when the user clicks on a button.
 a) Select frame 1 in the *Go* layer. Now select the *Go* button instance on stage.
 b) Double click on the On action in the movie control actions list.
 c) Make sure the checkboxes in the Event options located on the right-hand side of the Actions panel have Release and Release Outside checked. The code added to the bottom of the panel should look as follows.

```
on (release, releaseOutside) {
}
```

 d) Now we will specify what happens when the user releases the mouse button. Double click on the Play action within the *Movie Control* sub-folder. This will cause the rest of the timeline to play when the user clicks on the Go button. Your code should now look as follows:

```
on (release, releaseOutside) {
 play ();
}
```

 e) Save your file and then test your movie to make sure the movie plays when the Go button is pressed and released. Select Control | Test Movie.

4. Finally, let's add the Go To action to send the movie to a specific frame.
 a) When the movie reaches the end of the timeline, we are going to have it return to the frame labeled *Stop*. To do this, select frame 10 (the last frame) in the *Actions* layer.
 b) Insert a keyframe (press F6) in frame 10.
 c) In the Actions panel, double click on the Go To action in the *Movie Control* subfolder list. The code should look as follows:

```
gotoAndPlay (1);
```

 d) In the middle of the Actions panel, use the pull-down menu in the *Type* field to change the selection to Frame Label. In the *Frame* field, use the pull-down menu to select Stop. The *Frame* field will show you a list of all the frame labels. Since we currently only have one frame label, *Stop*, that is the only one on the list. You are telling the movie to go to the frame labeled *Stop* when it reaches frame 10. When the movie is sent back to the frame labeled *Stop* (frame 1), the movie will stop playing because you placed a stop action in that frame several steps ago.
 e) Save your file and test your movie to see how it works. Select Control | Test Movie. You will learn much more about actions in later chapters. This is just to get you started.

C H A P T E R

14

Using Button

Symbols

Introduction

Button symbols are an easy way to add interactivity and navigational control to your Flash movies. This type of symbol is specifically designed to correspond with the user's mouse actions and will make your life much easier by removing a lot of the programming work from creating buttons that appear to "go up and down." Button symbols make it very easy to create various "button states," including the normal button position (Up), the condition when a user's mouse moves over the button (RollOver), and the condition when the user clicks on a button (Down). Without Flash, these "button states" are frequently programmed with JavaScript on a traditional web page.

To add even more interesting visual effects, you can place a movie clip inside a button to create an eye-catching animated button. Later in this chapter, you will give this a try. By the end of this chapter you will be able to:

• *Describe the Button timeline*

• *Describe the characteristics of button symbols*

• *Enable button instances on the stage*

• *Nest movie clips in a button symbol*

• *Test animated buttons*

• *Describe the basic purpose of the Actions panel*

• *Add an action to a button instance*

The Characteristics of Button Symbols

Button symbols are very different from both graphic and movie clip symbols. As you learned in previous chapters, both graphic and movie clip symbols have their own timelines and stages, where you can add animation. Movie clips act as mini-movies that can play independently of your main movie timeline, whereas graphic symbols are tied more closely to the main movie timeline. Let's review what you learned in Chapter 8 about the general characteristics of button symbols.

• *ActionScripts can be attached to button instances to add interactivity.*

• *Sounds can be added to various button states.*

• *Movie clips can be placed within button frames to create animated effects for a button.*

• *The Hit frame is an invisible frame that defines the button's "hot area" (i.e., the area that responds to mouse activity).*

Button symbols have a very unique timeline containing only four frames. These frames correspond to the "mouse states" Up, Over, Down, and Hit. Each frame is named according to its state. These button states combine to provide a

visual response to a user's mouse actions. It is important to understand that, unlike graphic and movie clip symbols, a button symbol cannot actually be animated. Button symbols "jump" to one of four frames, depending on the mouse action that occurs. Therefore, the Button Symbol timeline is tied directly to the user's activity. The four frame types are as follows.

- *Up frame: Contains the image of the button as it appears in the normal "up" position with no user interaction. This would be considered the "default" state of the button and what the user sees when the movie loads initially.*

- *Over frame: Contains the "rollover" image that appears when a user places the mouse cursor over the button instance's hit area and the button appears to be depressed.*

- *Down frame: Contains the "down" image that appears for a brief time when the user clicks on the button instance's hit area and the button appears to be depressed.*

- *Hit frame: An invisible frame in which you can define the boundaries of the active area of the button. This is basically like defining a "hot spot" (i.e., clickable active area) for your button.*

At first, it may seem limiting to have only four frames in your button timeline as you begin to design buttons. In practice, however, these four states actually do provide the illusion of the button moving up and down in response to the user's mouse actions. Remember as you design your buttons that you can always add extra layers as you work. To create even more "active" effects, later in this chapter you will learn to place movie clips in a button symbol to provide animation within your button designs. Think of the elaborate buttons you can make using layers and movie clips!

Enabling Buttons

When you drag a button symbol onto the stage, you will not be able to see the symbol "in action" unless you enable the button. Enabling a button will allow you to preview each of the four button states on your stage as you work. Enabling a button means that any button instances on the stage will respond to your mouse actions (Up, Over, Down, and Hit). This gives you a preview of your buttons. You will also notice, however, that once Enable Buttons is turned on you will no longer be able to select the button to move it or alter it in any way.

You can enable a button by selecting the menu option Control | Enable Simple Buttons. See figure 14-1. To turn Enable Buttons off, just repeat the Control | Enable Simple Buttons selection. The check mark next to the Enable Buttons option in your pull-down menu will disappear to signify that this command is now inactive.

Shortcut

The keyboard shortcut for Enable Simple Buttons is:

Ctrl + Alt + B (PC)

Opt + Cmd + B (Mac)

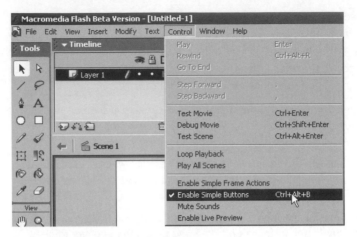

Fig. 14-1. Enabling buttons on the stage.

Guided Tour 14A: The Button States

During this tour you will take a first-hand look at the four button states that can be used to create buttons within your Flash movie. We will be looking at a completed version of a button so that you can get a better understanding of these various button states.

 CD-ROM

1. Select the menu option File | Open.

2. Locate and open the *button_01.fla* file in the *Chapter14* folder on the companion CD-ROM.

3. To enter Symbol Editing mode, double click on the instance of the *red_glow_button* symbol on the stage in the main timeline. See figure 14-2.

Fig. 14-2. The red_glow_button symbol.

4. Take a look at the timeline within the *red_glow_button* symbol. The time-line of every button consists of the same four frames: Up, Over, Down, and Hit. Scroll through and preview these four frames.
 * *The Up frame has an image of a metal-rimmed red button, which provides a strong visual cue to the viewer that this is a clickable object. Click on the Up frame in the timeline and look at the image on the stage.*

- *The Over frame contains the same image with an added feature: the button appears to be lit when the viewer rolls the mouse cursor over the button. Click on the Over frame in the timeline and look at the image on the stage.*

- *The Down frame has the same button image but the interior light is even brighter, providing affirmation to the viewer that something is happening after clicking on the button. Click on the Down frame in the timeline and look at the image on the stage.*

- *The Hit frame contains a green circle. This green circle is invisible to the viewer and serves only to map out the area of the button that is actually clickable (therefore, it is the same shape and size as the part of the button the viewer sees on screen). Click on the Hit frame in the timeline and look at the image on the stage.*

5. Save the file to the *SaveWork* folder on your computer

6. Select the menu option Control | Test Movie to test the movie.

7. Roll over the button to see the Over frame, and then click on the button to see the Down frame. Note that you never see the green spot that is in the Hit frame. It only defines what part of the button is clickable.

8. Close the preview and then close the *button_01.fla* file without saving any changes.

Practice Exercise 14-1: Creating Button Symbols

Description

In this exercise you will create a button that responds to mouse actions. You will do this by creating a button symbol. You will first add artwork to each frame (button state) in the Button timeline, and then see how to enable buttons for preview on the stage. In this exercise you will:

- *Create a new button symbol*
- *Assemble each button state in Symbol Editing mode*
- *Enable the button for preview on the stage*

Take a Look

Before beginning the exercise, let's take a look at the exercise in its completed state so that you can clearly see what it is you are about to build.

1. Use the menu option File | Open and locate the *Chapter14* folder on the companion CD-ROM. Find the file named *red_glow_button.fla*. Double click on the file to open it. If you are going to use the file from the CD-ROM, make sure to Save As, using the same file name, into the *SaveWork* folder.

Shortcut

The keyboard shortcut for Test Movie is:

Ctrl + Enter (PC)

Cmd + Return (Mac)

CD-ROM

·T/P·

If you don not turn off Enable Simple Buttons, you will not be able to select or edit your button instances on the stage. When buttons are enabled, the button instances respond only to mouse actions and will display the corresponding frames in their button symbol timeline. Enabling buttons allows you to preview the action of the buttons, but you will not be able to edit them while they are enabled.

2. The file *red_glow_button.fla* should now appear in your copy of Flash.

3. Make sure the button is not enabled, by selecting the Control menu and looking to see if there is a check mark next to Enable Simple Buttons. If there is a check mark, select Enable Simple Buttons, which will remove the check mark and turn off button enabling on the stage. If there is no check mark, simply click on the background to close the menu.

4. To enter Symbol Editing mode, double click on the instance of the *red_glow_button* symbol on the stage in the main timeline.

5. Take a look at the button timeline within *red_glow_button*. The timeline of the button consists of four frames: Up, Over, Down, and Hit. Select each frame to look at these four button states while in Symbol Editing mode.

6. Now enable the button by selecting the menu option Control | Enable Simple Buttons. Now click on the Scene 1 tab to leave the Symbol Editing mode. You can now use the mouse to click on the button to view the various button states in play. Note the following properties of this completed exercise.

 • *The Up, Down, and Over frames each contain a different graphic of the button.*

 • *The Hit frame contains the clickable area that will trigger button actions.*

 • *The menu option Control | Enable Simple Buttons determines whether the button will respond to mouse actions on the stage (enabled), or be selectable and/or editable (not enabled).*

Storyboard: On Screen

Figure 14-3 shows you how the stage will look when you finish this exercise.

Fig. 14-3. Button as viewed on stage.

Storyboard: Behind the Scenes

Figure 14-4 shows you how the stage and timeline will look once you finish your button.

Fig. 14-4. Completed stage and timeline.

Step-by-Step Instructions

Go Solo

CD-ROM

Shortcut

The keyboard shortcut
for Insert | New
Symbol is:

Ctrl + F8 (PC)

Cmd + F8 (Mac)

1. First we will tackle the basics for creating a new button symbol.
 a) Select the menu option File | Open. Locate and open the *practice_button.fla* file in the *Chapter14* folder on the companion CD-ROM. Save this file to the *SaveWork* folder on your own computer, using the current file name.
 b) Select the menu option Insert | New Symbol. Name the symbol *red_glow_button*, and select Button as the behavior.
 c) Click on OK. The *red_glow_button* timeline appears. Double click on layer I and rename it *Graphics*.
 d) Select frame I (the Up frame) in the *Graphics* layer.
 e) Use the keyboard shortcut Ctrl + L (Mac: Cmd + L) to view the library.
2. Now we have some work to do.
 a) Select the Up frame.
 b) Drag an instance of the *button_bg* symbol and drop it anywhere on the stage. The Info panel is probably already open, but if not, select the menu option Window | Info. Now click on the center position in the Registration icon next to the X and Y position boxes. Reset both the X and Y coordinates of the *button_bg* symbol to 0. This centers the symbol on the crosshair (i.e., center point) of the stage.
 c) Select the Over frame in the timeline. Press the F6 key to insert a keyframe.
 d) Select the Down frame in the timeline. Press the F6 key to insert a keyframe.

·T/P·

Notice that we are inserting graphic symbols into the frames in the button timeline. These graphic symbols contain artwork that was converted to a symbol and added to the library. Embedding symbols inside another symbol is often called "nesting symbols," and you will use it often throughout this book. It is not necessary to nest symbols inside the button frames to create your buttons. You can also draw directly on the stage with the Flash drawing tools to create the content for each button state.

e) Select the Up frame in the timeline. Drag an instance of the *red_disk_up* symbol from the library onto the stage. Don't worry about where, we'll take care of that in the next step.

f) Reset both the X and Y coordinates of the *red_disk_up* symbol to 0 in the Info panel.

g) Select the Over frame in the timeline. Drag an instance of the *red_disk_over* symbol onto the stage.

h) Reset both the X and Y coordinates of the *red_disk_over* symbol to 0 in the Info panel.

i) Select the Down frame in the timeline. Drag an instance of the *red_disk_down* symbol onto the stage.

j) Reset both the X and Y coordinates of the *red_disk_down* symbol to 0 in the Info panel.

k) Select the Hit frame in the timeline. Press the F7 key to insert a blank keyframe.

l) Drag an instance of the *hit_area* symbol to the stage. Reset both the X and Y coordinates of the *hit_area* symbol to 0.

m) Select the Scene 1 tab below the timeline to return to the main movie.

n) Drag an instance of the *red_glow_button* symbol onto the stage. You will notice that the button does not behave like a button yet. At this point, a button will behave like any other graphic while on the stage.

3. We could test our movie at this point (Control | Test Movie), but remember that there is a shortcut that allows you to preview button instances on the stage without testing the movie. Let's review this.

a) Select the menu option Control | Enable Simple Buttons. Click on the background to clear the blue selection marquee around the button.

b) Move the mouse cursor over the *red_glow_button* symbol. It shows you the Over frame! Next, click on the *red_glow_button* symbol. Now you see the Down frame! The Hit frame is evidenced every time you roll over or click on the button (if you did not have anything in the Hit frame, the button would not have an active, clickable area). Outstanding!

c) Select the menu option Control | Enable Simple Buttons once again to disable button actions. Now you can select and edit the button like any other instance.

4. Save your work, but keep this file open. You will use it in the next exercise.

Practice Exercise 14-2: Creating Animated Buttons

Description

In the previous exercise you learned to set up a button that responds to mouse actions. In this exercise we are going to take a few additional steps to

animate a button by nesting movie clip symbols inside a button timeline. In this exercise you will:

- *Use the Swap Symbol function to replace a nested graphic symbol with a movie clip symbol.*

- *Test the button in order to view the embedded movie clip.*

Take a Look

Before beginning the exercise, let's take a look at the exercise in its completed state so that you can clearly see what it is you are about to build.

 CD-ROM

1. Use the menu option File | Open and locate the *Chapter 14* folder on the companion CD-ROM. Find the file named *animate_button.swf*. Double click on the file to open it.

2. The file *animate_button.swf* should now be playing on your screen.

3. Try out the button. Note the following properties of this completed exercise.
 - *Mouse actions activate different frames (Up, Over, Down, and Hit) in the button symbol.*

 - *There is an animated movie clip (a slow blinking) that plays continuously as long as the mouse remains within the target area.*

 - *Clicking on the button results in the display of the Down frame.*

4. When you are finished, close the *.swf* file by clicking on the X in the upper right-hand corner.

Storyboard: On Screen

Figure 14-5 shows you how the stage will look when you finish this exercise.

Fig. 14-5. Completed stage.

Storyboard: Behind the Scenes

Figure 14-6 shows you how the stage and timeline will look once you finish animating your button.

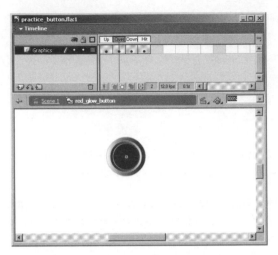

Fig. 14-6. Completed stage and timeline.

Step-by-Step Instructions

1. We are going to continue to build on the previous exercise, which you should still have open from the last exercise. If you did not complete the previous exercise or would rather use a completed version of the previous exercise, you can open the *red_glow_button.fla* file located in the *Chapter14* folder on the companion CD-ROM.

 a) In the library, double click on the *red_glow_button* symbol to enter Symbol Editing mode.

 b) Select the Over frame.

 c) Select the instance of the *red_disk_over* symbol on the stage. This is the red disk in the center of the button. If you see two selection marquees on stage, click on the background first to deselect both images (background of the button and the *red_disk_over* image). Now click on red image in the center of the button.

 d) In the Properties panel, click on the Swap button. See figure 14-7.

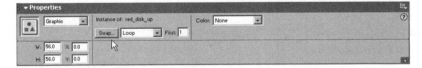

Fig. 14-7. Swap Symbol button.

 e) The Swap Symbol dialog window appears. See figure 14-8.

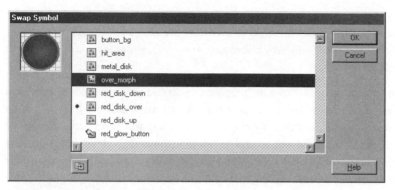

Fig. 14-8. Swap Symbol dialog box.

The *red_disk_over* symbol was the graphic symbol you added to the Over frame in the previous exercise. An alternate approach would have been to open the *red_glow_button* symbol in Symbol Editing mode. Then, you could delete the *red_disk_over* symbol in the Over frame and drag the *over_morph* movie clip symbol into the Over frame in its place. We had you use the Swap Symbol option because it is the quickest and most efficient method.

f) Select the *over_morph* movie clip symbol from the list of symbols, and then click on OK.

g) The *red_disk_over* symbol has now been replaced by the *over_morph* movie clip symbol. In the upper left-hand corner of the Properties panel, in the Symbol Behavior field, change the selection from Graphic to Movie Clip.

2. Let's test it out!

a) Click on the Scene 1 tab.

b) Select the menu option Control | Enable Simple Buttons.

c) Move the mouse cursor over the button. Why does the movie clip you nested in the Over frame not work, even with buttons enabled? This is because a movie clip, regardless of where it is nested, cannot be previewed on the stage at any time. In other words, you must test your movie in order to see a movie clip in action.

d) Select the menu option Control | Enable Simple Buttons once again to disable the button.

e) Select the menu option Control | Test Movie to preview the movie. Move the mouse cursor over the button and away we go! As impressive as it appears, an animated button is pretty easy to construct. Try one in your next project!

Adding Actions to Button Instances

You have had a lot of experience in previous exercises modifying instances of symbols on the stage. As a quick review, remember that an instance refers to a copy of a symbol that has been placed on the timeline. Each time you add a symbol to the timeline, you are adding an instance of that symbol. With button symbols, this concept becomes even more important when we start talking about adding actions to a button.

·T/P·

Do not despair if your movie clips do not work on the stage. Just remember that you must test your movie in order to play the movie clips. Because movie clips have a timeline that is independent from the main movie timeline, they do not respond to normal commands (using the Enter/ Return key or the controller) for stepping through the main movie's frames. Select the menu option Control | Test Movie. Or, you can use the keyboard shortcut Ctrl + Enter (Mac: Cmd + Return) to test your movie as your users would see it.

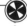

CD-ROM

To this point we have not given our button any instructions about what to do after the user clicks on it. Flash provides the capability to add many types of actions to buttons, thereby allowing you to create movies with a great deal of interactivity.

It is important to note, however, that when you add an action to a button, you will always be adding the action to a particular instance of the button, not to the button symbol. In other words, you are adding the action to a particular copy of the button and not to the "original." Remember this, because it may help save you a lot of time scratching your head later on, wondering why your button does not work!

Adding actions to an instance of a button rather than to the symbol itself is actually a very powerful feature of Flash. By doing this, you can reuse a symbol in many situations in your movie, without having to create an entirely new symbol to reflect each new action.

Practice Exercise 14-3: Adding Actions to Button Instances

Description

A button – even an animated button – does not serve much purpose unless something happens when the user clicks on it. In this exercise you will learn to attach actions to button instances so that something happens when the button is clicked on. In this exercise you will:

- *Create labels for frames in your timeline that will be used by button instances*
- *Assign actions to button instances to provide navigational control within the Flash movie*

Take a Look

Before beginning the exercise, let's take a look at the exercise in its completed state so that you can clearly see what it is you are about to build.

1. Use the menu option File | Open and locate the folder named *Chapter 14* on the companion CD-ROM. Find the file named *button_actions.swf*. Double click on the file to open it.

2. The file *button_actions.swf* should now be playing on your screen.

3. Try out the buttons and, as a side note, we hope that you will enjoy the "tongue-in-cheek" humor within the exercise. Note the following properties of this completed exercise.

 - *Click on the History button and observe the change.*

- *Click on the Testimonials button and observe the change.*
- *Click on the Home button and observe the change.*

Storyboard: On Screen

Figure 14-9 shows you how the stage will look when you finish this exercise.

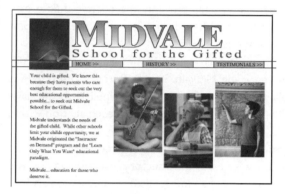

Fig. 14-9. Completed stage.

Storyboard: Behind the Scenes

Figure 14-10 shows you what the stage and timeline will look like once you finish assigning actions to your buttons.

Fig. 14-10. Completed stage and timeline.

Step-by-Step Instructions

1. Let's start out using some groundwork laid for you.
 a) Select the menu option File | Open.

Go Solo

CD-ROM

b) Locate and open the *midvale_1.fla* file in the *Chapter14* folder on the companion CD-ROM.

c) Select the menu option File | Save As to save a copy of this file in the *SaveWork* folder on your computer. You can keep the same file name.

d) Take a look at the existing timeline. There are five layers that constitute a three-frame movie. The *Actions and Labels* layer has a stop action in each of the frames. This prevents the *midvale_1.fla* movie from playing frame to frame. When the movie loads, the Stop command stops the movie at frame 1.

e) Drag the playhead through each of the frames. Each frame has different information regarding Midvale School. Because the movie is not designed to play through all frames, actions applied to the navigation buttons will be used to take the viewer to each section within the movie.

f) Select the menu option Control | Test Movie to preview *midvale_1.fla*. On the first screen we see the introductory information for the school, and if we mouse over the Home, History, or Testimonials buttons we get a rollover effect with the button appearance. Clicking on the buttons does not take us anywhere, yet; this is what you are going to build. We will need to label the frames we want to navigate to and then apply actions to the buttons so that they will take us to those labeled frames.

g) Close the SWF file and return to *midvale_1.fla*.

2. First let's set up the labels in your timeline.

a) Select frame 1 in the *Actions and Labels* layer.

b) In the Properties panel, type *Home* into the Frame Label field, shown in figure 14-11.

Fig. 14-11. Frame Label field in the Properties panel.

c) Select frame 2 in the *Actions and Labels* layer.

d) In the Properties panel, type *History* into the Frame Label field.

e) Select frame 3 in the *Actions and Labels* layer.

f) In the Properties panel, type *Testimonials* into the Frame Label field.

3. Next, we need to assign the action to the button instances. But first make sure the buttons are not enabled. Select the Control menu and make sure there is not a check mark by Enable Simple Buttons (if there is, just click on it to remove the check mark).

a) Select the instance of the Home button on the stage.

b) If your Actions panel is not already open, select the menu option Window | Actions, or expand the panel if it is already open. See figure 14-12. Get accustomed to working with this dialog panel; you will use it extensively as you develop further projects with Flash MX!

Script window

Fig. 14-12. Actions panel.

c) Click on the *Actions* folder to reveal the subcategories of actions. Click on Movie Control to open Actions in the category. Double click on the On action. Check the box next to Release Outside at the top of the panel. The following code appears in the window at the bottom of the panel. You may need to click and drag the Action Panel title bar upwards to make the Action panel a little larger so that you can read the code in the Script window.

```
on (release, releaseOutside) {
}
```

To see the code better, you can also undock the Actions panel. Click on the dots in the upper left-hand corner of the gray bar to drag the panel to a different location on the screen. You can then resize the panel window to display more of the code.

d) Double click on Go To from within the list of Movie Control actions. Select the radio button next to *Go to and Stop* at the top of the panel. The code now reads as follows.

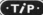 ·T*i*P·

If your panel arrangement is set to default, the Actions panel should be collapsed and located above the Properties panel at the bottom of the screen. To expand the panel, click on the Expand arrow in the upper left-hand corner of the gray bar labeled Actions. To revert to the default panel set, select the menu option Window | Panel Sets | Default Layout.

 ·T*i*P·

There are several types of events that occur in Flash movies. In this case, we are working with mouse events, or events that occur based on a user's mouse interaction with the object on the screen. In general, an event triggers an action (something that happens in your Flash movie).

```
on (release, releaseOutside) {
  gotoAndStop (1);
}
```

release and
releaseOutside are both
mouse events with
similar definitions.
In this case, the on
(*release*) event takes
place when the user
releases the mouse
while still over the
button's hit area. The
on (*releaseOutside*)
event takes place when
the user releases the
mouse after moving
the cursor outside
the button's hit area.

e) Look at the top of the Actions panel. In the Frame Type field, change the selection to *Frame Label*. In the Frame field, change the selection to *Home*. The code now reads as follows.

```
on (release, releaseOutside) {
  gotoAndStop ("Home");
}
```

f) This code you have just entered basically states that upon release of the mouse, the movie will go to and stop at the frame labeled *Home*. Select all lines of the code by clicking and dragging the cursor (thus, highlighting) from the first line of code to the third and releasing. In Windows, right click (Mac: Ctrl + click) on the selected code, and select Copy from the menu.

g) Select the instance of the History button on the stage.

h) In the Actions panel, right click (Mac: Ctrl + click) on the Script window (see figure 14-12), and select Paste from the pop-up menu.

i) Click to highlight the *gotoandStop* code, and in the Frame Label field, change the frame label from *Home* to *History*. The code now reads as follows.

```
on (release, releaseOutside) {
  gotoAndStop ("History");
}
```

j) Select the instance of the Testimonials button on the stage.

k) In the Actions panel, right click (Mac: Ctrl + click) on the Script window, and select Paste from the pop-up menu.

l) Click to highlight the *gotoandStop* code, and in the Frame Label field, change the frame label from *Home* to *Testimonials*. The code now reads as follows.

```
on (release, releaseOutside) {
  gotoAndStop ("Testimonials");
}
```

4. Save the completed file.

5. Select the menu option Control | Test Movie or Control | Enable Simple Buttons. The buttons now navigate you through the site just as they should. Great job!

C H A P T E R

15

Application

Chapter:

Movie Clip and

Button Content

Introduction

One of the simplest ways of adding interactivity for your user is to create elements that respond to mouse events, such as clicking on a button. The button symbol in Flash makes it easy to create interesting buttons that respond to a user's mouse activity (rollover and click) by changing the visual design of the button. The movie clip symbol can also be added to a button symbol to create buttons that respond to mouse events with design changes and animated effects.

Movie clips with their independent timelines can also be used to create some interesting effects in the main movie timeline. They are the most versatile symbol, and will enhance the appearance and activity that takes place in your site. In this exercise, you will create some fun movie clips that will give your site an added boost. By the end of the chapter you will be able to:

- *Add ActionScript to the main timeline that will*
 - *Stop*
 - *On (release)*
 - *gotoAndStop*
 - *gotoAndPlay*
- *Create button symbols*
- *Create a movie clip that will later be added to a button*

Application Exercise: Movie Clip and Button Content

Description

In this application exercise you will now create the buttons for your movie interface. You will also create some movie clips that will be used in some of the roadside attractions you come across.

Take a Look

CD-ROM

Before beginning the exercise, let's take a look at the exercise in its completed state so that you can clearly see what it is you are about to build.

1. Use the menu option File | Open and locate on the companion CD-ROM the folder named *Chapter15*. Locate the file named *application_15.fla*. Double click on *application_15.fla* to open the file.

2. The file *application_15.fla* should now appear in your copy of Flash.

3. Preview the movie. Take a moment to look through the timeline.

Storyboard: On Screen

Figure 15-1 shows what will be seen on stage when the program file is complete.

Fig. 15-1. Completed stage.

Storyboard: Behind the Scenes

Figure 15-2 shows how the timeline will look when the exercise is completed.

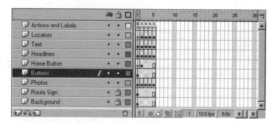

Fig. 15-2. Completed timeline.

Application Project Steps

Complete this exercise on your own, guided by following the general steps. These steps do not include the details of how to accomplish these tasks, as the "how to" has been covered in earlier chapters. You can always refer back to the completed example you viewed in the "Take a Look" section of this exercise.

NOTE: The following steps are intended as a guide, but this is your project, so please feel free to make whatever variations you would like.

1. Open *application_11.fla*. You can either use the copy you created and saved in the *SaveWork* folder on your computer or the copy in the *Chapter11* folder on the companion CD-ROM.

2. Add a new layer and name it *Actions and Labels*. Position it at the top of the layer stacking order.

3. Select frame 1 of the of the *Actions and Labels* layer and add a keyframe. Label the frame *Home*.

4. Add the following ActionScript to the frame.
   ```
   stop ();
   ```

5. Select frame 2 of the *Actions and Labels* layer and add a keyframe. Label the frame *Underdale*.

6. Add the following ActionScript to the frame.
   ```
   stop ();
   ```

7. Select frame 3 of the *Actions and Labels* layer and add a keyframe. Label the frame *Chikapee*.

8. Add the following ActionScript to the frame.
   ```
   stop ();
   ```

9. Select frame 4 of the *Actions and Labels* layer and add a keyframe. Label the frame *Wagonrut*.

10. Add the following ActionScript to the frame.
    ```
    stop ();
    ```

11. Select frame 5 of the *Actions and Labels* layer and add a keyframe. Label the frame *Bulldozer*.

12. Add the following ActionScript to the frame.
    ```
    stop ();
    ```

13. Create a new button symbol named *Exit 101*. In its Symbol Editing Mode window, rename the existing layer *Graphics*.

14. Select the Up frame and drag a copy of the Sign graphic symbol onto the stage and position it at X=0.0, Y=0.0.

15. Using the center-justified, white, 10-point, sans serif, bold, static text settings, enter *EXIT 101* and position it at X=0.0, Y=0.0.

16. Select and add a keyframe to the Over, Down, and Hit frames (you may delete the text from the Hit frame if you want to).

17. Select the instance of the *Exit Sign* graphic in the Over frame. Change the tint effect of the instance to 30% #FFFF00, and change the text to *Contact Us!* in the Over and Down frames.

18. Return to the main movie timeline.

19. Create a *Buttons* folder in the library and drag the *Exit 101* button symbol into it.

20. Create a new button symbol named *Exit 102* exactly as you created the *Exit 101* button symbol, except that this time enter the text *EXIT 102* in the Up frame and *E-mail Us* in the Over and Down frames.

21. Return to the main movie timeline and drag the *Exit 102* button symbol into the *Buttons* folder.

22. Create a new button symbol named *Home* exactly as you created the *Exit 101* button symbol, except that this time enter the text *HOME*.

23. Return to the main movie timeline and drag the *Home* button symbol into the *Buttons* folder.

24. Create a new button symbol named *Go* exactly as you created the *Exit 101* button symbol, except that this time enter the text *GO!*.

25. Return to the main movie timeline and drag the *Go* button symbol into the *Buttons* folder.

26. Create a new button symbol named *Send* exactly as you created the *Exit 101* button symbol, except that this time enter the text *SEND!*.

27. Return to the main movie timeline and drag the *Send* button symbol into the *Buttons* folder.

28. Create a new button symbol named *Bulldozer, TX*. In its Symbol Editing window, rename the existing layer *Graphics*.

29. Select the Up frame and draw a circle with a red fill, and a black stroke with a stroke height of 2. Resize the circle to W=9.5, H=9.5, and position it at X=0.0, Y=0.0.

30. Using the center-justified, #666666, 10-point, sans serif, bold, static text settings, enter *BULLDOZER Texas* and position it at X=0.0, Y=-27.9.

31. Add a keyframe to the Over frame, and change the color of the text to black. Replace the existing stroked circle with an instance of the *Yellow Glow* graphic symbol.

32. Insert a blank keyframe in the Down frame of the *Graphics* layer.

33. Draw a rectangle in the Hit frame of any color (W=69.0, H=44.0) and position it at X=-0.5, Y=-19.0.

34. Return to the main movie timeline and drag the *Bulldozer, TX* button symbol into the *Buttons* folder.

35. Create a new button symbol named *Chikapee, AZ* exactly as you created the *Bulldozer, TX* button symbol, except that this time enter the text *CHIKAPEE Arizona*.

36. Return to the main movie timeline and drag the *Chikapee, AZ* button symbol into the *Buttons* folder.

37. Create a new button symbol named *Underdale, NV* exactly as you created the *Bulldozer, TX* button symbol, except that this time enter the text *UNDERDALE Nevada*.

38. Return to the main movie timeline and drag the *Underdale, NV* button symbol into the *Buttons* folder.

39. Create a new button symbol named *Wagonrut, NM* exactly as you created the *Bulldozer, TX* button symbol, except that this time enter the text *WAGONRUT New Mexico*.

40. Return to the main movie timeline and drag the *Wagonrut, NM* button symbol into the *Buttons* folder.

41. Create a new layer in the main movie timeline and name it *Buttons*. Position it above the *Photos* layer.

42. Select the first frame of the *Buttons* layer and drag an instance of the *Underdale, NV* button symbol onto the stage. Position it at X=218.4, Y=333.9.

43. Assign the following ActionScript to the instance of the *Underdale, NV* button.
    ```
    on (release) {
      gotoAndStop ("Underdale");
    }
    ```

44. Select the first frame of the *Buttons* layer and drag an instance of the *Chikapee, AZ* button symbol onto the stage. Position it at X=275.9, Y=353.9.

45. Assign the following ActionScript to the instance of the *Chikapee, AZ* button.
    ```
    on (release) {
      gotoAndStop ("Chikapee");
    }
    ```

46. Select the first frame of the *Buttons* layer and drag an instance of the *Wagonrut, NM* button symbol onto the stage. Position it at X=395.7, Y=329.9.

47. Assign the following ActionScript to the instance of the *Wagonrut, NM* button.
    ```
    on (release) {
      gotoAndStop ("Wagonrut");
    }
    ```

48. Select the first frame of the *Buttons* layer and drag an instance of the *Bulldozer, TX* button symbol onto the stage. Position it at X=499.0, Y=328.9.

49. Assign the following ActionScript to the instance of the *Bulldozer, TX* button.
    ```
    on (release) {
       gotoAndStop ("Bulldozer");
    }
    ```

50. Select the first frame of the *Buttons* layer and drag an instance of the *Exit 101* button symbol onto the stage. Position it at X=597.2, Y=400.2. You will add the ActionScript to this button later in the book.

51. Select the first frame of the *Buttons* layer and drag an instance of the *Exit 102* button symbol onto the stage. Position it at X=597.2, Y=447.1. You will add the ActionScript to this button later in the book.

52. Create a new layer in the main movie timeline and name it *Home Button*. Position it above the *Buttons* layer.

53. Select frame 2 of the *Home Button* layer and insert a keyframe. Drag an instance of the *Home Button* symbol onto the stage and position it at X=46.0, Y=447.1.

54. Assign the following ActionScript to the instance of the *Home Button* symbol.
    ```
    on (release) {
       gotoAndStop (1);
    }
    ```

55. Save your file in the *SaveWork* folder.

Next, let's create a couple of animated movie clips to be used later in the book.

1. Create a new movie clip symbol named *Route Movie*. In its Symbol Editing window, drag a copy of the *Route 67* graphic onto the stage. Resize the instance of the *Route 67* symbol to W=208.1, H=207.9, and position it at X=0.0, Y=0.0. Add keyframes at frames 10 and 20 of the *Route Movie* timeline.

2. Rename the existing layer *Route 67*.

3. Select the *Route 67* instance in frame 10 and resize it to W=220.8, H=220.5. Reposition it at X=0.0, Y=0.0.

4. Create a Motion tween between frames 1 and 10, and another between frames 10 and 20.

5. Create a new layer above the *Route 67* layer and name it *Actions*.

6. Insert a keyframe at frame 20 of the *Actions* layer and assign the following ActionScript to it.
    ```
    gotoAndPlay (1);
    ```

7. Test the animation and then return to the main movie.

8. Create a new movie clip symbol named *Text Movie*.

9. Rename the existing layer *Text*.

10. Select frame 1 of the *Text* layer.

11. Assign the following text properties.
 Font: _sans

 Font Height: 20

 Bold: selected

 Color: Black

 Center Justified Paragraph

 Static Text

 Use Device Font

12. Enter the following text, with a hard return at the end of the first line.
 Route 67 . . .

 America's Other Scenic Highway!

13. Insert a keyframe at frame 50. Change the text to read as follows.
 Visit beautiful Underdale, NV

 for undisturbed natural beauty!

14. Insert a keyframe at frame 110. Change the text to read as follows.
 Stop awhile in Chikapee, AZ

 for "fun" with a capital "F"!

15. Insert a keyframe at frame 170. Change the text to read as follows.
 Explore Wagonrut, NM

 and come face-to-face with exotic wildlife!

16. Insert a keyframe at frame 230. Change the text to read as follows.
 Discover Bulldozer, TX

 and its culinary delights!

17. Insert a keyframe at frame 290. Do not change the text.

18. Create a new layer above the *Text* layer and name it *Actions*.

19. Insert a keyframe in frame 290 of the *Actions* layer and assign the following ActionScript to it.
 `gotoAndPlay (1);`

20. Test the animation and then return to the main movie.

21. Save your file as *application_15.fla* in the *SaveWork* folder on your computer.

C H A P T E R

16

Adding Sound

Introduction

Unlike traditional HTML editors and the web sites created with these tools, Flash easily provides true multimedia authoring capability, all within the Flash authoring environment. To this point you have seen how you can add text, graphics, and animation to your Flash project. In this chapter you will learn how easy and fun it is to add sound.

When incorporating sound into your Flash projects, think about your purpose for adding it. Some sounds may be used as a background to set a certain tone for your site. Music and environmental sounds can evoke a particular mood or feeling that can be very effective.

Other uses of sound can include playing a sound effect in response to a user's action, such as a "click" as the user selects a button. This sound lets the user know that the program is responding to interaction. You will work with this example in an exercise later in this chapter that shows you how to add sound to a button symbol.

Another reason to include sound capability within your project is to make use of narration to supplement or reinforce information provided visually through text and/or graphics. Increasing the number of media channels generally increases the effectiveness of the message being communicated. Narration can be synchronized to the actions taking place on screen, or can be used as an element that plays independently of the timeline. You may discover other reasons for using narration within your Flash project. The use of sound includes the following.

- *Music and sound tracks: Can add dynamic support for on-screen graphics or animation, as well as increase the general level of user/viewer interest in your project.*
- *Narration (audio track): Can provide information that either supports or that is in addition to what is presented via text, graphics, and/or animation.*
- *Sound effects: Can accompany user actions, provide additional feedback concerning a user response or required action, and be used as a technique to "grab and focus" the user's attention to a particular point of interest.*

By the end of this chapter you will be able to:

- *Describe a few advantages to and concerns about using prerecorded audio*
- *Describe a few advantages to using professional talent and a recording studio*
- *Describe what is needed to record your own sound*
- *Describe the basic properties involved in recording sound (e.g., sampling rate, sampling size, channels, and file format)*
- *List the sound file formats available for use in Flash*
- *Describe the differences between event and streaming sounds*

- *Import sound into your Flash movie*
- *Synchronize sounds to particular events in your movie timeline*
- *Apply effects to imported sounds*
- *Control the length of sound files*

Obtaining Sound Files

If you have sound files prepared for you in the appropriate digital format, you may not need to read the following section. However, it is more likely that most of you will at some point be faced with the question "Where do I get the sound files I need for my Flash applications?"

Prerecorded Music and Sound Effects

One answer to the question of "where" is to purchase sound effects or music tracks from any number of vendors that make such products available for multimedia use. There are literally thousands of sound effects that have been recorded, and almost as many music segments representing a wide variety of different musical styles. Typically these sound files are supplied on CD-ROM or can be downloaded, with at least a couple of different file formats available for each audio selection.

There are also a few software programs available for purchase that allow you to select a preexisting recording and edit it in a variety of ways, including changing the length (time) of the musical segment to fit your specific time requirement. Assuming you can find the selections you need, the next and equally important factor in the use of prerecorded sound files is being very careful about examining the license agreement for the music or sound effects to see what limitations and obligations you must comply with to use the sound file. Your best bet is to look for music and sound effects products that very clearly state "Royalty Free Use" of their sound files. In other cases, you may need to pay a small licensing fee.

Be advised that you may not use the commercially recorded popular music you listen to on your stereo without prior written permission (and probably a fee with restrictions of use) from the producer, publisher, and/or performer of that music. This still may be an option, especially if the distribution of your application is not for sale and is intended for a small, targeted audience. It is best to check first before spending a lot of time and effort working with something you may not be able to use. Educators should familiarize themselves with the laws regarding "Fair Use" of copyrighted materials for educational purposes. If you have a question about what constitutes "Fair Use," your best bet is to ask the legal experts that represent your institution or school district.

Using Professional Talent and Studio

There are times when you will not be able to purchase "clip sound files" but must record your own. For example, you may find yourself in need of high-quality "professional" narration to accompany the text, graphics, or animation that appears on screen. Without question, the most professional results will be achieved by using professional talent and a recording studio. Of course, everything comes with a cost. Depending on your needs and budget, this option may be "expensive," but you may want to check it out.

Most talent agencies will provide you with recorded samples of work from a variety of their clients, so that you can select the voice or two that best meets your project's specific needs. You can then be present in the studio during the recording to ensure proper pronunciation or vocal emphasis by the voice talent.

You will need to provide copies of the script to the talent and the studio's technician, and you will want to keep a copy for yourself. You might want to break the script down, so that each audio file you need (per screen or per sequence) is recorded, identified, and provided to you as a separate file. This means that you should also provide the file name for each file. Organize and plan ahead. Get everything ready before you go to the studio. Once you get there, you are generally "on the clock" and paying for time.

The technician at the recording studio will probably ask you a number of questions pertaining to the format and properties of the sound files to be delivered to you (these properties are briefly discussed in the next section). When the recording and editing is finished, the studio will be able to provide you with a CD-ROM with all digital sound files ready to be imported into Flash.

Recording Your Own Sound

The Equipment You Will Need

What if you have little or no budget; what are your alternatives? This should not be a problem; recording sound is pretty easy to do. At a minimum, you will need three things, with a fourth component recommended, as follows.

- *Sound card in your computer*
- *Microphone*
- *Sound editing software*
- *Recording device (recommended, not required)*

Sound Card: You probably have a sound card in your computer already. Even if you do not plan to record sound, any computer intended to run your application with sound will need a properly installed sound card (most computers

these days include a built-in sound port) to play any sound file. Almost all sound cards will include at least two input ports: one for use with a microphone, and a second as a line input for use with another playback device (such as a tape recorder or MP3 player). Most of these input ports require a standard "Sony-type" or "RCA-type" plug. The sound card, combined with the use of the sound editing software, will capture and convert sound into a digital format that can recognized by the computer and by Flash.

Microphone: You may have one already, or you may need to purchase one. The quality of a microphone can vary quite a bit, but you should not have to spend more than about $50 to get a fairly decent one. You may want to buy a "unidirectional" (i.e., limited-range) microphone to help eliminate recording stray (unintentional sounds). Inexpensive microphones will probably have a "Sony-type" or "RCA-type" jack that can be plugged directly into the computer's microphone input. If you are not going to use a recording device, an inexpensive microphone will do fine. Many computers also have built-in microphones that can be used to record short audio clips.

Sound Editing Software: You may have a "lite" version of this software already, as some type of sound editing software is generally included with sound cards. There are also Windows and Mac utilities that provide the basics needed for recording and limited editing. If you are going to do more than a little recording, you may want to purchase a more full-featured sound editing software program that will help you do this work more quickly and efficiently.

Recording Device: Even though you can connect the microphone directly to the computer and record using the sound editing software, there are a few good reasons for using a recording device. First, sound files can quickly take up a lot of space on your computer's hard drive. How many selections are you going to record? How many times are you going to have to repeat the selection to get a good "take"? Just think of the many times you have observed the scene on TV or in the movies in which a director says, "Take 5," "Take 10," and so on. Even professional talent will need to repeat lines to achieve the desired result. Each "take" will gobble up a lot of hard drive space.

If you will be doing more than a little recording, you may want to get a decent recording device, along with a good-quality microphone, and record first into the recorder. You can then identify the "good" takes and transfer these to the computer via the "line output" from the recorder into the "line input" of the sound card. Use the sound editing software just as you would with direct microphone use. There are many types of recording devices you can purchase. Some examples are a DAT recorder, mini-disk player, tape recorder, and MP3 player. When you are searching for a recording device, just make sure that it has ports for line in/out cables that can be connected to the sound card on

·T*i*P·

Try using a headset that is a combination of earphones and microphone.

your computer. Also make sure you can make clean electronic connections, without any "buzz," "hum," or other noise.

The Recording Environment

You will want to find a nice quiet place to record your narration. This generally means away from windows, high-traffic areas (vehicles and people), elevators, stairways, doors that open/close frequently, and loud voices next door. You will be surprised at how many stray (unintentional) sounds you may pick up as you record. You may not even hear them until you listen to the recording later.

If the description of this "nice quiet place" has just eliminated all possibilities at your normal place of work during the day, you may want to consider this same place at night or during the weekend, or find a quieter alternative. Position your "talent" so that when the microphone is aimed directly at the speaker's mouth, it will be pointing to the quietest area of the room. Unless you have a microphone stand and other equipment, it will probably be easier to have your talent sit comfortably at a table, with the microphone mounted in a stable position directly in front of the speaker's mouth.

You will need to experiment, but will probably want to place the microphone no farther than 8 to 12 inches from the speaker's mouth. Try to avoid anyone holding the microphone, as this will undoubtedly produce unwanted noise. Make sure there is room for the speaker to place the script (perhaps on a typist's copy stand) so that it can be easily read. Holding and turning pages can also produce unwanted noise. The computer and/or recording device should be placed well out of range of the pickup pattern from the microphone. Figure 16-1 provides a suggestion for how you might arrange your recording space.

· T𝑖P ·

Most robust sound editing software, such as Gold Wave or SoundEdit, will allow you to filter out "noise" that was picked up from the environment or from the recording device. With such programs, you can isolate this noise and delete it. Of course, it is still better to try to avoid noise rather than have to deal with it later.

Fig. 16-1. Example of recording arrangement.

Properties of Sound Files

We might describe "real-life" as a continuous stream of changing events. If we listen to a rock band playing, we hear a constantly changing series of notes, varying loudness, changing beat, changing instruments, and so on. In the digital world of computers, if you want to record and play back this sound, you need to capture and represent this continuous stream of events as a long series of individual "moments frozen in time." Each digital "frozen moment" is a sample of that music at a specific point in time.

Our ability to digitally represent live music is significantly influenced by four properties related to how we "sample" or capture these individual "moments frozen in time." These properties include sampling rate, size of sample, mono/stereo capability, and to some extent file format. To give these properties a concrete reference point, examine figure 16-2, which shows the dialog window used to set up properties for recording sound files in Sound Forge (Sonic Foundry).

Fig. 16-2. Sampling rate in the New Data window of Sound Forge.

Sampling Rate: Relates to how often a "sample" is taken; that is, how many times per second. The sampling rate is generally expressed as "cycles per second" or in the measuring unit, hertz (Hz). The pull-down menu for sampling rate allows you to select a rate ranging from 2,000 to 96,000 Hz. The higher the sampling rate (the higher the number), the better the quality of your digital representation of the music. However, as you increase the sampling rate, you also increase the size of the resulting sound file.

For most computer applications, you will probably find that a sampling rate somewhere between 12 and 22 thousand Hz will do the trick. As a comparison, audio CDs are recorded at 44 Hz. Many computer speakers are of a fairly poor quality, and therefore high-quality recording is frequently a wasted effort, in addition to dramatically increasing file size, which in low-bandwidth environments (typical modem Internet access) will significantly degrade perform-

ance. You should experiment with various sampling rates, depending on your needs. The end result is also influenced by two sound properties: sample size and channel.

Sample Size: Relates to the size of the "container" used to store the "sample." If we use a large "container," we will have a lot more room to store a lot more information about the "sample." Typically most computer systems provide 8- or 16-bit "containers" (see figure 16-3, left side). Sound cards are described as either 8-bit or 16-bit. As you might imagine, 16-bit sound files offer considerably better quality over 8-bit, but again, they are considerably larger than 8-bit files.

Fig. 16-3. Sample size (left) and channels (right).

Channels: Relates to whether the file will offer multiple channels (stereo) that may contain different information or a single channel (mono), playing the same information on both speakers (see figure 16-3, right side). For games and other applications for which you are trying your best to create a more realistic environment, you may want to try stereo. For most applications, however, you probably will not add much to the quality by using stereo. In addition, stereo will add significantly to file size, so go with mono. Channels can also be adjusted in the Publish settings of your Flash movies. You can convert stereo to mono with some of the compression settings in Flash, which will change the audio settings in the exported movie.

Format: Relates to the characteristics of the file type used for the sound file. Flash supports several sound file formats for import, as described in the next section. The format you choose will generally be determined by the capabilities of the computers and environment your application will be delivered into. Flash also allows you to select audio compression settings for your exported movies in the Publish settings. Using the Publish settings applies a global compression to all audio files in your Flash movie, giving you less control over the final quality of each sound. However, you can also change the compression set-

ting individually by using the Sound Properties window in the library. The compression options in Flash are Default, ADPCM, MP3, Raw, and Speech.

Sound File Types Supported by Flash

You can import the following file types for use in Flash.

- *MP3 (Windows and Macintosh): A compressed file format that features high-quality sound with small file sizes that are smaller than WAV or AIFF files but that retain much of their quality considering the amount of compression applied.*
- *WAV (Windows only): The standard file format for audio files within Windows. With QuickTime 4 installed, WAV files can be used interchangeably on Mac and PC.*
- *AIFF (Macintosh only): This file format was developed by Apple as a standard Mac sound file format.*

The following alternate file types can also be imported if QuickTime 4.0 or later is installed on your system.

- *AIFF (Windows and Macintosh)*
- *Sound Designer II (Mac only)*
- *System 7 sounds (Mac only)*
- *Sun AU (Windows and Mac)*
- *Sound Only QuickTime Movies (Mac and Windows)*
- *WAV (Windows and Mac)*

Practical Considerations When Using Sound

Now that we have told you that there can be significant benefits to adding sound to your Flash applications, we also need to point out that there are a few practical considerations regarding the use of sound. The first issue is related to performance, especially in the Internet environment with slower modem connections. As you add sound to your Flash program, it can significantly increase the movie's file size. As is the case with all Flash files, as the file size increases so does the time required to download and "write to screen" – especially with low-bandwidth access. There are also some considerations for how Flash keeps pace between audio and frames during playback. At the end of this chapter, we will discuss some solutions to this issue.

Another important issue is related to whether the use of sound is appropriate in the environment in which your typical user/viewer will access your Flash project or web site. If someone is accessing your Flash site from an office or other public setting and is not using headphones, loud music or sound effects

can be an annoyance to others in the area, especially if the sound cannot be easily turned down or off.

One way to deal with this last issue is to apply some of what you learned in using ActionScripts as you design your interface. Giving your user control over turning sounds on or off can be a great way to create a user-centered site that appeals to a wide variety of people. Just remember that with the ability to turn off sound, you will have to be careful when designing the project so that no important information will be lost if the sound is turned off.

Guided Tour 16A: Adding Sound to the Timeline

In this tour you will see how easy it is to import sounds into your Flash movie. Flash will store the imported sound in the library, along with the other symbols, and give it a unique icon (which looks like a speaker) to remind you that this particular item is a sound. See figure 16-4.

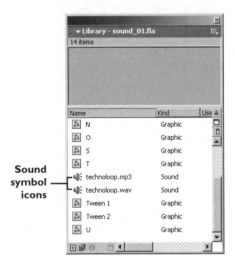

Sound symbol icons

Fig. 16-4. Sound symbols after importing two different sound formats.

1. Let's start with an existing file.
 a) Select the menu option File | Open.
 b) Locate and open the *sound_01.fla* file in the *Chapter16* folder on the companion CD-ROM.
 c) Select the menu option File | Save As to save a copy of the file in the *SaveWork* folder on your computer. Name it *my_sound_01.fla*.
 d) Take a look at the existing timeline. There are 14 layers with a looping 84-frame animation. You should recognize this content. You created it in an earlier exercise.

CD-ROM

e) Select the menu option Control | Test Movie to preview the movie. There is a fair bit of action going on, but where is the music to accompany it? Let's add some sound to make this file complete. See figure 16-5.

Fig. 16-5. Sound_01 when it opens.

2. Now let's prepare the timeline for sound.
 a) Select the top layer (layer *F*) in the timeline.
 b) Click on the Add Layer icon located under the Layers panel.
 c) Double click on the name of the new layer and type in *Sound*.
 d) Now let's import a new sound. Select the menu option File | Import.
 e) In the dialog window that opens, set the Files of Type option to All Sound Formats.
 f) Locate and select the *technoloop* file (select either MP3 or WAV, depending on which is supported by your computer) in the *Chapter 16* folder on the companion CD-ROM. Click on the Open button.
 g) Select the menu option Window | Library. Notice that the sound has been imported directly into the library.

3. Now we can add the sound to the timeline.
 a) Select frame 1 in the *Sound* layer.
 b) Drag an instance of *technoloop* from the library and drop it anywhere on the stage. Notice that it does not show up on the stage. The sound is only visible in the *Sound* layer of the timeline.
 c) Select the menu option Control | Test Movie to preview the movie again. Much better, but the music ends rather abruptly. How can we improve it?

4. How about fading it out? Let's take a look.

·T/P·

The sound files used in this chapter are available in MP3 or WAV format in order to accommodate Mac users who do not have QuickTime 4 or later installed. You may use either format, but PC users will probably want to use the WAV format. Mac users will probably want to use the MP3 format.

a) Select frame 1 in the *Sound* layer.

b) In the Properties panel, adjust the sound properties by using the pull-down menu in the Effect field and select Fade Out. This will cause the sound to fade out as it nears the end of the sound.

c) Select the menu option Control | Test Movie to preview the movie again. Good, this is a much more polished ending.

5. Let's stop for a moment and take a closer look at the options on the Properties panel that deal with sound and find out what they are all about. Figure 16-6 shows you the Frame Properties panel. Notice that selecting a frame makes the Frame Properties panel active. Within the Frame Properties panel there are many options for dealing with sound. We will focus on the options on the right side of the panel: Sound, Effect, Sync, Loop, Edit, and File Properties. The options on this panel are described in the following.

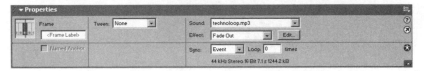

Fig. 16-6. Properties panel for sound.

Sound Field: The first field on this panel is the Sound pull-down menu. This function will allow you to choose any sound you want from those that are already in the library. You can use the Sound field to assign a sound to a frame, or to swap one sound for another within a frame that already has a sound file added to it.

Effect Field: This pull-down menu gives you the opportunity to choose from a number of popular effects you can apply to your sound. The options are: None, Left Channel, Right Channel, Fade Left to Right, Fade Right to Left, Fade In, and Fade Out. The Custom option will open up the Edit Envelope dialog box, which is discussed in more detail in the next guided tour.

Sync Field: This pull-down menu allows you to change the nature of the sound's playback. You can choose Event, Start, Stop, or Stream. The difference between Event and Stream is discussed in more detail in the next section.

Loop Field: This field allows you to type in the number of times you want the sound to loop before it stops playing.

Edit Button: Pressing this button opens the Edit Envelope window, shown in figure 16-7. The Edit Envelope window is explored in the next guided tour.

File Properties: Once a sound file has been identified in the Sound field, the gray area on the bottom edge of the panel will show you the current file's properties, which include sampling rate, sample size, channels, and file size. These

settings cannot be altered in the Properties panel, but are simply presented here as information.

Fig. 16-7. Edit Envelope window.

·T/P·

Although file properties cannot be edited in the Properties panel, they can be edited in the library. Highlight the file in the library and click on the Properties icon (looks like a lowercase i) to adjust these settings.

6. Let's take a look at another place to review sound properties. Double click on the *technoloop* file in the library. You can see that this opened the Sound Properties window. See figure 16-8. Within this window, you can rename the sound, import other sounds, and change the compression from Default to MP3, ADPCM, Raw, or Speech formats. If you select one of these compressions, you will also be able to change the bit rate and quality settings.

Fig. 16-8. Sound Properties window.

Sound Sync Options: Event, Stream, Start, and Stop

When you use sound in your timeline, you will need to determine how the sound is synchronized with your movie timeline. You can control this with the Sync field in the Properties panel. In Flash, synchronization has to do with how the audio plays in relation to the frames in the timeline and during the download process. There are four sync settings in Flash that have different properties and applications.

Event: An event starts in the keyframe where it is inserted and will continue to play to the end of the sound file, regardless of the length of the movie timeline. Event sounds are commonly used for background music and effects that do not require that the music correspond to particular frames in the animation.

Stream: Stream should be used when the audio and animated frames need to keep pace with one another. With this option selected, the audio is tied to each frame in the layer. However, remember that the sound instance becomes the dominant media element (or the driving force) as the Flash program plays. The frames try to keep up with the sound; but if they cannot, sometimes Flash will skip frames in order to keep up with the sound. Stream sounds end when the movie timeline ends.

Start: This sync setting allows you to start a new instance of a sound while simultaneously stopping an instance of a sound previously playing.

Stop: This allows you to stop sounds from playing in your timeline.

CD-ROM

Guided Tour 16B: Sound Effects

In this tour we will take a closer look at how to edit sound effects using both the Properties panel options and the Edit Envelope window. After completing this tour, you will be ready to start working with sound in the practice exercise that follows.

·T*i*P·

Mac users should note that *sound_02.fla* is currently using a WAV file. If your computer cannot play WAV files, you can replace the WAV file in the *Sound* layer with the *technoloop.mp3* file you will find in the library.

1. Let's start with an existing file.
 a) Select the menu option File | Open.
 b) Locate and open the *sound_02.fla* file in the *Chapter16* folder on the companion CD-ROM.
 c) Select the menu option File | Save As to save a copy of the file in the *SaveWork* folder on your computer. Name it *my_sound_02.fla*.
 d) Select the menu option Control | Test Movie to preview the movie. This is identical to the file we just completed in the last tour. The sound is set to Event, and already has a Fade Out effect applied to it.
2. Let's experiment with different sound settings and see what happens.

a) Locate the *Sound* layer at the top of the timeline and select the first frame (you should see a thumbnail preview of the sound waveform in the *Sound* layer).

b) Take a look at the Properties panel. If it is closed, select the menu option Window | Properties to open it.

c) In the Sync field of this panel, change the option from Event to Stream.

d) Select the menu option Control | Test Movie to preview the movie. Setting the Sync option to Stream allows the sound to play along with the animation a bit better. Instead of playing independently of the animation timeline and stopping a couple of seconds prematurely, the sound now plays in a more synchronized fashion.

e) Close the Preview window to return to the main movie.

f) Locate the *Sound* layer at the top of the timeline and select the first frame.

g) Click on the Edit button in the Properties panel.

h) The Edit Envelope window now opens. The Edit Envelope window provides a view of two "envelopes" (or views) of the sound's waveform. The waveform envelopes represent the left and right speaker channels. The amplitude or loudness of each sound is indicated by the height of the signal relative to the baseline on which it is centered; the larger the signal, the louder the sound. See figure 16-9.

Measured in seconds Measured in frames

Fig. 16-9. Edit Envelope window.

Each envelope includes white square "handles," which allow us to adjust the volume of that particular channel by dragging the handle up or down. You can add more handles by clicking inside the envelope and then moving each handle to the desired volume level. You can have up to eight handles within an envelope, adjusting each independently,

·T/P·

It is a great idea to add a sound layer to your Flash movie so that you can keep your audio clips in one layer. You did something similar to this in previous practice exercises with the *Actions and Labels* layer. Although this is mainly an organizational tip, it can help keep your timeline from becoming cluttered and difficult to read.

to create your own audio effects. To remove an envelope handle, drag it off the window. You can use these handles and the Effect pull-down menu (at the top left) to apply the same effects you saw in the Effect pull-down menu of the Properties panel.

i) Adjust the following options according to your own preferences.

• *Change the Left or Right channel envelope by dragging the envelope handles to change the volume level at different points in the sound.*

• *Click on the Zoom In or Zoom Out button to display more or less of the sound in the window.*

• *Switch the time increment between seconds and frames by clicking on the Seconds or Frames button.*

j) After trying a couple of these controls, click on OK.

k) Select the menu option Control | Test Movie to preview the movie with your custom sound.

3. Experiment! Try a few more variations on the same sound.

Practice Exercise 16-1: Adding Sound to a Button

Description

In this exercise we will take an existing button and add sound to it. By adding sound, we can enrich the user's experience by giving them another level of response to the button when a mouse event occurs. In this exercise you will:

• *Edit a symbol that already exists in the library*

• *Import the sounds we wish to add*

• *Assign the sounds to the proper button states*

Take a Look

CD-ROM

Before beginning the exercise, let's take a look at the exercise in its completed state so that you can clearly see what it is you are about to build.

·T/P·

Mac users should note that *button_complete.fla* is currently using a WAV file. If your computer cannot play WAV files, you can use the MP3 format in the following exercise.

1. Use the menu option File | Open and locate on the companion CD-ROM the folder named *Chapter16* and the file named *button_complete.fla*. Double click on this file to open it.

2. The file *button_complete.fla* should now appear in your copy of Flash.

3. Select the menu option File | Save As to save a copy of the file in the *SaveWork* folder on your computer using the same file name.

4. Select the menu option Control | Test Movie to see the movie play back. Note the following properties of this completed exercise.

• *Sounds for particular mouse events are nested within the corresponding button symbol frames.*

• *A button can have more than one sound nested within it.*

Storyboard: On Screen

Figure 16-10 shows you what the button will look like on the stage when you have completed this exercise.

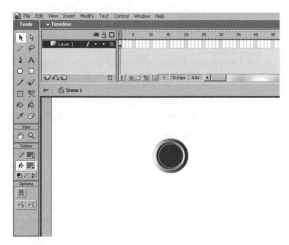

Fig. 16-10. Completed stage.

Storyboard: Behind the Scenes

Figure 16-11 shows what the timeline of the *red_glow_button* symbol will look like when you have completed this exercise.

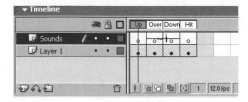

Fig. 16-11. Completed timeline.

Step-by-Step Instructions

1. Let's get busy.
 a) Select the menu option File | Open. Locate and open the *button_01.fla* file in the *Chapter16* folder on the companion CD-ROM.

CD-ROM

Go Solo

b) Save a copy of the file in the *SaveWork* folder on your computer, using the name *button_exercise.fla*.

c) Note that there is only one frame in this movie timeline.

d) Select Control | Test Movie to view the movie. There appears to be a visible difference in the button when you roll over or press the button, but there is no sound. Kind of boring, so let's make it better.

e) Close the test window to return to the main movie.

f) Press Ctrl + L (Mac: Cmd + L) to access the library if it is not already visible.

g) Locate the *red_glow_button* symbol and double click on it to edit the symbol.

·T/P·

We have included both the MP3 and WAV formats. Select and use whichever is compatible with your computer. Make sure you select the same format for the *downclick* and *rollover*.

h) The *red_glow_button* timeline appears. This timeline has the four standard frames that constitute a button symbol: Up, Over, Down, and Hit. These frames all exist within the same layer.

i) Click on the Insert Layer icon in the timeline.

j) Double click on the new layer name and rename it *Sound*.

k) Select the frame in the *Sound* layer that corresponds to the Over frame. Press the F7 key to insert a blank keyframe. There is a difference between inserting a keyframe (F6) and inserting a blank keyframe (F7). If there is content in the preceding keyframe and you use the Insert Keyframe option (F6), the content in that preceding keyframe will be copied and placed onstage at the location of the new keyframe that is being inserted.

In contrast, if you use the Insert Blank Keyframe (F7) option, you will insert a new keyframe without any content, regardless of what is in the preceding keyframe.

In this case we want an empty keyframe, so we used the Blank Keyframe option (F7).

l) Select the frame in the *Sound* layer that corresponds to the Down frame. Press the F7 key to insert a blank keyframe.

2. Now for the sound. Select the menu option File | Import. Locate and then import the *downclick* and *rollover* sound files from the *Chapter16* folder on the companion CD-ROM.

3. Let's apply sound.

a) Select the Over frame in the *Sounds* layer.

b) Select the *rollover* file in the library. Click on the Play button (it looks like a little arrow) in the Library Preview window to get an audio preview of the sound.

c) Drag an instance of the sound onto the stage and drop it anywhere. A thumbnail preview of the sound waveform appears in the Over frame.

 d) Look at the Properties panel. Make sure the Sync field is set to *Event*.

4. Let's apply sound using a different method.
 a) Select the Down frame in the *Sounds* layer.
 b) Select the *downclick* file in the library. Click on the Play button in the Library Preview window to get an audio preview of the sound.
 c) In the Properties panel, click on the pop-up window next to Sound and select the *downclick* file from the list. Make sure that the Sync field is set to *Event*. A thumbnail preview of the sound waveform appears in the Down frame.

5. Let's experience what we have done.
 a) Select the menu option Control | Test Movie to view the movie.
 b) Roll your cursor over the button to trigger the Over sound, and click to hear the Down sound. Pretty sharp! It is easy to see how sound adds so much more to an interactive experience.

Workarounds Regarding the Use of Sound

The biggest limitation of using sound in your Flash projects has to do with file size. Sound files can dramatically increase the size of a Flash movie, and thereby slow down performance. When a movie is published to the SWF format, it is automatically compressed and prepared for the web environment.

Starting with Flash 5 and continuing with MX, it is now possible to import MP3 compressed sounds. MP3 audio files are characterized by small file sizes that retain high-quality sound despite large amounts of compression. MP3 is a codec, or compression algorithm, used specifically for digital sound files. The use of MP3 allows you to import a much smaller sound file into your movie, thus decreasing the overall file size.

As mentioned earlier in this chapter, you can also choose the MP3 option in the Publish settings to compress sounds when they are exported from Flash. Using the Publish settings will globally compress all audio files in your movie using one compression setting upon export. You can also individually set compression settings by using the Sound Properties window in the library, thereby having more control over each sound's compression.

Another workaround for the amount of space that large sound files take up in your movie is to loop smaller sound clips. Looping is extremely helpful if you want a clip to play for an extended period, or if your clip is not long enough when synchronized with the animation in your movie.

17

Application Chapter: Creating Sound Effects

Introduction

The Flash library allows you to store many types of media, including symbols, bitmaps, and sounds. Throughout this book, we have talked about the user experience. Sounds can add a great deal of interest in a site by setting the mood and tone.

It is important to choose sounds selectively and to use them in an effective way. This exercise is designed to show you how richly textured a site can become with the addition of sound effects. If you think of your web site as a separate environment a user is stepping into, you will not want to ignore the auditory senses.

Application Exercise: Creating Sound Effects

Description

In this application exercise you will create sound effects for your site.

Take a Look

CD-ROM

Before beginning the exercise, let's take a look at the exercise in its completed state so that you can clearly see what it is you are about to build.

1. Use the menu option File | Open and locate on the companion CD-ROM the folder named *Chapter17*. Locate the file named *application_17.fla*. Double click on *application_17.fla* to open the file.

2. The file *application_17.fla* should now appear in your copy of Flash.

3. Preview the movie. Take a moment to look through the timeline.

Storyboard: On Screen

Figure 17-1 shows what can be seen on stage when the exercise is completed.

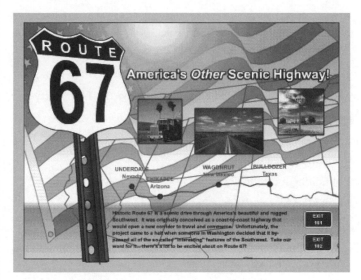

Fig. 17-1. Completed stage.

Storyboard: Behind the Scenes

Figure 17-2 shows how the timeline will look when the exercise is completed.

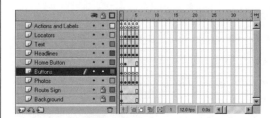

Fig. 17-2. Completed timeline.

Applications Project Steps

Complete this exercise on your own, guided by following the general steps. These steps do not include the details of how to accomplish these tasks, as the "how to" has been covered in earlier chapters. You can always refer back to the completed example you viewed in the "Take a Look" section of this exercise.

NOTE: The following steps are intended as a guide, but this is your project, so feel free to make whatever variations you would like.

1. Open *application_15.fla*. You can either use the copy you created and saved in the *SaveWork* folder on your computer or the copy in the *Chapter15* folder on the companion CD-ROM.

2. Enter Symbol Editing mode for the *Bulldozer, TX* button symbol.

3. Add a new layer and name it *Sound*. Position it below the *Graphic* layer.

4. Insert a keyframe in the Down frame of the *Sound* layer.

5. Drag an instance of the *car_horn* sound file from the *Sounds* folder of the library into the Down frame.

6. Enter Symbol Editing mode for the *Chikapee, AZ* button symbol.

7. Add a new layer and name it *Sound*. Position it below the *Graphic* layer.

8. Insert a keyframe in the Down frame of the *Sound* layer.

9. Drag an instance of the *car_horn* sound file from the *Sounds* folder of the library into the Down frame.

10. Enter Symbol Editing mode for the *Underdale, NV* button symbol.

11. Add a new layer and name it *Sound*. Position it below the *Graphic* layer.

12. Insert a keyframe in the Down frame of the *Sound* layer.

13. Drag an instance of the *car_horn* sound file from the *Sounds* folder of the library into the Down frame.

14. Enter Symbol Editing mode for the *Wagonrut, NM* button symbol.

15. Add a new layer and name it *Sound*. Position it below the *Graphic* layer.

16. Insert a keyframe in the Down frame of the *Sound* layer.

17. Drag an instance of the *car_horn* sound file from the *Sounds* folder of the library into the Down frame.

18. Enter Symbol Editing mode for the *Exit 101* button symbol.

19. Add a new layer and name it *Sound*. Position it below the *Graphic* layer.

20 Insert a keyframe in the Down frame of the *Sound* layer.

21. Drag an instance of the *car_engine* sound file from the *Sounds* folder of the library into the Down frame.

22. Enter Symbol Editing mode for the *Exit 102* button symbol.

23. Add a new layer and name it *Sound*. Position it below the *Graphic* layer.

24. Insert a keyframe in the Down frame of the *Sound* layer.

25. Drag an instance of the *car_engine* sound file from the *Sounds* folder of the library into the Down frame.

26. Enter Symbol Editing mode for the *Go* button symbol.

·T/P·

We have included both MP3 and WAV formats. Select and use whichever format is compatible with your computer.

27. Add a new layer and name it *Sound*. Position it below the *Graphic* layer.

28. Insert a keyframe in the Down frame of the *Sound* layer.

29. Drag an instance of the *car_engine* sound file from the *Sounds* folder of the library into the Down frame.

30. Enter Symbol Editing mode for the *Home* button symbol.

31. Add a new layer and name it *Sound*. Position it below the *Graphic* layer.

32. Insert a keyframe in the Down frame of the *Sound* layer.

33. Drag an instance of the *car_engine* sound file from the *Sounds* folder of the library into the Down frame.

34. Enter Symbol Editing mode for the *Send* button symbol.

35. Add a new layer and name it *Sound*. Position it below the *Graphic* layer.

36. Insert a keyframe in the Down frame of the *Sound* layer.

37. Drag an instance of the *car_engine* sound file from the *Sounds* folder of the library into the Down frame.

38. Return to the main movie timeline. Enable Simple Button Actions and try out the buttons.

39. Save your file as *application_17.fla* in the *SaveWork* folder on your computer.

Organizing

Movies

Introduction

Creating successful Flash projects requires creative energy and dedication, but also depends heavily on project management and organization. Planning how your Flash program is designed and constructed will ultimately affect how efficiently your program will download over the Web. Some important concepts and techniques you will learn about in this chapter are dividing your Flash program into scenes, linking to other external movies, and thinking through your project's organization. By the end of this chapter you will be able to:

- *Use the Scene panel*
- *Add a scene to your movie*
- *Toggle from one scene to another*
- *Use actions to move from one scene to another*
- *Create a preloader*
- *Load and unload external movies with actions*

Using Scenes

Early in this book we used the example of a theatrical or movie production to explain the metaphor used for the Flash interface and environment. When you watch a play, the production is generally divided into scenes. These scenes are creative tools and techniques that allow the screenwriter to organize and develop the story line in a logical and meaningful way – by time period, by location, by event, and so on.

Your Flash program can also be divided into scenes. Using scenes can help you to organize your project content into different categories. How you structure the categories (scenes) and what you put in each scene is often heavily influenced by the type of application you are building (e.g., web site, presentation, instruction, game, and so on), file size, and personal working habits.

There is certainly no requirement or obligation to use more than one scene. This is simply an option that may help you keep more organized. Perhaps an example would help. Let's say you want to build a web site, using Flash to create the entire thing. Take a look at figure 18-1.

Fig. 18-1. Example of designing with Flash scenes.

You are looking at the Magic Media home page and web site interface. The following is one possible organizational scheme for the Flash program.

- *Scene 1, The Jukebox Interface: Includes everything connected with the interface, the animated "bubbles" on each side, an animated banner at the top, and six navigational buttons (these are the categories) across the top.*

- *Scene 2, The General Information Button: Everything that will be displayed or heard concerning the general information. Does not include the Jukebox interface.*

- *Scene 3, The Class Descriptions Button: Everything that will be displayed or heard concerning the Class Descriptions. Does not include the Jukebox interface.*

- *Scene 4, The Class Schedule Button: Everything that will be displayed or heard concerning the Class Schedule. Does not include the Jukebox interface.*

- *Scene 5, The Faculty Button: Everything that will be displayed or heard concerning the Faculty Information. Does not include the Jukebox interface.*

- *Scene 6, The Workshop Button: Everything that will be displayed or heard concerning the Workshop. Does not include the Jukebox interface.*

- *Scene 7, The Products Button: Everything that will be displayed or heard concerning the Products area. Does not include the Jukebox interface.*

As is the case with any development project, the more thoroughly you plan and organize before you start, the better the results in terms of development efficiency and ease of modification.

Playback of Scenes

Scenes allow you to segment or "chunk" part of a long movie timeline into manageable portions. Once you create a scene in your movie, this new scene will appear as a blank movie until you paste or insert content into the timeline. By default, every Flash movie contains one scene when it is created. The Scene icon below the timeline, as illustrated in figure 18-2, indicates which scene you are currently working in.

Scene Icon

Fig. 18-2. Scene icon below the timeline.

You can very easily add a new scene by selecting the menu option Insert | Scene. Once you have multiple scenes to work on, you can select which scene you would like by clicking on the Edit Scene icon (see figure 18-3) and selecting a scene from the pop-up menu that lists all the scenes you have created. Figure 18-3 shows three scenes previously created, with scene 3 selected as the scene to be worked on. In the first practice exercise you will learn how to add and select scenes via the Scene panel.

Fig. 18-3. Edit Scene icon and pop-up menu.

Scenes in your movie are played back linearly – one scene after another – in the same fashion that Flash plays back frames in the timeline. Flash will play back scenes in order, without pause, unless an action is inserted within a frame or an event is triggered that then causes the movie to play in a nonlinear fashion. Essentially, if there are no actions in place to stop or reroute the timeline, Flash reads scenes as if they were all part of the main movie timeline and plays them consecutively in the order they appear in the Scene panel.

Planning Ahead with the Use of Outline and Storyboard

When should you create a new scene? For that matter, what is going to happen in your movie? And what types of user interactions will be added? These are common questions for Flash developers that need to be answered before you start to create your project in Flash. Although this is not a book on multimedia project development, there are some tools that can help you plan your Flash project, before you even launch the program.

Content Outline

Before you begin creating the project in Flash, we suggest using one or more paper-based tools will help you plan, organize, and design your project. The first and simplest tool is the content outline, just like most of us had to create before writing term papers in school. The content outline requires that you think about and "commit to paper" the content you want to include, while also forcing you to deal with how to organize and sequence this content. Going back to our example of the Jukebox web site, a content outline of this concept might look as follows.

I. Jukebox Interface (Scene 1)
- A. Foundation Image
 - 1) Jukebox image (sides/curved top)
 - 2) Speakers
 - 3) Company Name
- B. Navigational Buttons
 - 1) General Information
 - 2) Class Descriptions
 - 3) Class Schedule
 - 4) Faculty
 - 5) Workshops
 - 6) Products
- C. Side Animations
 - 1) Basic Elements
 - 2) Animation Effect 1
 - 3) Animation Effect 2
- D. Banner Animation
 - 1) Basic Elements
 - 2) Animation
- E. Opening Page Animation
 - 1) Basic Elements
 - 2) Animation

II. General (Scene 2)
- A. Company Background
- B. Location and Directions
- C. Local Hotels

And so on.

Content outlines can become even more detailed, including a listing of all elements, conceptual descriptions about art/animation, and directions or notes for programming. There is no "right" or "wrong" approach to a content outline. It is really the issue of whatever will help you organize and plan the project before you actually start to create it.

Storyboard

Another paper-based design tool is the storyboard. What constitutes a storyboard and what it looks like vary quite a bit from one multimedia developer to another. However, the common element is that a storyboard helps you visualize what the screen will look like before you actually create it. A single sheet of paper is generally used to represent a single frame – with a large area where you can "quick-sketch" what the graphic and text elements will look like and where they will be placed on the stage. Frequently, programming

notes are also included, detailing what transition or animation effects will be used, where the current frame will branch to next, what navigational controls are active/ inactive, and other types of information.

Storyboards are planning tools that have long been used by filmmakers, theater directors, set designers, advertisers, and animators as they develop concepts for creative projects. They can be as detailed or as simple as you want, or as time allows, but they are an important part of the development process for most multimedia projects.

Practice Exercise 18-1: Creating a Movie with Multiple Scenes

Description

This exercise will give you practice adding multiple scenes to a movie. You will learn how to paste content into a new scene and will see firsthand how Flash automatically plays back a movie with multiple scenes when no actions are inserted in the timeline. You will also see how changing the order of scenes in the Scene panel affects the playback of your movie.

The movie we are going to use in this exercise includes animation for a fictitious company with an equally fictitious web site. For the sake of this exercise, we will break the existing animation into separate scenes (making it easier to edit parts of the movie without having to work in a single, large timeline). In later exercises we will correct the order of the movie playback. In this exercise you will:

- *Add and label multiple scenes in a movie*
- *Move content from one scene to another*
- *Test playback for a movie with multiple scenes*

Take a Look

Before beginning the exercise, let's take a look at the exercise in its completed state so that you can clearly see what it is you are about to build.

 CD-ROM

1. Use the menu option File | Open and locate on the companion CD-ROM the folder named *Chapter18*. Locate the file named *dotcomsat_1.fla*. Double click on this file to open it.

2. The file *dotcomsat_1.fla* should now appear in your copy of Flash.

3. Select the menu option File | Save As to save a copy of the file in the *SaveWork* folder on your computer using the same file name.

4. Select the menu option Control | Test Movie to view the movie. Note the following properties of this completed exercise.

- *Each scene represents a logical break in the continuity of the movie.*
- *Scenes play in the order they are stacked, unless directed otherwise.*
- *Different scenes within the same movie share a common library.*

Storyboard: On Screen

Figure 18-4 shows you what the stage will look like when this exercise is completed.

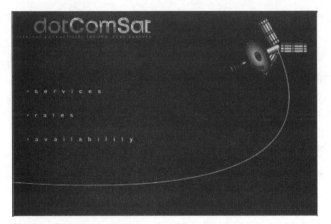

Fig. 18-4. Completed stage.

Storyboard: Behind the Scenes

Figure 18-5 shows you what your timeline in the *Main Body* scene will look like after you have completed this exercise.

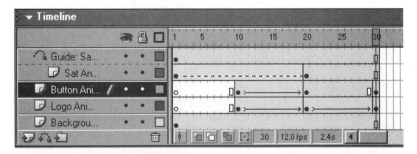

*Fig. 18-5. Completed timeline in **Main Body** scene.*

Step-by-Step Instructions

1. Let's divide and conquer!

 a) Select the menu option File | Open. Locate and select the file named *dotcomsat_start.fla* from the *Chapter 18* folder on the companion CD-ROM. Select File | Save As and save the file into the *SaveWork* folder using the file name *my_dotcomsat_start*.

 b) Select the menu option Window | Scene. The Scene panel appears on screen, with scene 1 listed.

Go Solo

CD-ROM

 c) Click on the Add Scene icon. See figure 18-6. Name the new scene *Intro Animation*. To rename the scene, double click on the current name, type in the new name, and press the Enter/Return key. This should be a familiar process, in that you follow this same procedure to rename layers.

 d) Click on the Add Scene icon and name the new scene *Main Body*.

Duplicate scene | Delete scene
Add scene

Fig. 18-6. Scene panel.

 e) Select scene 1 in the Scene panel to return to the timeline in scene 1.

 f) You may want to use your mouse to click and drag the Layer panel downward so you can see all the layers without scrolling. Select frames 16 through 55 in the following layers.

 - *Guide: Animated Sat*
 - *Animated Sat*
 - *Logo Mask*
 - *Logo*
 - *Blue Spot*

 g) Select the menu option Edit | Cut Frames (make sure you select Cut Frames, located about half way down the Edit menu).

h) Click on the Edit Scene icon located next to the magnification pull-down menu below the timeline. See figure 18-7. Select *Intro Animation* in the Scene panel to go to the *Intro Animation* scene.

Edit Scene icon

Fig. 18-7. Edit Scene icon.

i) Select frame 1 in the *Intro Animation* timeline. Select the menu option Edit | Paste Frames (make sure you select Paste Frames, located about half way down the Edit menu) to paste in all frames and layers you cut from the previous scene.

j) Select the menu option View | Go To | Scene 1 to return to the *Scene 1* timeline.

k) Select frames 56 through 85 in the following layers.

- *Guide: Sat Animation*

- *Sat Animation*

- *Button Animation*

- *Logo Animation*

- *Background Elements*

l) Select the menu option Edit | Cut Frames (make sure you select Cut Frames, located about half way down the Edit menu).

m) Select *Main Body* in the Scene panel.

n) Select frame 1 in the *Main Body* timeline. Select the menu option Edit | Paste Frames (make sure you select Paste Frames, located about half way down the Edit menu).

2. Let's tidy up.

a) Select *Scene 1* in the Scene panel to return to the *Scene 1* timeline.

b) Delete all layers except the two at the top of the stacking order: *Masthead* and *Background Elements*.

c) Select the menu option Control | Test Movie to preview the movie. Deselect the menu option Control | Loop to prevent the playback from looping. The movie plays as it did before. As the playhead gets to the end of one scene, it jumps to the next scene listed in the stacking order of the Scene panel. Close the Test window to return to the main movie.

d) In the Scene panel, drag the *Intro Animation* scene and place it above the *Main Body* scene, just as you have previously done with layers.

Shortcut

To delete multiple layers at once, select the topmost layer you want to delete, hold down the Shift key, and select the bottommost layer you want to delete. All layers in between will also be selected. Then click on the Trash Can icon to delete.

To select multiple layers that are in a random stacking order, hold down the Ctrl key, click on each layer that needs to be deleted, and click on the Trash Can icon.

e) Select the menu option Control | Test Movie to preview the movie. Deselect the menu option Control | Loop to prevent the playback from looping. The order of the playback has now changed, and drastically alters the look and continuity of the movie. We will use actions in the next exercise to control the playback of the scenes (although we could just use the stacking order for a simple movie like this).

f) Close the preview to return to the main movie.

g) Select File | Save As and save the file into the *SaveWork* folder using the file name *my_dotcomsat_1.fla*

Practice Exercise 18-2: Using Actions with Scenes

Description

In this exercise you will use some basic actions to control the way your movie timeline plays from scene to scene. You will see how to stop the timeline from moving to the next scene, and how to set up an action to move to the next scene. In this exercise you will:

* *Add new layers and insert keyframes*
* *Insert the Go To action to change scenes*
* *Change the stacking order of scenes*
* *Insert the Stop Action.*

Take a Look

Before beginning the exercise, let's take a look at the exercise in its completed state so that you can clearly see what it is you are about to build.

1. Use the menu option File | Open and locate the folder named *Chapter18* on the companion CD-ROM. Find the file named *dotcomsat_2.fla*. Double click on this file to open it.

 CD-ROM

2. The file *dotcomsat_2.fla* should now appear in your copy of Flash.

3. Select the menu option File | Save As to save a copy of the file in the *SaveWork* folder on your computer using the same file name.

4. Select the menu option Control | Test Movie to view the movie. Note the following properties of this completed exercise.

 * *The introductory animation automatically plays upon loading the file.*
 * *The main page animation continually plays in a loop.*
 * *The menu choices are not yet active.*

Storyboard: On Screen

Figure 18-8 shows you what the stage will look like when this exercise is completed.

Fig. 18-8. Completed stage.

Storyboard: Behind the Scenes

Figure 18-9 shows you what the timeline will look like when this exercise is completed.

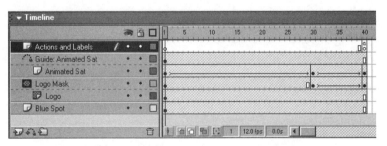

Fig. 18-9. Completed timeline in the Intro Animation scene.

Step-by-Step Instructions

1. Let's get started.

 a) Select the menu option File | Open. Locate and select the file named *dotcomsat_1.fla* from the *Chapter18* folder on the companion CD-ROM, or use the the file *my_dotcomsat_1.fla* that you completed in the last exercise.

Go Solo

CD-ROM

b) Select *Scene 1* in the Scene panel. Add a new layer in the *Scene 1* timeline and rename it *Actions and Labels*. Make sure the new layer is at the top of the stacking order.

c) Insert a keyframe (F6) in frame 15 of the *Actions and Labels* layer.

d) With frame 15 of the *Actions and Labels* layer selected, select the menu option Window | Actions to open the Actions panel if it is not already open.

e) Click on the Actions folder in the Actions panel. Click on the Movie Control subfolder to expand this list of actions.

f) Double click on the Go To action. The following ActionScript code is added to the bottom of your Actions panel.

```
gotoAndPlay (1);
```

g) In the Scene field of the Actions panel, change the option from *<current scene>* to *Intro Animation*. The code now reads as follows.

```
gotoAndPlay ("Intro Animation", 1);
```

h) Select *Intro Animation* in the Scene panel. Add a new layer in the *Intro Animation* timeline and rename it *Actions and Labels*. Make sure the new layer is at the top of the stacking order.

i) Insert a keyframe in frame 40 of the *Actions and Labels* layer.

j) Select frame 40 in the *Actions and Labels* layer.

k) Double click the Go To action. The following ActionScript code is added to your Actions panel.

```
gotoAndPlay (1);
```

l) In the Scene field of the Actions panel, change the option from *<current scene>* to *Main Body*. The code now reads as follows.

```
gotoAndPlay ("Main Body", 1);
```

2. Let's add some finishing touches.

a) Select *Main Body* in the Scene panel. Add a new layer in the *Main Body* timeline and rename it *Actions and Labels*. Make sure the new layer is at the top of the stacking order.

b) Insert a keyframe in frame 30 of the *Actions and Labels* layer.

c) Select frame 30 in the *Actions and Labels* layer.

d) Double click on the Stop action. The following ActionScript code is added to your Actions panel.

```
stop ();
```

e) Select the menu option Control | Test Movie to preview the movie. Deselect the menu option Control | Loop to prevent the playback from looping. The order of the playback is much more fluid and log-

ical. Despite the stacking order in the Scene panel, we are able to control the playback by using basic actions.

f) Close the Test window to return to the main movie.

g) Save your file as *my_dotcomsat_2.fla* in the *SaveWork* folder.

Using a Preloader

A preloader is a small animation program that loads quickly and plays while the main Flash program is loading in the background. The preloader gives the person waiting at the other end of the pipeline a visual indication that something is being downloaded and that the system is not hung up. Many sites use a very simple "Loading" statement with an animated effect that gives the illusion of activity. Some sites also use a countdown that makes its way down to zero over a certain amount of time.

Because Flash uses streaming media, it is not necessary for the entire program file to download before the Flash file begins playing. However, with the use of a preloader, you can ensure that a specified number of frames in the movie have downloaded first so that a user can experience seamless animation as the Flash movie begins to play.

Practice Exercise 18-3: Building a Preloader

Description

Preloaders work by using actions to create a conditional loop attached to a keyframe in the preloader's scene. This conditional loop checks to make sure the specified frame has loaded before it starts playing the next scene in the movie timeline. In this exercise you will:

• *Set up a conditional loop*

• *Create the ActionScript for the condition that all frames of the movie have been downloaded.*

• *Create the ActionScript for the condition that all frames of the movie have not been downloaded.*

Take a Look

CD-ROM

Before beginning the exercise, let's take a look at the exercise in its completed state so that you can clearly see what it is you are about to build.

1. Use the menu option File | Open and locate the folder named *Chapter18* on the companion CD-ROM. Find the file named *dotcomsat_3.fla*. Double click on this file to open it.

2. The file *dotcomsat_3.fla* should now appear in your copy of Flash.

3. Select the menu option File | Save As to save a copy of the file in the *SaveWork* folder on your computer using the same file name.

4. Select the menu option Control | Test Movie to preview the movie. Note the following properties of this completed exercise.

 • *The introductory animation automatically plays upon loading the file.*

 • *The main page animation continually plays in a loop.*

 • *The menu choices are not yet active.*

Storyboard: On Screen

Figure 18-10 shows you what the stage will look like when this exercise is completed.

Fig. 18-10. Completed stage.

Storyboard: Behind the Scenes

Figure 18-11 shows you what the timeline will look like when this exercise is completed.

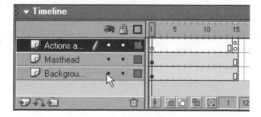

Fig. 18-11. Completed timeline in the **Preloader** *scene.*

Go Solo

CD-ROM

Step-by-Step Instructions

1. Let's get started.

 Select the menu option File | Open. Locate and select the file named *dot-comsat_2.fla* from the *Chapter18* folder on the companion CD-ROM, or use the file *my_dotcomsat_2.fla* that you completed in in the previous exercise.

2. Now let's set up a conditional loop for the preloader.

 a) If the Scene panel is not currently open, select Window | Scene. Double click on the label *Scene 1* in the Scene panel. Rename this scene *Preloader*.

 b) While still in the Preloader scene, select frame 10 of the *Actions and Labels* layer. Insert a keyframe (F6).

 c) In the Properties panel, assign frame 10 the label *Frame Check*, as illustrated in figure 18-12.

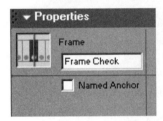

Fig. 18-12. Labeling a frame in the Properties panel.

 d) Open or expand the Actions panel.

 e) Click on the Actions folder in the Actions panel, and then click on the Conditions/Loops subfolder to display the actions that allow you to set up conditional loops.

 f) Double click on the If action. The following ActionScript code is added to the bottom of your Actions panel.

```
if (<not set yet>) {
}
```

 The If action allows you to set up a conditional *if/then* statement in your timeline similar to: *If a certain event occurs, then do....*

 g) Make sure the *if (<not set yet>)* line is highlighted in the code located in the Script window, as shown in figure 18-13. You will now use the Condition field to set up the first part of the if/then statement.

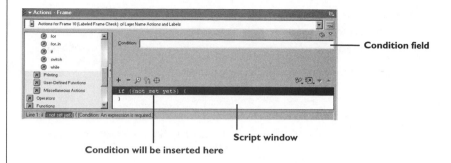

Condition field

Script window

Condition will be inserted here

Fig. 18-13. Script window of the Actions panel.

h) Click on the plus (+) sign (i.e., the Add New Item to Script button) found above the Script window, as shown in figure 18-14. This pull-down menu allows you to quickly scroll through menus that correspond with the blue icons found in the left-hand pane of the Actions panel.

Add New Item to Script button

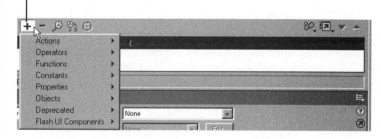

Fig. 18-14. Add New Script Item button.

i) Having clicked on the Add New Item to Script button, you should now see a pop-menu. Scroll to Properties/_framesloaded. Click on the _framesloaded property to replace the <not yet set> portion of the *if* statement with the new code. Your code should now read as follows.

```
if (_framesloaded) {
}
```

j) Let's finish the *if* portion of the statement and then break it down. Click on the Add New Item to Script button again and scroll to Operators/Comparison Operators. Select >= from the list, and click to add it to the code. Your code should now read as follows.

```
if (_framesloaded>=) {
}
```

·T/P·

For those of you who worked with earlier versions of Flash, you may have used the *ifFrameLoaded* action to create a preloader. The use of this action has been deprecated, or is discouraged. Instead, *_framesloaded* is encouraged, because there is more flexibility to create customized *if* / *then* then statements.

k) Click on the Add New Item to Script button again and scroll to Properties/_totalframes. Click on the _totalframes property to add this to your *if* statement. Your code should now read as follows.

```
if (_framesloaded>=_totalframes) {
}
```

l) Let's break this statement down.

if: Sets up an initial condition that must be met in order for something else to happen

(_framesloaded>=_totalframes) – the condition that must be met.

_framesloaded: Indicates the number of frames that have been loaded in a movie while it is streaming.

>= : Greater than or equal to.

_totalframes: Refers to the total number of frames in a movie or movie clip instance.

So, if we put this all together, if the frames loaded during movie streaming are greater than or equal to the total number of frames in the movie, then . . . what?

3. So, what happens then?

a) We have set up our condition. Now we must indicate what happens when that condition is met.

b) Click on the Add New Item to Script button and select Actions | Movie Control | *goto*. Click on *goto* to add this line to your code. Your code should now read as follows.

```
if (_framesloaded>=_totalframes) {
gotoAndPlay(1);
}
```

c) With the *gotoAndPlay(1)* line highlighted, use the pull-down menu in the Scene field to select *Intro Animation*. See figure 18-15. Your code should now read as follows.

```
if (_framesloaded>=_totalframes) {
gotoAndPlay("Intro Animation", 1);
}
```

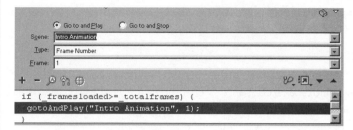

Fig. 18-15. ActionScript in progress.

d) Let's put it all together. Our *if/then* statement now says that if the frames loaded during movie streaming are greater than or equal to the total number of frames in the movie, the movie will jump to the *Intro Animation* scene and automatically begin playing this scene at frame 1.

4. Now we have to define what happens if all frames in the movie are not loaded.

a) Select frame 15 in the *Actions and Labels* layer of the *Preloader* scene. Let's now modify the code that already exists in the Script window.

b) Click on the line of code and use the pull-down menu in the Scene field to select Preloader. Now select the Type field to select the Frame Label option. Finally, use the pull-down menu in the Frame field and select the Frame Check option. The code now reads as follows.

```
gotoAndPlay ("Preloader", "Frame Check");
```

Remember, early on in this exercise we labeled frame 10 *Frame Check* to indicate that in frame 10 Flash should check to see if all frames are loaded. If the conditional statement in frame 10 is not met, the timeline will play to frame 15, at which point it loops back to the frame labeled *Frame Check* and the entire *if/then* statement is checked once again. It will continue to loop this way until the condition has been met.

c) Select the menu option Control | Test Movie to view the movie. Deselect the menu option Control | Loop to prevent the playback from looping. Because the file is already on your system, you may not notice any delay or file buffering from downloading it. You can emulate the download by selecting View | Show Streaming from the menu, adjusting the download speed by selecting the menu option Debug, and then selecting any of the modem speed presets.

d) Close the Test window to return to the main movie.

e) Save your file as *my_dotcomsat_3.fla* in the *SaveWork* folder.

Practice Exercise 18-4: Loading and Unloading Movies

Description

We are continuing to build on the program we have been developing throughout the practice exercises in this chapter. In the final exercise of this series, you will learn how to load and unload external movies from your main movie timeline. In this exercise you will:

- *Set up a Load Movie action*
- *Set up an Unload Movie action*
- *Set up all menu selection controls*

Take a Look

Before beginning the exercise, let's take a look at the exercise in its completed state so that you can clearly see what it is you are about to build.

1. You will need SWF files in order to proceed.
 a) Select the menu option File | Open. Locate and select the following files from the *Chapter18* folder on the companion CD-ROM. Save (Save As) each file, using its original name, into the *SaveWork* folder on your local hard drive.

 - *intro_info.fla*
 - *availability_info.fla*
 - *rates_info.fla*
 - *services_info.fla*

 b) Select the menu option Control | Test Movie to view each movie. (Testing will produce the SWF file for each movie and save it in the *SaveWork* folder. Note that we have also included the SWF version of each file on the companion CD-ROM, in the *Chapter18* folder.) Close all files.

2. Use the menu option File | Open and locate on the companion CD-ROM the folder named *Chapter18*, and then locate the file named *dotcomsat_final.fla*. Double click on this file to open it.

3. The file *dotcomsat_final.fla* should now appear in your copy of Flash. Select File | Save As and save the file using the same file name into the *SaveWork* folder.

4. Select the menu option Control | Test Movie to test the movie. Note the following properties of this completed exercise.

- *To preview this exercise, you must have performed steps 1a and 1b of this "Take a Look" section to publish the SWF files necessary for the menu selection Load Movie Action.*

- *The main file has multiple animation loops.*

- *Each menu selection loads a new file with additional information.*

Storyboard: On Screen

Figure 18-16 shows you what the stage will look like when this exercise is completed.

Fig. 18-16. Completed stage.

Storyboard: Behind the Scenes

Figure 18-17 shows you what the timeline will look like when this exercise is completed.

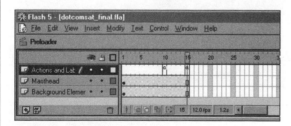

Fig. 18-17. Completed timeline.

Step-by-Step Instructions

1. Let's begin the last exercise in this series.

Go Solo

a) Select the menu option File | Open. Locate and select the file named *dotcomsat_3.fla* from the *Chapter18* folder on the companion CD-ROM, or use the file *my_dotcomsat_3.fla* that you completed in the last exercise.

b) If you did not perform steps 1a and 1b in the "Take a Look" section, you will need to complete steps b, c, and d before proceeding. If you already performed these steps, you can skip to step 2.

Select the menu option File | Open. Locate and select the following files from the *Chapter18* folder on the companion CD-ROM. Select the menu option File | Save As and save each file, using its original name, into the *SaveWork* folder on your computer.

- *intro_info.fla*
- *availability_info.fla*
- *rates_info.fla*
- *services_info.fla*

c) Select the menu option Control | Test Movie to view each of the Flash files previously listed. As each Flash file is tested, it creates an SWF file in the same directory in which the Flash authoring FLA files are located. These SWF files are the files that will be loaded into a movie when the Load Movie or Unload Movie actions are used.

d) Close all movie previews, and close *intro_info.fla*, *availability_info.fla*, *rates_info.fla*, and *services_info.fla*.

2. First, we want to set up the Load Movie action via a Frame action.

a) In the *Main Body* scene of *dotcomsat_3.fla*, select frame 30 of the *Actions and Labels* layer. There is a Stop action there that prevents the timeline from going on to the third scene, *Intro Animation*. See figure 18-18.

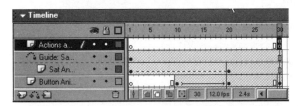

Fig. 18-18. Stop action in frame 30 of the Main Body scene.

b) In the Script window in the Actions panel, click to highlight the *stop* code. Click on the Actions folder in the Actions panel, click on the Browser/Network subfolder, and double click on the Load Movie action.

c) In the URL field of the Actions panel, type in *intro_info.swf* and change the Location field option to Level 1. The code now reads as follows.

Levels represent the hierarchy of movies that have been loaded into the Flash Player. The root movie is level 0, with each subsequent movie loaded occupying a different level in relation to the others. Level 0 is considered the parent layer, which also dictates such things as frame rate of movies on other levels.

```
stop ();
  loadMovieNum ("intro_info.swf", 1);
```

This loads an external movie into our main movie.

d) Select the menu option Control | Test Movie to view the movie. Deselect the menu option Control | Loop to prevent the playback from looping. When the movie preview gets to the last frame, *intro_info* is loaded into the main movie. Note the *Welcome* text that appears. But suppose we want to replace this information when the Services, Rates, and Availability buttons are pressed? This calls for the Unload Movie action!

3. We need to now set up the remaining controls.

 a) Select frame 30 of the *Button Animation* layer in the *Main Body* scene.

 b) Select the menu option Window | Library to open the *dotcom-sat_3.fla* library. Drag an instance of the *Invisible Button* symbol onto the stage. Use the Info panel to position it with center registration at X=136 and Y=156.

 c) With the button instance still selected, open or expand the Actions panel. Click on the Add New Item to Script button (+) and select the Actions | Movie Control | On action to add to your code. The code now reads as follows.

   ```
   on (release) {
       }
   ```

 d) With the first line of code selected, use the Add New Item to Script button to select Actions | Browser/Network | *unloadMovie*. In the Location field of the Actions panel, change the Location option to 1. The code now reads as follows.

   ```
   on (release) {
       unloadMovieNum (1);
       }
   ```

 e) With the second line of code selected, use the Add New Item to Script button to select Actions | Browser/Network | *loadMovie*. With the new line of code selected, type in *services_info.swf* in the URL field and change the Location option to 1. The code now reads as follows.

   ```
   on (release) {
       unloadMovieNum (1);
       loadMovieNum ("services_info.swf", 1);
       }
   ```

 f) Create a duplicate of the *Invisible Button* instance you have just assigned the script to. Use the Info panel to position it at X=136 and

·T/P·

The URL field in the *loadMovie* action indicates where to find the movie that will be loaded into the current movie. In this exercise, we are using relative links to the movie files. Therefore, according to the path in this URL, the SWF file to be loaded must be located in the same folder as our current file. You could just as easily use an absolute link to a full web address (e.g: *http://www ...*) in the URL field.

·T/P·

Create a duplicate by using the menu option Edit | Duplicate, or the keyboard shortcut Ctrl + D (Mac: Cmd + D).

Y=201, with center registration. You might need to collapse the Actions panel to see your stage better.

g) With the second button instance still selected, expand the Actions panel. Select the third line of code. Type in *rates_info.swf* in the URL field. The code now reads as follows.

```
on (release) {
  unloadMovieNum (1);
  loadMovieNum ("rates_info.swf", 1);
}
```

h) Create a duplicate of the *Invisible* button instance you have just assigned ActionScript to. Use the Info panel to position it at X=136 and Y=248. Collapse your Actions panel if you need to see your stage better.

i) With the third button instance still selected, expand the Actions panel and select the third line of code. Type in *availability_info.swf* in the URL field. The code now reads as follows.

```
on (release) {
  unloadMovieNum (1);
  loadMovieNum ("availability_info.swf", 1);
}
```

So what does this code actually do? For starters, a press and release of any button will unload any movie that happens to be loaded in level 1. This includes the movie loaded due to the Frame action you assigned earlier. (Remember, the movie loaded in the Frame action consists of welcome text.) This will also take care of any movie you load with the use of the other buttons. After the movie is unloaded, the *loadMovieNum* code will load a new movie in its place--essentially replacing the welcome text with new text related to each link.

4. Let's try it out.

a) Select the menu option Control | Test Movie to preview the movie. Deselect the menu option Control | Loop to prevent the playback from looping. The *intro_info.swf* movie is loaded because of the Frame action in the last frame. When we press a button, we unload whatever movie is loaded into level 1 and replace it with another.

b) Close the preview to return to the main movie.

c) Save your file as *my_dotcomsat_final.fla* in the *SaveWork* folder.

CHAPTER

19

Application

Chapter: Setting

Up Scenes

Introduction

A large part of completing a successful and functional Flash site is planning the structure of your site. Early on in this application project, you created a scene that represents the main body of your Flash site. Now it is time to create additional structural features to enrich the interface design.

One of the features in Flash that can help you structure your project is the ability to create scenes. Scenes allow you to divide your movie into categories that act as separate timelines. With the addition of some simple actions, you can control how the buttons in your interface navigate between the scenes and how they play each of these timelines.

You can also use other actions to load external movies into your main web site. Learning how to use these features will help you think about how you want to structure sites in the future.

Application Exercise: Setting Up Scenes

Description

This application exercise allows you to link the movies you have been working on by adding scenes. You will also add commands so that some of these movies can be loaded or unloaded into your main movie file. When you finish this exercise, you will have the basis of a well-constructed web site.

Take a Look

CD-ROM

Before beginning the exercise, let's take a look at the exercise in its completed state so that you can clearly see what it is you are about to build.

1. Use the menu option File | Open and locate on the companion CD-ROM the folder named *Chapter19*. Locate the file named *application_19.fla*. Double click on this file to open it.

2. The file *application_19.fla* should now appear in your copy of Flash.

3. Select the menu option File | Save As to save a copy of the file in the *SaveWork* folder on your computer using the same file name.

4. Select the menu option Control | Test Movie to view the movie.

Storyboard: On Screen

Figure 19-1 shows what can be seen on stage when the exercise is completed.

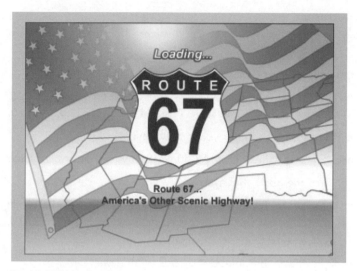

Fig. 19-1. Completed stage.

·T/P·

All application exercises from this chapter forward will make use of the WAV format for sounds. However, we have supplied each library, in each exercise, with the MP3 format for all sound files. If you would like to change the sound format, please do so. If you are using the MP3 format, you may find it more convenient to use your version of the last completed exercise for the beginning of the next application exercise.

Storyboard: Behind the Scenes

Figure 19-2 shows how the timeline will look when the exercise is completed.

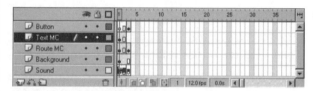

Fig. 19-2. Completed timeline.

Applications Project Steps

Complete this exercise on your own, guided by following the steps. These steps do not include the details of how to accomplish these tasks, as the "how to" has been covered in earlier chapters. You can always refer back to the completed example you viewed in the "Take a Look" section of this exercise.

NOTE: The following steps are intended as a guide, but this is your project, so feel free to make whatever variations you would like.

1. Open *application_17.fla*. You can either use the copy you created and saved in the *SaveWork* folder on your computer or the copy in the *Chapter17* folder on the companion CD-ROM.

2. Create a new scene and name it *Preloader*. Move it above the *Index* scene in the scene stacking order. You will use this layer in the next application exercise.

3. Rename the existing layer in the *Preloader* timeline as *Background*.

4. Drag an instance of the *Total Background* symbol out of the *Graphic Images* folder of the library and onto the stage. Position it at X= 320.0, Y=140.0.

5. Insert two (2) more frames in the *Background* layer.

6. Create a new layer and name it *Route MC*. Move it above the *Background* layer.

7. Select frame 1 of the *Route MC* layer.

8. Drag an instance of the *Route Movie* movie clip symbol out of the *Movie Clips* folder in the library and onto the stage. Position it at X= 320.0, Y=198.6.

9. Insert a blank keyframe in frame 3 of the *Route MC* layer.

10. Select frame 3 of the *Route MC* layer.

11. Drag an instance of the *Route 67* graphic symbol out of the *Graphic Images* folder in the library and onto the stage. Resize it to W=208.1, H=207.9, and position it at X=320.0, Y=198.6.

12. Create a new layer and name it *Text MC*. Move it above the *Route MC* layer.

13. Select frame 1 of the *Text MC* layer.

14. Drag an instance of the *Loading* graphic symbol out of the *Graphic Images* folder in the library and onto the stage. Position it at X= 326.3, Y=67.3.

15. Drag an instance of the *Text Movie* movie clip symbol out of the *Movie Clips* folder in the library and onto the stage. Position it at X= 316.9, Y=356.6.

16. Delete frame 3 of the *Text MC* layer.

17. Create a new layer and name it *Button*. Move it above the *Text MC* layer.

18. Select frame 3 of the *Button* layer and insert a blank keyframe.

19. With frame 3 of the *Button* layer selected, drag an instance of the *Go* button symbol out of the *Buttons* folder in the library and onto the stage. Position it at X=320.0, Y=370.8.

20. Assign the following ActionScript to the instance of the *Go* button symbol.

```
on (release) {
  gotoAndStop ("Index", "Home");
}
```

21. Create a new layer and name it *Sound*. Move it to the bottom of the layer stacking order.

22. Select frame 1 of the *Sound* layer and use the Sound panel to insert the *Loading_beat* sound symbol.

23. Set the sound properties as follows: Effects (None), Sync (Start), and Loops (50).

24. Select frame 3 of the *Sound* layer and insert a keyframe.

25. With frame 3 selected, set the sound properties as follows: Sound (*Loading_beat*), Effects(None), Sync (Stop), and Loops (0). This will stop *Loading_beat* from playing. You will set up the rest of this scene in a later exercise.

26. Create a new scene and name it *Contact*. Move it below the *Index* scene in the scene stacking order.

27. Drag an instance of the *Total Background* symbol out of the *Graphic Images* folder of the library and onto the stage. Position it at X= 320.0, Y=140.0.

28. Rename the existing layer in the *Contact* timeline *Background*.

29. Select frame 1 of the *Background* layer and drag an instance of the *Questions* graphic symbol out of the *Graphic Images* folder of the library and onto the stage. Position it at X= 361.3, Y=112.9.

30. With frame 1 of the *Background* layer still selected, drag an instance of the *Road Sign* graphic symbol out of the *Graphic Images* folder of the library and onto the stage. Resize it to W=208.8, H=483.5, and position it at X= 112.3, Y=221.2.

31. Insert one (1) more frame in the *Background* layer.

32. Create a new layer and name it *Home Button*. Move it above the *Background* layer.

33. Select frame 1 of the *Home Button* layer.

34. Drag a copy of the *Home Button* symbol out of the *Buttons* folder in the library and position it at X=46.0, Y=447.1.

35. Assign the following ActionScript to the instance of the *Home Button* symbol

```
on (release) {
  gotoAndStop ("Index", "Home");
}
```

You will set up the rest of this scene in a later exercise.

36. Save your file as *application_19.fla* into the *SaveWork* folder.

·TIP·

Use whichever sound format you wish. Both MP3 and WAV have been provided in the library.

C H A P T E R

20

Publishing

Flash Movies

Introduction

Publishing is the final step in creating your Flash movies. To publish means to make available for widespread public distribution. Once you reach the publishing stage, you will be choosing how to package your movie so that it can be distributed to your audience. There are several ways a Flash movie can be packaged. You have had a lot of practice in previous chapters building interactive movies. The standard FLA file allows you to edit movies in Flash, but is not viewable through a browser. To use Flash files in an HTML document, or even as a standalone presentation, you must publish your movie in the appropriate format. By the end of this chapter you will be able to:

- *Change the Flash Publish settings for a specified format output*
- *Publish a Flash movie*
- *Use the Bandwidth Profiler to optimize your movies before export*
- *Describe the role of the Flash Player*
- *Describe the general process of inserting a Flash movie into an HTML file, using Dreamweaver*

·T/P·

You can choose to publish or export your Flash projects. These terms refer to the same process, but each produces very different results, as you will discover in the details presented in the next couple of sections.

Shortcut

The Publish shortcut is: Shift + F12 (PC and Mac)

Publishing Your Movie

Once you finish creating your movie, the next step is to publish it in one or many formats. You have two options when you publish your file. You can either use the Export feature to specify one file format for your movie, or use the Publish Settings option to specify multiple file formats and publish them all at once. When you test movies in Flash using the Control | Test Movie command, you may have noticed that instead of creating a temporary file Flash generates an SWF file with the same file name as your FLA file. The SWF file is added to the same directory. This SWF file is a Shockwave file created in order to display all actions and movie clips in your project accurately – just as they would display when viewed through a browser or projector.

Export Options

There are two export options in Flash: Export Image and Export Movie. When you export a file in Flash you are actually saving and converting the existing FLA file into another file format. Exporting is similar to publishing because you are generating new file types based on the original movie. However, when you export your Flash movie, you can only choose one format at a time. The export options available in Flash allow you to use your movies, or images from your movies, in a wide variety of formats.

Export Image

Selecting the menu option File | Export Image produces a list of "save" options that convert selected frames of your movie into static graphic images. You can select these file types by choosing from the format options shown in figure 20-1.

·T/P·

When you use the Export Image option for saving out static images from your Flash movies, Flash exports the graphics placed on the stage from the frame you have currently selected.

Fig. 20-1. Format options in the Export Image dialog window.

The formats described in the sections that follow are available for exporting static images of individual frames of your Flash movie files.

Windows and Mac Platforms

- *Adobe Illustrator (AI): Adobe Illustrator format allows you to use Flash files in a drawing program such as Illustrator or FreeHand.*

- *AutoCAD DXF: This file format is used to export files for use with CAD software.*

- *EPS 3.0 with preview: Encapsulated Postscript File, often used for importing graphics into desktop publishing applications.*

- *Flash Player SWF: Shockwave file format used for delivering Flash movies through the Flash Player, generally through the Flash Player plug-in on a web site. This file format is not editable in Flash, although files in this format can be imported into Flash and converted back to FLA file format. You do have the option of protecting (locking) SWF files during the export process, so that they cannot be imported and edited by other users.*

- *FutureSplash Player (SPL): FutureSplash was the precursor to Macromedia Flash. You can still export Flash files as FutureSplash files. However, they can lose some of their Flash MX functionality.*

- *GIF Image: A compression format developed by CompuServe that is used for images with 256 colors or less. This file format supports transparency and interlacing. This format is one of the most common image formats on the Web today.*

- *JPEG Image: A "lossy" compression format used for 24-bit images. This format is one of the most common image formats on the Web today. Supports progressive download, but does not support transparency.*

- *PNG Image: A file compression format developed for use on the Web, although it is not used or supported as frequently as GIF or JPEG. PNG is also the native file format for files created in Macromedia Fireworks. PNG files combine the characteristics of GIF and JPEG files, such as interlacing, smoothing, and dithering. PNG also supports multiple levels of transparency.*

Mac-only Export

- *PICT File (PCT or PIC): This bitmap format can be exported from a wide variety of image editing programs and is considered the native file format for bitmaps generated on a Macintosh.*

Windows-only Export

- *Bitmap (BMP): This image format can be exported from a wide variety of image editing programs and is considered the native file format for Windows users.*

- *Enhanced Windows Metafile (EMF): Common Windows file format in 32-bit applications, created to replace Windows Metafiles (WMF).*

- *Windows Metafile (WMF): Common Windows 3.x file format.*

Shortcut

The keyboard shortcut for exporting a movie is:

Ctrl + Alt + Shift + S (PC)

Option + Shift + Command + S (Mac)

Export Movie

Selecting the menu option File | Export Movie produces a list of file formats for saving your movie into the common SWF format, as well as other movie formats. You can select these file types from the format options shown in figure 20-2. There are several other formats that are not available through the Export Movie or the Export Image menu option. If you want to save stand-alone projector files, such as a Windows EXE file, you will find this option under the Publish Settings option, discussed in material to follow.

Fig. 20-2. Format options in the Export Movie dialog window.

The file formats discussed in the following sections are available for exporting Flash movie files.

Windows and Mac Platforms

• *Adobe Illustrator (AI) Sequence: Adobe Illustrator format allows you to export a sequence of frames for use in a vector drawing program such as Illustrator or FreeHand.*

• *Animated GIF: Popular file format for saving small, self-running frame-by-frame animations for web pages that do not require a plug-in.*

• *DXF Sequence: Converts each frame in the movie into individual DXF files.*

• *EPS 3.0 Sequence: Encapsulated Postscript File; creates a series of EPS files based on each frame in the movie timeline.*

• *Flash Player (SWF): File format used for delivering Flash movies through the Flash Player, generally through the Flash Player plug-in on a web site. This file format is not editable in Flash, although they can be imported into Flash and converted back to an FLA file format. However, you do have the option of protecting (locking) SWF files during the export process, so that they cannot be imported and edited by other users.*

• *FutureSplash Player (SPL): FutureSplash was the precursor to Macromedia Flash. You can still export a movie in FutureSplash format, although you may lose some of the capabilities of Flash MX in the conversion.*

• *GIF Sequence: Converts each frame in the movie into individual GIF files.*

- *JPEG Sequence: Converts each frame in the movie into individual JPEG files.*
- *PNG Sequence: Converts each frame in the movie into individual PNG files.*

Windows Only

- *Bitmap (BMP) Sequence: This image format can be exported from a wide variety of image editing programs and is considered the native file format for Windows users.*
- *Enhanced Windows Metafile (EMF) Sequence: Common Windows file format in 32-bit applications, created to replace Windows Metafiles (WMF).*
- *Windows AVI: Converts movies into Windows video by changing files into a series of bitmaps, but does not preserve any interactivity.*
- *Windows Metafile (WMF) Sequence: Common Windows 3.x file format.*
- *WAV Audio: Exports only the sound from a movie into a WAV sound file.*

Mac Only

- *PICT Sequence (PIC, PCT): Creates a series of PICT files based on each frame in the movie timeline.*
- *QuickTime Video (MOV): Converts files into a series of bitmap images that can be played back through the QuickTime Player as QuickTime video.*

Publish Settings

Using the Export feature to save your Flash movie into multiple formats requires that you repeat the Export Image or Export Movie command for each type of file you want to create. Flash includes another option, Publish Settings, which allows you to choose multiple file settings for export, as well as other publishing options that are not available through the Export feature. For example, Publish Settings allows you to select an option for creating an HTML file with the code already inserted for displaying your Flash movie. In addition, you can choose to create a standalone projector file for both Windows and Macintosh through the Publish Settings window.

Publish Settings also allows you to set global export of sound compression and load options for your Flash movie in one window, without having to export your movie multiple times. All file formats selected are published at once through the Publish Settings window, and are simultaneously saved in multiple formats. Selecting the menu option File | Publish Settings opens the Publish Settings window, shown in figure 20-3. The tabs at the top of this window allow you to toggle between different options. The guided tour that follows will give you a closer look at the Publish Settings feature and the choices on each tab.

Fig. 20-3. Publish Settings feature.

Selecting the menu option File | Publish Preview provides you with an opportunity to view your movie in the output setting of your choice. Figure 20-4 shows you the options available. Notice that some options in the Publish Preview list are grayed out and unavailable for viewing. The Publish Preview options that are available are based on the choices made in the Publish Settings feature. The default options available are Flash and HTML. Selecting the HTML option creates an HTML file for your SWF file. This HTML file contains code that will allow your movie to be displayed through your browser. Selecting Flash Preview will launch a sample SWF file, just like the file created when you select Control | Test Movie.

Fig. 20-4. Publish Preview options.

Guided Tour 20A: Publish Settings

1. Select the menu option File | Publish Settings. Note that there are three default tabs on the Publish Settings dialog window: Formats, Flash, and HTML. See figure 20-5. This is where you select the file formats and specifications for the files you want to publish.

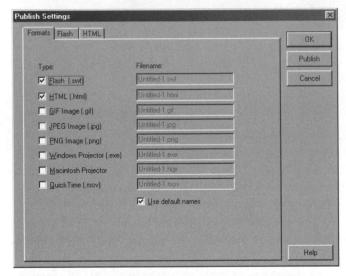

Fig. 20-5. Default tabs in the Publish Settings dialog window.

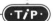
2. Click on the box next to each of the formats listed here. Note that as you place a check mark in each box a corresponding tab is added to the Publish Settings window. Selecting the box next to any of the formats shown on this tab will activate and add the corresponding panel, with its various adjustable options. See figure 20-6. Let's take a closer look at each panel.

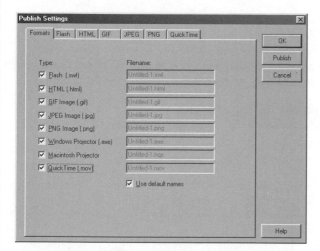

Fig. 20-6. Publish Settings window showing all formats.

3. Select the Flash tab and look at its options, shown in figure 20-7.

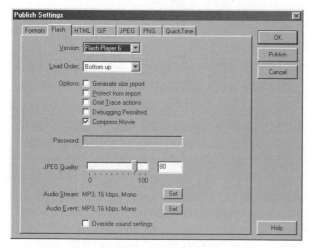

Fig. 20-7. Flash tab and options.

- *Version: Designates which version of the Flash Player you are publishing for. Not all of Flash MX's features will work in movies published as earlier Flash versions.*

- *Load Order: Sets the order in which Flash will load and draw a movie's layers for display in the Flash Player. The movie will either load per the Bottom Up or Top Down option.*

• *Generate Size Report: Produces a report that gives you the breakdown of data in the final Flash Player file, showing you which frames could cause potential slowdowns over an Internet connection. This file is saved in the same folder as your exported movie, and can be opened in Notepad (Windows), SimpleText (Mac), or any other text editor. See figure 20-8.*

Fig. 20-8. Sample size report.

·T/P·

If you do not want others to be able to edit or copy any part of your Flash application, make sure to select Protect from Import.

• *Protect from Import: Prevents viewers from importing your SWF file and converting it back into a Flash movie for editing.*

• *Omit Trace Actions: Makes Flash ignore any Trace actions in the movie. Trace actions are an ActionScript code that can help you test and debug a movie by sending comments to the Output window during playback. Omit Trace Actions prevents the Output window from opening and displaying your trace comments.*

• *Debugging Permitted: Activates and allows the debugging of a Flash movie from a remote location. You can choose to password protect your movie file if you select this option. Right-clicking (Mac: Ctrl + click) on the movie as it plays in the browser will activate the Debugger. If someone opens your movie with the Debugger, they can potentially learn how you created certain applications unless debugging is off or is password protected.*

• *Compress Movie: Placing a check mark in this field will compress the Flash movie to reduce file size and download time. By default, this option is checked as On. This option has the greatest effect when a file has a lot of text or ActionScript. A compressed file only plays with the Flash Player 6.*

• *Password: Type in a password to restrict unauthorized access and debugging of a Flash movie that has debugging permission. To remove your password, delete the information in the Password field. This field is inactive unless Debugging Permitted has been selected.*

• *JPEG Quality Slider: Used to globally control bitmap compression throughout your movie. Low quality creates smaller files, whereas high quality creates larger files. The 100 setting provides the highest quality and least compression.*

• *Audio Stream: Clicking on the Set button opens a window in which you can set the exported stream rate and compression for all movie sounds set to Stream in the Sound panel.*

• *Audio Event: Clicking on the Set button opens a window in which you can set the exported rate and compression for all movie sounds set to Event in the Sound panel.*

• *Override Sound Settings: Overrides any settings in the Sound Properties window found in the library for your individual sounds. It also creates a larger high-fidelity audio movie for local use, and a smaller low-fidelity version for the Web.*

4. Select the HTML tab and look at its options. See figure 20-9.

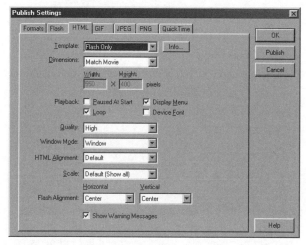

Fig. 20-9. HTML tab and options.

• *Template: The pull-down menu in this option gives you a variety of options for creating support files that will display the movie in different players and browsers. Basic templates contain code for displaying the movie in a browser. More advanced templates contain the necessary HTML code for enabling browser detection and other such features, as well as calling up plug-ins*
for things such as the QuickTime Player.

• *Info Button: Select a particular Template option, and then select the Info button next to it, to get more information about each template available in the pull-down Template menu.*

• *Dimensions: Sets the values of the Width and Height attributes in the Object and Embed tags. Match Movie maintains the current size of the movie. Pixels allows you to enter the number of pixels in the Width and Height fields. Percent uses a percentage relative to the browser window.*

• *Playback: These options control the characteristics of playback, as well as other control features for a movie when it is displayed in a browser. Paused At Start pauses the movie until a user clicks on a button in the movie or selects Play from the shortcut menu. Loop repeats the movie playback when it gets to the last frame of the movie. Display Menu displays a shortcut menu when users right click (Mac: Control + click) on the movie in their browser. See figure 20-10 for an example of the Display menu. Device Font directs your movie to pull fonts that most closely resemble the device fonts specified in your movie from your user's hard drive.*

See Chapter 7 for a more complete discussion of device fonts.

Fig. 20-10. Display menu.

• *Quality: Determines the trade-off between processing speed and applying antialiasing. Low prioritizes playback speed over appearance and does not antialias objects or text. Auto Low initially prioritizes speed but improves appearance whenever possible. Auto High prioritizes speed and appearance equally at first but decreases appearance for speed whenever necessary. Medium will antialias, but does not smooth bitmaps. High prioritizes appearance over speed and always uses antialiasing. It will smooth bitmaps if the movie does not contain animation, but bitmaps are not smoothed if the movie has animation. Best prioritizes the display quality and does not consider speed at all. Output is antialiased, and bitmaps are always smoothed.*

- *Window Mode: This is for Windows Internet Explorer 4.0+ with the Flash ActiveX control. Window plays a Flash Player movie in its own window on a web page. Opaque Windowless moves elements behind your Flash movies to restrict them from showing through. Transparent Windowless shows the background of the HTML page on which the movie is embedded through any transparent areas within the movie.*

- *HTML Alignment: This option positions the Flash movie window within a browser window. Default centers the movie in the browser window and crops the edges if the browser window is smaller than the movie. Left, Right, Top, or Bottom aligns the movie along that particular edge of the browser window, and then crops the remaining three sides if needed.*

- *Scale: Places the movie within specified boundaries if you have changed the movie's original width and height. Default (Show All) displays the entire movie in the specified area while maintaining the original aspect ratio of your movie. No Border scales the movie to fill a specified area, and keeps the movie's original aspect ratio, although it crops the movie if necessary. Exact Fit will display the entire movie in a specified area without maintaining its original aspect ratio.*

- *Flash Alignment: Sets how the movie is placed within the movie window and how it is cropped, if necessary. Horizontal allows you to select the Left, Center, and Right options. Vertical alignment allows you to select the Top, Center, and Bottom options.*

- *Show Warning Messages: This setting displays error messages if tag settings are in conflict.*

5. Select the GIF tab and look at its options. See figure 20-11.

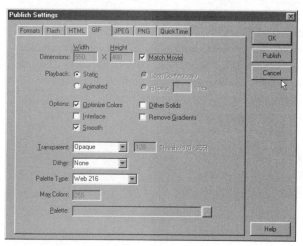

Fig. 20-11. GIF tab and options.

> **⚠ CAUTION**
>
> You must have GIF selected (a check mark placed next to the option) on the Format tab for the GIF tab to appear in the Publish Settings window.

• *Dimensions: Allows you to either enter a width and height in pixels for the exported bitmap image or to select Match Movie to make the GIF the same size as the Flash movie.*

• *Playback: Determines whether Flash will create a still (static) image or an animated GIF (animation). If you select Animated, you can then select Loop Continuously, or enter the number of times you want it to loop before going static.*

• *Options: Establishes a number of appearance settings for the exported GIF. Optimize Colors removes any unused colors from a GIF's color table. Interlace makes the exported GIF display gradually in a browser as it downloads. Do not interlace an animated GIF file, as you may get unexpected results! Smooth applies antialiasing to a bitmap to produce a high-quality bitmap image and improve the text display quality. Dither Solids applies dithering to solid colors and gradients. Remove Gradients will convert all gradients in the movie to solid colors.*

• *Transparent: Sets the transparency of the background and how alpha settings are converted in GIF format. Opaque makes the background a solid color. Transparent makes the background transparent. Alpha sets partial transparency based on the number in the Threshold field.*

• *Dither: Determines how the pixels of all available colors will combine to simulate colors that are not available in the current palette. None will turn off dithering. This usually produces smaller files but may provide a few unsatisfactory colors. Ordered provides quality dithering with a small increase in file size. Diffusion will provide the best quality but will increase both file size and processing time.*

• *Palette Type: Establishes the image's color palette. Web 216 uses the standard 216-color browser-safe palette. Adaptive analyzes the colors in the image and fabricates a unique color table. Web Snap Adaptive is the same as the Adaptive palette option except that it "snaps" very similar colors to their best match in the Web 216 color palette. Custom specifies a palette you have optimized for the selected image.*

• *Max Colors: Sets the number of colors used in the GIF image. This option is only available if you select either the Adaptive or Web Snap Adaptive palette.*

• *Palette: Click on the Ellipsis Button (. . .) to the right of the empty field to browse for, locate, and select the custom palette file you want to use. This option is only available if Palette Type is set to Custom.*

6. Select the JPEG tab and look at its options. See figure 20-12.

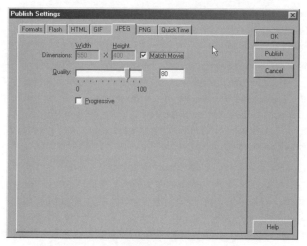

Fig. 20-12. JPEG tab and options.

• *Dimensions:* Allows you to enter a width and height in pixels for the exported bitmap image, or to select Match Movie to make the JPEG the same size as the Flash movie.

• *Quality:* Sets the amount of JPEG file compression to be used.

• *Progressive:* Gradually displays JPEG images in a web browser.

7. Select the PNG tab and look at its options. See figure 20-13.

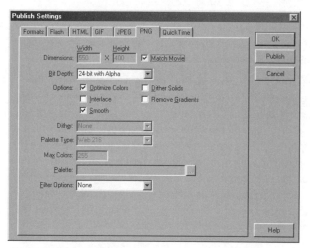

Fig. 20-13. PNG tab and options.

• *Dimensions:* Allows you to enter a width and height in pixels for the exported image, or to select Match Movie to make the image the same size as the Flash movie.

CAUTION

You must have JPEG selected (a check mark placed next to the option) on the Format tab for the JPEG tab to appear in the Publish Settings window.

CAUTION

You must have PNG selected (a check mark placed next to the option) on the Format tab for the PNG tab to appear in the Publish Settings window.

- *Bit Depth: Sets the number of bits per pixel and colors to use in creating the image. Use 8-bit for a 256-color image, 24-bit for thousands of colors, and 24-bit with Alpha for thousands of colors with transparency (32 bits).*

- *Options: These specify the appearance settings of the exported PNG file. Optimize Colors will remove the unused colors from the file's color table. Interlace makes the exported PNG display in a browser incrementally while it is downloading. Smooth antialiases an exported bitmap and improves text display quality. Dither Solids will apply dithering to solid colors and gradients. Remove Gradients will convert all gradients in the movie to solid colors.*

- *Dither: Determines how the pixels of all available colors get mixed to simulate colors that are not available in the current palette. None turns dithering off. Ordered provides quality dithering with only a small increase in file size. Diffusion provides best-quality dithering but will also increase the file size and processing time. This option is only available if Bit Depth is set to 8-bit.*

- *Palette Type: Establishes the image's color palette. Web 216 uses the standard 216-color browser-safe palette. Adaptive analyzes the colors in the image and uses them to generate a unique color table. Web Snap Adaptive is the same as the Adaptive palette option except that it "snaps" very similar colors to their best match in the Web 216 color palette. Custom specifies a palette you have optimized for the selected image. This option is only available if Bit Depth is set to 8-bit.*

- *Max Colors: Sets the number of colors used in the PNG image. This option is only available if you select either the Adaptive or Web Snap Adaptive palette.*

- *Palette: Click on the Ellipsis Button (. . .) to the right of the empty field to browse for, locate, and select the custom palette file you want to use. This option is only available if Palette Type is set to Custom.*

- *Filter Options: This option sets a line-by-line filtering method to make the PNG file more compressible. None turns filtering off. Sub transmits the difference between every byte and the value of the corresponding byte of the prior pixel. Up transmits the difference between every byte and the value of the corresponding byte of the pixel immediately above. Average uses the average of the two neighboring pixels (left and above) to predict the value of a pixel. Path computes a simple linear function of the three neighboring pixels (left, above, upper left), and then chooses as a predictor the neighboring pixel closest to the computed value. Adaptive analyzes the colors in the image and creates a unique color table for the selected PNG.*

8. The Windows Projector Publish option creates an executable (EXE) file that anyone can view if they have the Flash ActiveX plug-in or the Flash Player installed on their system. Viewers do not need to have Flash installed to view this type of file. This file has no Publish options.

CAUTION

When the Windows Projector option is checked on the Format tab, you will not get an accompanying tab in the Publish Settings window in order to further customize this option.

9. The Macintosh Projector Publish option creates an executable file that anyone can view if they have the standalone Flash Player installed on their system. Viewers do not need to have Flash installed to view this type of file. This file has no Publish options.

10. Select the QuickTime tab and look at its options. See figure 20-14.

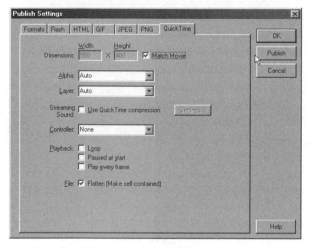

Fig. 20-14. QuickTime tab and options.

- *Dimensions: Allows you to enter a width and height in pixels for the exported QuickTime movie, or to select Match Movie to make the QuickTime movie dimensions match the stage dimensions.*

- *Alpha: Controls the transparency of the Flash track in the QuickTime movie. QuickTime separates audio, video, and Flash content into separate tracks in movies. Alpha Transparent makes the Flash track transparent and shows any content in tracks behind the Flash track. Copy makes the Flash track opaque and masks any content behind the Flash track. Auto makes the Flash track transparent if it is on top of any other tracks, but opaque if it is the bottom track or the only track in the movie.*

- *Layer: Controls where the Flash track plays in the stacking order of the QuickTime movie. Top places the Flash track on top of all other tracks. Bottom places the Flash track behind all other tracks. Auto places the Flash track in front of other tracks if Flash objects are in front of video objects within the Flash movie, and behind all other tracks if Flash objects are not in front.*

- *Streaming Sound: Allows Flash to export all audio within the Flash movie into a QuickTime sound track. This will recompress all audio using the audio settings selected in the Settings window.*

CAUTION

When the Macintosh Projector option is checked on the Format tab, you will not get an accompanying tab in the Publish Settings window in order to further customize this option.

CAUTION

You must have QuickTime selected (a check mark placed next to the option) on the Format tab for the QuickTime tab to appear in the Publish Settings window.

Settings: Only available if the Streaming Sound option is checked. Clicking on this button will open a window in which audio settings can be selected.

Controller: Determines the type of QuickTime controller used to play the exported movie. The options are None, Standard, and QuickTime VR.

Playback: Controls how QuickTime plays a movie. Loop repeats the movie when it reaches the last frame. Paused At Start pauses the movie until a user clicks on a button in the movie or selects Play from the shortcut menu. By default, this option is deselected and the movie begins to play as soon as it is loaded. Play Every Frame displays every frame of the movie without skipping. This option does not play sound.

File Flatten (Make self-contained): Combines the Flash content and any imported video content into a single QuickTime movie.

Optimizing Movie Files

Publish Preview allows you to see how your movie will look in different file formats. For Flash movies that will stream over the Web, looks are not the only issue; performance is often critical. That is why Flash includes the Bandwidth Profiler, which provides you with information about how your movie will stream using slow or fast modem connections.

As you tested your movies during previous practice exercises, you may have noticed that a new set of menu items appeared at the top of the screen when your SWF test file was displayed. You can access the Bandwidth Profiler from this menu that only appears in the SWF file by selecting View | Bandwidth Profiler. See figure 20-15 for a look at the menu used to access the Bandwidth Profiler.

Shortcut

The Bandwidth Profiler shortcut in Test Movie is:

Ctrl + B (PC)

Cmd + B (Mac)

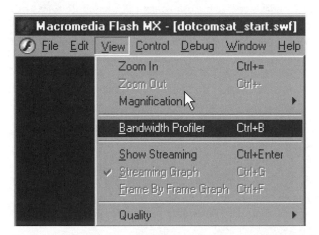

Fig. 20-15. View menu in SWF files to access the Bandwidth Profiler.

·T/P·

The menu option View | Bandwidth Profiler is only available in a Flash SWF file.

Guided Tour 20B: Bandwidth Profiler

You will want to use the Bandwidth Profiler to view the download perform-
ance of your movie in a graphic format. The Profiler shows you how much data
is being sent for every frame of the movie, according to a modem speed you
define. You can use the Bandwidth Profiler to simulate a range of modem
speeds. Remember that the Flash FLA file format is the editable format, and
that the SWF is the Shockwave format you will use to distribute your pro-
grams over the Web. It is the SWF file format you will use with the Bandwidth
Profiler. Let's jump in and give it a try.

1. Select the menu option File | Open. Locate and select the file *sample.swf*
 in the *Chapter20* folder on the companion CD-ROM. This file automati-
 cally loads to the Flash Player, because it is an SWF file. The movie should
 now be running. It does not currently have sound in it, just animation.

CD-ROM

2. Select the menu option View | Bandwidth Profiler to reveal a dynamic bar
 graph that indicates the frame-to-frame download performance of this
 movie, based on the default modem setting (you will change this in a
 minute). See figure 20-16.

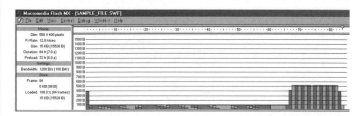

Fig. 20-16. Bandwidth Profiler.

a) The Bandwidth Profiler uses real-world estimates of typical online
 performance (not theoretical speed) to provide the simulation of a
 live download. We all know that our actual connection/download
 speed is generally far less than what is technically possible. For
 instance, a 28.8K modem can optimally download data at about 3.5
 Kbps. Flash, however, will simulate this modem by using a 2.3Kbps
 connection that is more typical of real-world connections. Flash can
 also simulate a 14.4K modem, a 56.6K modem, and other customiz-
 able options. We will look at where we can choose these different
 speeds in the next step, but first let's take a closer look at the
 Bandwidth Profiler.

b) The left side of the Profiler contains various sections that display dif-
 ferent types of information regarding the movie as a whole. These sec-
 tions are Movie, Settings, and State. Let's look at these individually.

• *Movie: This section includes the dimensions, frame rate, size in bytes and kilobytes, duration, and any preloaded frames represented by number of seconds.*

• *Settings: This section shows the available (simulated) bandwidth and varies according to the setting you select under the Debug menu option.*

• *State: This section shows the current state of the movie in terms of the currently loaded frame, percentage of download completed, total frames, and size of any selected frame within the frame-by-frame graph.*

c) The right section of the Bandwidth Profiler – resembling the timeline – shows both the timeline header and graph. Each bar in the graph represents a particular frame in the movie. The height of the bar corresponds to that particular frame's total size in bytes. The taller the line, the more bytes of information that particular frame contains. Any frame block extending above the red line in the graph indicates that the Flash Player may be forced to halt playback until the entire frame downloads.

d) The red line located below the timeline header indicates the maximum real-time bandwidth available based on the current (simulated) connection speed (as specified in the Control menu). You can click on any bar on the graph and see its settings displayed in the left-hand window. Doing this will also stop the movie if it is playing.

3. Select the menu option Debug. The Debug menu options are shown in figure 20-17.

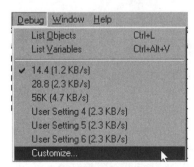

Fig. 20-17. Debug menu options.

a) Select the 14.4 Modem setting. Select Control | Play to watch performance at this speed.

b) Select the 56.6 Modem setting. Select Control | Play to watch performance at this speed.

4. By selecting the menu option View | Show Streaming, you can turn the streaming bar on and off. The streaming bar indicates the number of frames loaded during the simulated download.

5. By selecting the menu option View | Streaming Graph, you can display which frames will cause pauses in the playback. Its default view will display alternating blocks of light gray and dark gray. These blocks represent individual frames. Because the first frame stores a symbol's content, it is often larger than other frames, which hold only instances (copies) of a symbol.

6. By selecting the menu option View | Frame by Frame Graph, you can display the size of each frame. This view helps you see which frames are contributing to streaming delays. If any frame's block extends above the red line in the graph, the Flash Player halts playback until the entire frame downloads.

Guided Tour 20C: Publishing Movies

In this tour you will go through the steps to publish a movie using the Publish Settings menu option. Specifically, you will publish associated HTML and projector files, as well as a size report.

1. Let's export!
 a) Select the menu option File | Open. Locate and select the file named *sample.fla* from the *Chapter20* folder on the companion CD-ROM.
 b) Save (Save As) the file to the *SaveWork* folder on your own system.
 c) Select the menu option File | Publish Settings.
 d) On the Formats panel, select Flash, HTML, and Windows or Macintosh Projector (depending on your system).
 e) Select the Flash panel. Assign the following settings.

 Version: Flash Player 6

 Load Order: Top Down

 Generate Size Report: Selected

 Protect from Import: Selected

 Omit Trace Actions: Not selected

 Debugging Permitted: Not selected

 Compress Movie: Selected

 Password: Blank

 JPEG Quality: 80

 Audio Stream: MP3, 32Kbps, mono

If you have sound clips in your timeline, take the time to look at the Bandwidth Profiler. Sound files can cause movies to skip frames, especially if the Sync option is set to Stream in the Sound panel. Streamed sound can cause the movie to skip frames over slow connections in order for the animation to keep up with the audio track.

CD-ROM

It is generally a good idea to save the final version of a Flash file in its own folder so that it and the other files that are published are easily located and accessed. We are not doing that in the this tour, but in a production environment this tip may help you stay organized.

Audio Event: MP3, 32Kbps, mono

Override Sound Settings: Selected

f) Select the HTML panel. Assign the following settings.

Template: Flash Only

Dimensions: Match Movie

Paused at Start: Not selected

Loop: Selected

Display Menu: Not selected

Device Font: Not selected

Quality: Auto High

Window Mode: Window

HTML Alignment: Default

Scale: Exact Fit

Flash Alignment: Center both Horizontal and Vertical

Show Warning Messages: Selected

Do not click on the following buttons, just read what they do. Clicking on the OK button at this point would allow you to return to the main movie without losing the settings you have assigned. Cancel will clear your selections and return you to the main movie.

g) Let's do go ahead and click on the Publish button to publish the Flash SWF file, a size report, the HTML document, and the Projector file. You should see a progress window briefly appear on screen. Each of these files will be given the same name as the Flash authoring (FLA) file it was published from. After publishing, click on OK to save the settings and return to the main movie.

h) Minimize Flash and look inside the *SaveWork* folder on your computer. You should find a sample report, sample SWF, sample HTML, and sample Projector file. We have also included these files on the companion CD-ROM, in the *Chapter20* folder.

·T*i*P·

If you publish a file without changing the Publish settings by using the menu option File | Publish, Flash will use the default Publish setting. This means that an SWF and HTML file will be automatically generated.

Inserting Flash Movies into HTML Documents

Most projects created in Flash are exported using the Flash Player (SWF) format, and then inserted into HTML documents that can be uploaded to a server and viewed through a web browser such as Internet Explorer or Netscape. (You will see an HTML example in material to follow.) HTML (HyperText Markup Language) is the basic language for creating most pages on the Web. To view things like graphics or multimedia files, such as Flash movies, you must insert a few lines of HTML code that instruct the browser to load and play these files using a particular plug-in. It is helpful to think of HTML as the glue that binds the many elements found on a web page.

The Flash Player Plug-in

Flash movies also require a plug-in in order to play through a browser. A plug-in is a very small software application installed in your browser and used to play various types of media files, such as video and Flash movie files. The Flash Player plug-in is used to launch and play SWF files created in Flash. The Flash Player has been included in the later versions of all major web browsers (including Internet Explorer and Netscape). However, a user may not have the latest version of the Flash plug-in installed. The latest version of the Flash Player can be downloaded from the Macromedia web site at the following address (as of this book's publication date).

www.macromedia.com/downloads/

Shockwave Player Plug-in

The Shockwave Player plug-in is a second Macromedia web player. The Shockwave Player will play both Flash and Director content. It is a larger file than the Flash Player and will take longer to download and install. The latest version of the Shockwave Player can be downloaded from the Macromedia web site at the following address (as of this book's publication date).

www.macromedia.com/downloads/

Sample HTML Code for Flash Files

For many web designers, the idea of hand coding pages that contain multimedia files such as Flash Player movies may seem daunting, but the process is actually easier than most people think. Let's take a look at the source code that was published in the previous practice exercise.

1. Double click on the file named *sample.html*. This file was generated if you completed the previous practice exercise, and is located in the *SaveWork* folder on your computer.

2. In your browser, view the HTML source code.

 a) In Netscape, select View | Page Source. Alternatively, in Internet Explorer, select View | Source.

3. The source code should look something like that shown in figure 20-18.

Fig. 20-18. HTML source code.

Wow! If you do not know anything about HTML, aren't you glad that Flash generated this code for you? Let's look at another possibility.

Inserting Flash Movies into Dreamweaver Documents

For those of you who are looking for some help generating the HTML documents for your Flash movies, you may want to download the trial version of Macromedia Dreamweaver MX. Dreamweaver MX is a powerful web development tool designed to blend seamlessly with Macromedia's other web development software, such as Flash MX and Fireworks MX.

The Dreamweaver MX interface shares many of the same interface elements as Flash MX and the other products in Macromedia's MX software family. Examine figure 20-19. The first thing you will notice is that Dreamweaver is not a timeline-based program. Everything in Dreamweaver centers around the main Document window — a blank window in which you can insert images, text, and multimedia files such as Flash movies.

·T/P·

Trial versions of all of Macromedia's software are available for download at *www.macro media.com/downloads/*. These trial versions are fully functional and are good for a 30-day review before purchase.

Fig. 20-19. Dreamweaver MX interface showing Document window.

In its most basic form, Dreamweaver works like a text editor. You can type text directly into the main Document window, run a spell check, and use alignment and style tools such as bold, italic, right align, and center align. You can easily insert other elements to the page by clicking on icons representing Flash files, URL links, e-mail links, tables, images, Fireworks HTML, rollover images, and other objects.

If you want to insert a Flash movie into your Dreamweaver document, perform the following steps.

1. First, make sure to save your Dreamweaver document. Anything you insert into an HTML file must have an associated path to that file on your hard drive. When the file is displayed in a browser, the browser looks for those files wherever the path tells it to look. A published HTML file and all associated media files reside on a server. When you are creating your file on our hard drive, you can use relative links to establish paths from your HTML file to the media files. You can preserve these links by transferring the directory structure, exactly as it appears on your computer, to the server.

2. Click on the Insert Flash icon located on the Common tab. A dialog box will appear that asks you to find your Flash movie. Find it on your computer and then click on OK.

3. A gray box with a small Flash icon will be inserted into your document. That is all there is to it!

If you would like help learning Dreamweaver, please check out another of our books in the Inside Macromedia Series: *Dreamweaver MX*. This book also includes more details about importing and playing Flash movies from within Dreamweaver.

Guided Tour 20D: Sharing a Library

Shared libraries are an efficient way of creating a central storage area for all elements used in multiple Flash movies, especially for multiple movies in one web site. It is easy to set up a shared library, and equally easy to link to objects in it. So, what does a shared library have to do with exporting and publishing files? For other movies to link to shared elements in a library, the SWF file with a shared library in it must be exported and posted to a web server, where other movies can link to it when they are played back.

1. Let's take a quick look at how to turn a library element into a shared object.
 a) First, find and open the file named *shared.fla* in the *Chapter20* folder on the companion CD-ROM.
 b) Your stage and timeline will be empty when the movie opens, but that is okay because all we are really interested in is the library. Open the library by selecting Window | Library. You should see an assortment of objects and symbols in the library, as illustrated in figure 20-20.

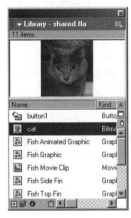

*Fig. 20-20. The **shared.fla** library.*

·T/P·

If the item you want to share is a movie clip, button, or graphic symbol, you can also click on the Properties icon in the library and select the Advanced button in order to view Linkage properties.

 c) Select the *cat* bitmap in the library list. In the Library Options menu, select Linkage from the list, as illustrated in figure 20-21.

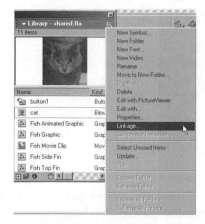

Fig. 20-21. Linkage option in the Library Options menu.

 d) The Symbol Linkage Properties window will appear.

 e) Select the checkbox next to Export for Runtime Sharing to allow the item to be linked to other movies. The Linkage Properties window should now look like what is illustrated in figure 20-22. Do not close this window yet; you will continue to work with it in the steps that follow.

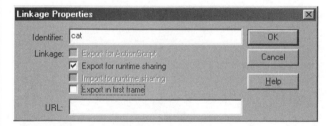

Fig. 20-22. Linkage Properties window.

2. Let's link to a shared library.

 a) For a movie to display any shared elements, you must post your shared library to a web server after the file that contains it has been exported in SWF format. Once it is posted on a web server, any other files that use the shared library will be able to link to it and load it into their movie file.

 b) First, define the URL where your shared library is going to reside. This requires that you know where you want to place the SWF file with the shared library.

 c) In the Linkage Properties window, as shown in figure 20-24, type in the URL where the SWF file will reside, and then click on OK.

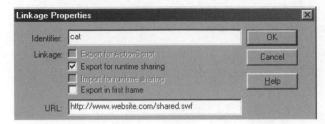

Fig. 20-23. URL field in the Linkage Properties window.

3. Now you can link to a shared library item in your destination movie.

 a) Open the destination movie, or the movie that will link to the shared item. To open a shared library, select the menu option File | Open as Library. Find the movie on your hard drive and double click on it. Notice that only the library opens.

 b) Now you can drag any shared elements out of the shared library and into a new movie. When the movie containing these links is exported, it will look for those library elements at the designated URL, instead of exporting those shared elements in its own library. At runtime, the destination movie will download the shared items from the movie at the designated URL.

C H A P T E R

21

Application Chapter: Building a Preloader

Introduction

Once you have most of your site built, it is time to start thinking about what happens once you publish your site and people start visiting it. As with most sites on the Web, you will have users visiting your site during times of high traffic. Some of these users will also be using very slow Internet connections. These conditions contribute to increased download time and decreased performance on screen.

Because Flash utilizes streaming technology, your user does not have to download the entire movie file before viewing it. Instead, the movie is designed to begin playing as it is being downloaded. This is a terrific Flash feature. However, during less-than-optimal conditions, streaming media will also experience delays and less-than-fluid performance.

A well-designed preloader can make a user's experience much better by letting them know that although the site is still downloading something is happening in the background. A preloader can actually serve to keep the user engaged and interested.

In our continuing quest to actively think about our user's experience, in this exercise we are going to build a preloader to occupy the screen while at least part of the program downloads. By having commonly used elements download in the background as the preloader is on screen, performance for the main program should also be significantly improved.

Application Exercise: Building a Preloader

Description

In this application exercise, you will learn to add a preloader to your main movie site. This exercise will show you how to use Frame actions to control how your movie is initially loaded and displayed.

Take a Look

CD-ROM

Before beginning the exercise, let's take a look at the exercise in its completed state so that you can clearly see what it is you are about to build.

1. Use the menu option File | Open and locate on the companion CD-ROM the folder named *Chapter21*. Locate the file named *application_21.fla*. Double click on this file to open it.

2. The file *application_21.fla* should now appear in your copy of Flash.

3. Select the menu option File | Save As to save a copy of the file in the *SaveWork* folder on your computer using the same file name.

4. Select the menu option Control | Test Movie to view the movie.

Storyboard: On Screen

Figure 21-1 shows what can be seen on stage when the exercise is completed.

Fig. 21-1. Completed stage for the preloader.

Storyboard: Behind the Scenes

Figure 21-2 shows how the timeline will look when the exercise is completed.

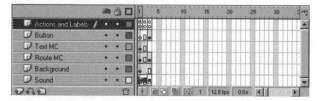

Fig. 21-2. Completed timeline for the preloader scene.

Applications Project Steps

Complete this exercise on your own, guided by following the steps. These steps do not include the details of how to accomplish these tasks, as the "how to" has been covered in earlier chapters. You can always refer back to the completed example you viewed in the "Take a Look" section of this exercise.

NOTE: The following steps are intended as a guide but this is your project, so feel free to make whatever variations you would like.

1. Open *application_19.fla*. You can either use the copy you created previously and saved in the *SaveWork* folder on your computer or the copy in the *Chapter19* folder on the companion CD-ROM.

2. Select the *Preloader* scene and create a new layer named *Actions and Labels*. Move it to the top of the stacking order.

3. Select frame 2 and insert a blank keyframe.

4. Select frame 3 and insert a blank keyframe.

5. Remember the frame labels we assigned to the *Index* scene in an earlier chapter? We will use those to identify when the main body of the web site has been downloaded and is ready for viewing.

6. The last frame of the *Index* scene was labeled *Bulldozer*, and therefore we will target *Bulldozer* as our cue to get out of the preloader.

7. Select frame 1 of the *Actions and Labels* layer and assign the following ActionScript to it.

```
if(_framesloaded >= _totalframes) {
    gotoAndStop("Preloader", 3);
}
```

8. We want to stop the playback when we get to frame 3, so that the viewer can use the Go button that we have placed there. Let's set that up next.

9. Select frame 3 of the *Actions and Labels* layer and assign the following ActionScript to it.

```
stop ();
```

These actions satisfy the *if* condition. Let's work on creating the rest of the conditional loop. What happens if the *if* condition is not met?

10. Select frame 2 of the *Actions and Labels* layer and assign the following ActionScript to it.

```
gotoAndPlay (1);
```

This completes the conditional loop. If the frame is loaded, we will go to frame 3. If the frame is not loaded, we go to frame 2, where we loop back to frame 1 and check again. Easy!

11. Save your file as *application_21.fla* and use Test Movie to watch your preloader at work (do not forget to use the Show Streaming option).

CHAPTER

22

Advanced Actions: Creating Drag-and-Drop Movie Clip Actions

Introduction

This chapter focuses on applying more advanced actions while creating basic and advanced drag-and-drop activities in your Flash movies. The information presented here will build on many concepts learned in earlier chapters, such as nesting symbols inside one another, and adding actions to the timeline. You will also work with a conditional *if/then* statement to set up the target parameters for the drop component of this activity. By the end of this chapter you will be able to:

• *Create a basic drag-and-drop activity*
• *Embed a button in a movie clip*
• *Use the startDrag action to drag a movie clip*
• *Use the stopDrag action to stop the drag action on a movie clip*
• *Customize the ActionScript code for a drop activity*

What is Drag-and-Drop?

Drag-and-drop is an interactive capability in Flash that lets a user move objects on the screen by clicking on and then dragging an object using the mouse. When the user lets go of the mouse button (and the object), the interaction can be programmed to have the object "snap to the center" of a specified location, return to its original location, or stay exactly where the user released the mouse.

The drag-and-drop technique is a great way to reach out and grab the user by the proverbial collar in order to get him to interact with the program you have created. You can ask the user to drag/drop an object to match an item to a list, to "fill in the blank," to place an object in an ordered list, to assemble parts to make a whole, and any number of other possibilities you might imagine and create.

The first rule for setting up a Drag action in your Flash movie is to make sure you are working with movie clips. The only objects that can be used with the Drag action in Flash are movie clips. In figure 22-1, the Actions panel is open and the *Movie Clip Control* subfolder inside the *Actions* folder has been expanded to show the list of possible actions.

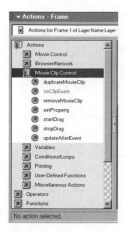

***Fig. 22-1.** Movie clip control actions.*

Once you have an instance of a movie clip symbol inserted into your timeline, you are then able to attach the *startDrag* action to that instance so that a user can move (or drag) this movie clip around the stage. Unless otherwise specified, this movie clip will remain "draggable."

Because a movie clip has a separate timeline that is not dependent on the frames in the main movie timeline, a movie clip can continue to play through its own timeline as it is being dragged. The combination of movie clips and the *startDrag* action has tremendous potential for creative uses in many different types of Flash applications, including gaming activities, educational activities, e-commerce, and other types of interactive web applications.

The *stopDrag* action contains various components that allow you to control what happens when the user stops dragging (and lets go of) the selected movie clip. In Guided Tour 22A, you will take a quick look at the *startDrag* and *stopDrag* actions.

Guided Tour 22A: startDrag and stopDrag Actions

1. Let's open the Flash file you will be working with and look at these new actions.

 a) Select the menu option File | Open. Locate and select the file named *wiggly_start* from the *Chapter22* folder on the companion CD-ROM.

 b) Select the menu option Window | Library to open the *wiggly_start* library.

 c) Drag an instance of the *Wiggly Guy* movie clip onto the stage.

CD-ROM

·T/P·

Remember, an instance is a copy of a library symbol that has been added to your movie.

·T/P·

As you start to add ActionScript code, try to think about what the code is directing your movie to do. In step 2e, there is an event (*onClipEvent*) that triggers a *startDrag* action. The term *Event* refers to things the user does, such as a mouse button or key press, or things that occur in your timeline, such as load or unload. Events and actions often work in tandem, kind of like cause and effect. An event causes or triggers an associated effect (or action).

2. Now let's open the Actions panel and access the *startDrag* and *stopDrag* actions. Remember, these actions can only be applied to movie clips!

 a) Select the instance of the *Wiggly Guy* symbol on the stage.

 b) Expand the Actions panel if it already is displayed on your desktop, or select the menu option Window | Actions to display the Actions panel, if it is not already on your desktop.

 c) Click on the *Actions* folder to expand it. Then click on the *Movie Clip Control* subfolder (please note this subfolder is different than the Movie Control subfolder you will find listed above it) to expand it.

 d) Scroll down the expanded list to find the *startDrag* action.

 e) Double click on the *startDrag* action. The following code is added to the scripting window in the Actions panel, shown in figure 22-2.

   ```
   onClipEvent (load) {
       startDrag ("");
   }
   ```

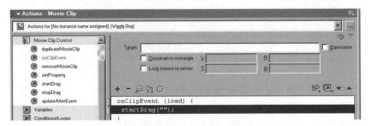

Fig. 22–2. The startDrag code in the Actions panel.

3. This code is the basic architecture of the *startDrag* action. As with most actions, there are parameters (or guidelines for operation) you have the option of assigning. Parameters always appear above the script window in the Actions panel.

4. Select line 1 of the code, *onClipEvent (load) {*. Note that the top of the Action panel has changed and displays the options (or parameters) that are available for Event. Let's take a closer look at these options without changing anything.

Load: This action occurs when the movie clip instance appears in the timeline.

EnterFrame: This action occurs as each frame is played, similar to actions attached to a movie clip.

Unload: This action occurs in the first frame after the movie clip is removed from the timeline.

Mouse down: This action occurs when the mouse button is pressed.

Mouse up: This action occurs when the mouse button is released.

Mouse move: This action occurs every time the mouse is moved.

Key down: This action occurs when a key is pressed.

Key up: This action occurs when a key is released.

Data: This action occurs when data is received in a loadVariables or _loadMovie action.

5. Now select line 2 of the code, *startDrag (" ") ;*, and note that new options (parameters) for this line of code now appear above the Script window in the Actions panel.

 Target: This is the target path of the movie clip you wish to drag.

 Constrain to rectangle (left, top, right, bottom): These are values that relate to the coordinates of the movie clip's parent, and specify a constraint rectangle for the movie clip. These are optional arguments.

 Lock mouse to center: This is a Boolean value that states whether the dragged movie clip is locked to the center of the movie clip (true) or locked where the user first clicked on the movie clip (false). This is an optional argument.

6. You have now looked at the foundation code structure for the *startDrag* action, as well as the respective arguments and parameters used to create a wide variety of drag-and-drop interactions. Many variations are possible within the context of a drag-and-drop interaction because of the large number of options you have to choose from.

7. Close the file without saving it.

Practice Exercise 22-1: Creating a Basic Drag Action

Description

In this exercise you will learn how to attach a Drag action to the Wiggly Guy, an animated character that lives within a movie clip. (You will activate the animation later in the chapter.) You will also experiment with the settings available when using the *startDrag* action, and you will ultimately test your movie to see how it works. In this exercise you will:

* *Resize and reposition a movie clip instance on the stage*

* *Insert the startDrag action and set various associated parameters*

Take a Look

Before beginning the exercise, let's take a look at the exercise in its completed state so that you can clearly see what it is you are about to build.

CD-ROM

1. Use the menu option File | Open and locate on the companion CD-ROM the folder named *Chapter22* and the file named *wiggly_1.fla*. Double click on this file to open it.

2. The file *wiggly_1.fla* should now appear in your copy of Flash.

3. Select the menu option File | Save As to save a copy of the file in the *SaveWork* folder on your computer using the same file name.

4. Select the menu option Control | Test Movie to view the movie. Note the following properties of this completed exercise.

 • *You can click on and drag the Wiggly Guy anywhere on the stage.*

 • *At this point in the exercise, once you have started to drag the Wiggly Guy, the mouse seems "attached to" the Wiggly Guy (he seems to be stuck to the mouse). You will fix that in the next exercise.*

Storyboard: On Screen

Figure 22-3 shows the stage once this exercise is completed.

Fig. 22-3. Completed stage.

Storyboard: Behind the Scenes

Figure 22-4 shows the timeline once this exercise is completed.

Fig. 22-4. Completed timeline.

Step-by-Step Instructions

1. Let's get started!
 a) Select the menu option File | Open. Locate and select the file named *wiggly_start.fla* from the *Chapter22* folder on the companion CD-ROM.
 b) Select the menu option Window | Library to open the *wiggly_start* library.
 c) Drag an instance of the *Wiggly Guy* movie clip onto the stage.
 d) With the instance of the Wiggly Guy selected, use the Properties panel to resize the *Wiggly Guy* movie clip to W=43.8 and H=92 and set his position at X=378 and Y=285.
 e) With the instance of the *Wiggly Guy* movie clip selected, open the Actions panel.
 f) Click on the *Actions* folder in the left-hand portion of the Actions panel to expand the folder. Click to expand the *Movie Clip Control* subfolder. Scroll down the list of actions and double click on *startDrag*. The following code is added to the Script window.

    ```
    onClipEvent (load) {
      startDrag ("");
    }
    ```

 g) Select line 1 of the code. Select *Mouse down* from options listed in the Event options displayed above the Script window. The code now reads as follows.

    ```
    onClipEvent (mouseDown) {
      startDrag ("");
    }
    ```

 h) Select line 2 of the code. Select *Lock Mouse to Center* (it is very important that you select this field by placing a check mark next to it). The code now reads as follows.

    ```
    onClipEvent (mouseDown) {
      startDrag ("", true);
    }
    ```

 i) Select the menu option Control | Test Movie. Click on the Wiggly Guy to begin the drag operation. But whoa, we can drag, but the problem is that we cannot drop him! This is because we did not include a Drop action in the code. Let's close the preview to return to the main movie timeline.
 j) Save your file as *_my_wiggly_1* in your *SaveWork* folder on your computer.

CD-ROM

Go Solo

·T/P·

If your Library panel is in the way, you can dock, or attach it to the panels on the right side of your screen. Hold down your mouse on the dots on the left side of the panel's gray title bar, and drag the panel into place.

·T/P·

Selecting *Mouse down* means that the action will occur when the mouse button is pressed. The user initiates this Mouse-down event and it triggers the *startDrag* action.

·T/P·

true added to this code uses a Boolean statement that says it is true that the mouse will be locked to the center of the movie clip.

2. Next, you will learn an alternate way to attach a Drag or Drop action to a movie clip by nesting a button within the movie clip.

Practice Exercise 22-2: Nesting a Button in a Movie Clip for a Drag Action

Description

Although movie clips are the only symbols that can have Drag and Drop actions attached to an instance, you can always nest other symbols inside a movie clip in order to work around this problem. If you want to use a button symbol behavior that responds to the user's mouse actions, all you have to do is nest a button symbol inside the movie clip symbol. Think of the movie clip as an invisible container that allows you to capitalize on the strengths of both types of symbols.

In this exercise you will build on what you developed in the last exercise, and will insert a button symbol in a movie clip symbol. You will then add a *startDrag* to an instance of the movie clip and see how the button symbol and movie clip work together. In this exercise you will:

- *Edit the Wiggly Guy and add a new layer*
- *Add an Invisible button with an On Mouse Event action*
- *Add startDrag with actions*

Take a Look

CD-ROM

Before beginning the exercise, let's take a look at the exercise in its completed state so that you can clearly see what it is you are about to build.

·TIP·

We have used the WAV format here but have also included the MP3 file in the library, if you would like to exchange the sound files.

1. Use the menu option File | Open and locate on the companion CD-ROM the folder named *Chapter22*. Locate the file named *wiggly_2.fla*. Double click on this file to open it.

2. The file *wiggly_2.fla* should now appear in your copy of Flash.

3. Select the menu option File | Save As to save a copy of the file in the *SaveWork* folder on your computer using the same file name.

4. Select the menu option Control | Test Movie to preview the movie. Note the following properties of this completed exercise.

 - *You can click and drag the Wiggly Guy anywhere on the stage.*
 - *As you drag the Wiggly Guy around, a sound file plays and the Wiggly Guy wiggles.*
 - *You still cannot let go or get the Wiggly Guy to stop screaming!*

Storyboard: On Screen

Figure 22-5 shows the stage once this exercise is completed.

Fig. 22-5. Completed stage.

Storyboard: Behind the Scenes

Figure 22-6 shows the timeline once this exercise is completed.

Fig. 22-6. Completed timeline.

Step-by-Step Instructions

1. Let's get started!
 a) Select the menu option File | Open. Locate and select the file named *wiggly_1* from the *Chapter22* folder on the companion CD-ROM, or use the version (*my_wiggly_1*) you completed and saved in the *SaveWork* folder on your computer from the last exercise.
 b) Select the menu option Window | Library to open the *wiggly_1* library.
 c) Double click on the movie clip symbol for the Wiggly Guy in the library to view the movie clip's timeline in Symbol Editing mode.
 d) Create a new layer in the movie clip's timeline. Name it *Button* and make sure it is at the top of the stacking order.

CD-ROM

Go Solo

e) Lock the *Figures* layer to ensure that you do not accidentally move something in that layer.

f) Select frame 1 of the *Button* layer and drag the *Invisible Button* instance from the library out onto the stage.

g) Position the *Invisible Button* instance directly over the *Wiggly Guy* movie clip that is already on the stage. You can drag the *Invisible Button* instance with your mouse for big movements and use the keyboard arrow keys for small movements. In the Properties panel, type *invisible* in the Instance Name field.

h) With the *Invisible Button* instance selected on the stage, expand or open the Actions panel.

i) Click on the *Actions* folder, and then the *Movie Control* subfolder. Again pay attention that there are two subfolders with similar names. This subfolder is at the top of the list. Scroll down the list of Movie Control actions and double click on the On action. The following code appears in the Script window.

```
on (release) {
}
```

j) Make sure that line one of the code is selected. In the Event options in the top part of the panel, click on the Release option to remove the check mark. Now click on the Press option to place a check mark there. The code now reads as follows.

```
on (press) {
}
```

k) Make sure that line 1 of the code is selected. Now click on the Add New Item to Script button (+ sign above code) and select Actions | Movie Clip Control | *startDrag* from the pop-up menu. In the upper portion of the panel, look for the *Lock mouse to center* option that is located below the Target field. Click on the check box to place a check mark next to the *Lock mouse to center* option (it is important that you do not overlook selecting this option). The code now reads as follows.

```
on (press) {
  startDrag (" ", true) ;
}
```

l) Select the menu option Control | Test Movie. Click on the Wiggly Guy to begin the drag operation. We can drag, but we still cannot drop him! These last steps were designed to show you how to create a drag operation by nesting an instance of a button symbol inside a movie clip symbol.

CAUTION

Make sure you are in Normal mode in the Actions panel in order to follow these instructions.

2. So why should we create a drag operation by using a nested button? Because nesting a button allows us to take the simple drag-and-drop operation and combine it with event-triggered animation and interactivity!

3. Let's add a couple more lines of code and find out why we call this guy "wiggly" in the first place. This will give us an opportunity to explore our options.

4. Let's close the preview to return to the movie clip timeline.

5. Now let's add to the fun.

 a) You should still be in Symbol Editing mode for the *Wiggly Guy* movie clip symbol. If not, double click on the Wiggly Guy in the library. Select the *Invisible Button* instance on the stage and then select line 1 of the code in the Actions panel. Click on the Add New Item to Script button (+ sign), and select Actions | Variables | With from the pull-down menu. The code now reads as follows.

```
on (press) {
  with (<not yet set>) {
  }
  startDrag (" ", true) ;
}
```

 b) With line 2 highlighted, type *invisible* in the Object field located in the panel above the Script window. This field identifies the instance of the button symbol you named *invisible* as the object of this action. The code now reads as follows.

```
on (press) {
  with (invisible) {
  }
  startDrag (" ", true) ;
}
```

 c) With line 2 of the code highlighted, click on the Add New Item to Script button and select Actions | Movie Control | goto. The code now reads as follows.

```
on (press) {
  with (invisible) {
    gotoAndPlay (1);
  }
  startDrag (" ", true) ;
}
```

 d) With line 3 of the code highlighted, look at the top of the panel. In the Frame field, type in 2. The code now reads as follows.

·T/P·

In previous versions of Flash, the Tell Target action was used to control movie clips. In Flash MX, the Tell Target action has been deprecated. It is suggested that you use the With action, as specified in this exercise. The main difference is that Tell Target requires a path string to indicate a movie clip. The With action can be used with both movie clips and other objects because it uses the object as its parameter.

```
on (press) {
  with (invisible)  {
    gotoAndPlay (2);
  }
  startDrag (" ", true) ;
}
```

Now when the drag operation gets initiated, we will be triggering the animation we have set up in frames 2 through 5 of the *Wiggly Guy* movie clip timeline.

e) Select the menu option Control | Test Movie. Click on the Wiggly Guy to begin the drag operations. Ugh! What a noise! This is a quick example of how we can nest a button within a movie clip to trigger other actions along with the drag and drop. It is also a reason to examine the Drop action! Let's do that now.

f) Close the preview window and return to the movie clip timeline. Save your file as *my_wiggly_2* in the *SaveWork* folder.

Practice Exercise 22-3: Drop Actions

Description

So far you have learned how to control the drag portion of the drag and drop. When a movie clip is dropped, a number of things can happen to it, depending on the conditions you set up in your ActionScript. In this exercise you will continue working with the Drag action created in an earlier exercise and learn to set up specific targets for dropping your drag object. To achieve this, you must use advanced components of ActionScript, called conditional statements. The most familiar type of conditional statements, especially to many programmers, is the *if/then* statement. This statement says that if a condition is met, then an event will occur.

One of the great things about using movie clips is that they can serve as drop targets for other movie clips that are being dragged. This means that you can also trigger other movie clips to play, depending on how the *if/then* statement is constructed in the Actions panel. In this exercise you will:

• *Edit the movie clip and* Invisible Button *instance within it to add the* stopDrag *action*

• *Add another* tellTarget *action, coupled with a* Go To, *that will stop the screaming*

Take a Look

Before beginning the exercise, let's take a look at the exercise in its completed state so that you can clearly see what it is you are about to build.

1. Use the menu option File | Open and locate the folder named *Chapter22* on the companion CD-ROM. Find the file named *wiggly_4.fla*. Double click on this file to open it. (You will have a *wiggly_3.fla* file halfway through the current exercise, but the final version of the exercise is *wiggly_4.fla*.)

2. The file *wiggly_4.fla* should now appear in your copy of Flash.

3. Select the menu option File | Save As to save a copy of the file in the SaveWork folder on your computer using the same file name.

4. Select the menu option Control | Test Movie to view the movie. Note the following properties of this completed exercise.

 • *You can click on and drag the Wiggly Guy anywhere on the stage.*

 • *As you drag the Wiggly Guy around, a sound file plays.*

 • *When you let go of the Wiggly Guy outside the target, the screaming stops and Wiggly Guy goes back to his original position.*

 • *When you let go of the Wiggly Guy inside the target, the screaming stops and the Wiggly Guy snaps to the center of the target.*

We have used the WAV format for the file, but have included the MP3 format in the library, if you would like to exchange the sound file formats.

Storyboard: On Screen

Figure 22-7 shows the stage once this exercise is completed.

Fig. 22-7. Completed stage.

Storyboard: Behind the Scenes

Figure 22-8 shows the timeline once this exercise is completed.

CD-ROM

Go Solo

Fig. 22-8. Completed timeline.

Step-by-Step Instructions

1. Here we go.
 a) Select the menu option File | Open. Locate and select the file named *wiggly_2.fla* from the *Chapter22* folder on the CD-ROM, or use the version (*my_wiggly_2*) you completed and saved from the last exercise.
 b) Open the library, if it is not already open.
 c) Double click on the movie clip for the Wiggly Guy (in the library) to open it in Symbol Editing mode.
 d) Select frame 1 of the *Button* layer. Select the *Invisible Button* instance on the stage and open (or expand) the Actions panel. The following code is already there from the previous exercise.

```
on (press) {
  with (invisible) {
    gotoAndPlay (2);
  }
  startDrag ("", true) ;
}
```

 e) Select line 6 of the code (see the Tip in the margin). Click on the *Actions* folder, and on the *Movie Control* subfolder. Scroll down the list of Movie Control actions and double click on the On action. The following code appears in the Script window.

```
on (press) {
  with (invisible) {
    gotoAndPlay (2);
  }
  startDrag ("", true) ;
}
on (release) {
}
```

 f) Make sure line 7 of the code is highlighted. Click on the Add New Item to Script button and select Actions | Movie Clip Control | *stopDrag*. The following code appears in the Script window.

·**T/P**·

To view line numbers, click on the pull-down menu in the upper right-hand corner of the Actions panel (on the gray bar indicated by a bulleted line symbol). Select View Line Numbers. You can also use the blue arrow icon just above the Script window.

```
on (press) {
  with (invisible) {
    gotoAndPlay (2);
  }
  startDrag ("", true) ;
}
on (release) {
  stopDrag ();
}
```

g) Select the menu option Control | Test Movie. Click on the Wiggly Guy to begin the drag operations, and then release the mouse to drop him in place.

Uh-oh, we dropped him but we still need to use another action. We told the target to go to and play frame 2. We now need to tell the target to go back to frame 1 to stop the screaming and wiggling when we release the mouse!

h) Close the preview window and return to the movie clip timeline. Make sure you still have the *Invisible Button* instance selected and that the Actions panel is open. The code from the previous steps reads as follows.

```
on (press) {
  with (invisible) {
    gotoAndPlay (2);
  }
  startDrag ("", true) ;
}
on (release) {
  stopDrag ();
}
```

i) Select line 7 of the code. Click on the Add New Item to Script button and select Actions | Variables | With. Type *invisible* in the Object field located in the panel above the Script window. The following code appears in the Script window.

```
on (press) {
  with (invisible) {
    gotoAndPlay (2);
  }
  startDrag ("", true) ;
}
on (release) {
  with (invisible) {
  }
  stopDrag ();
}
```

·T/P·

We have again stated that an event (*On Mouse Release*) will trigger an action (*stopDrag*).

j) Select line 8 of the code. Click on the Add New Item to Script button and select Actions | Movie Control | *goto*. The following code appears in the Script window.

```
on (press) {
  with (invisible) {
    gotoAndPlay (2);
  }
  startDrag ("", true) ;
}
on (release) {
  with (invisible) {
    gotoAndPlay (1);
  }
  stopDrag ();
}
```

·T/P·

Changing *gotoAndPlay* to *gotoAndStop* tells the *Wiggly Guy* movie clip to go to frame 1 and stop playing through the timeline.

k) Select line 9 of the code. In the panel above the Script window, select the Go to and Stop option (radio button). The code now reads as follows.

```
on (press) {
  with (invisible) {
    gotoAndPlay (2);
  }
  startDrag ("", true) ;
}
on (release) {
  with (invisible) {
    gotoAndStop (1);
  }
  stopDrag ();
}
```

l) Select the menu option Control | Test Movie. Click on the Wiggly Guy to begin the drag operations, and then release the mouse to drop him in place.

m) Close the preview window and return to the movie clip timeline. Save the file as *my_wiggly_3.fla* in the *SaveWork* folder.

n) Finally! We click to drag and wake him up, and release to drop and make him quiet. Now, what do we do if we want him to return to his original location when we drop him?

o) Make sure you still have the *Invisible Button* instance selected and that the Actions panel is open. The code from the previous exercise reads as follows.

```
on (press) {
  with (invisible) {
    gotoAndPlay (2);
  }
  startDrag ("", true) ;
}
on (release) {
  with (invisible) {
    gotoAndStop (1);
  }
  stopDrag ();
}
```

p) Select line 1 of the code. Click on the Add New Item to Script button and select Actions | Variables | Set Variable. In the Variable field (located in the panel above the Script window), type *initial_x*. Make sure the Expression box is *not* checked. In the Value text box, type *_x*. Make sure the Expression box *is* checked. The following code appears in the Script window.

```
on (press) {
  initial_x = _x;
  with (invisible) {
    gotoAndPlay (2);
  }
  startDrag ("", true) ;
}
on (release) {
  with (invisible) {
    gotoAndStop (1);
  }
  stopDrag ();
}
```

q) Select line 2 of the code and right mouse click (Mac: Ctrl + click) over it. Select Copy from the context menu. Right mouse click (Mac: Ctrl + click) again, and select Paste from the context menu.

r) Select line 3 from the code. In the Variable field above the Script window, change the variable name *initial_x* to *initial_y*, and the value *_x* to *_y*. The following code appears in the Script window.

```
on (press) {
  initial_x = _x;
  initial_y = _y;
  with (invisible) {
    gotoAndPlay (2);
```

·TiP·

Remember that a variable is a fixed name for a changing value. The variable *initial_x* stands for the initial *x* coordinate of the Wiggly Guy image on the stage. The variable name allows you to define a value, but we could just as easily have called the variable by a different name in order to define the *x* coordinate. The code *_x* is actually a property that is pre-defined in ActionScript as the *x* coordinate of the movie clip in relation to the parent timeline (main movie, in this case). If you open the Properties book in the Actions panel, you will see the *_x* property. Use the menu option Help | ActionScript Dictionary to look up the meaning of properties and other ActionScript code.

```
        }
        startDrag ("", true) ;
    }
    on (release) {
      with (invisible) {
        gotoAndStop (1);
      }
      stopDrag ();
    }
```

s) That sequence of code creates two new variables: *initial_x* and *initial_y*. On the press of the mouse, these two variables take note of the original X and Y coordinates (*_x* and *_y*) of the movie clip and assign these coordinates numbers to the variables as values. We can now use the Set Property action to recall the value of the original X and Y positions (remember, they are stored in the *initial_x* and *initial_y* variables) and return the dragged movie clip to that position.

t) Select line 9 of the code. Click on the Add New Item to Script button and select Actions | Movie Clip Control | *setProperty*. In the Property field, using the pull-down menu (located in the panel above the Script window), select *_x(X Position)*. In the Value field, type *initial_x*. Make sure the Expression box next to Value is checked. The following code appears in the Actions window.

```
on (press) {
    initial_x = _x;
    initial_y = _y;
    with (invisible) {
      gotoAndPlay (2);
    }
    startDrag ("", true) ;
}
on (release) {
    setProperty ("", _x, initial_x);
    with (invisible) {
      gotoAndStop (1);
    }
    stopDrag ();
}
```

u) Select line 10 of the code and right mouse click (Mac: Ctrl + click) over it. Select Copy from the context menu. Right mouse click (Mac: Ctrl + click) again, and select Paste from the context menu.

v) Select line 11 from the code. In the Property field, use the pull-down menu to change the property *_x(X Position)* to *_y(Y Position)*, and man-

ually type in a change for the value *initial_x* to *initial_y*. The following code appears in the Actions window.

```
on (press) {
  initial_x = _x;
  initial_y = _y;
  with (invisible) {
    gotoAndPlay (2);
  }
  startDrag ("", true) ;
}
on (release) {
  setProperty ("", _x, initial_x);
  setProperty ("", _y, initial_y);
  with (invisible) {
    gotoAndStop (1);
  }
  stopDrag ();
}
```

w) Select the menu option Control | Test Movie. Click on the Wiggly Guy to set the _x and _y values of the two variables, and begin the drag operations. Once you set the _x and _y values, when you release the mouse to drop him, he returns to his initial X and Y position on the stage!

2. Let's add one final twist to the exercise: let's set up a target we can drop him onto. Let's set it up so that if we drop the Wiggly Guy over the target area he will snap to its center, but if he falls outside of it he will return to his original spot. This will take a little deleting, rewriting, and rethinking through the exercise.

We will first change the "how" of establishing the initial X and Y positions. Currently the X and Y positions are set on the mouse click. Therefore, if the Wiggly Guy is outside the target area he will return to the spot established on the mouse click. In this case, if he does not land in the target area he will always return back to this same spot.

But what happens to the Wiggly Guy once he lands within the target area and we start to drag him again? If the target is his starting point on the mouse click, he will return to this starting point if he lands inside (because we coded him to do so). If he lands outside the target area he will also return back inside the target area because the initial mouse click established an X and Y position inside the target area.

What do we do then? Easy: we establish the initial X and Y of the *Wiggly Guy* movie clip when it first loads into the movie (instead of on the mouse click).

3. So let's give it a try, and set up the target.
 a) Close the Preview window and return to the movie clip timeline.
 b) Click on the Scene 1 tab below the timeline to return to the main movie timeline.
 c) Insert a new layer in the main movie timeline. Rename it *Target* and make sure it is at the bottom of the stacking order.
 d) Select frame 1 in the *Target* layer.
 e) Select the menu option Window | Library to open the library. Drag an instance of the *Drop Target* movie clip to the top left-hand part of the stage. (You might need to collapse the Actions panel to see your stage better.) Make sure the instance of the *Drop Target* movie clip is selected on the stage, and then expand the Properties panel.
 f) Type *target_area* in the Instance Name field. This is a unique name we assigned to this particular instance of the *Drop Target* movie clip to distinguish it from any other instances (copies) of the symbol we might add to the movie later on.

4. Now to reestablish the initial X and Y positions.
 a) Select the instance of the *Wiggly Guy* movie clip on the stage.
 b) With the instance of the *Wiggly Guy* movie clip selected on the stage, expand the Actions panel. If you have been using the exercises you created and saved previously, you may see code associated with the Wiggly Guy movie clip from these earlier exercises. Carefully delete this code by highlighting it and clicking on the Minus icon. However, before you delete anything, make sure you are in the Scene 1 timeline.
 c) Click on the Add New Item to Script button and select Actions | Variables | *Set variable* from the pull-down menu. In the Variable field above the Script window, name the variable *initial_x*, and in the Value field, assign a value of *_x* (make sure Expression is checked next to Value).
 d) Keep line 2 of the code selected.
 e) Add another Set Variable action by copying/pasting as you previously learned to do with the right mouse click (Mac: Ctrl + click). Name the variable *initial_y*, and assign a value of *_y* (make sure Expression is checked next to Value). The code now reads as follows.

```
onClipEvent (load) {
   initial_x = _x;
   initial_y = _y;
}
```

CAUTION

Before you delete anything, make sure you are in scene 1, and are *not* in Symbol Editing mode for the Wiggly Guy.

This creates two new variables, *initial_x* and *initial_y*, and assigns them values equal to the X and Y positions of the movie clip when it loads into the movie. This establishes the "return" point for the movie clip if we release it outside the target area. We need to adjust the existing code to accommodate these two variables.

5. Let's rewrite the movie clip ActionScript attached to the nested invisible button.

 a) Collapse the Actions panel. Double click on the movie clip symbol for the *Wiggly Guy* movie clip in the library to enter Symbol Editing mode.

 b) In the *Wiggly Guy* timeline, select the *Invisible Button* symbol instance on stage and expand the Actions panel. The code from the previous exercise reads as follows.

```
on (press) {
  initial_x = _x;
  initial_y = _y;
  with (invisible) {
    gotoAndPlay (2);
  }
  startDrag ("", true) ;
}
on (release) {
  setProperty ("", _x, initial_x);
  setProperty ("", _y, initial_y);
  with (invisible) {
    gotoAndStop (1);
  }
  stopDrag ();
}
```

For the remainder of the exercise we will work in Expert mode so that we can type in our own code. (Come on now, this is getting pretty familiar to you by now!) Click on the Option menu at the top right of the gray bar in the Actions panel, and select Expert Mode. This will allow us to write our own code in the Actions panel, just as we would write in a text editing program.

 c) Drag the mouse over lines 2 and 3 to select them. Press the Delete key to delete lines 2 and 3. The code now reads as follows.

```
on (press) {
  with (invisible) {
    gotoAndPlay (2);
  }
  startDrag ("", true) ;
}
```

```
on (release) {
  setProperty ("", _x, initial_x);
  setProperty ("", _y, initial_y);
  with (invisible) {
    gotoAndStop (1);
  }
  stopDrag ();
}
```

d) Next, click the mouse at the very end of the line that reads *on (release)* { to create an insertion point for new text. Press the Enter/Return key and type in the following code.

```
if (eval(_droptarget) == _root.target_area) {
  setProperty ("", _x, _root.target_area._x);
  setProperty ("", _y, _root.target_area._y);
  with (invisible) {
    gotoAndStop (1);
  }
  stopDrag ();
} else {
```

This code creates the conditional statement for us that says that if we drop the dragged movie clip on the instance named *target_area* (our *_droptarget*), then we will assign the dropped movie clip the same X and Y coordinates as the *_droptarget*. It will also go to frame 1 and stop playing.

The } *else* { line we wrote tells the movie clip what to do if the condition is not met. In this case, the movie clip will snap back to its original X and Y positions (established when the movie clip loaded and recorded in the variables *initial_x* and *initial_y*). The complete code now reads as follows.

Click the mouse at the very end of the last line and press the Enter/Return key. Type in another } at the end of the code.

```
on (press) {
  with (invisible) {
    gotoAndPlay (2);
  }
  startDrag ("", true) ;
}
on (release) {
  if (eval(_droptarget) == _root.target_area) {
    setProperty ("", _x, _root.target_area._x);
    setProperty ("", _y, _root.target_area._y);
    with (invisible) {
```

```
            gotoAndStop (1);
          }
        stopDrag ();
      } else {
        setProperty ("", _x, initial_x);
        setProperty ("", _y, initial_y);
        with (invisible) {
          gotoAndStop (1);
        }
        stopDrag ();
      }
    }
```

e) It's pretty easy to make typing mistakes while writing code, so go back and carefully check your code line-by-line with the code above. Correct it as needed.

f) Select the menu option Control | Test Movie. Drop the Wiggly Guy over the target and he snaps to the center. Drop him outside the target, and he returns to his original position.

g) Save the file as *Wiggly_4* in the *SaveWork* folder. Outstanding job!

·T*i*P·

The *_droptarget* code is a property that can be found inside the Property Actions book in the Actions panel. The *_droptarget* property allows you to compare the specified target area with the coordinates of the mouse release. If they are equal to the target area, the *x* and *y* coordinates of the dragged movie clip instance do not revert to the initial *x* and *y* positions, but instead go to the *x* and *y* coordinates of the target area.

CHAPTER

23

Creating Forms

in Flash

Introduction

As you develop Flash web sites, at some point you may want to gather information from site visitors. In Flash, you can create interesting forms with editable text fields that look as inviting as the rest of your site. Instead of standard HTML-based forms and surveys that look rather ordinary and institutional, forms in Flash can be designed using any of Flash's drawing and animation tools. These sections of your Flash web site can be as creatively designed and crafted as any other aspect of your site. They can be fun, interactive, and engaging for your site visitors. If they are visually interesting, more people may want to fill out your forms.

Just as with other functions in Flash, editable text fields can be put to many other uses. Do not limit yourself to thinking only about forms as you go through this chapter. Think about how you might incorporate editable text fields into games, instructional activities, and anything else you may dream up for your site. By the end of this chapter you will be able to:

- *Insert editable text fields*
- *Use the Text Options panel*
- *Set variables for text fields*
- *Describe how forms are processed*
- *Create a form*

Editable Text Fields

You have had plenty of practice in previous chapters using the Text tool in the toolbox to insert text elements as part of your project. In this chapter we are going to create input text boxes so that your users can type in text as they respond to survey questions on your site. We will use the Properties panel to select the type of text object to use. Figure 23-1 shows these options in the pull-down menu in the Properties panel. We covered some of this information in Chapter 7, but to review, the following summarize the text options available to you.

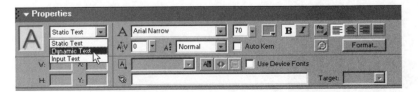

Fig. 23-1. Text type pull-down menu in the Properties panel.

Static text: Static text is the most commonly used text type in Flash applications that do not require dynamically updated information, or input by the user. Unlike text formatted with HTML tags, static text in Flash allows you to select specific fonts to apply to your text, so that they can then be embedded into the final SWF file that is exported. This preserves the visual appearance of the font you have applied to your text, and ensures that the font displays accurately in the user's Flash Player. You can also use device fonts with static text.

Dynamic text: Dynamic text is updated by information provided by a server-side software application (Macromedia's Generator, as an example) that feeds new information to the Text field. This is useful in applications for which frequently updated information is valuable, such as with stock quotes or weather information. Dynamic text is updated by specifying variables, or fixed names associated with a changing value. These changing values might be such as numbers for stock quotes that are constantly being updated, and "fed" to the Dynamic Text field.

Input text: Input text boxes are invisible text boxes that have a variable attached to them, just like dynamic text. However, input text allows you to set up text fields that require a visitor to type information into these fields. The visitors to your site have an opportunity to supply feedback using forms, to make purchases (e-commerce), and otherwise interact by providing information in these text fields.

Guided Tour 23A: Text Options in the Properties Panel

First, let's take a look at the fields related to text in the Properties panel, and learn how to use them to create forms. Figure 23-2 shows the Text Options panel with the default options displayed.

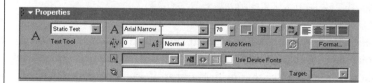

Fig. 23-2. Properties panel showing the default static text options.

1. Select File | New to open a new file.

2. Select the Text tool. The Properties panel will change to reflect text options.

3. Click on the pull-down menu for the Text type field located on the left-hand side of the panel. Note that this field has three options for setting the behavior of text in your Flash movie. The default setting for text boxes to

be inserted is Static Text, with Dynamic Text and Input Text as the other available options. You used the Static Text option in a previous exercise.

4. Now select Dynamic Text. This option gives you a range of new settings, as illustrated in figure 23-3. You can use dynamic text boxes to automatically and dynamically update information, such as daily temperature, stock prices, and other rapidly changing types of data. The use of dynamic text boxes generally requires some type of server-side support, such as a database that supplies the information to be displayed in the dynamic text box.

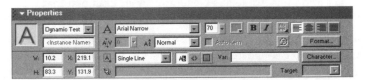

Fig. 23-3. Properties panel showing the Dynamic Text options.

4. Now go back to the pull-down menu for the Text type field and select the Input Text option and look at the available settings, as shown in figure 23-4. We are going to take a little closer look at these options because we will be working with them in the following practice exercise.

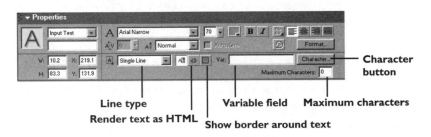

Character button

Line type
Render text as HTML Show border around text Variable field Maximum characters

Fig. 23-4. Properties panel showing the Input Text options.

Line Type Menu: Click on the pull-down menu and take a look at the options: Single Line, Multiline, Multiline No Wrap, and Password. The option you select here will depend on the type of text field you need. If you are asking for information such as a site visitor's last name, a Single Line option will be sufficient for inputting this type of information. In other cases, you might need to provide space for a longer reply, such as for an answer to a survey question. Use the Multiline setting for longer responses. Multiline No Wrap indicates that the text will *not* automatically wrap to the next line when the right-hand border of the text box is reached. The last setting is Password. This option affects how the text entered by the user is displayed in the text field. Typically circles, squares, or other symbols "cover up" whatever you type as your password in a browser.

Render Text as HTML: This field allows you to retain rich text formatting in your text field, including such things as font styles using HTML tags.

Show Border Around Text: This button turns on the border outline and border color for the text box so that the input box is visible.

Variable: Perhaps one of the most important fields in the current panel is the Variable field. A variable is a name given to a value that changes depending on circumstance. We will use variables in the practice exercise later in this chapter.

Max. Chars: Once you have chosen which line type response is appropriate, you will also need to set the upper limit of characters the user can type in. The Maximum Character field is where you set this limit.

Character Button: The Character button contains Embed Font options that allow you embed the outlines of an entire character set, or only certain characters from a font in your exported SWF file. These options are (from top to bottom, as illustrated in figure 23-5): No Characters, All Characters, Only Uppercase Letters (A-Z), Only Lowercase Letters (a-z), Only Numerals (0-9), Only Punctuation (!@#$%...), and Only And These Characters (additional characters). You can turn on any or all of the "Only" selections simultaneously.

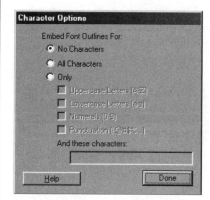

Fig. 23-5. Embed Font options in the Character Options window.

Form Processing

When we set up forms in Flash, we are essentially setting up a front end – what the user actually sees – with a lot of details behind the scene. It is a little like setting up a display in a store window: there is much more inside the store, and the point of the display window is to get shoppers to come through the door. Forms in Flash are like window dressing. Once the user fills them out, the processing takes place on the back end; that is, behind the scenes on the web server.

Web forms on HTML pages are often processed by CGI scripts that reside on the web server. Once the user presses the Submit button, the data in the form is sent to this script, which then processes the information and puts the data into categories based on the variable names set up in the form. Often this data is e-mailed to someone, or added to a database – depending on the script used to process it. Flash uses actions to send ("pass") the variables you set up in your text fields to a web server for processing.

A CGI script is an example of a server-side application because it is a program that executes on a web server. CGI applications can be written in several programming languages, including C, Perl, Java, and Visual Basic. Examples of CGI applications include search features, guestbooks, and other types of functions in which data needs to be submitted and processed for collection. When a user submits the data within a form (usually by pressing a Submit button), the associated CGI script is triggered and begins to run through its tasks.

The opposite of a server-side application is a client-side application. A client-side application runs on the end user's machine instead of on the web server. Often, client-side applications run through a user's browser and are written as Java scripts, applets, or ActiveX controls.

Practice Exercise 23-1: Creating a Form

Description

We have looked at the various settings in the Text Options panel. In this exercise you will set up a form for a web site. In this exercise you will:

- *Create a design for a form*
- *Insert input text boxes*
- *Assign variables to those boxes*

Take a Look

Before beginning the exercise, let's take a look at the exercise in its completed state so that you can clearly see what it is you are about to build.

1. Use the menu option File | Open and locate the folder named *Chapter23* on the companion CD-ROM. Look inside this folder and locate the file named *form.fla*. Double click on this file to open it.

2. The file *form.fla* should appear on your screen.

3. Take a look at the form you will create on the stage.

4. Select the menu option File | Save As to save a copy of the file in the *SaveWork* folder on your computer using the same file name.

5. Select the menu option Control | Test Movie to preview this file.

6. Fill out the form so that you can see how it works. When you are finished, close this file and let's get started! Note the following properties of this completed exercise.

 • *The form allows the user to type in all relevant information.*

 • *Behind the scenes, all user information is stored in variables.*

 • *There is no Submit button for sending the form for processing.*

Storyboard: On Screen

Figure 23-6 shows how the stage will look once you have completed this exercise.

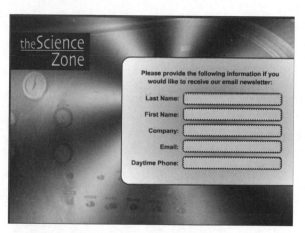

Fig. 23-6. Completed stage.

Storyboard: Behind the Scenes

Figure 23-7 shows you what the timeline will look like when the exercise is completed.

Fig. 23-7. Completed timeline.

Step-by-Step Instructions

1. Let's start with a blank document.
 a) Select the menu option File | New to create a new Flash file.
 b) Select the menu option Modify | Document to open the Movie Properties box.
 c) Change the background color to black and click on OK.
 d) Now that you have created your base file, select the menu option File | Save and save the file in the *SaveWork* folder, typing in the file name *myform.fla*.

2. Now we need to add elements to the library so that we can start building this form.
 a) Select the menu option File | Open as Library.
 b) Locate and select the file *form_items.fla* in the *Chapter23* folder on the companion CD-ROM.
 c) When you open a movie as a library, the only thing that appears on your stage is the movie library, as illustrated in figure 23-8. These symbols will be added to the *myform.fla* library once they are dragged to the stage.

Fig. 23-8. New library from Open as Library command.

3. Now that we have symbols to work with, let's start building.
 a) Double click on layer 1 in the timeline and rename it *Background Image*.
 b) Look in the *form_items* library and drag the bitmap *machinebkg.jpg* to the stage. Position it so that it covers the background of the stage.
 c) Once you get the image in place, lock this layer.
 d) Create a new layer above the *Background Image* layer and name it *Logo*.
 e) Drag the *Logo* symbol from the *form_items* library and place it on the stage.
 f) In the Properties panel, set the *x* coordinate to 0.0 and the *y* coordinate to 31.0.
 g) Lock the *Logo* layer.
 h) Create a new layer above the *Logo* layer and name it *Form Background*.
 i) Drag the *box* symbol to the stage and set the *x* coordinate to 217 and the *y* coordinate to 76.
 j) Lock the *Form Background* layer.

4. The background is set. Now let's create the text for our form.
 a) Create a new layer above the *Form Background* layer and name it *Form Text*.
 b) Select the Text tool in the toolbox and click anywhere on the stage to insert a new text box.
 c) Expand the Properties panel.
 d) Make the following selections in the Properties panel: Select Static Text from the pull-down menu; set the Font option to Arial; set the Size option to 12, and change the Color option to Black and Bold; and activate the Right Alignment option.
 e) Click in the text block on the stage and type in the following (pressing the Enter/Return key twice after each line).

 Last Name:

 First Name:

 Company:

 Email:

 Daytime Phone:

 f) Create a new text box with the same settings. This time, however, change the alignment setting to Center.
 g) In the new text box, type in the following (you can wrap the text into the second line at whatever break point you would like).

 Please provide the following information if you

 would like to receive our email newsletter:

 h) Move both text blocks until they are arranged as shown in figure 23-9.

·T*i*P·

You can use your Arrow tool to reposition text boxes on the Stage. However, remember that if you want to resize a text box, you must select the Text tool first and then use the handle to resize the box.

409

i) Save your file.

Fig. 23-9. Text form in progress.



·T/P·

To view just the elements on the stage, select View | Work Area to turn off visibility of the gray work area around the stage.



5. Almost finished! The final step is to add the input text fields and set up the variables.
 a) Add a new layer to the timeline above the other layers. Name this layer *Text Field Background*.
 b) From the *form_items* library, drag the *text_entry* symbol to the stage. Add an instance of this symbol next to each form element, as illustrated in figure 23-10.
 c) Turn on the rulers by selecting the menu option View | Rulers. Drag a guide line from the left-hand ruler to use as a placement guide, if necessary.
 d) Lock the *Form Background* layer and the *Form Text* layer.

Fig. 23-10. Positioning the text_entry symbols.

 e) Create a new layer and name it *Input Text*. Make sure it is the top layer.
 f) Select the Text tool from the toolbox.

g) In the Properties panel, select Input Text from the Text type pull-down menu.

h) Click and drag over the green field next to Last Name to create an input text box. Use the Arrow tool to reposition as necessary.

i) Select the Input text box next to Last Name and take a look at your Properties panel. Set the Line type field to Single Line, set Max Char to 50, and name the variable *lastname*. Make sure the HTML and Border buttons are turned off.

j) Make sure your alignment is set to Left.

k) Set the text options to Arial, Black, Bold, 12.

l) Repeat steps *f* through *k* for the other four form fields, giving them the following variable names: *firstname*, *company*, *email*, and *phone*.

m) Save your file.

n) Select Control | Test Movie to see how your form works.

o) Good job! In the next chapter you will learn to add a Submit button to make your form functional.

CHAPTER 24

Application

Chapter:

Information Form

Introduction

In many instances, you might want to gather information from the visitors to your site for marketing purposes, or just to find out what types of things they like or dislike about your site's design. Creating forms and surveys using editable text fields in Flash is an easy way to obtain feedback about your site. You can also use ActionScripts to send that information to a script on a server that collects and stores the data in a specified manner.

Application Exercise: Information Form

Description

Now that you have the bulk of your site built, we can add some bells and whistles. First, you will build an input form for the visitors to your site to fill out. You will then make your form functional so that you can collect the information you have asked for from your site visitors.

Take a Look

CD-ROM

Before beginning the exercise, let's take a look at the exercise in its completed state so that you can clearly see what it is you are about to build.

1. Use the menu option File | Open and locate on the companion CD-ROM the folder named *Chapter24*. Locate the file named *application_24.fla*. Double click on this file to open it.

2. The file *application_24.fla* should now appear in your copy of Flash.

3. Select the menu option File | Save As to save a copy of the file in the *SaveWork* folder on your computer using the same file name.

4. Select the menu option Control | Test Movie to view the movie.

Storyboard: On Screen

Figure 24-1 shows what can be seen on stage when the exercise is completed.

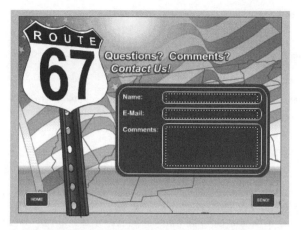

Fig. 24-1. Completed stage for the information form.

Storyboard: Behind the Scenes

Figure 24-2 shows how the timeline will look when the exercise is completed.

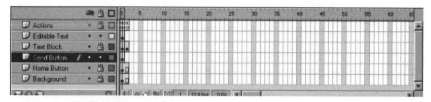

Fig. 24-2. Completed timeline for the contact scene.

Application Project Steps

Complete this exercise on your own, guided by following the steps. These steps do not include the details of how to accomplish these tasks, as the "how to" has been covered in earlier chapters. You can always refer back to the completed example you viewed in the "Take a Look" section of this exercise.

NOTE: The following steps are intended as a guide, but this is your project, so feel free to make whatever variations you would like.

1. Open *application_21.fla*. You can either use the copy you created and saved in the *SaveWork* folder on your computer or the copy in the *Chapter21* folder on the companion CD-ROM supplied with this book.

2. Go to the *Contact* scene.

3. Create a new layer and name it *Actions*. Position it at the top of the layer stacking order.

4. Select frame 1 of the *Actions* layer and assign it the following ActionScript.

    ```
    stop ();
    ```

5. Select frame 2 of the *Actions* layer and insert a keyframe. Assign the following ActionScript to frame 2 of the *Actions* layer.

    ```
    stop ();
    ```

6. Create a new layer and name it *Text Block*. Position it above the *Home Button* layer.

7. With frame 1 of the *Text Block* layer selected, drag an instance of the *Text Block* graphic symbol out of the *Graphic Images* folder of the library and onto the stage. Position it at X=423.6, Y=278.6.

8. Select frame 2 of the *Text Block* layer and insert a keyframe.

9. With frame 2 of the *Text Block* layer selected, drag an instance of the *Thank You* block graphic symbol out of the *Graphic Images* folder of the library and onto the stage. Position it at X=423.6, Y=278.6.

10. Lock all layers of the *Contact* scene.

11. Create a new layer and name it *Editable Text*. Position it above the *Text Block* layer.

12. Delete frame 2 of the *Editable Text* layer.

13. Select frame 1 of the *Editable Text* layer.

14. Create a text block that corresponds to the "Name" space of the *Text Block* symbol. Assign it the following properties. Make sure no other properties are checked or selected.

 Text Type: Input Text

 Font: _sans

 Font Height: 14

 Font Color: White

 Align: Left Justified

 Line Type: Single Line

 Variable: visitorName

 Max Characters: 35

15. Create a text block that corresponds to the "E-Mail" space of the *Text Block* symbol. Assign it the following properties. Make sure no other properties are checked or selected.

 Text Type: Input Text

 Font: _sans

 Font Height: 14

 Font Color: White

 Align: Left Justified

 Line Type: Single Line

 Variable: visitorEmail

 Max Characters: 35

The script you use on your server to process form data may require specific names for your variables. For your own projects, check the "Read Me" files associated with your script to make sure.

16. Create a text block that corresponds to the "Comments" space of the *Text Block* symbol. Assign it the following properties. Make sure no other properties are checked or selected.

 Text Type: Input Text

 Font: _sans

 Font Height: 14

 Font Color: White

 Align: Left Justified

 Line Type: Multiline

 Selectable: Selected

 Variable: visitorComments

 Max Characters: 5000

You can add hidden variables to your form by selecting the first frame of the first layer and using a Set Variable action.

Now that we have the graphics in order, let's set up an ActionScript that will be similar to what you will use to customize forms on your own web site. In this exercise, we will use a fictitious web address, which you can use as a model.

17. Create a new layer and name it *Send Button*. Position it above the *Home Button* layer.

18. Delete frame 2 of the *Send Button* layer.

19. Select frame 1 of the *Send Button* layer.

20. Drag an instance of the *Send Button* symbol out of the *Buttons* folder of the library and position it at X=597.4, Y=447.1.

·T/P·

The *Get URL* code sends the form variables and values to a script, usually located in the CGI bin of your Web site's server.

21. Assign the following ActionScript to the *Send Button* symbol.

```
on (press) {
  Get URL("http://www.YourDomainNameHere.com/cgi-
      bin/script.pl","_self","POST");
}
on (release) {
  gotoAndStop (2);
}
```

Now let's go back to the *Index* page and set up navigation to this page.

22. Select the *Index* scene.

23. Select the instance of the *Exit 101* button symbol on the stage and assign the following ActionScript to it.

```
on (release) {
  gotoAndStop ("Contact", 1);
}
on (release) {
  Selection.setFocus( "visitorName" );
}
```

The first three lines should look familiar enough, and the following lines set up a blinking cursor in the first input text field you created. This is a visual cue for the viewer to start typing (and in the spot we want them to start typing!).

24. Save the file as *application_24.fla*.

C H A P T E R

25

Application

Chapter:

Publishing

the Site

Chapter Topics:

- *Introduction*

- *Application Exercise: Publishing the Site*

Introduction

Once you have completed your Flash web site, it remains to publish and deliver it to your audience. Flash's Publish Settings and Export features give you multiple options for saving your movies into a format for web delivery, for CD-ROM delivery, or for using single frames of your movies as static graphics.

Once you have published your site, what happens next? The next step is to put your site on a server in order for people to connect to it. Using the Publish Settings window in Flash, you will have an HTML file with an accompanying SWF file ready to be put on a web server. Transferring data to a server uses a vehicle known as the File Transfer Protocol (FTP). There are many FTP software programs you can download free of charge, or as shareware at a nominal fee.

WS_FTP is a popular program for the PC, whereas Fetch is a program popular with Mac users. If you use Dreamweaver to design your web pages, you can use the built-in FTP program found in the site management tools. Whichever FTP program you choose, you will need some basic information to connect to your server. In general, you will need a host name (server name), a user ID, and a password. These details vary depending on the server account you are using.

This application chapter will walk you through publishing your *Route 67* site, but you must have access to your own web server space to actually post the files to a server. Server space is not provided with this book. If you have an Internet service provider for a dial-up account, chances are you may have a small amount of server space for personal use that comes with your dial-up connection. You may want to contact your provider and find out. Let's get started with your last application exercise.

Application Exercise: Publishing the Site

Description

In this application exercise you will publish your finished *Route 67* project and get it ready for posting on a web server. Although you will not actually post it on a server, you will be given general instructions for how you can do this with your own server space. First, let's get your site published and ready to go.

Take a Look

Before beginning the exercise, let's take a look at the exercise in its completed state so that you can clearly see what it is you are about to build.

1. Locate the folder named *Chapter25* on the companion CD-ROM. Find the file named *application_final.html*. Double click on this file to open it in your default web browser.

2. The file *application_final.html* should now appear in your default web browser.

3. Select the menu option File | Save As to save a copy of the file in the *SaveWork* folder on your computer using the same file name.

4. Select the menu option Control | Test Movie to view the movie.

Storyboard: On Screen

Figure 25-1 shows what can be seen in your web browser when the exercise is completed.

Fig. 25-1. The published movie within a browser window.

Storyboard: Behind the Scenes

Figure 25-2 shows you how your new *mysite* folder will look once your files have been published. Your *mysite* folder might have additional files in it, depending on the options chosen in the Publish Settings option.

Fig. 25-2. The mysite folder.

Application Project Steps

Complete this exercise on your own, guided by following the steps. These steps do not include the details of how to accomplish these tasks, as the "how to" has been covered in earlier chapters. You can always refer back to the completed example you viewed in the "Take a Look" section of this exercise.

NOTE: The following steps are intended as a guide, but this is your project, so feel free to make whatever variations you would like.

1. Open *application_24.fla*. You can either use the copy you created and saved in the *SaveWork* folder on your computer or the copy in the *Chapter24* folder on the companion CD-ROM.

2. Create a new folder on your hard drive and name it *mysite*.

3. Save a copy of your file as *application_final.fla* in the new *mysite* folder. This will help keep the files you are going to publish organized.

4. Open the Publish Settings option by selecting the menu option File | Publish Settings.

5. You want to create files in the SWF as well as HTML format, in that you are going to publish this movie on the Web.

6. On the Flash tab in your Publish Settings option, make selections for the options Load Order, Options, JPEG Quality, Audio Settings, and the appropriate version of Flash.

7. On the HTML tab in your Publish Settings option, make selections for the options Template, Dimensions, Playback, Quality, Window Mode, HTML Alignment, Scale, and Flash Alignment.

8. Click on the Publish button to publish your new files in the *mysite* folder.

9. Find and open the *mysite* folder on your computer. Double click to open the HTML file in your default browser, to check out what you have created.

10. You now need to "FTP" your file to a web server. You may want to check with your Internet service provider to see if you are entitled to server space along with your dial-up account. If you do have server space, you will also need a host name, user ID, and password to get into the server space.

11. You will also need an FTP program. Figures 25-3 and 25-4 show examples of the information required, respectively, for WS_FTP and Fetch. The information entered in these fields is not a valid FTP site.

Fig. 25-3. WS_FTP connection screen.

Fig. 25-4. Fetch connection screen.

12. Once you are connected to a server using your FTP program, you can copy files from your hard drive to the server. In figures 25-5 and 25-6, you can see how the screens for WS_FTP and Fetch, respectively, will look once you have connected to the server. Notice that you can see the directory structure for the server and can choose which folder to put things into. Most servers have a *public_html* or *www* folder in which you can publish your files so that they will be available on the Web.

Fig. 25–5. WS_FTP interface when connection is established to a server.

Fig. 25–6. Fetch interface when connection is established to a server.

INDEX